# ART TALK
## THE EARLY 80S

# ART TALK
## THE EARLY 80s

Edited by
Jeanne Siegel

A DA CAPO PAPERBACK

Library of Congress Cataloging in Publication Data

Artwords 2.
  Art talk: the early 80s / edited by Jeanne Siegel.
      p.   cm. – (A Da Capo paperback)
  Reprint. Originally published: Artwords 2. Ann Arbor, Mich.: UMI Research Press, c1988.
  Includes index.
  ISBN 0-306-80414-X (pbk.)
  1.  Art, Modern – 20th century – Themes, motives. I. Siegel, Jeanne. II. Title.
N6490.A73  1990                  90-3711
700'.9'048 – dc20                    CIP

## for my father

This Da Capo Press paperback edition of
*Art Talk: The Early 80s* is an unabridged
republication of the edition published in
Ann Arbor, Michigan in 1988, under the title
*Art Words 2: Discourse on the Early 80s*. It is
here reprinted by arrangement with Jeanne Siegel.

Published by Da Capo Press, Inc.
A Subsidiary of Plenum Publishing Corporation
233 Spring Street, New York, New York 10013

# Contents

# Illustrations

# Acknowledgments

I want to thank the publishers of the following periodicals: *Arts, View, Interview, Bomb, Flash Art, Journal,* and *Profile,* for granting permission to reprint interviews. Barry Blinderman and Donald Kuspit generously conducted interviews specifically for this book.

Thomas Lawson made valuable suggestions and I am deeply grateful to a young colleague, Monroe Denton, for his ideas and editing of the manuscript, and to my assistant, Gary Sherman for his help and patience in assembling it.

I am most indebted to all the artists who so willingly participated. In the interviews which I personally conducted, I found them surprisingly receptive and they contributed immensely to my understanding of this period.

# Introduction

This book is not a survey. It is a collection of interviews with artists who have achieved prominence in the early 80s. My admiration for these artists is enormous; I find them among the most important and innovative, but there are others I would have liked to include. It is small comfort—but comfort nevertheless—that many of those omitted are at least acknowledged in various interviews.

The artists who were chosen represent various points of view and address issues that came into sharp focus in the early 80s. Although I have hinted at a semblance of categories in the ordering of the interviews, I have avoided grouping them under headings. Such grouping might, at first glance, seem easily done, but there is ultimately a great deal of overlapping and many crosscurrents. I have tried to present a diversity of attitudes. It's too early to establish definitive slots for the early 80s. The first six interviews are with artists who had already achieved a prominent critical standing but either came to serve as mentors to the younger artists of the early 80s or were looked upon in a new light.

The book is unabashedly conceived from a New York perspective. By that, I mean the artists were chosen from among those who exhibited prominently in New York City. Such geo-centricity may present certain problems or limitations in terms of our reading of these artists, and I have tried to incorporate an awareness of this as part of the material (see Benjamin Buchloh's interview with Gerhard Richter as a surprising illustration of this phenomenon). As justification for this decision, I still see New York in the early 80s as the center of the art world. In other words, the dream of most artists in both Europe and the United States was still to find success in New York. This is coupled with the expanding commodification of art, a phenomenon to which New York is certainly a major contributor.

Five interviews published here for the first time were conducted specifically for this book. I conducted over a third of the interviews; the rest were undertaken by a variety of other critics. It seemed appropriate to have critics

with special areas of expertise in early 80s art included in this project. The 80s are about many voices. In the contrasting voices of an interview which establishes openness of discourse, this form may be the ultimate postmodernist expression.

Most of the interviews are with artists who were described as "post" modernist at the outset of this period. A great deal of the critical dialogue of the early 80s centered around defining Postmodernism, sorting out the artists who qualified, locating and registering the demise of Modernism.

The term Postmodernism is notably difficult to define in relation to the fine arts. It seemed more coherent in architecture where it was characterized by a system of repeatedly used, recognizable concrete elements. Its usage here preceded its usage in the other arts. Postmodernism was first labeled by Charles Jencks in 1975. According to Jencks, it expressed dissatisfaction with modernism's commitment to pure form, which looked sterile and had become boring because it lacked an understanding of the urban context. This was replaced with what he called double coding; that is, "a building speaks on two levels at once—to other architects—and to the public at large."[1] Postmodernism stressed a sense of "place." It appropriated historicizing architectural vocabulary but dissembled the meanings those historical styles possess by combining contradictory stylistic references. It could be playful or dramatic while emphasizing surface ornamentation. It substituted spectacle for history.

Jencks signaled a major change, but his definition was followed by a great many revisions and substantive additions on the part of other architectural historians. Nor did it take long for a similar sorting out process to develop in other visual arts to distinguish between so-called authentic postmodernist works and regressive ones.

Photography seems a reasonable place to locate this phenomenon. The artists who used this medium, albeit in specific ways, were heralded as *the* postmodernists. Here was the disengagement from modernism's dictates and the return to the representational. The (late) surfacing and influence of European structuralist and poststructuralist theory in the United States played a major role in the emphasis of early 80s photography—photography shown in fine art galleries. Through the use of photography new issues such as the rejection of "aura" and the undermining of the distinction between original and copy have been located as postmodernist. This photographic activity involves an appropriation of imagery or image-making strategy from media sources such as TV, films, newspapers, magazines, books. Implied here is the loss of a belief in the value of originality, the loss of creativity as traditionally conceived, which leads to the conclusion that painting—a unique art involving the hand—no longer speaks for our time, a time of *mechanical reproduction.*

Acting as a kind of father figure, John Baldessari was not only a major precursor of photographic "appropriation" but also played a part in the breakthrough of photography into fine art galleries. The role of photography and its relation to fine art as well as the museum's disregard of it is discussed forcefully in the interview with him.

In the introduction to my first book of interviews, which covered the 60s and early 70s, I argued that the interview format was beginning to find a valuable and legitimate place in the literature of art. In part, this sprang from a more conceptual approach to art-making, which introduced text into the work. Texts in conceptualism often announced the artist's intention. Other art activity of the period prompted the artist to play the new, more public role of performer or video artist. The artist began to become aware of the newly receptive climate for art—for the possibility of "making it"— aided by the growing dissemination of information through the media.

The activity of the media undoubtedly accounts in part for the escalation of interest in the artist's words. Personalities became as important as the art object; the exemplar here is Andy Warhol, who leads the table of contents. Paradoxically, Warhol—the least articulate of artists—founded both *Interview* magazine in 1972 and his own television program in the 1980s especially to conduct interviews with celebrities.

Despite these occasional forays into other areas of the public arena, interviews in the 80s were concentrated in the art world. The number of interviews appearing in art periodicals increased dramatically. Regular interviews, many with American artists, in the Milan-based *Flash Art* (which began in 1967 but merged with *Heute Kunst* in 1977) signaled the cross-cultural exchange that was to take place in the early 80s.

In the late 70s and early 80s a host of new magazines appeared and made themselves felt. *October*, even as it assumed the most theoretical and radical stance, published interviews almost from its inception in the spring of 1976. *Heresies*, a journal devoted to the examination of art and politics from a feminist perspective, published its first issue (with reproductions of Nancy Spero's *Bomb Shitting* and *Torture in Chile*) in January 1977. It features interviews with some regularity. In March 1979, *Real Life* magazine had its first issue. Thomas Lawson, its founder-editor and a visual artist, put one of Sherrie Levine's photographic collages on the cover. The magazine favored interviews and several of them were conducted by Lawson. *Artforum* acquired a new editor, Ingrid Sischy, who speeded up the magazine's shift from formalism to a more interdisciplinary content. Lawson became a reviewer there in October 1980. Two other artist-directed publications, *ZG* in London from 1980 and *Bomb* from spring, 1981, assumed a broader sociocultural outlook. *Bomb* especially favored the interview format and published five in its first issue.

Not every new publishing venture featured interviews. From differing positions in the political spectrum, Art Criticism and The New Criterion focused attention on a belletristic criticism. The first issue of the former appeared in the spring of 1979, coedited by Lawrence Alloway and Donald Kuspit. Funded by the State University of New York at Stony Brook, it, along with October, indicated an institutionalization of criticism as well as the breaking down of barriers between art history and contemporary criticism. Hilton Kramer's New Criterion, funded largely by politically conservative private foundations, has steadfastly maintained its attack on new critiques in all areas of the arts and culture since its inception in 1982.

Major museum exhibitions reflected a decided change in focus by the late 70s. A distrust of the idealistic hope for perfection which underlay much minimalism could be detected in the "Bad Painting" show at the New Museum, in January 1978. This museum, which distinguished itself from other museums in being dedicated to showing experimental work of a controversial nature (and is therefore similar to the periodicals in closing the gap between art history and contemporary work), presented a selection designed to assault New York sensibilities by centering on works of artists who were distinctly renegades, outsiders to the cooler concerns of the moment. "Bad Painting" was significant in being the first museum show to register the shift from late formalism to figurative work "that avoids the accepted conventions of high art."[2] It disregarded the convention of stylistic similarities in favor of iconography and attitude. The essay by Marcia Tucker was prophetic, indicating tendencies that were to expand in the early 80s, such as the artist's willful borrowing from the past, work influenced by non-high-art sources such as commercial and popular art or kitsch, and the use of parody. It rejected the concept of progress, and argued for freeing the work from value judgments. Much of the work fell into what might be called an eccentric variation of Expressionism.

In December 1978, "New Image Painting" at the Whitney Museum featured 10 young artists, each of whom favored a single image emerging from a monochrome field. Without their representational images these would have been minimalist paintings. Now they announced the resurgence of painting, considered dead throughout the 70s when minimal sculpture, site-specific and other more ephemeral conceptual works held sway, often leaving behind only documentation. Above all, these images indicated the return of an interest in the object.

Barbara Rose's 1979 exhibition at the Grey Art Gallery, New York University, "American Paintings: The Eighties," attempted unsuccessfully to claim a fresh position for artists, many already quite familiar to us in the 70s. She argued a shared commitment to postcubist modernism in a recon-

ciliation of figuration (almost all abstract) with postcubist space. This exhibition was of such uneven quality that it served as a catalyst for one critic to argue that we had finally arrived at the end of painting.

In June 1980, Colab (Collaborative Projects, Inc.) organized the "Times Square Show," calling attention to a new, raw, anti-"culture" energy within its scruffy setting, a former massage parlor on 41st Street and 7th Avenue. In this show Keith Haring, Kenny Scharf, Christy Rupp, John Ahearn and some 100 other artists surfaced. The work centered on sex, money, and violence. There were political references to blacks, capitalism, Iran. Schlock and crudity were part of the statement. There was a gift shop where cheap art objects were sold. As Lucy Lippard put it, the show rebelled against the cleanliness and godliness of the art world institutions. It was about art being about something other than art.[3]

In October that same year, Group Material, an artists' collective founded by Tim Rollins, opened with a storefront space on East 13th Street. Addressing political and social issues, each exhibition has investigated a particular theme. "Alienation" was one of the first of many, continuing to the present.

"New York/New Wave," curated by Diego Cortez, was held at P.S. 1 in 1981. Artists such as Haring and Jean-Michel Basquiat bridged the gap between graffiti and Neo-Expressionism—the style that became known as the image of the East Village.

Again, it was the New Museum that went one step further in a show called "Events" in 1981, inviting artist-run independent groups, founded as alternatives to commercial galleries and museums, to show and to assume curatorial control. One such operation was Fashion Moda, a storefront gallery which had officially formed in the South Bronx under the direction of Stefan Eins as a multicultural base from which to interact with the community. In the New Museum show a number of graffiti artists (including Haring) were included.

In December 1982, "Image Scavengers: Painting" and "Image Scavengers: Photography" opened at the Institute of Contemporary Art in Philadelphia, surveying a phenomenon which embraced a great number of artists, many interviewed in this book. This two-part exhibition emphasized art that was committed to the mediated image as an analogue more convincing than nature. It acknowledged the return of figuration in recent paintings, focusing on one aspect of it, the one which "appropriates from mass media or popular culture." In the catalogue Thomas Lawson is quoted as saying that the penetration of the mass media has made the possibility of authentic experience difficult, if not impossible. Originality of action has lost its claim—it refers only to advertisements, TV shows, the movies. Among the painters included as "Image Scavengers" were Lawson, David Salle, Robert

Longo, and Walter Robinson. An artist's typical resistance to curatorial grouping is made clear in Salle's interview where he denies an involvement with popular culture or the mechanism of the media.

"Image Scavengers: Photography" focused on the same question of appropriation of imagery from media sources—TV, films, newspapers, books. Three of the photographers are included in this book—Barbara Kruger, Sherrie Levine, Cindy Sherman. They are viewed from the point of view of "deconstructing" the imagery of mass culture by placing it in another context.

The cultural critique of appropriation that distinguished the Philadelphia I.C.A. artists had been indicated in a 1977 Artist's Space exhibition, "Pictures," which would prove seminal to the development of postmodernist principles. Douglas Crimp, in his catalogue essay, locates the innovation of a group of artists in a development out of Minimalism and its preoccupation with the "theatrical." The relationship to performance art here set forth is defined by the characteristics of temporality and presence. Such theatricality—combined with the placement of the individual work between or outside the specific art form, but not confined to any particular medium and all the while appropriating freely from mass culture—disengages the work from any connection with Modernism and its demand for integrity of the medium. In the 80s, according to Crimp, the literal temporality and presence of theater is reinvested in the pictorial image. Sherman and Longo reflect and expand on these issues in their interviews.

Meanwhile, major exhibitions were taking place in Europe, allowing for an international spread of ideas. Documenta 7 (Kassel, Germany, 1981) included among a great many others Joseph Beuys, Warhol, Baldessari, Richter, Hans Haacke, Georg Baselitz, Anselm Kiefer, Kruger, Levine, Enzo Cucchi, Jenny Holzer, Francesco Clemente, Longo, Sherman, Salle, and Haring.

The shift to painting accelerated through the Royal Academy's 1981 "The New Spirit in Painting," which included Baselitz, Kiefer, Richter, Schnabel, and Warhol. Berlin's "Zeitgeist" reunited curators and many of the more contemporary artists from the London show in 1982, but with the major and memorable addition of a sculptural centerpiece by Beuys.

New York City began to view the more important European artists rather late. Originally, artists tended to be viewed in nationalist contexts, as when the Guggenheim Museum presented "Italian Art Now: An American Perspective" in 1982. Of the "3 Cs"—Chia, Cucchi, and Clemente— who were to take center stage in the so-called Neo-Expressionist, imagistic painting that appeared in New York in the early 80s, the first two were included. The exhibition supported the theoretical position of Achille Bonito Oliva that he had identified as the "trans-avantgarde." According to Oliva,

this tendency was of international scope, bringing the tradition of painting back into art, overturning the idealism of progress in art which was manifested in the 70s, and adopting in its place a nomadic position with no privileged ethic, no certainty of ideas. The trans-avantgardists borrowed from the art historical past, roaming freely in all directions.

Most of the European artists labeled Neo-Expressionist were well established in Germany or Italy long before we saw them. Baselitz had his first solo show in Berlin in 1961 and one almost every year thereafter. In 1979 he showed at the Stedelijk Van Abbemuseum, in Eindhoven, the Netherlands, and at the Whitechapel Art Gallery in London. But it was not until 1981 that he had his first solo show in New York—a year after he and Kiefer represented Germany in the Venice Biennale. Furthermore, as Buchloh pointed out, these artists had actually introduced figurative subject matter and expressive gestural and chromatic qualities into their art in the early 60s.[4]

Upon the arrival in New York of the new German and Italian art, a critical battle began that raged throughout 1981, tapering off around the middle of 1982. Lawson responded to the argument that painting was dead. In his seminal article, "Last Exit: Painting," Lawson confronts the issue of painting's continued usefulness in an age of Postmodernism. Might not some subversive use be made of all the reports of painting's death? He makes some distinctions between various Neo-Expressionist painters, separating those who remain content to make essentially decorative works from those, including himself, who want to attempt a complex strategy that would make painting an equal of photography as a critical, fully postmodern art.[5] (He elaborates on this in his interview.) Other issues specifically brought into focus by Neo-Expressionism were the viability of maintaining aura or uniqueness in *peinture;* the question of the credibility of any revival of an early style; the role of nationalism and its motives; the role of abstraction versus representationalism; the difference between the European and the American Neo-Expressionists; the influence on Europeans of earlier American art.[6]

The concept of a Neo-Expressionist movement was generated by critics but many of the artists rejected it. For example, neither Baselitz nor Kiefer acknowledges such a classification in his interview. The former points to a variety of northern influences, while Kiefer is more focused on philosophical/spiritual concepts. The general weakness of the Neo-Expressionist portmanteau is revealed when forced, as it frequently was, to include the Italians. Cucchi does share with the Germans a strong national bent in the form of an attention to his own cultural heritage and mythology. He suggests the reason imagery is surfacing is that it gives a crisis-stricken world something solid "to cling onto." Perhaps his seeming naiveté and distortions of figures

could label him expressionist, but more striking is his search for the primordial.

If one had to choose the single American artist who trumpeted the early 80s, it would be Schnabel. He seemed to justify the return to painting in the most vigorous way. He became the focus in any discussion of American Neo-Expressionism. With his plate paintings, first shown in 1979, he was linked to Jackson Pollock not only through their alloverness but because of the perpetuation of the modernist myth of the artist as hero. But simultaneously he manifests himself as the closest to the European sensibility (for example Kiefer), in tackling grand themes, references to landscape, use of religious and historical symbols, and his intensely autonomous nature.

Any investigation of the early 80s must include a discussion of a specifically New York phenomenon—the East Village. This was a place, a happening that could be viewed from many angles. It was a meeting point for the artists associated with the alternative spaces mentioned earlier. It offered room to enormous numbers of artists (at least 500) who had flowed into New York and had no place to show. The galleries fast-forwarded the new imagistic and figurative modes. The area attracted new collectors with its low prices. Its small spaces dictated smaller, more objectlike works, which have now become commonplace. Haring showed at the Fun Gallery; Mike Bidlo, at Gracie Mansion.

Walter Robinson reminisces sympathetically and with a great deal of wit about the origin and ambiance of the East Village. What he doesn't discuss is the reversal that came about when artists already represented by established Soho galleries began to show in the East Village as guest artists. Clemente did so in 1983, with Lawson, Golub, Bleckner, and Levine following. Other artists, such as Robinson, were represented both in Soho and the East Village.

East Village art was initially associated with an indigenous expressionism. But a more austere, precise and cerebral East Village art was shown at International with Monument, Cash Newhouse, and Nature Morte (all run by artists). It's ironic that the artists who did not represent the stereotypical image of the East Village were the ones to move on to Soho. Among them was Peter Halley.

East Village art at its worst was stylistically labeled by one critic "backlash trash," but in terms of content this "bad art" raised political, social and ethnic questions that were to resonate throughout the art world. The commercialization of art, its speedy production, the hype—all attributes identified with the East Village—were symptomatic of activities in the larger network, such as the lionization of both artist and dealer in the Julian Schnabel/Mary Boone relationship from 1979 onward. These questions,

interestingly enough, do not figure prominently in the interviews, with one exception—Andy Warhol.

Warhol's use of reproducible images produced in series and multiples served as a symptom of the great hollowness in much art of the period—an awesome absence, if not of the original, then in a belief in the *power* of the original. This was made explicit when Warhol converted his artist's loft into the Factory, turning out reproducible commodities under the heading of Art, almost becoming the "machine" he had long ago compared himself to. He anticipated the transformation of high art into a branch of the culture industry, a shift that has marked the last 10 years.

A succession of political crises marked the early 80s, although none with the galvanizing power of the previous decade's Vietnam embroglio. A fear of similar engagement, this time much closer to this country's borders, was spurred by American involvement in Central America, especially Nicaragua, where the Sandinista forces defeated Somoza loyalists in 1979 and were able to institute a government based on their "Historical Program" outlined in 1969. An artists' protest against increased American involvement in the region was the basis of the 1984 "Artists Call" exhibitions, which were coordinated throughout the country (although centered on the two coasts) as a mark of resistance, the largest concerted political movement ever on the part of American artists. Even as "Artists Call" was being planned, the political situation worsened with the deployment of American troops to the island of Grenada. Hans Haacke's interview describes a particularly threatening instance of university censorship of his contribution to the show, which focused on the Grenada involvement.

Haacke's career is of interest in his examination of systems, which began with physical concerns but shifted to a critique of social structures in the early 70s. His *MOMA-Poll* at the Museum of Modern Art initiated a direction in his work which linked art to its institutions and their role in political power, capitalist corporate power and governmental policy. Haacke has addressed the issue of South African apartheid, this period's most glaring example of minority rule, several times since 1978. But it was actually only in the 80s, when critical attention began to focus on the role of politics and the deconstruction of institutions, that Haacke's work was fully addressed in New York.

Leon Golub, whose political activism antedated even Vietnam protests, continued to maintain his liberal critiques of American injustice toward third-world countries and the repression of racial minorities up to the present time. But his images changed. Whereas his figures from the 1960s were generalized, with his "Mercenaries" and "Interrogations" series, beginning in 1979, they have become more historically specific. In his interview,

Golub takes a very aggressive and confrontational stance, stressing immediacy. The comparison between Golub's and Haacke's means for expressing political issues is provocative. Golub's work may seem anecdotal and his images can be associated with real events; Haacke, who uses actual documentation to construct a finished work, calls Golub's paintings "topical." They both have the role of the media on their minds.[7]

Nancy Spero's involvement as a political activist dates back at least to 1969 with an art conjoining politics and feminism. In her "Codex Artaud" series in 1971, she began to combine appropriated images and brutal, riveting texts. Her focus was on woman as victim in rape or war. In the late 70s and early 80s she discarded text and shifted to depicting women more in control of their bodies. They became joyous and active.

Both Barbara Kruger and Jenny Holzer like to agitate in the gallery and on the street. Kruger produces a lot of billboards, and Holzer has slapped posters with inflammatory statements around town. At the time of the 1984 Reagan campaign they both participated in a "Sign on a Truck" piece stationed at Grand Army Plaza and in other public spaces throughout New York City. Each has also made incendiary work for the Spectacolor Board in Times Square, as have Nancy Spero and others.

A new, unusual and unusually terrifying threat hit home throughout the art world during this period. Acquired immunological deficiency syndrome (AIDS), originally dubbed gay-related immunological deficiency (GRID) by the U.S. government, took its inexorable toll in the art world, as throughout American society. Ross Bleckner was, to my knowledge, the first artist to address this catastrophe as a major theme. In December 1984, he showed *Memory of Larry,* a commemorative piece for a friend who had died of AIDS. In February 1986 he exhibited a series of similar elegiac paintings.

A sense of disillusionment and cynicism permeated the 80s art world despite the hype and purported individual success stories. An experience of this despair was accompanied by a questioning of the theoretical supports from within. The question of "meaningfulness" arose from the breakdown of belief in modernism's myth of the hero and the heroic, the loss of the sublime, and the denial of progress. Was it possible to make a positive statement? What was the best way? Salle asks in his interview, "Is our sensibility more accepting than previous generations? . . . maybe we really are morally bankrupt. And maybe it's fun."

Expressing this conflict, Salle layered images and styles, spreading a multiplicity of independent elements that refused to cohere into traditional narrative. The lack of coherence is a real statement about the confused connections of modern life. Salle's images, seemingly derived from pornography, art history, or comic books, are swallowed up by a sea of interconnectedness into a new field of interstices frightening in its appropriateness.

Nostalgia pervaded the visual arts—not unlike politics, the media, all of culture. On the one hand it was attributed to an inability to focus on our own present. A more radical view considered it the result of a leveling of history, the severing of history from determinism. In art, it was manifested through a borrowing from any historical source for either content or style. How the artists approached or ignored these symptoms served to separate them into three categories critically. There were the modernists, late modernists, and postmodernists.

The art forms of the 70s—conceptual, minimal, and performance art—were already engaged in a rejection of modernist dicta. Shedding clearly defined aesthetic categories, art situated itself between or outside traditional divisions, not confining itself to any particular medium. It borrowed from mass culture. Performance art, for example, shared elements of temporality and presence with theater. Laurie Anderson is a good example. While minimalists were using repetition and real time, Anderson set up her own irregular intervals. She struck a note of real sentiment and intimacy. She was seductive, occasionally political. Anderson's effect on Robert Longo and Cindy Sherman is frequently discussed; she has come to be seen as containing the characteristics that would define one particular strain of Postmodernism.

It was among women and feminist artists (excepting Richard Prince) that photographically derived Postmodernism took hold. Sherrie Levine's first and most audacious work was in making a copy print from a reproduction of a well-known photograph and calling it her own. In this single gesture, she raised the issue of authorship, originality, and uniqueness. She went on to copy drawings and watercolors by leading modernist artists from reproductions, the latter particularly clarifying the distinction between original and copy.

Through certain manipulations and shifting of roles, Cindy Sherman deconstructed the assumptions of a recognizable "author." Sherman accomplished this by donning costumes to mask herself and instead of her own image evoked distillations of cultural types.

These artists, along with Barbara Kruger, challenged stereotyped cultural beliefs about women, women's roles, and their depiction. This activity forms part of an ongoing history of feminism; it continues to question the centrality of the art-for-art's sake discourse but through a variety of new critical strategies. Whereas in the 70s, feminists were seeking a "true" image, a "positive" image of women, by the early 80s artists posited that there is no "true" image but that identity is produced through representation. These artists attempt to analyze how meaning is produced.

Kruger, whose main preoccupation is gender and representation, exposes images as a fiction conveyed by the media which perpetuates power

relations. Both she and Levine are engaged in undermining male domination. Both are very aware of psychoanalytic criticism, which forms part of their feminist theoretical explorations.

Although appropriationism by definition deals with a strategy of altering the original through insertion into a different context, it was left to Louise Lawler to make the issue of context her specific message. By photographing works of art installed in public and private collections, re-presenting the work of art in specific spatial and temporal milieus, she exposes institutional power. Lawler achieves prominence in the mid-80s.

The art of the early 80s, including Postmodernist art, seems a reaction to and re-engagement with the art of the 60s. It draws on Pop. It is involved in the making of objects; it favors the commodity. Unlike much of the art of the 70s, it is available. Its opposition to 60s rhetoric is more direct and intense, but it has given birth to a new rhetoric that is every bit as absolutist.

The legacy of the 70s is apparent in its conceptual approach. Work is strategic; Longo speaks of this. The highly intellectualized Levine has thought through her ideas before starting. Most American artists were exposed to conceptualism in their formative years, and many of the new painters have practiced it. It is more explicit in works such as those of Holzer or Kruger where language or language/image relationships are used as a means of critiquing modes of representation. Then there are the artists Thomas Lawson and Peter Halley who have functioned as critics, articulating in print ideas that fuel their own work.

Halley is most explicit about his theoretical position vis-à-vis his use of geometry. ''The Crisis in Geometry'' (Arts [Summer 1984]) comes closest to articulating Halley's views in ways discernible in his paintings. In this article, he questions the purpose of the geometric in our culture. He examines geometry in relation to its changing role in cultural history rather than as an a priori ideal of the mental process. His conclusions are grounded in Foucault's Discipline and Punish and Baudrillard's Simulations, texts which he believes have influenced the production of geometric art and may aid in decoding the geometric work produced during these years of crisis.

The re-emergence of geometry in early 80s art (tagged as Neo-Geo) shares a disenchantment with modernist geometric painting. But it may relate either to a romanticism such as Bleckner's; an art-historical awareness, pronounced in Levine's recent stripe paintings; or, in the case of Halley, to the infiltration of technology as it makes itself sharply felt.

By the middle of the 80s the issues that distinguished the deconstructors and simulationists from the romantics and idealists had become codified by the critics, while at the same time, the boundaries between the two showed signs of dissolution.

One of the virtues of these interviews is that they offer a counterbalance

to the overdetermined art criticism that typified the early 80s. I am not claiming that the artist's statement represents an absolute truth to be set against a constructed historical narrative. But it is a different point of view. Invariably, the artists' words add up to *more* than the rhetoric surrounding their work. It is interesting to observe the relation between the artist and his/her attitude toward current critical theory. The interviews register individual distances from or proximity to this theory.

The increasing popularity of the interview format reflects its importance for the compilation of a history in the making. The interview format strives for momentary clarity and refinement of ideas rather than the closing of debate, offering itself to further reading, contemplation, and critique. Perhaps one proof of the importance of interviews is that critics will often quote from one to substantiate their own arguments.

Artists' evaluations of other artists' work are usually fresh and thought-provoking; there is much of that here. The increasing numbers of interviews reveal the artist as articulate, often intellectual, clearly able to engage in an objective dialogue about his/her work and world view.

**Notes**

1. See Charles Jencks, *The Language of Post-Modern Architecture.*

2. See Marcia Tucker, essay in *Bad Painting* (museum catalogue) (New Museum, January-February 1978).

3. See Lucy Lippard's review, *Artforum* (October 1980).

4. Two articles represent the polar positions of that time: Benjamin H. D. Buchloh, "Figures of Authority, Ciphers of Regression: Notes on the Return of Representation in European Paintings," *October*, No. 16 (Spring 1981), and Donald B. Kuspit, "Flak from the 'Radicals': The American Case against Current German Painting," in Jack Cowart, ed., *Expressionisms: New Art from Germany* (The St. Louis Art Museum, 1983).

5. See Thomas Lawson, "Last Exit: Painting," *Artforum* (October 1981).

6. It's worth noting that a huge exhibition, "The New American Painting," which showed all the major abstract expressionists, took place in Berlin at Baselitz's art school in 1958.

7. Even as this manuscript moves toward press, new issues point to the extreme political consciences of these artists. A survey conducted by the *Village Voice* asked many artists, including Golub and Haacke, if they would permit their work in a Central Intelligence Agency collection currently being formed. Both reacted in a way that stressed the significance of the media: "The only reason to accept would be to turn it into a public game; to make a piece which would be thrown out so it would become a public issue" (Haacke) and, "In reality no, but in theory I would love to be inserted into their space. . . . In my own naive way I would like to confront them" (Golub). See: Elizabeth Hess, "Art of the State," *Village Voice* (February 16, 1988).

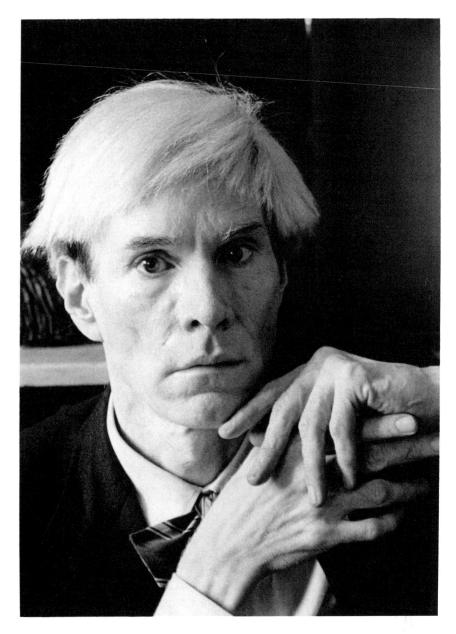

Andy Warhol
*(Photograph © Hans Namuth 1985)*

# Modern "Myths": Andy Warhol

*Barry Blinderman*

*Warhol became known as a Pop artist in the early 60s but he took on much larger proportions in the 80s. As Blinderman has pointed out, by this time "Warhol himself is a myth. He has come to symbolize success and stardom in the arts, yet somehow remains an elusive figure. The mystification surrounding his public image renders it difficult for some to see his art for what it really is—powerful, persistent images that have never failed to capture the spirit of the time."*

*In this late interview, Warhol discusses his "Modern Myths," a series of ten silkscreens. These mythical figures, his heroes and villains, are drawn from advertising, comics, film, TV, and updated classics.*

*Warhol had already acknowledged that the results of his artistic endeavors were marketable, profit-oriented goods. But by now he had entered what he termed his Business Art period, which followed his Art period. This new and final phase is reflected in the interview. Warhol died in 1987.*

---

BARRY BLINDERMAN    How did the "Myths" series come about?

ANDY WARHOL    Ron Feldman, who published the prints, has a lot of wonderful ideas. He and I went through lists of people. Actually, I wanted to do a whole Disney series with Donald Duck and other characters, but I ended up using only Mickey Mouse.

BB    Did you see the Whitney Disney exhibit?

---

This interview, conducted in Warhol's Factory in August 1981, was originally published in *Arts Magazine* (October 1981).

AW   Yes. It was interesting to see how other people did so much of the work. I liked the show so much that I went to see *The Fox and the Hound.* That movie looked like it was done 50 years ago because the backgrounds were so painterly. But I wish the Whitney show had been larger; I wanted to see more.

BB   This series brings your work full circle in a sense. You did a Superman painting in 1960, and Lichtenstein and Oldenburg did Mickey Mouse shortly afterward. Here it is over 20 years later, and you're painting these characters again.

AW   I know, I just can't believe I did it. But this time it was more complicated. We had to go through getting copyrights and everything like that.

BB   Now that the history of Pop art is behind Superman and Mickey Mouse, do these characters mean anything different to you than when you originally painted Superman?

AW   No, it just means that I liked it then and I still like it now.

BB   "Myths" really captures the American spirit from a lot of different angles.

AW   The only one I didn't understand was *The Shadow,* and that was me, so. . . .

BB   The image of *The Witch* is really striking. Is that Margaret Hamilton, the same woman who played the Wicked Witch in *The Wizard of Oz?*

AW   Yes, she's so wonderful. She lives right in this neighborhood. She looks and acts the same as she did back then.

BB   There's probably no child or adult in this country who hasn't seen *Oz.* It's easily as American as Mickey Mouse.

AW   I wonder if kids who see that movie think it's a new movie or an old movie. Some kids know about old movies and other haven't even heard of some of the stars that were around.

BB   What impressed me most about *The Witch* was the color. The way the shape and color interact reminds me of things Ellsworth Kelly used to do. I've always wanted to know if you ever thought of your paintings in the 60s in terms of Kelly and Noland, your contemporaries doing abstract art.

AW   I always liked Ellsworth's work, and that's why I always painted a blank canvas. I loved that blank canvas thing and I wish that I had stuck with the idea of just painting the same painting, like the soup can, and never painting another painting. When someone wanted one, you would just do

another one. Does anybody do that now? Anyway, you do the same painting whether it looks different or not.

BB    Yes, for example the *Dracula* looks similar to the way you did Kafka in the last series. Both emerge from the darkness like ghosts. So does the *Mammy*. Powerful image and color have been the issue from the start. Was the Superman you used from a DC comic?

AW    Yes. I wanted to do Wonder Woman, too.

BB    Did you consider using one of the movie or TV actors for your Superman?

AW    Well, I thought the man who played in the TV series [George Reeves] looked just like the comic book character.

BB    More than half of the Myths are based on TV or movie characters. Is this to say that modern myths are mostly made on the screen?

AW    Yes, I guess so. . . . Afterward, yes. But the TV is so much more modern.

BB    From the beginning you've been doing prints in one form or another—from the blotted paper technique to rubber stamps, and then to silkscreens, which you use to this day.

AW    The silkscreens were really an accident. The first one was the *Money* painting, but that was a silkscreen of a drawing. Then someone told me you could use a photographic image, and that's how it all started. The *Baseball* painting was the first to use the photo-silkscreen.

BB    When you first began using silkscreens, you were concentrating on removing your personal touch from the work. Now your paintings have a lot of brushwork and drawing, and are expressionist by comparison.

AW    I really would still rather do just a silkscreen of the face without all the rest, but people expect just a little bit more. That's why I put in all the drawing.

BB    As a portraitist, what do you feel is most important to express?

AW    I always try to make the person look good. It's easier if you give somebody something back that looks like them. Otherwise, if I were more imaginative, it wouldn't look like the person.

BB    How many shots do you take for each portrait? Do you take them all yourself?

AW    Yes, I take them all. Usually about 10 rolls, about 100 shots.

BB    Do you still use the SX-70?

AW    No, I use the "Big Shot" now.

BB    What's been the general response to the portraits from the people who commissioned them?

AW    The Polaroids are really great because the people can choose the photo they want. That makes it easier. And this camera also dissolves the wrinkles and imperfections.

BB    Polaroid is like color TV in a way. It has its own idea about what blue is or what red is. It's a very subjective color that seems like it was custom-made for your art.

AW    Yes, it seemed to be. But it's hard to do whole bodies with it. I haven't learned to take whole bodies with it yet. I do have a camera that can take whole bodies, though.

BB    The camera has been an essential part of your art for so long. I saw some early Campbell's soup can drawings at a Guggenheim drawing show some years ago. How did you do those drawings? Were they projected onto the paper?

AW    Yes. They were photographs that I projected and traced onto the paper. I used both slides and opaque projectors in those days. I also used a light box.

BB    Your use of photography as a direct source for images was pretty unique at that time, and is interesting to consider in view of the continued use of photographs by the Photo-Realists several years later. What did you think of Photo-Realism when you first saw it?

AW    I loved all their work.

BB    I thought your recent book POPism expressed the true sense of the 60s, both positive and negative. You really point out the exhilaration of that decade. In one part of the book, you say you felt like you could do anything then. You had gallery shows, made films and produced the Velvet Underground.

AW    Yes, but there are a lot of kids who are doing the same thing now. It probably will be back again.

BB    I know a young artist who does drawings, reliefs, plays in a band, and makes films and video. I don't know where he gets all his time.

AW   If you don't get so involved in business, you can have the time. Since we have a business here, I can't do all the fun things I did at one time.

BB   No more rock bands?

AW   No, we're managing Walter Steding and the Dragon People. We're doing a video promo of that right now at our studio downtown.

BB   I've seen some of Steding's portraits. He's a good painter, too. . . . Throughout *POPism* you wonder if Picasso had heard of your work yet. Did he ever?

AW   I don't know—I never met him. We just know Paloma. Now her husband is writing the Paris gossip column for *Interview*.

BB   Since at least 1970, particularly with the *Jaggers* and *Jews,* there are some stylistic touches that bring to mind Cubism and Picasso's succinct way of drawing. Was he an influence?

AW   I was trying to do the portraits differently then. Since the transvestites portraits, I've tried to work more into the paintings. I may have been think-ing of Picasso at the time.

BB   For a whole new generation of figurative artists, you're now the Picasso figure of sorts. Many young artists I speak to name you as a major inspira-tion. What do you think about this new image-oriented art?

AW   I like every art in New York. It's so terrific and there's so much of it.

BB   Do you have any favorite artists or galleries?

AW   There are so many artists that are so good now that it's very hard to pick out one or two. It's hard for me to go to galleries because the kids stop me all the time. There was a show at the Whitney of young artists that I liked—Lynda Benglis and the young guy who does the chairs [Scott Burton].

BB   Did you see the Times Square Show last summer?

AW   No, I didn't, but I saw pictures of it in magazines and the newspaper. It looked like the early 60s—the Reuben Gallery and places like that.

BB   There's an excitement in the air that seems quite similar in spirit to the early Pop days.

AW   It was funny then—I guess there was a different mood. Now, in New York I just notice how beautiful the people are. Since there's no war that everybody's going to, they have the pick of the best athletes, models, and actors. They always had great girl models, but now the boy models are just as good. The pick is so much better now because they're all in New York

Andy Warhol, "Myths," *Howdy Doody*, 1981
Silkscreen, 38″ × 38″.
*(Photograph by eeva-inkeri; courtesy Ronald Feldman Fine Arts)*

instead of in the army. Sixties actors were all peculiar-looking people and now the new stars are really good-looking, like Christopher Reeve.

BB    What about the art world?

AW    Twenty years ago was such a different time for artists, too.

BB    Now that we've come out of 70s art, artists can do paintings of people instead of putting sticks on the floor. Painting is a vital issue now, whereas 10 years ago people were talking about the end of painting.

AW    Well, *I* did. I always said that back then.

BB    Was that tongue-in-cheek or did you really think that you had stopped painting?

AW    I was serious. We wanted to go into the movie business, but every time we went out to Hollywood nothing much ever really happened. Then I was shot. It took me a long time to get well, and at that point it was easier to paint than to try the movies.

BB    How often do you paint now?

AW    I paint every day. I'm painting backgrounds out there right now. *Interview*'s getting so much bigger that they're moving me out of the back. So I'm painting out front, and also come in Saturdays and Sundays a lot.

BB    In *Painter's Painting,* the movie by Emile de Antonio, you pointed to Bridget Polk and said that she was doing all of your paintings. And then she said, "Yeah, but he's not *painting* now." Did people call you up after that and try to return their paintings?

AW    Yes, but I really do all the paintings. We were just being funny. If there are any fakes around I can tell. Actually there's a woman who does fakes that really aren't fakes. She's doing everybody, even Jasper Johns.

BB    So many people insist that other people do your paintings.

AW    The modern way would be to do it like that, but I do them all myself.

BB    The accessibility of your art has always been important. I can walk around the Village and see a *Jagger* or a *Mao,* or I can see a portrait retrospective at the Whitney, or see a *Kafka* or a *Buber* at a synagogue. You have such a large and diverse audience.

AW    We sell more of the Mick Jagger prints in the Village than anywhere else, which is very surprising. Nobody ever did anything about the prints. These little galleries downtown were doing more by just coming up here and getting some and putting them in the window. They look funny down

there but they really sell. The tourists walk about and buy them. Castelli is going to do a retrospective of the prints sometime soon.

BB    It's good that your art can be bought by all kinds of people, at least the prints.

AW    People think that my art is so expensive, and they're amazed when they find out that they can just walk in and buy one.

BB    In the last issue of *Interview* you mentioned that you were working on a Madonna and Child series, or actually mothers with babies at their breasts.

AW    Yes, we've been renting models from an agency called "Famous Faces." You just rent a baby and a mother. I've photographed about 10 of them already.

BB    The theme makes me think back to Raphael's fat cherubs. Yours must be so different.

AW    Well, not really. They're beautiful babies because they're models and the mothers are sort of beautiful, too.

BB    I see you're doing some landscapes out there in the studio. That's an unusual subject for you, isn't it?

AW    Yes. I was commissioned to do the Trump Tower. I also did a series of ten German landmarks: houses, churches, and other buildings.

BB    It's a good idea, considering that most of your recent paintings are portraits.

AW    Well, these are portraits of buildings.

BB    You're also painting shoes now. I remember seeing an illustrated book of shoes you did before you were known as a painter.

AW    That was so long ago. Recently, someone commissioned me to do a painting of shoes. I liked it so I started doing more of them.

BB    Any other new painting themes?

AW    I'm doing knives and guns. Just making abstract shapes out of them.

BB    Like the Hammer and Sickle series?

AW    Yeah.

BB    What else is in the works?

AW  I'm a Zoli model now. Also, I'm doing a Barney's ad for the *Times*. I'm actually trying to get the Polaroid commercial, but that's so hard to get. And we're doing that TV fashion show once a week.

BB  Do you think you'll ever do the show you used to talk about that you'd call "Nothing Special"?

AW  The mayor's the only one who can give you a cable station. I still want to do that show, though. We'd just put a camera on a street corner. People watch anything nowadays.

BB  What American artists do you admire?

AW  I always say Walt Disney. That gets me off the hook.

BB  Didn't you once mention that you liked Grant Wood?

AW  I used to love his work. But my favorite artist now is Paul Cadmus. I also like George Tooker.

BB  Tell me the story of how you photographed Howdy Doody.

AW  Well, since then I've found out that there are three Howdy Doodys. The guy who owned the original brought him in here. Actually, I found somebody recently who looks like Howdy Doody and it would have been better to do him, just like the way we used Margaret Hamilton as The Witch, or the Santa and Uncle Sam that they always use in the ads. Everyone likes the Howdy print. But do you think people would really like to have one in their living room?

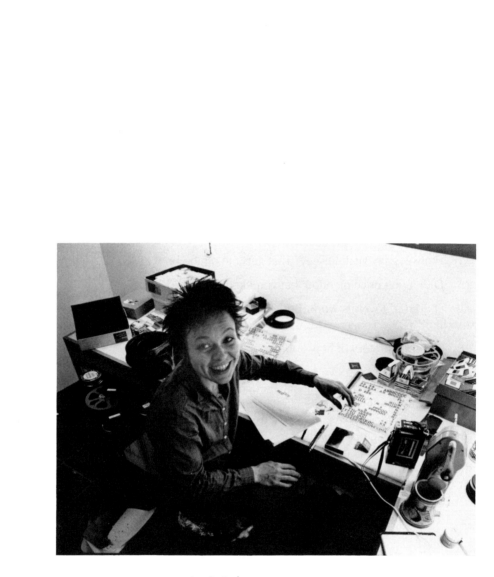

Laurie Anderson
*(Photograph © Caterine Milinaire)*

# Laurie Anderson

*Robin White*

*Laurie Anderson is exemplary of the late 70s. A multimedia artist, she com-
bines song, traditional and electronic musical instruments, "natural"
sounds, slides, film and texts. She has performed on the street, in galleries,
in theaters. While other performance artists were engrossed in themselves,
she (despite her reservations) talked to the audience. She wanted to have
her work become part of the popular culture. She crossed over into the
entertainment world.*

*Anderson had a direct influence on the early 80s performance art of
Robert Longo and others. Her influence extended to artists who incorporated
the theatrical in two-dimensional work, such as Cindy Sherman. Perhaps it
stretches further, as in the paintings of David Salle (a performance artist
early on), transformed here into a layering of images, with many events
taking place simultaneously.*

*In this interview Anderson concentrates on defining her position within
the arts from a formal standpoint. She separates herself from traditional
theater. She stresses "space" as a governing factor in the ordering of a
performance piece. She thinks in sculptural terms. Her manipulation of
instruments and inventive use of sound as voice captured the art world and
the new music world simultaneously.*

-----

ROBIN WHITE  This afternoon you were reading a story over the telephone
to Liège, in Belgium. It was a live radio broadcast, via satellite, and that

This interview, conducted in Oakland, California in 1979, was originally published in *View*
(January 1980).

made me wonder about where was the first place that you found support for the work that you're doing. Because in the art world it's pretty unusual to do such entertaining, intelligent work.

LAURIE ANDERSON    I think the first thing that I did in terms of the downtown New York art world was a show at the old Artists' Space that used to be on Wooster Street. The way it worked was that they would ask a few more established artists to invite younger artists to do a show. Vito Acconci asked me to do this show and—I'd been working with sculpture and painting and trying a lot of different things . . .

RW    When was this?

LA    This was '74, I think. The show was photographs and writing on the wall. It was large writing—I guess I was thinking of the kinds of narrative things that were around at the time—Roger Welch, Peter Hutchinson and Bill Beckley. Eventually it occurred to me that big writing is kind of spooky—like on subways.

RW    Like *graffiti*.

LA    Yeah! Like an eight-foot-high CHICOOOO. Besides, it goes by so fast on the train, and you can't read it. Billboards began to make less and less sense to me—why write so big? Reading is such a private experience, it seemed more appropriate to put the writing in books. In my case I was interested in the difference between how you would read it and how it would sound if somebody spoke it, because my writing style, like most people's, is more stilted than my speaking style. When you write something down you write grammatically, and all of the natural hesitations are edited out. And you don't feel the movement of the thought. So I began to think that it was important to say things rather than to write them and put them on the wall.

The first performance I did was called *As:If* and it was about language probably more than anything else. On one side of the structure of the piece was water and on the other was words. I tried to be very diagrammatic and structural in one way and loose in another. The diagrammatic part was a kind of subtext, on slides. I was interested in metaphor. There was always a comparative structure going on, on one side water, and on the other, words. All of the stories that I have told and all of the things I've talked about were sort of part of a cycle of the humors. The next piece I did turned out to be about fire. I never got around to earth and air—I abandoned this literal metaphor structure after awhile—it's kind of boring.

RW    Vito was coming to visual art from the literary tradition—and you came out of a literary tradition too, in a way?

LA    I'd always done a lot of writing. I wrote a novel when I was 12 years old—quite a good novel now that I think about it.

RW    And your family were storytellers from way back?

RW    Oh yeah, well, they're liars from way back! There are a lot of people in this family and it's always been a very verbal situation—a lot of talking—and just, just to hold your place in this mob scene you had to talk. You had to defend yourself and that's the way you did it. I've been looking at, thinking about, the human voice.

RW    Do you emphasize the verbal over the visual in most of your work?

LA    I find myself doing more audio things than visual, although the visual is still a real important part of it. . . .

RW    I was so impressed with your multileveled approach in the piece that I saw in San Francisco. The lighting, the darkened stage, and images projected behind you—the film and the slides added to the dimension of mystery and magic that I felt really hovered in the air.

LA    I really like to work in the dark. My ideal evening here in New York in my own place is to turn off the lights and turn on all the equipment. I have a sort of irresponsible attitude in terms of energy: the more "tech," the better as far as I'm concerned. So I plug in all the equipment and really just play with it, until something occurs. The right layering and leveling becomes a kind of intersection between things that are, not illustrating each other, but supporting each other, in terms of the kind of movement I want to make. Yeah, I like to work in the dark. One of my sisters is an actress and theater basically gives me the creeps. I just can't respond to it; I've never been able to believe in it really.

It's just very spooky to me. It seems to me that people already have several voices, without pretending that they are someone else and trying to convince other people of it. I like theater for the—play itself, I mean Shakespeare. . . . I thought about it a lot last spring when I was trying to write something about the difference between theater and performance. I was thinking of it in a couple of ways: one is that in theater there is, first of all, character and then motivation, and finally situation. For instance, if you want to have earthquakes in your play, you might have a character who's really interested in earthquakes, a geologist. Or you might tell the story of something that happened during an earthquake that the characters remember and they bring it up in the play.

RW    There has to be a logical sequence.

LA    Yes. There has to be motivation for the character to say or do something. In a performance, though, you don't have to have character. If you want to talk about earthquakes all you have to do is say "earthquakes," and whatever follows from it. So that's a big jump.

RW    So you don't feel at all tied to theater? What you do seems much closer to entertaining, I mean night club or cabaret almost. I was surprised by the performance that I saw in San Francisco because it seemed like an evening out—watching you perform a series of songs—from a sort of repertoire. You might almost request favorites, you know? The material can be used over and over again, I suppose?

LA    Well some of it can.

RW    This is called *Americans on the Move?*

LA    Yes. This is the first part of a four-part series about American culture. This first part is transportation, the second part is money, the third is kind of the psychosocial situation and the fourth is, ah, love. All of the pieces, in some way or another, in the first part relate to transportation; they have a diagrammatic connection to each other.

RW    Are the other parts already written? Have you performed them?

LA    Rather than finish the whole thing and call it the final form, I like doing things in different situations because each time you have a completely different physical set-up. You can learn a lot. I'm not used to performing on raised proscenium stages, so when that happens, it changes things quite a bit. I put whole different parts in that I wouldn't include if I were working in a flat space like the one in San Francisco. That was a fairly flat space, although the audience was sort of on a slant.

RW    Also, I suppose you relate to the audience differently, depending on the physical set-up of the space?

LA    Originally my idea was not to be this person on a stage, mostly because that idea reminded me a lot of theater. I wanted the work to be about space, in a certain way, so I used architectural images that wouldn't jar with the space so much . . .

RW    Like that piece at the Whitney in 1976 where you sang and talked in front of a film of the window in your loft, with the curtains blowing—things like that?

LA    Yes. So the performing space would be a logical extension of the room itself, without being reminiscent of some other situation. It was another way to hide, to be in the dark, to not be there, to be a bulge in the film surface. And then I thought—since I have spent a lot of time working as a sculptor, ideas about space were real important to me, and I wanted to emphasize physical presence in a real room rather than—well, for example—the best performance is like a bad movie. Because you go to a movie, you sit down and you feel the popcorn under your feet, you think, ugh, Coke sticking to the arm of your seat, and if it's a bad movie you sit through the whole thing, looking at where the exit signs are and whether there are tassles on the curtains—and if it's a good movie you fall away and then you come back, and you notice those things again.

In my first performances you felt that spatial situation, your own presence in the room the whole time. I began, at that point, sending standing waves through the audience. Just really emphasizing the room tone . . .

RW    When was this? What are standing waves?

LA    It was in the mid-70s. The standing waves were just barely audible; they produced a physical sensation. You became aware, because of these waves, of your placement in the room. It's like being blind, in a sense, because you feel the space behind you; it's a way to prevent falling into an illusion, into film space. I really wanted to, umm . . .

RW    Locate people in reality?

LA    Yes, exactly. I began to understand that my idea of space in terms of performances was really almost as if people were there for scale. I mean I set it up so that they would feel their physical presence. That's very sculptural, spatial. But it's not about energy.

RW    It's also not so much about communicating.

LA    I think I really wanted to ignore the fact that there were people there because I was nervous. I thought I'd be a librarian, you know. It's what I always wanted to be—or a scholar, someone who's near books and near ideas. I got into the work I do through a series of things that I thought seemed logical and then when I found that I was—there were people, that's when I turned out the lights and wanted to be a voice in the dark.

RW    You seem to make real effort to engage the audience in a way that doesn't exist with certain other people. Like Terry Fox, his attitude about the audience has been either they get it or they don't—the responsibility lies with them.

LA   I do feel like one of the things that's real important to me is to keep the performances as short as possible. That's following my attitude toward my work, since it's composed of very short segments. I don't have ideas for longer than three minutes, generally. I also realize that this is an evening and you've asked someone to come to a certain place, at a certain time. The people who come didn't go to a movie that night; they didn't go somewhere else, they came to this. So I really feel an obligation to do it—to compress and make my thoughts as clear as possible. Generally a concert won't take longer than an hour and 15 minutes, maybe an hour and a half.

RW   Something that impressed me when you came to San Francisco was that although your work is not at the stage where students in art schools could have read a lot about Laurie Anderson, your lecture was jammed and the performance was sold out. Obviously word of mouth really operated very effectively for you. You have a reputation that precedes you, without benefit of the usual art magazine kind of syndrome. The students in San Francisco are into the punk aesthetic a lot, into music a lot. Did they make the connection to you through that? Have you been involved very much with music outside the art world?

LA   That's important to me. When I go to universities and art schools, something that I try to emphasize to people when I talk to them is this: there is a structure set up, all set up for the universities and the galleries and the museums and the magazines, just like any other installment plan in the country. They'll tell you what to do and they'll tell you what the requirements are and what gallery you're supposed to join and they have it all laid out. But I think there are other ways to be an American artist rather than going through that circuit. You can find your own way. Artists are supposed to be innovators and yet we have our own little system set up which is very closed and which doesn't really infiltrate the culture.

RW   One of the courses that you taught was called "Principles of Art History," and you subtitled the course "Scruples," as in moral principles. And also you wrote a song that was a quote from Lenin called *Ethics Is the Aesthetics of the Future.* I can perceive a relationship between those things and something that John Cage said, which was that art should be useful—should influence the way we experience things outside an art context. Were you thinking along similar lines?

LA   "Use" is a dangerous word.

RW   Cage illustrated his meaning of "useful" with a story about being stuck in traffic—if you can transfer the experience of listening to music to the experience of listening to truck horns, or other sounds around you, you

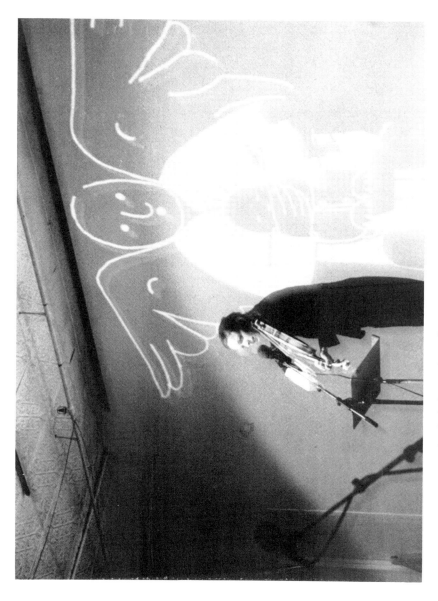

Laurie Anderson, Scene from *Americans on the Move*, 1979
Performed at the Kitchen.
*(Photograph by D. James Dee; courtesy Holly Solomon Gallery)*

can possibly get something besides indigestion from any situation. That's useful.

LA    I see. That reminds me of probably the first performance that I ever did, in 1972, in Vermont. I was spending the summer in the tiny little town of Rochester, and every Sunday evening there was a concert in the gazebo with the local band. People would come in their cars and park around the gazebo. They wouldn't get out of their cars . . .

RW    Like going to a drive-in.

LA    Exactly! It was a drive-in concert. The band is just kind of playing away, "toot, toot, toot," and at the end of each song, instead of applauding, people honked their horns. Majestic sounds. A hundred cars, trucks, motor-cycles all honking! The applause sounded better than the concert. So a friend and I decided that we would have a concert of cars. We scored three pieces for various pitches, but at first we couldn't find anyone in Rochester who really wanted to be in a car concert.

Then we decided that the way to do it would be to audition cars. So we set up a little booth at the local supermarket—"Is your Dodge a C# ?"—and people would then go, "Oh well, I hope so." It was a wonderful concert. We had the audience sitting in the gazebo and the orchestra of cars parked around them. The rim of the mountains, green mountains, around, created a wonderful sort of supersonic stereo effect.

So, yes, a sort of "Cagean" attitude to sound is always useful—even in a traffic jam.

RW    I was thinking about the use of humor, the use of fantasy and story-telling in your work. Magic is related to fantasy—you don't use conven-tional magic but you use a kind of high-tech magic. Like the voice harmo-nizer, and the slide projections, where the slide image is projected into the dark void behind you and captured fleetingly by the violin bow you wave in front of it. Also the warmth and energy that come out of the performances that you do—there's a new emphasis on these elements that wasn't there I think, most of the way through the 70s, you know? I think the decade was basically serious, logical, abstract and cerebral.

LA    It was a strange decade. I've forgotten it already—of course I forget easily; I have no memory of anything—a lot of horrible things have hap-pened to me but I erase them quickly and I think I've had a great life.

RW    You remember what you want to remember.

LA    That used to be a theme in things that I did. I was using myself directly in my performances; I was the material at a certain point. Like anyone who recounts their past, I found that it became another past. You have what happened to you, and also you have what you said about what happened to you.

One of the first performance pieces—the first one in the series called *For Instants*—was really about the experience of editing material. I think there was a story about Joe Gould in it. He wrote an autobiography, extremely excessive and beautiful. He left out nothing. Then at one point he decided he was going to edit it. There would be this long paragraph: " . . . today for lunch I had chicken with tomato sauce and a little basil and oregano, and the spaghetti was cooked *al dente,* just correctly" . . . about three paragraphs long. And when he edited it, he crossed out the whole page and just wrote, "Had Chicken Cacciatore today."

I think there was also something about Faulkner in that piece as well. The anecdote was that Faulkner used to invite townspeople up to his place in the evening and encourage them to talk so that he could use them as material. He would sit on the porch and they stood below on the lawn. There was only light on the porch, and whenever someone said something that Faulkner considered out of character, he would shade his eyes and say, "Do you mind moving away, you're blocking the light." In *For Instants* there was a very bright light on the screen from a film projector, and projected onto that same surface was white writing on a black slide; you could only see that white writing if the light of the film projector was blocked out. I played a violin duet for tape and violin in which my hand moved back and forth in front of the film projector making it possible to see the written words only when the shadow made it dark enough to see through the double layer of light. The hand with the bow looked like it was holding a pencil.

RW    As if you were writing.

LA    Yes. And as my hand moved, you could see the lyrics for the song: "White on white, left to right. Could you move away, you're blocking the light." Editing and blindness were the themes, in a sense, in that piece. And in a lot of those performances I was dealing with the difference between writing and talking.

RW    I was thinking about how you started out using your past as material. Some other artists whom I've spoken with who also used their past, their own lives—Chris Burden, Terry Fox, Vito Acconci—have now all moved beyond the exploration of their own pasts and are working much more with what happens when you put the work out into society, into the culture.

LA   Exactly, that's the transition I've tried to make as well. I decided that there are a lot of things going on in the world and that my work didn't have to be so self-reflecting. Suddenly the world was full of things to think about.

RW   So your first big piece is *Americans on the Move?*

LA   Yes. But others led up to it. Over a period of three years or so I began using a lot of political things in my work. One of the first ones was a story about Stephen Weed. It was a song for two microphones and two speakers. I moved from microphone to microphone, from left to right, and there were also two lights:

> . . . Stephen Weed/was asked by the FBI/to come in and answer a few questions/and they had it set up/so that there was an agent on his right/and an agent on his left;/they alternated questions/so that in order to answer them/he had to keep turning his head. /And he said that after a few hours of doing this/he realized that no matter what questions they asked/or what answer he gave,/the answer always looked like "no . . . no . . . no."

Most of the work that I do is two-part or stereo, not monolithic at all—so there's always the yes/no, he/she, or whatever pairs I'm working with.

But even with this American cultural cycle, It's one person's viewpoint and I still use "I." Another good transition for me was that I learned that I could say "you," and that was real exciting.

RW   Have you designed any new instruments recently?

LA   I'm going to get a new instrument tomorrow. I'm really excited about it! It's a keyboard on which you can set pitch variations, then as you feed signals into it, let's say it's a series of words, the pitch changes so that there's a song generated by the words. Generally it's a studio instrument like the harmonizer. The harmonizer's really lovely. I use it for—well, that was the low and high of the voice situation in the "Transportation" part of *Americans on the Move.*

RW   You know what that reminded me of, a little bit: being in a seance and having the medium be possessed by another spirit and take on the spirit's voice.

LA   I do have that sensation. But it's more especially when I play the violin, because the violin is, for me, another voice. The violin is my vocal range pretty much, and I feel that in the duets I do, talking and playing become really the same thing. And of course the way the whole instrument works is just so beautiful. I like to combine electronics with the violin; it's like

combining the twentieth and nineteenth century. Electronics is so fast and the violin is a hand instrument.

RW   The combination of nineteenth and twentieth century is like incorporating history into the present.

LA   Incorporating, and *updating*, history. For me, the action of the bow seems like an endless source of images, or ways to be. A lot of the pieces that I've made come out of this action. A lot of the stories I use are about this kind of balance or glide activity. One of the first ones I did was *Unfinished Sentences*, which has a very linear design. There was a sentence, a bow-length sentence, and then the bow just goes you know, this way, like that . . .

RW   A bow-length sentence, in other words, a sentence you would speak while you were moving the bow over strings? Or was it one of the tape bows?

LA   It was strictly acoustic—using a bow with tape is another variation on that. Actually, the thing about using tools is that you need constant access to them. I like to work with whatever equipment I have and not plan things for equipment that I don't have—because it teaches things, the material does, in doing it; it teaches me things.

I have a plan to make a disc this spring, a video disc, which is real exciting to me. They're just coming out now, video disc players. They're all so odd looking—they're just like the first phonographs. Clumsy. And about to change the world.

John Baldessari
(Photograph © Blake Little 1988)

# John Baldessari: Recalling Ideas

*Jeanne Siegel*

*Baldessari, now 56 years old, taught at Cal Arts until this year, where he has been a major force throughout the 70s and early 80s in changing ideas about what constitutes art. His students included David Salle, Jack Goldstein, Troy Brauntuch, Ross Bleckner, Eric Fischl, Matt Mullican and James Welling.*

*In his own work, it is not surprising in light of his living in southern California most of his life that he has drawn heavily on film and advertising in his photographic images. He is a primary figure not only in moving away from painting but as an "appropriator." The interview reveals a sophisticated mind with a popular bent.*

JEANNE SIEGEL   Much of your work of the late 60s and early 70s when you began to use text was commenting on art—some of it ironic perhaps; anyway, it stayed within the art context. You were intellectualizing the processes of art. Am I right in saying that constituted what a good deal of the work was about?

JOHN BALDESSARI   I think so. I think the art as an activity became a subject matter for me and the text pieces I was doing at the time were simply culled from reading and so they in fact were statements taken out of their context and recontextualized on canvas in the gallery in order to invest them with meaning.

So, for instance, if I did a piece about "no new ideas entering this

This interview was conducted at the Sonnabend Gallery in New York during the artist's exhibition there in November 1987.

work," obviously there are ideas there, because it's an idea already, but what I'm trying to test is a case of belief or not belief and then if we believe, then it's art, if we don't believe then it's not art, that sort of situation.

But to answer your general question, the content of the work, usually I'm putting out a statement about art and then subjecting it to scrutiny, to question.

There's a very strong theme that seems to occur in my work and it was in some early works called "choosing," which is the idea of choice and I remember back at that time—this was the period of Minimalism and Conceptualism—and I was trying to strip away all of my aesthetic beliefs and trying to get to some bedrock ideas I had about art—what did I really think art was essentially? And one of the things that in this reductivist attitude I arrived at, was the "choice"—that seems to be a fundamental issue of art. We say this color over that or this subject over that or this material over that. And there, of course, comes in another theme of mine about is there some sort of dichotomy between art and life at all and investigating that. Because in the old existentialist idea, choice-making may be fundamental to your existence and making life authentic, and so much of my work currently in my exhibition is about the moment of decision and about fate intervening and chance eroding and disrupting our powers to make a decision.

JS   What about *Police Drawing* which you made in '71?

JB   Let me tell you briefly how that piece worked. A friend of mine, who was teaching this drawing class at a community college, knew a police artist. He had never seen me and I walked into this friend's drawing class unannounced, wandering around, and left in about 10 or 15 minutes, and then the police artist came in and didn't see me and my friend asked the class to describe me to him. Then he, by their information, made a drawing of **me** and I came in and we compared the drawing to myself.

I guess there the investigation was about the efficacy of language and conversely its unreliability, which is an ongoing theme of mine about how do words mean what they mean, and this idea of the sliding signifier and how it can go away from the object and so on. As I said, confusion with words and images—can they be interchangeable, can one thing stand in front of the other and what would the results be? So here we have a very primitive experiment. It was, again, concerning assumptions about art. I think what I was examining there is how can verbal information get translated into visual information.

JS   A later body of work which became a key one, at least critically, was *Blasted Allegories* (1978). It had a more complicated and sophisticated

structure, involving both juxtaposition of words and images, with captions opposing the photos.

JB   I think in those works, the underlying idea that I was trying to do was to give the public some inkling, some insight into how my mind works, and so you could almost see those as sketches, preparatory drawings for some finished work. That's what I'm trying to convey. I want those to be seen as that kind of work—playing, mind playing, as being interesting perhaps in itself.

JS   One critic concluded that in this work there was signified a kind of a self-revision of sorts; that you had rewritten your own status as a conceptual artist in that the idea, the word, the meaning were no longer primary.*

JB   I think at that point certainly I was putting up for examination my ambivalence about word and image, that I could really not prioritize one or the other, and I think what I'm positing there is that a lot of our work comes out of that inability to prioritize, and that is an image more important or is a word more important than an image? They seem to be interchangeable for me and I think it's my constant investigation into the nature of both that propels me with a lot of my work because a word almost instantly becomes an image for me, and an image almost instantly becomes a word for me—it's that constant shifting I think that animates my activity.

JS   On the other hand it seems to me you had a gradual shift toward image—expunging the word.

JB   Exactly. I think the reason for that is that when I first started using language I didn't see too much of that being done. You know, there's Braque and Lichtenstein, Cubists, Futurists, Dadaists, and so on, but it seems like what was really prioritized in art was image and I said well, why shouldn't the words be at least given equal time. So I zeroed in on that. And the other reason why I began using photographic imagery and words is that it seemed to be a common parlance more so than the language of painting which seemed to be kind of an elitist language. I thought most people do read newspapers and magazines, look at images in books and TV, and I said this is the way I'm going to speak, be more populist in my approach. And again, it's about an effort to communicate.

Then I began to see more and more people using language in art so I figured okay, the battle's been won and let's go on to something else. That's the same reason I use photography—to get it acceptable in an art gallery.

---

*See Hal Foster, "John Baldessari's 'Blasted Allegories,'" *Artforum* (October 1979).

Now we know it's very common, and I figure it's no big deal, another battle won, and so that's why I've expunged the word. I would hope that when you look at these images you feel a sense of language and literature behind them.

JS    Behind this is a strong affinity to Barthes's writing?

JB    To the written word. I mean literary theorists do interest me and I do read them and certainly with Barthes's idea of the various languages available to use to communicate, but that entire field does interest me immensely of course.

JS    A quote of yours about photography—"The real reason I got deeply interested in photography was my sense of dissatisfaction with what I was seeing. I wanted to break down the rules of photography—the conventions." What do you see as those rules or conventions to be broken down?

JB    Well, at the time I was at high school and I got hooked on photography via chemistry and I wanted to develop my own photographs and I began to really get steeped in that body of information. I started looking at camera annuals, going to photography exhibits, listening to photographers speak— parallel to my interest in art. And I've got to say art and photography were seldom commingled and I got very confused. I said, well, why do photographers do one thing and artists do another thing? It's all about image-making and then I began to say photographs are simply nothing but silver deposit on paper and paintings are nothing more than paint deposited on canvas, so what's the big deal? Why should there be a separate kind of imagery for each? And I think that really got me going. I didn't see painters doing paintings of glassware and glass shelves or sand dunes and receding snow fences. Why does that interest photographers and not painters? There were a few people at the time like Suskind doing intriguing work but he was simply using the painter's eye, replicating that imagery in photography. Well, I thought that stupid.

JS    Some of the problems that you're raising continue to plague us.

JB    Absolutely. And now there's this love/hate relationship because there are all these exhibits about art and photography. I recently got irritated with a curator and I finally said to him, I see a lot of photographers wanting to be artists. I don't see many artists wanting to be photographers. It seems to me it's a one-way track here, and I think that upset him, but that's the case.

The best thing artists have done for photographers is they've raised their prices. That's one reason why they're interested. Maybe it's a forced marriage of art and photography—a shotgun wedding.

JS   Let's talk about political references in your work.

JB   A fine example might be *Kiss/Panic* in 1986 where a series of hands pointing guns outward surround a close-up of the central image of mouths kissing.

JS   When did violence first appear as a theme?

JB   I think partly the idea of violence came about at the same time I began exploring movie stills as source material. I was exploring those stills a lot, not in a programmatic fashion but in a kind of oceanic fashion—I would go to these vast bins of unsorted movie stills and develop piles according to various themes. One theme that became evident to me was this rather bulging file of images of people engaged in violent acts. First it was entitled "violence" and then I got subthemes: all kinds of guns being held by various people for example.

So I said obviously that's a *big* theme in our folklore in movies and so I just had to do some work with that. And the whole stuff of violence and sex being equated and the gun being phallic and my interest in Freud at that time. I was reading about group psychology and the idea of the possessiveness of the group and how interpersonal relationships can be threatening and can panic the group, so I had the kiss, it was close up, over a panicked group running in all directions and then the guns pointed out protecting that situation from outside intervention. Also I was trying to get across the idea of the person's panic when a relationship is severed in some sort of D. W. Winnicott fashion, about the almost primal need for the other. It's wrapped in a feeling of panic when that occurs.

JS   There's another "violent space" series?

JB   *Violent Space*. There I was trying to use violent subject matter as content and balancing/neutralizing by how I handled the space, how I handled the formal arrangement. So it's almost like I'm putting a violent situation on one hand and opposing it with formalistic devices on the other where they all sort of balance. And thereby the title—it's space juggled with violent activity.

JS   There's something that I'm conscious of in your work all the way through. I am as aware of a formal arrangement as I am of the content.

JB   I like to play with that. Sometimes I will just present information in the easiest fashion, there it is, put a rectangle or square around it. In other words, all I'm interested in is presenting information in the most economical way.

Other times I will work from without, and use the idea of the frame and

an external composition in a very rational fashion. And I am giving a lot of attention to it. I think what I'd like to do is to balance that out with very chaotic internal (inside the frame) situations and it's almost like I'm orchestrating all these elaborate parts into this final composition.

I've used two kinds of framing situations in the last 10 years, one where I call it framing without, where I mentioned you accept the square or the rectangle and then we can go into other geometric variations like the equilateral triangle, a circle, extended rectangle, what have you, and then I compose within that, or framing from within: there I take a shape—the subject matter that I'm using dictates the frame.

For instance, if I have a shot of a table in perspective, then in the frame situation a triangle, truncated perhaps, will be appropriate and will be dictated. Lately I play the framed against the unframed.

JS   In some works you have structured a group of photographs that are individually framed into a total shape.

JB   I think all of that arises from what we call "the edge problem" or how you escape the idea of the edge. I've gotten into some bizarre situations. I remember a show I did where I had one of those movie stills of the great white hunter holding a boa constrictor and just by cutting around the boa constrictor in his hand, I got this rather phallic shape.

At the time I was trying to escape the rectangle, the square and so on and so I made a stencil of that and I placed it upon my camera viewfinder so that I began to compose within this new shape and try to find compositions that would fall within this rather bizarre outline. I made a whole show out of that, so you saw the original image when you came in and then the rest of the images that were the same shape, but by photographing various movie stills and making things compose within the new shape, then you saw the matrix plus all its offspring marching around the wall.

So there's a case where I've used a very eccentric sort of shape—anything but a right angle. There's a book called *Close Crop Tales* where I've simply utilized various-sided images—it starts out a three-sided story and then all the images are three-sided, then four-sided, five-sided, six-sided—I think I got up to eight-sided images—and all the images are the different sides dictated by the internal composition, so there was a three-sided shape triangle, then there's something in there that dictates those three sides. If it's five sides, there's something inside there that dictates five sides. All of the framing is dictated by what is inside.

JS   Would you agree that in a certain way, historically, you're acting as a bridge in the break from formalist ideas to the reintroduction of content?

JB   Obviously, there's a love/hate relationship going on. I remember at the

time all of this introduction to conceptual art, I was accused by my more rigorous peers that I was betraying the cause and now it's funny how time changes that. Now I might be accused of being too much of a formalist. It's all about shifting values, you see, and I enjoy that, I rather do.

JS    Wasn't one of the original dictums of conceptual art that you should make it immediately recognizable, easily understood?

JB    Exactly, which in a way it's kind of laughable because now we look back on the form that a lot of the stuff is cast in—you can say that's formal too, that's a structuring device—it's the most opaque thing—it's not about easy access at all.

I'm interested in language but there are various forms we can use, the fable form, for example. There are all kinds of literary devices and as pointed out by the Poststructuralists, there's no neutral form. It's all style and it was a lie told us back then that there was some neutral way to communicate information.

JS    Another changing perspective seems to exist in the attitude toward aesthetics. When I look back now at a number of conceptualists, for example Joseph Kosuth, the aesthetic aspect of the works stands out.

JB    I think it's funny—I think it's a rather broad current phenomenon. If you go back to some of the very early instances of conceptual art, almost everybody was into the joke—if you walk in a gallery where's the art? Now there's no way you can miss it, right? Kosuth starting out with labels—now he's doing giant works with neon covering all of Castelli Greene Street; myself much larger works introducing color, Robert Barry working with canvas and paint, Lawrence Wiener doing large works of statements in paint, bronze, charcoal, etc. We've all changed.

JS    This stretches to embrace earth artists as well. The current exhibition of Robert Smithson's reconstructed nonsites looks exquisite. Do you remember them that way?

JB    It's a revisionist idea—the way we knew it was sort of rough and awkward and messy and now he's all cleaned up with chrome and glass and causing to me a complete misreading.

JS    A lot has been said about your humor. What role does it play in your work?

JB    Very early on, back in the late 60s, there was a comparison of myself with William Wegman (at least on the West Coast) in articles and in shows. That seems to be (I hope Bill will forgive me) a useful device for me to answer your question. I think, unless I am badly misreading Bill—is that he

John Baldessari, *Kiss/Panic*, 1984
Black and white tinted photographs, 80″ × 72″.
*(Photograph by Jon Abbott; courtesy Sonnabend Gallery)*

makes it a conscious attempt at humor. I told him once that in his drawings, I said, Bill, you're somewhere a cross between James Thurber and Matisse and I think he liked that. They have this beautiful kind of elegant line and it's Bill is like Matisse trying to be funny. And I said, "Your work could easily be in the *New Yorker*." Whereas I don't try for humor. I enjoy humor a lot and in the art world I'm considered a great repository of jokes and funny stories, but if I were trying for humor the works would be much different. I think when there's humor it's as a result of something else, and I think when I say something else that I'm trying to get beneath the veneer of the world and trying to understand the world.

There are a couple of early works like one called *A Different Kind of Order: (The Art Teacher's Story)*. It was a story I heard about a painting instructor and he had all his students paint balanced on one foot. And his idea was that it would disrupt their normal idea of order or balance. And there was another piece I did called *A Different Kind of Order: (The Thelonious Monk Story)* concerning another story I read about where all the pictures were level on the wall and Monk would put them off balance and his wife would come back in and put them back, and etc., and the end of the story is eventually she left them askew.

JS   Of course, there are different categories of humor. For instance, irony is currently in favor.

JB   I prefer humor in the sense let's say that of Freud or Wittgenstein. Or in one special sense I think Sol LeWitt is hilarious. The obsessiveness in those works. I sometimes think he is getting a big laugh too. It's about being obsessed with an idea of the world or seeing paradoxes in the way the world is. I don't play it for laughs is what I'm trying to say.

JS   You've had an extensive teaching career. How did that fit in with your career as an artist?

JB   I have these parallel lives, that of being an art educator and an artist and they run simultaneously. I started teaching when I first got out of school in 1957 and then it ran nonstop until the present, as well as doing art. And I don't feel that I've been cheated or robbed. I enjoyed it. I persisted in doing it because I find the two activities related. I feel that when I'm teaching I'm explaining what I do in my art, using words and the blackboard, and when I'm doing art I'm talking about what I'm teaching about, and they're all didactic activities. It's all about communicating ideas and the problems of doing that.

JS   Somebody said recently that you represented the alter ego of Paul Brach who invited you to become part of the Cal Arts faculty, in that you stood for everything he did not.

JB   I think so. I thought Paul was quite wonderful in what he allowed. For instance, he appointed as his assistant dean Allan Kaprow and Allan certainly was everything Paul was not. And Allan brought in all the Fluxus people, Nam June Paik, and others.

JS   With Paul on one side and you on the other, didn't this create some sort of rift of ideas?

JB   We saw from the very start that sort of schizoid situation where there were the painters there and the crazies on this side and there was always that battle going on in a friendly way. I remember once when I was heading the visiting artists program and I was having a whole series of visitors coming from Europe and New York—Buren, Dan Graham, Ian Wilson— Paul, in a good-natured way, said to me, if you have one more of these invisible artists out here you're fired.

JS   I heard you used to bring back suitcases full of catalogues from Europe for the students to read.

JB   Yes, because I think when we teach we all compensate for the things we felt we're lacking in our own education and one of the things I felt lacking was that I never met a real artist until I was in my late twenties. My instructors were gentlemen artists that got their art degrees and then got teaching and they might paint a few paintings a year that they showed in the public library or something similar and that was it. So I never met a real obsessed, involved artist. When I got to Cal Arts, I said nobody really knows how to teach art but it seems like one way you might do it is to have a lot of artists around.

JS   Los Angeles really wasn't an area noted for painting, was it?

JB   No. I think what was holding sway there was something I would refer to as the Venice aesthetic—a bunch of artists who had a kind of aesthetic I really couldn't relate to. A lot about looks and finish and less about content and what art might be. Paul was very good at letting me dictate my own course, and I said, well, I would like to break the stranglehold of this aesthetic in Los Angeles. So most of the artists I brought in were from Europe or New York that were all doing this kind of stuff I'd seen and was involved in. And slowly the wall began to crack. And now what I would call the Venice voice is only one of many voices.

JS   Were there others that you could relate to?

JB   Ed Ruscha has been very important to me.

JS   In what way?

JB   In his investigation of language and imagery, his books, and he was one of the few artists from L.A. that had an influence in Europe, that not very many people have had, so I felt a kinship to him.

JS   How do you account for the fact that a number of the new artists who were studying at Cal Arts and obviously were influenced have returned to painting?

JB   Well, one theory I would have—it's very funny—most of those artists came in submitting paintings in their portfolios because that's what's taught in high school. And they got intrigued by other things, going into video, performance, conceptual art and nontraditional materials but I think once they got out of school they could see that none of those kind of artists were making a great amount of money and selling their work.

JS   So you see it as a strategic move based on the market rather than an aesthetic one?

JB   That's one of my theories. But this also involves the rise of yuppiedom; it's where people said wait a minute, all of a sudden the scales in their eyes were dropping from the 60s about peace and love and humanity and they said, why suffer? And so this thesis is that those ideas then were commodified by translating them into traditional art materials such as paint, wood, canvas, bronze and marble because museums were screaming they didn't have anything to show anymore, collectors were screaming that they had nothing to buy and so there was that need. I mean who wants to buy a little piece of paper. You can't put that up on your wall and show it to friends.

JS   One artist who acknowledged this strategy of returning to painting was Jack Goldstein.

JB   I think Jack is well equipped to say so. He was there. He was doing things like burying himself six feet underground and doing performance pieces, sculpture, and a lot of experimenting.

JS   There is a work of yours that is so close to Robert Longo's *Men in the Cities* but yours predates it.

JB   Robert knows that body of work from the Hallwalls days. It was wonderful. Some young artists from the State University College at Buffalo got this thing started which gave them studio space, via government money, plus they could show work and educate themselves and I commend it. I think that's what alternative spaces should be. But it doesn't occur anymore.

Now everybody wants to be in a gallery, but I thought it was wonderful—that was the heyday of those kinds of spaces. They would bring artists to Buffalo and wring them dry in getting information and then send them back and get the next one. It was a great art school.

I suppose I could have made a career of those images but it was not an idea that interested me in a special sense. Basically the idea is about disjunctiveness, I suppose, in contextualizing and so you see the effect but not the cause. I do continue to use this idea.

JS    What about David Salle? You must have been an influence on his thought processes.

JB    David is a friend and he is into several of my early works and he's one of the students I talked with and felt very close to. He came to Cal Arts as a painter and then he went into video and photographic pieces, and so on. And I think his paintings show a lot of that kind of thinking, media images, disjunctive images, and that thinking was available there.

I felt one of the jobs I could do was to bring back information quickly to the students and tell them about shows I had seen, show them slides, show them catalogues. But unfortunately students at other schools would get this two years later. Two years later is quite a bit before that stuff would get into the art magazines and they would see it in shows. So many students not only had the edge of information from New York and Europe but they were always surrounded by artists from all over the world. Not very many schools could offer that so they came out with I would say a good two-year edge on the students from other schools. And also I would say get to New York right away and usually they did.

JS    Wasn't Jonathan Borofsky an instructor there too? How did you feel about him?

JB    I asked Jon if he would come to Cal Arts. I liked him. I liked his work. I thought it was very crazy and I thought he would be somebody who could be very useful. And he was very good there because he was a counterbalance to the more cerebral, acerbic wing, let's say.

JS    It seems that your reading references follow the transitions of thinking from the 70s to the 80s. Your initial concern was with Claude Lévi-Strauss and Wittgenstein and then on to Derrida, Barthes, Foucault and the Poststructuralists. Is that true or is this some critical attempt to locate your concerns within this theoretical field?

JB    I think we're never isolated. We're always a child of our own time and there's some people that are available to us in any part of the world. I have to say literature has always interested me and I think the reason is that I'd

lived in a ghetto outside of San Diego (National City), and my culture had to be through reading, and that's the way I learned about the world. So writers always interested me, almost more so than artists, and I always could see that writers were working on similar problems that artists were working on but reading about writers gave me a one-step remove. If you read about artists too closely, it's like the shark is not going to criticize salt water. But if you get one step over you can see your writer grappling with a problem that you can solve very quickly but you can't solve as an art problem. But there are parallel problems, so that's why I've always read about writers and literature.

JS    But we're talking about a certain class of writing.

JB    I understand and I don't like it so much that a certain group of writers are fashionable and so I sometimes force myself to get over into some sort of dumb area of reading.

JS    In your teaching did you assign these texts?

JB    No, not like it's done now, where it's the word of God. I might have called it to people's attention.

JS    Recently you have introduced painting into your photographs. Do you have a specific underlying meaning for painting the large colored dots which cover faces?

JB    Well, I can speak about its genesis in that I had a growing file that I entitled "civic portraits." Probably not a very good generic term but what I meant was that that kind of photograph that would occur on the metro page about bank presidents opening a bank or a lawyer's club passing a gavel to somebody else, an official opening of a bridge or planting a tree—but I hated looking at them because it was all about a life that I detested. But I figured anything with that strong emotional reaction to me, must be valuable to use. I didn't know how to do it. And so this material lay dormant for a long time and somehow I had to find a way to use this stuff. It was very visceral—I tried to mutilate the photographs, spray paint over them, nothing. I had these labels around, these circular price stickers, and once I just covered over the faces and there was such a flood of relief, you couldn't believe it felt so satisfying to obliterate those people.

At the same time it solved a lot of problems in that these were not necessarily public figures, where you can use their image freely. There was always a chance of libel especially where most of it was from the Los Angeles area, so I didn't want to take the chance of getting sued.

Another bonus was that these people could be seen not as Mayor Bradley or Police Chief Gates or what have you but they cold be seen as

types—*the* mayor, *the* police chief, *the* student, whatever, and they became repertory. After that I could move around.

First I began using them in white, then I began to use color and, in an old idea from conceptual art, of not using color in a relational way—a little bit of red next to this amount of green looks nice—but it's coded. The red means danger, green can mean safety. And so I began to color-code people, just like when somebody we don't know walks into a room and we say oh, oh, here comes trouble, or this person looks like a safe person, in that kind of fashion. So I would say well, here's a mayor of the town but watch out, he's dangerous or here is this aggressive person but don't worry, he's safe, or I could begin to confound things and say well, this person looks like he's angry but actually he's quite happy. And you'd get double readings going on in things of paradox and conflict.

So I developed my own coding, started out with red being dangerous and the green being safe or bucolic, and yellow was beginning to seem chaotic and bad and disorderly. Orange and violet are still a little problematic. I tend to use orange as an added antithesis to blue, you know—the flip side. And blue has something of the platonic ideal, something we aspire to. And I use violet very sparingly—I think once at a show as the antithesis of yellow.

JS    When did you start using this color code system?

JB    I was using that structural color code system back in the 70s. It would be *in* the photograph, not painted. *Throwing 4 Balls in the Air* (1972) is the same idea. These themes just pop up again.

JS    Color coding was used by Kandinsky in his late geometric paintings.

JB    His writings were an early influence.

JS    Is it accurate to say that from the 70s to now you have moved from a scientific, process-oriented, conceptual, even didactic approach which focused largely on art as its content, to a more expressionist, more politically loaded and less elitest attitude—one that attempts to reach out to a wider audience?

JB    Generally that could be said. I think I play my cards further from my chest presently.

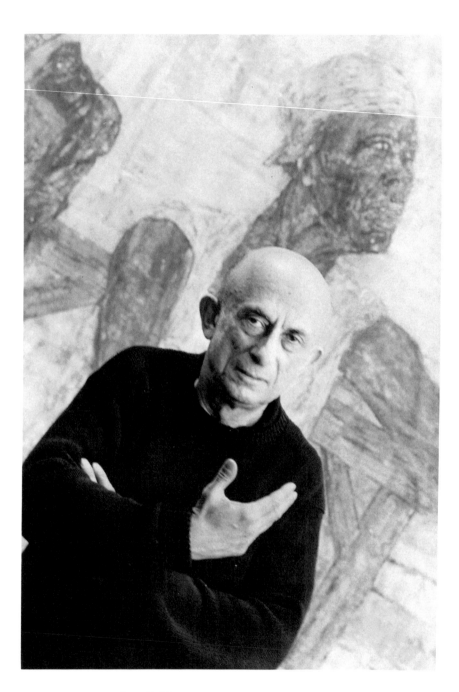

Leon Golub
*(Photograph by Cosimo Di Leo Ricatto, 1986)*

# Leon Golub: What Makes Art Political?

*Jeanne Siegel*

*Golub, now 62, was born in Chicago and later lived in Paris, only settling in New York in 1964. Despite this, his whole career as a painter has, in a sense, been a response to New York aesthetics and art world politics. He was active in the Artists and Writers Protest from 1964 to the end of the Vietnam War. He became a member of the Art Workers Coalition in 1969, and participated in the New York Art Strike in 1970. Today, he is on the Steering Committee for the Artists Call Against Intervention in Central America.*

*Long a maverick, his art increasingly appears "to the point." What's more, although disdaining "art for art's sake," he is one of the few artists who has managed to maintain the viability of certain modernist devices, no small achievement. In this interview Golub defines the "political," distinguishes between his early and recent work, and locates himself vis-à-vis younger artists.*

*Golub was given a retrospective at The New Museum in September 1984.*

---

JEANNE SIEGEL    Do you think political art has more impact today than it had in the 60s?

LEON GOLUB    Absolutely, imagery and political gesture are all over the place. You can't just ogle the system. To take on the system, you need subject matters of stress. It can't be done through abstract modes. Abstract

This interview, conducted at the artist's studio in New York in February 1984, was originally published in *Arts Magazine* (April 1984).

innovation is immediately absorbed in the logics of art. If one comes up with a new sense of structural possibilities, and makes some surprising constructions, that doesn't buck the art world. It changes dispositions toward form, and some of the acceptance levels, but it doesn't sweat anyone; it's welcome.

Caricatural, enigmatic, vulgar, street level kinds of things—the Surrealists, for example—had much more capacity to taunt, dissemble, and act out than let's say the Cubists. The work retains its irritable urgency. That doesn't make them better artists, but it offers different possibilities of how to accept or shift attitudes about what is going on.

JS    Then, for you, effective political art is when your statement evokes an immediate response from the viewer. In other words, you don't consider it political if it doesn't have an explicit connection. For example, Lucio Pozzi sees himself as political, but his political point of view is expressed through the way he presents his work, which is in various styles.

LG    How is that political?

JS    Pozzi's rejection of the notion of style is his personal solution to what he sees as the dilemma of the society in which he lives. He sees himself squeezed between two bureaucracies—one whose goal is media manipulation and publicity and the other is doctrinaire demagoguery. One establishes censorship in the making of art for the benefit of making work marketable, and the other puts limits on invention in the name of specific political goals. So his method of working is a way of avoiding belonging to the determinism of these two goal-oriented bureaucracies.

LG    I don't buy his options, and I don't see how working in various styles will protect him from the bureaucracies that threaten him.

JS    Perhaps it's comparable to the position of the Constructivists. They were abstract artists, but assumed a political stance and were considered so.

LG    But they made all sorts of attempts at changing society. If an artist works in several styles, it doesn't make it a critique of society. I think you've got here a strategy by which the artist hopes to improve his position as an artist. That's okay! I don't own the use of the "political," but I think there's a certain gratuitousness in various pickups of what is claimed as political. There is a "politics" of art world maneuver. Outside of the art world, it carries no connotation of political whatsoever, and even within the art world, it's dubious for its eclectic manipulation. Every artist that comes along fights a "politics" of survival. But if the idea of being political becomes relatively popular, then everyone can say they're political, no matter what they're doing, because it's such a zinging word. So the concept even-

tually becomes devalued. Except insofar as those out there in the "real" world [sic] react to the art as political and they respond or hit back.

JS   Robert Pincus-Witten (*Arts Magazine* [September 1983]) raised a somewhat similar question about your paintings—that they only take on meaning when presented through the bourgeois capitalistic art world.

LG   Absolutely. I am not going to transcend the art world. I operate in the art world, as it is, here and now. There are territories outside the art world! I propose to insert my work in such locations. It's stifled if its perimeters are art world ones. The work is a special kind of reportage on what goes on.

JS   Who else is forcefully dealing with the political?

LG   There are a lot of artists around, groups like PADD and Group Material, who are opening up a lot of areas, going out in the streets, so to speak, going public. Women artists in California have done similar kinds of things; also a lot of performance art is political.

JS   Is the graffiti artist political?

LG   Political in that out of repression, there was an assertion of self. By marking up subway cars, they assert themselves, discover a public presence, a will to power.

If they start doing graffitilike paintings for galleries, and if highly abstract, it may be beautiful art or not, but it's not political. It's political when it stands for manifestations, because it's fighting against a kind of oppression that was directed against them, both as individuals and the areas which they come out of, when their work hits in public arenas, and when targets are identifiable.

JS   How about younger artists in general?

LG   In general, young artists today depend less on forebears (if any), and are less interested in the categories and limits by which the art world has been traditionally defined. They are more interested in what you might call life experience, in relatively direct transcription of circumstances—political, sexual, whatever. It's not so much that the new imagery is Neoexpressionist or anything else; it's anti-authority as to how the art world has been visualized and constructed. The kind of work that was in the Times Square Show, gestures about urban life, or, for example, Fekner's big signs in the South Bronx—these are reactive positions and while they may gain entrance to the art world, are likely to be resistant to being coopted or appropriated.

I would claim that my work, for example, cannot be totally appropriated by the art world. The nature of the work—it will not be caged! I insist that the work jumps its surround. I have tried to make my work unwantable!

I want it both ways. I want the work known, to sell it and live off it. But, at the same time, I want the work to be unendurable, to block appropriation. Now, Robert Pincus-Witten said that I can't have that position but then said maybe I do have that position. Okay. I try to resist. Who's going to say to what extent one is appropriated? There are artists who still are not appropriated.

JS   Who?

LG   Caravaggio. He's still as ugly as ever. There are images of his that set you back on your feet. They flatten you like you haven't been flattened for a while. I'm trying to say that he can't be totally appropriated, because he says something about the nature of existence which we don't like to acknowledge.

Just to keep the record clear, since I am an older artist who is being viewed in respect to younger artists, I don't want to take credit for something I haven't done. In other words, I didn't start this Neo-Expressionism or this new imagery. I didn't have a damn thing to do with it. These artists are not my children—they never knew I existed. A few might have known about me one way or the other, but certainly not in any determinative way. So, I'm more grateful to them than they have cause to be grateful to me.

JS   I'm not convinced that a number of the young American artists who have been classified as Neo-Expressionists belong there.

LG   Okay. Also, there are a lot of younger artists dealing with media—how the photograph is a secondary transcription from reality. And the painting that comes from the photo is a third transcription, which means that the artist has a formal take on it, because each take is reduced in turn, and what results is perhaps a shadow or trace of the original. Such takes on culture and the influence of media are "abstract." I have a different take, a pretty damn aggressive one and on the other side of the media scale. Media images are pale reflections of the "real," of what occurs, and I go after the tangible and gross acting out of events, an edgy wincing at what goes on. Given visual immediacy, events are pulled up short, a lopsided impact, history painting as raunchy sweaty public occurrence. This shock of events contrasts to the relatively passive media translations in much current art.

Then there's my confidence. Looking at the work, what you see is not just my confidence, but a gross version of American confidence in general. It is the confidence that we have the resources, we're tough, we can do it, we're number one. We're well intentioned, but get out of the way or we'll knock you down. That kind of thing. This contrasts to the relatively passive media translations in much current art.

JS   You separate yourself from artists who use photographs. Yet you use them.

LG   Lots of photos. A figure might be derived from 10 or 15 photographs. For example, an interrogator might derive from the gestures of a man fishing. I don't have photographs of interrogators. I project gestures from innocuous actions although I use some not-so-innocent photographs, such as from sado-masochistic publications. But the great majority of photographs have nothing to do with the subject at hand. I react to the fact that they are information-rich. I'm trying to get in the painting some of that kind of factuality, the straightforwardness, the relative objectivity, but particularly the kind of atomized information that seems to be dispersed within a photo-graph. This has to be understood in relation to what I just said about the "shock of events." History is not something back there then but what goes on now shoved in our faces. Ordinarily the paintings are synthesized from many "bits" of photo information but I also recreate specific events. For example, *Riot I* (1983) is based on a photo from Thailand in 1976, right-wing students killing left-wing students. The grinning 14- or 15-year old Thai rioters become 20-year-old western types but engaged in a similar vicious action. Similarly, *White Squad (El Salvador)* of 1983 is derived from a photo from El Salvador, a local death squad member overlooking the victim shoved in a car trunk. The photo defines and précises the situation. The painting takes off from there into a totalizing visualization of the public nature of the event and its propulsion into our space and our recognition of this fact, our shocked presence and implied complicity or fear—as against the confidence/uneasy awareness of the police agent.

   *Riot II* (1984) took off from a photo of a guy giving the finger, an up-yours gesture! I conceived of the three figures as the types who took to the street against Allende, frenzied anger and mindless hostility.

JS   That gives it a contemporaneity which distinguishes these works from some of your earlier ones.

LG   The *Gigantomachies* of the 1960s were relatively generalized, an un-ending of existential struggle. The men all looked more or less the same. While I used wrestling and soccer photos, the primary sources were late Greek and Roman sculpture. Photos gave me information on body positions, but were used schematically. Today photos offer immediate contextualiza-tion and a terse means for precise delineation of aspect and look in tense confrontations.

JS   How did you utilize photographs in the political portraits?

LG  I made political portraits from 1976 to 1979, trying to get the specific physiognomy of Brezhnev or Mao or Dulles, blandness of skin and look and the curious fact that these people had so much power in their hands. To see them as media figures caught through the photograph, specific looks, sagging skin, to capture a grimace or smile. That gave me access to the interplay between people, the way people scrutinize or avoid each other. Since 1979 in the large format paintings, the making peaks in the looks that they give each other, and what those looks imply.

JS  What about *Horsing Around* and *The White Squads*—what do those themes mean to you?

LG  White Squad is another name for death squad. They pick up people and disappear them. There's nothing new about all this. Violence oils the machines of power. St. Peter was crucified upside down just like in Chile or Argentina. The difference is that St. Peter's death was given a transcendental meaning while the facts were recorded. Today we report the facts also. They don't have transcendental meaning, but it hasn't changed that much.

The scenes are generally vulgar, raucous, violent. I often, however, show individuals at rest, joking around—it doesn't take much joking around until a couple of them are at each other, rub each other the wrong way—or show them at play, ''horsing around,'' playing with the girls who are playing around with the boys. The guy pats her on the rear, and she grabs his crotch, strutting for the camera in front of their pals. They may be a little more gross, and bigger, but it's not so different from everyone else.

JS  But despite the differences in your portrayal of people, it's pretty clear that you're still working off modernist precepts. The notion of presence is not only in your use of large scale but also in the frontal approach. Isn't that the same as earlier?

LG  The modern world is the up-front world, the world that is not distanced from us. It's at hand, to be picked up. At least, it seems that way. In actuality our attempts to organize the world, to organize our lives, even, are continually being thwarted by how power is laid on and perhaps by the mass nature of the modern world. All this information and communication technology, yet we are frequently blocked in getting our ideas across: who, where, how, when. But it's still the up-front world, information arriving in continuous atomized bombardments, often at cross purposes. We're in the middle of it in a strange, abstracted, but immediate way. If events occur in a virtually closed society, much of the information will not get through. There is no such thing as a totally open society! On the scale of things perhaps we're an 85 percent open society (a 65 percent open society?) which is

Leon Golub, *Riot I*, 1983
Acrylic on canvas, 120" × 164".
(*Photograph by David Reynolds; courtesy Barbara Gladstone Gallery*)

probably as good a percentage as has occurred in the history of civilization. So here and now we have quite a range of stuff coming at us.

A thing about contemporary art is immediacy, its reputed objecthood, so to speak. Objecthood is not just something that appears in certain phases of abstract art. There are psychological, informational objecthoods as well. The immediacy of simultaneous information impinging upon one, then atomized and dispersed. We intentionally play out randomization and contrarily condense information. I want to get the maximum amount of information density within the arena of the canvas. Arena in this sense corresponds to actuality or canvas as a potential public space rather than canvas as a nonreal, isolated aesthetic space. This implies a disjunctive space and disjunctive intentions, not to condense information but to explode it outward. The static object can be viewed as exploded, its density made static by the forces that struggle to contain the explosive content. What I insist on going after are unendurable images that originate outside the canvas. I'm trying to pick up the spectator, the voyeuristic spectator who's also myself, shove him inside the canvas, right in there with what's going on. The figures have stepped out of the canvas into the room, a fractured instant of stopped (incipient) action, tense interplays, frozen grins, sidling glances, slippages, and borderline cueing and miscueing between the "actors" on scene.

Again it's how we are alerted or pulled into these events, how we acknowledge this is going on. There is a near constant media flickering of attention or recognition (even when people are only half paying attention, a sludge in which nothing stands out, and things are nearly totally devalued).

Media bombardment makes us more nervous, but it also gives us an extra handle on events and possibilities. Perception has been stretched by media technologies; we perceive atomized information much more rapidly because we have much more to recognize simultaneously.

Events continuously pop up again for our reluctant attention. Media rather casually continually reinforces awareness of what one would rather ignore or repress. To what extent do we complete the painting (of an interrogation or riot, for example) by our complicit, our voyeuristic shock, our response to the invitation (to join in) of the painting? What kind of welcome is offered by the "actors" in the painting's drama, that is, to what extent do we accept the scene as "natural," how power is used and rationalized?

JS  How would you characterize the difference between the early work and the recent work in terms of receptivity to it?

LG  During the 60s, I was making paintings which were 10 feet high and 18 to 24 feet long, figures in strife, generalized, but violent. The work had to do with power conflicts in nonspecific environments. The art world didn't

know how to take them as they were counter to what was going on. Maybe it's broken down now, but there has been a ladder theory of art: one rung might be Abstract Expressionism; the next rungs would be Pop art, hard-edge painting, or Minimal sculpture. If art is viewed as one development following another, unless you're on that linear train, you don't exist. There was an almost unwilling respect given to my work, but care was taken not to get overinvolved for fear that the paintings might be so outlandish as to not have any art world relevance. In the 60s I got comments like, "It seems impressive, but we don't know where to locate it."

JS    And today?

LG    Today the work can be related to ideas which are rampant in the art world and to actual events and circumstances in the "real" world, so that observers outside the art world find that the work begins to press in on their worlds. This kind of connection is of great importance to me, for example, reproduction in poetry/critical publications or in Amnesty International's *Matchbox*. One connection occurred when *Penthouse* wanted to reproduce *Interrogation (I)* to illustrate an article on terror in Guatemala.

JS    Did you allow it?

LG    Sure. *Interrogation (I)* got seen by 5,000,000 men. Most of them are looking for crotch photos, but a good proportion are going to react to this image, too. And there are connections to other roots of behavior, for example, the sexual implications of the *Interrogations*. Sado-masochistic preoccupations are outside the scope of most people's interest. What is its generality? That kind of perverse pleasure takes on another significance in regard to how people are treated in places like El Salvador or Guatemala and all over the map. Then it's played out not as fantasy but as deliberate policy as regards tactics and strategies of domination, series of linkages of governing elites, and how our government permits its "friends" to get away with torture in various parts of the world. Perhaps no one in our State Department would light a match under a victim's fingernails, but they funnel U.S. monies for this kind of training and equipment, and it's justified on the basis that it's future stability we are interested in. "We're sorry about this, but there's not much we can do about it." Not that important on furtive levels in porno shops, it becomes pretty damn crucial by the time it gets into the control of populations.

JS    It sounds like you see political art today as having the possibility of some real force.

LG    Everybody knows artists don't change society, but that's too easy a way to put it. Artists are part of the information process. If artists only make

cubes, then what the world knows of art will be cubes. If there are artists who are doing other subject matters, including *Interrogations*, these start to enter into differential dialogues regarding the nature of art and circumstance. It may not change the world, but the contexts and operations of art shift. Art becomes part of the context of experience in unexpected ways. If Jacques Louis David had not existed, our notions of what was possible in that period of time would be much different. Visual history is important in providing a record of what is going on—levels of intention, levels of confidence, levels of aggression or control. New subject matters start to break down some of the barriers of that protected enclave, the art world as we've known it.

# Hans Haacke: What Makes Art Political?

*Jeanne Siegel*

*Hans Haacke, like Leon Golub, is obsessed by the idea of political power and how it is used, although he expresses this concern in very different ways. Haacke is conceptual, devious; he gives us a riddle to solve. Part sociologist, part researcher, mostly "do-gooder," Haacke digs for the facts. One English reporter, commenting on his Margaret Thatcher piece, said that Haacke, with his bold and defiant style, "loves to bite the hand that feeds him." Haacke will use many means—painting, photography, sculpture, text—to convey his message.*

*Born in Cologne in 1936, Haacke has lived in the United States since 1965. While very active in New York art politics, he nevertheless remains an internationally involved artist, showing more in Europe than here. Originally known for kinetic sculpture, he began to focus on political art in 1969. Since that time he has devoted himself to making us aware of the subversive linkages among art, politics, and big business. "How is art used and for what purpose?" he asks. In another way, his work has been a comment on ways of presenting information both within the art context and through the media.*

*In this interview Haacke discusses what political art means to him, how in retrospect he sees the now legendary cancellation of his show at the Guggenheim Museum in 1970, and two of his recent and most outrageous pieces.*

This interview was originally published in *Arts Magazine* (April 1984). It later appeared in German in the catalogue for a retrospective exhibition, "Hans Haacke nach allem Regeln der Kunst," at the Kunsthalle Bern in March 1985.

JEANNE SIEGEL   What do you mean by political art? Wouldn't you say, for example, that Leon Golub's paintings are obviously political because he deals with subjects that appear in the newspaper, that belong to a political arena?

HANS HAACKE   One important feature of Leon's work is certainly that we recognize something that we can relate to what we have read on the *political* pages of the newspapers. His paintings are informed by the historical moment in which they are produced. But I would not like to restrict so-called political art to topicality. Works that operate as a critique of ideology, without a direct link to a particular political event, should equally qualify. You may have noticed that I spoke of "so-called political art," kind of disassociating myself from the use of this label. Every time I hear it, I cringe. The term reduces the works it refers to to a crude, one-dimensional reading. Worse, however, it implies that works which are not called "political" have indeed no ideological and therefore no political implications. This, of course, is a fallacy. It is a myth cherished by everybody who promotes *art* and does not want to be seen as promoting one set of interests and ideas over another. Every product of the consciousness industry contributes to the general ideological climate.

JS   It was 12 years ago that you began to make political art. At that time the work fell under the umbrella of a theory that you called systems theory. How have you seen that evolve and perhaps change?

HH   I have not thought about systems theory for a long time. But I think my work today is compatible with systems concepts. Obviously, I still believe that things are interconnected and affect each other. The social world qualifies as an "open system"; i.e., it is an historical phenomenon, continuously subject to pressures from within as well as from outside. In turn, the art world, of course, is also an open system. It is not a self-sufficient ahistorical entity with universal values, as some like to make us believe.

JS   In 1970 you made a startling piece for the "Information" show at the Museum of Modern Art. Can you connect that piece with your more recent one of President Reagan?

HH   My *MOMA-Poll* at the Museum of Modern Art was probably the most aggressive work I had done up until then. It referred to the Vietnam War, Nelson Rockefeller's bid for re-election as governor of New York State, and his relationship with the Nixon policies in Indochina. Because of the site of the exhibition, it also implicated the Museum of Modern Art, which is

dominated by the Rockefeller family. And it took the title of the show literally: it produced "Information." The Reagan piece *(Oil Painting—Hommage à Marcel Broodthaers)* equally dealt with a highly charged political situation: the deployment of a new generation of nuclear missiles with potentially horrendous consequences. In the subtext you find allusions to the myths of power and art and the wave of conservative painting engulfing Documenta, the exhibition for which the piece was made. The media employed in the two cases obviously differ; in essence, however, I believe I'm on the same track.

JS    There is more "political art" being made now than there was 12 years ago. Also, there appears to be more receptivity to it. How would you explain that?

HH    I'm sure that has something to do with what's happening in Washington. But it may also be caused by the disaffection of many younger artists who are disgusted by the gallery scene. Planning strategies to become successful entrepreneurs in the consciousness industry appears not always to be compatible with the reasons for which they chose to become artists.

JS    Speaking of receptivity, do you believe that if you had the exhibition scheduled today that was originally planned for the Guggenheim Museum in 1970 (the work which documented Manhattan real estate holdings on the Lower East Side and in Harlem) they would still cancel the show? In other words, do you feel that museums are more open now?

HH    No.

JS    Occurring about six months before, in September 1970, you could say that the Modern was more open than the Guggenheim.

HH    It's hard to tell what the Modern would have done in regard to the three pieces the Guggenheim censored. It was certainly more difficult for the Modern to suppress my *MOMA-Poll.* I brought the question, the potentially controversial element, to the museum only on the night before the opening. That did not give them enough time to prepare a position which, at least temporarily, would have washed with an alert public. I think one has to consider the historical context: the show opened one month after the Ohio National Guard gunned down Kent State University students who were protesting the U.S. invasion of Cambodia. Outraged New York artists, in turn, had declared the *Art Strike.* So it was a rather sensitive period. It would have been quite unwise for the Modern, during the election campaign of Nelson Rockefeller, to censor a work dealing with the brother-in-law of the Museum's president. It would have backfired.

Hans Haacke, *Taking Stock (unfinished)*, 1983–84
Oil on canvas, wood, gold leaf, frame, 95″ × 81″ × 7″.
*(Photograph by Zindman/Fremont; courtesy John Weber Gallery)*

JS Surely the cancelling of your show backfired on the Guggenheim?

HH It's hard for me to measure. I'm surprised that people still talk about it 13 years later. I'm sure, however, if I had run into that problem during the second half of the 70s, there wouldn't have been much of a stir.

JS Do you think people really understood the exact circumstances which were behind the cancellation?

HH Officially the Guggenheim claimed my two works on New York real estate were libelous, a legal smokescreen. But there is nothing illegal about publishing public information. I relied on the files of the city Registrar's office which are open to the public.

JS I was always under the impression that the real reason was that some of the trustees of the Guggenheim Museum actually owned some of those buildings.

HH This is really fantastic! Everybody suspects that somehow or other the trustees were implicated. Obviously that says a lot about how suspect the cancellation of the show was. It also means that people would not be surprised to hear that the trustees of the Guggenheim Museum are slum-lords. But I have no clue that they do indeed have real estate interests in ghetto areas.

JS So, what was all the fuss about?

HH I can only interpret it as ideological censorship. The Guggenheim Museum does not want to have questions of property and social relations discussed on its premises. That could open a floodgate. It is at that level that the trustees are potentially vulnerable. A few years after this hoopla I learned that the branch of the Guggenheim family which is behind the museum had a large interest in the Kennecott Copper Corporation. Kennecott owned El Teniente, the largest Chilean copper mine. It was nationalized during the presidency of Salvador Allende according to a law passed unanimously by the Chilean parliament. Kennecott's name was later mentioned in congressional hearings on the destabilization of the Chilean democratic system by U.S. interests.

JS Do you think the Guggenheim incident affected your art?

HH Oh yes. I became much more aware of the forces at work and the interests that need to be protected in and through the art industry. And I think that, over the years, has manifested itself in my work.

JS Since the Guggenheim debacle you have constantly used big, powerful institutions as subject, always pointing to something suspect or corrupt.

HH   It is the contradiction between the image they project and what they do that interests me. These images are myths. They cover up and distract from analyzing reality. Most important, they prevent us from acting in our own interest. In case of doubt this multi-million-dollar public relations apparatus papers over inequities and supports practices which endanger the public.

While arguing in terms of the "marketplace of idea," in fact it does everything to monopolize that market and to buy out dissent. I am still amazed how easy it is to get the majority of people to support policies which benefit only a small minority at the majority's expense.

JS   Your political comment has been deeply involved in pointing out the uses of art for gains outside of art for its own pleasure. In 1975, in Seurat's *Les Poseuses,* you examined the relation of profit to a work of art. Then you went on to explore the use of art by powerful corporations (i.e., Mobil, Chase Manhattan Bank) to improve their image.

HH   One of the problems one faces, when one has become aware of the interconnectedness of the art world and the social world at large, is how to function without, in effect, affirming power relationships with which one does not agree. Maybe one way is to incorporate these very problems into the work and thereby to expose them, or one could lay enough mines so that, at least temporarily, the work functions in the intended way and is not immediately coopted. In the beginning, of course, I didn't have the ability and overview to be both part of the art scene and to look at it from the outside. Maybe it takes some alienating experiences to gain that distance. And then you realize that throughout history art has been an instrument to promote one thing or another. So you might as well acknowledge that tradition and give those things a lift that you believe in. I am afraid this sounds terribly melodramatic.

JS   You have just finished and exhibited two pieces in February. One, *U.S. Isolation Box, Grenada* (1983) was installed at the Graduate Center of the City University Mall in New York as part of the Artists Call Against Intervention in Central America. The other, *Taking Stock,* a portrait of Prime Minister Margaret Thatcher, was shown at the Tate Gallery, London. They couldn't have been more different in conception. *Isolation Box* looked like a minimal sculpture while the Thatcher resembled a painting by Van Eyck. How do you make these decisions?

HH   It grows out of the job at hand and the context into which the work is placed. Obviously there is a difference between the most established museum for modern art in England and a public mall in New York. By context I mean the physical characteristics and the social/symbolic meaning of the

exhibition site as well as the general historical and cultural parameters of the moment. The history of the Tate, what it does, what it represents, what its connections are to the government, to dealers, powerful collectors—all this makes the context.

JS   Then you don't make a piece until it is commissioned?

HH   For a good number of years I have produced works mostly for particular occasions. The context in which a work is exhibited for the first time is a material for me like canvas and paint.

JS   Stencilled on *Isolation Box* are some startling words: "Isolation Box, as used by U.S. Troops at Point Saline's prison camp in Grenada." On what did you base this information?

HH   I took it from a report by David Shribman in *The New York Times* of November 17. He gave a rather detailed description of these boxes. I also called him to clarify a few things. He provided the dimensions of the small slit openings above eye level and gave me a more elaborate description of the knee-high trap door through which the prisoners were forced to crawl into the box. Whoever designed these boxes knew how to humiliate people. On one of the inside walls Shribman found a scribbling: "It's very hot in here." There were 10 such boxes in the camp. When I read the article I was outraged. The use of these boxes violates the Geneva Convention as does the shackling and blindfolding of prisoners in Grenada violate international agreements on the treatment of prisoners.

JS   The slits give the piece a primitive look—like two huge black eyes peering at you. Perversely, the prisoner cannot see out and the viewer cannot see in.

HH   Yes, primitive and brutal, as the entire invasion of Grenada was primitive and brutal. It is true, the slits resemble the ominous look of visors in military gear. These isolation boxes are representative of the Reagan Administration's entire approach to Central America.

JS   Your work in the 70s made extensive use of texts. This has lessened. What is the power of the word versus the power of the visual image?

HH   If you have a lot of writing, it reaches only an audience that has the time and patience to read. Exclusively visual communication, on the other hand, often remains obscure. As we know, a photograph without caption can be interpreted in many ways—the caption directs the interpretation. The box captures people's imagination and provides the reader of its inscription with an immediate, visceral experience. The words alone would

not have the same impact. On the other hand, without the verbal explanation, the box can easily be mistaken as a bad minimal sculpture.

JS    Also, in earlier political pieces, you were interested in viewer participation. For example, in the "Information" piece, they could cast a vote.

HH    There are various types of participation. There is the immediate one of casting a ballot. And there is a more indirect participation, when people are provoked to rethink positions and then act upon them, a bit like Brecht thought about his theater. It's like throwing a stone into the water—the ripples widen and may eventually have an effect where it is difficult to trace them to the source. In the "Documenta" installation (Oil Painting—Hommage à Marcel Broodthaers), the viewer is literally on the carpet, between the anti-nuclear demonstrators and Reagan.

JS    And the explosive Taking Stock. How did that come about?

HH    Mrs. Thatcher, like President Reagan, directly affects the way we live. I don't believe their policies are good for us. Obviously the "great communicator" and his partner in London shape the consciousness of their respective nations. Now, in my own little capacity as a member of the consciousness industry, I am working the same turf, so to speak.

Last summer I went to England to prepare the show. I was interested to observe the election campaign, and I shared the concerns of many British people about the stationing of cruise missiles on their territory. I was also intrigued by Victorian art and the Victorian values propagated by Mrs. Thatcher. And then there were the Saatchis, a name that kept bubbling up in the art world. Charles Saatchi, as you can read in my painting on the foot of the column behind Mrs. Thatcher, is on the board of trustees of the Whitechapel Gallery in London and sits on the steering committee of the Patrons of New Art of the Tate Gallery. This group, in which art dealers are well represented, purchases contemporary art for the Tate. Saatchi, especially, among the "patrons" is suspected of having designs on the museum for contemporary art which will be one of four semi-autonomous entities that are planned for a newly restructured Tate Gallery, in the future. Charles and Doris Saatchi buy contemporary art wholesale, either on their private account or, as one can glean from the annual report of Saatchi and Saatchi Company PLC, as an investment for the company. The Saatchis' financial resources alone allow them to influence massively the market for contemporary art around the world. It is left to anybody's speculation whether there was or is indeed a connection to other galleries, as the art world gossip has it. But then the Saatchis can, of course, promote the art of their choice through positions on various boards. Frequently, collectors are invited to fill

such positions with the hope that some day they will give money or donate works to the institution, and it is only natural that the institutions then are attentive to the collector's wishes. Charles and Doris Saatchi don't seem to be timid to throw their weight around. They appear also to have profited from insider information: their large-scale purchases of works by Clemente and Morley before the exhibitions of these two artists at the Whitechapel Gallery have been registered in London with considerable suspicion. The potential for conflicts of interest also exists. Folk wisdom in London has it that it was not pure coincidence that the Tate Gallery gave Schnabel a one-man show and that 9 out of 11 works listed in the catalogue were owned by the Saatchis. In England people are not all cynically accepting but deeply resent what they view as corrupt practices, maybe because it is public institutions, supported by taxpayers and therefore publicly accountable, that appear in danger of being compromised.

JS   The painting is full of iconographic symbols. Can you explain some of them?

HH   One important element is the books on the shelves in the background. The titles on the spines, in Victorian typeface, identify them as advertising accounts of Saatchi and Saatchi. The company is the largest British advertising agency. Through a merger with Compton and McCaffrey and McCall here in New York, it now ranks as the eighth largest agency in the world. It trades its shares publicly here and in London. Saatchi and Saatchi became a household word in England when it ran Mrs. Thatcher's election campaign in 1979. They did it again last year, a very clever and vicious campaign, full of the demagogic tricks of the trade. In the advertising world it is generally assumed that the successful selling of Margaret Thatcher prompted her government to reward the agency with the lucrative British Airways account. They also handle the accounts of many other enterprises of the British government. And they do political business outside of Britain. Last year their South African affiliate ran the government party's campaign for the passage of a constitutional change, which many observers believe consolidated the apartheid system in South America. The British press has even mentioned the company as a possible agency to handle the re-election campaign of Ronald Reagan. Back in the art industry: Saatchi and Saatchi now does advertising for a good number of the major British art institutions. Among them are the British Arts Council, the British Crafts Council, the British Museum, the National Gallery, the National Portrait Gallery, the Royal Academy, the Serpentine Gallery, the Victoria & Albert Museum, and, of course, the Tate Gallery.

On the top shelf of the bookcase you see two broken plates, like Victorian knicknacks (in deference to Julian Schnabel), with portraits of Maurice

and Charles Saatchi. A golden palm leaf motif with their initials gives them a halo and so elevates the pair to patron saints of Margaret Thatcher.

The frame is a crossbreed between a frame around a Frederick Leighton and a Burne-Jones, both in the Tate collection. The composition has two halves. One focal point is the head of Margaret Thatcher. She sits on a chair with a full-size portrait of Queen Victoria on its back. The chair is now in the Victoria & Albert Museum. I painted Mrs. Thatcher in the regal pose she often strikes following the advice of her public relations advisors. She is being cast strategically in the role of the queen of England, even adopting the queen's style of clothing. No wonder that the people at Buckingham Palace don't particularly care for Thatcher. The London public recognized her facial expression as typical. I painted it after a press photograph. The second focal point of the painting is the head of Pandora on the little table. This sculpture by Harry Bates from 1890 is in the collection of the Tate and, by coincidence, was on display in the entrance rotunda of the museum when my show opened. I don't have to tell you the story of Pandora, but I invite you to speculate about the relationship between the two women.

The paper that's about to fall off the table tells the viewer that a Saatchi-controlled company, in 1977–78, sold art works valued at £380,319. According to its annual report this company (Brogan Developers Ltd.) was formed in 1972 specifically to "deal in properties and Works of Art." In the same report one can read: "During the period the company entered into the art market by acquiring a portfolio of well-known contemporary paintings. These were acquired on behalf of the company by the individual director [Charles Saatchi] responsible during the course of a number of visits to leading American and European galleries and collectors." The paper at Mrs. Thatcher's foot, which you have to read by tilting your head, tells you that Saatchi and Saatchi Company PLC listed in 1982 among its fixed tangible assets "furniture, equipment, works of art and motor vehicles" with a gross replacement cost of £15,095,000. Net after depreciation amounted to £8,059,000. It is specifically stated that no depreciation is provided for art works. Anybody can draw conclusions from this information about the power the Saatchis represent on the art market. Their influence, of course, unavoidably extends to the production, distribution, and evaluation of art works in general, and thereby by design or unwittingly it affects contemporary consciousness.

JS    In the 70s, you were working in a fairly consistent conceptual style. At least, your work was presented through the medium of language. This went hand in hand with the focus in the 70s on both information dissemination and participation on the part of the viewer. When you dealt with corporations the format had the appearance of a slick commercial corporation's

advertisements. Now with the general return to painting, to symbol and allegory, you are doing the same. Do you have to keep up with trendy art styles in order to make a political comment? In other words, you use style in the service of content.

HH    My work of the early 70s no doubt was less sensuous. At least in part that was due to the nature of the polls I was conducting then. The need to present large amounts of information, as you see it in the "tombstones" of the two pieces on the provenance of paintings, made them conform to the look of so-called conceptual art. The form then and now is closely linked to the content, or better, they fuse. Implicit is sometimes a mocking adoption of the imagery that is associated with the subject, and in passing that can include references to the trendy styles of the day. Blending into the landscape can be helpful for the survival of what matters. While a gold-leafed frame can be beautifully luscious, it also serves as a signifier. When I deal with corporations I adopt the corporate look. But even in those dry polling pieces was an element of fun and games. People enjoyed marking where they lived on maps with pins.

JS    This amounts to a rejection of style in the modernist sense.

HH    This is nothing new. Like so many other things we owe this to Duchamp. Appropriation is just a new, fancy word for it. Not having a trademark look as such is not particularly interesting. The deliberate adoption of existing modes, however, can be a powerful signifying tool. That distinguishes it from the opportunistic following of the latest fads.

JS    Wasn't there an attempt at censorship of *Isolation Box* when it was installed in the CUNY mall?

HH    Yes; for the administration of the Graduate Center there seems to have been a question as to whether to keep it in the show. When I returned from London, I found it pushed into an unlit corner of the mall, and it was rotated so that its inscription was difficult to see. The political message of the piece had been effectively sabotaged. I raised hell and other people complained. Finally it was restored to the way we had agreed it to be installed before my departure.

The *New York Post* wanted to run an article about the controversial box. However, as I'm told, when the editor learned that it was not a figment of my imagination but supported by facts, he killed the story. The *Wall Street Journal* on the other hand steadfastly stuck to its idea that the isolation box was what it called "the most remarkable work of imagination." In an editorial it attacked me and Tom Woodruff, who had made a memorial to Maurice Bishop for the show, spouting that we were "in proper company"

with "the greatest collection of obscenity and pornography" down the road from the CUNY campus on 42nd Street. And the *Journal* upbraided the Graduate Center for ever having admitted such "cultural flotsam" on its premises.

JS    Aside from these specific confrontations that are the results of the individual works, which I think you really relish, what do you see as some of the theoretical problems that artists who make political art face?

HH    One of the problems is that there are few models. The socially engaged art of the nineteenth century is too far away. And with the usual notable exceptions that are always quoted, much of what has been produced during this century is rather primitive. Socialist Realism and Fascist art certainly are not sources of inspiration.

JS    Are there other problems the political artist faces?

HH    Aside from the problems associated with the possibility of cooptation and the paralysis this can lead to, there is always the problem of not having access to audiences at a level where it counts. And so-called political art is scrutinized much more critically than other works. It is much harder to get away with mediocre works. Dealing with *real* subjects requires a commensurate sophistication.

Joseph Beuys
*(Photograph © Peggy Jarrell Kaplan 1981)*

# Joseph Beuys

*Achille Bonito Oliva*

In 1961 Beuys was appointed a professor of monumental sculpture at the Düsseldorf Academy of Art. He was dismissed in 1972 for his political stance of freedom for all students whereupon he officially started the Free International University (FIU). His students included Anselm Kiefer, Sigmar Polke, and Jörg Immendorff, among others. With Kiefer, undoubtedly, the importance of material as substance derived from Beuys's conception of sculpture, now converted into two-dimensional work.

Beuys's influence in Europe, particularly Germany, was profound. Radical was his widened concept of art—its relation to anthropology, politics, history, life. He was, like Warhol, a cult figure, where persona (he, the professor, Warhol, the dandy) and performance are as significant as the work.

Beuys came to New York in 1974 and performed a one-week action, Coyote, "I Like America and America Likes Me," where he lived with and engaged in a dialogue with a live coyote, at the René Block Gallery. He conducted an open dialogue at The Kitchen. In 1979 the Guggenheim Museum gave him a retrospective. He evoked strong responses in New York: greatly admired (Julian Schnabel acknowledged that Beuys had been a great inspiration to him) or, in other circles, considered a charlatan—based on the assumed incredibility of his myth of his own survival.

This interview predates the opening of the FIU and a great deal of his work had yet to be conceived, but Beuys's philosophy was clearly formed by this time.

---

This interview, conducted in Naples, Italy in 1971, was originally published in Achille Bonito Oliva's *Dialoghi d'artista, Incontri con l'arte contemporanea 1970–1984* (Electa, 1984).

---

ACHILLE BONITO OLIVA    All your works, from the drawings of 1946 up to the current projects, gestures and actions, have contained the same implicit ideology and the same poetics. What are the recurrent themes?

JOSEPH BEUYS    During the various phases of my work, I have made environmental spaces and done actions at the same time, and I consider my drawings not as separate things, but in close connection with all the works that follow. Indeed, my drawings foreshadow the actions that I later carried out. There are many themes, but they all revolve around a central problem: man, simply man. In purely scientific terms, I would say the central concern is one of anthropology, illustrated in as many ways as possible. I found out in an elementary manner in my own life that the times we live in are ill-suited to man. This problem appears in a purely instinctive way in the early drawings, and gradually becomes more explicit and conscious. Sometimes animals appear, too, for I think there is a relation between animals and man.

ABO    A few of the concerns that appear again and again in your works are recurrent themes of the German Romantic culture. Do you recognize them in your work?

JB    I think I belong to this cultural tradition. But the historical continuity of the German Romantic tradition—the tradition of Novalis, and in part, Goethe—was broken by the positivistic concept of science with which man carried out the industrial revolution. However, the method I've taken up is not the same as Novalis's, because Novalis considered the relation between man and transcendental powers, rather than that between man and matter.

ABO    In Novalis the themes of death and night are means of approaching reality. For you the themes of cruelty, nature, and time are aspects of an art which does not aspire to imagery or form, but to a process of liberation.

JB    Yes, I agree. I can make a sketch here. The concept of science created by the middle class in order to free itself from a feudal system has become very effective, but the revolutionary thought it contains, which was formulated also during the French Revolution—freedom, equality, brotherhood—could not be implemented, because the middle class had protected itself against an even more numerous class—the proletariat—using the discriminating concept of science, calling evolution that which is only the revolution of technical understanding. Thus, it was not possible to attain a global development of human qualities. This method has aided technical progress only, without making history, but acting on man politically in a repressive

and authoritarian manner. This is a sociological affirmation, even if sociology is a human science, and thus cannot arise from what is schematically considered science. Science, on the basis of positivistic reasoning, takes a polemical stand toward art: art is worthless, it has no social importance, it's useless, it absolutely is not a vehicle of revolution, only science can be revolutionary. On the contrary, I affirm that only art can be revolutionary, especially when one frees the concept of art from its traditional technical meaning, and passes from the area of art to that of anti-art, from gesture to action, in order to place it at the complete disposal of man. The only vehicle of revolution is an integral concept of art, whence even a new concept of science is born.

ABO    When you say *art = man*, you are making an idealistic statement. Which man are you talking about? If it's historical man, man is not free; if it's ahistorical man, then it is man without a model, whom science also hypocritically claims to serve.

JB    Here I've written, *art = man = creativity = science*. When the middle class says science is useful to man, it is correct. But you have to look at the content. Let's say this is man—and this the positivistic concept of science—and this the concept of art—then this concept of art does not negate the concept of science, but includes it. The moment artists, creative people, realize the revolutionary potential of art (creativity)—here I again equate art, creativity, freedom—at that moment they will recognize the true objectives of art and science. Now I'm combining art and science in a larger concept built around creativity. The problem is a broad-ranging one, and embraces many concepts. In fact, freedom is linked to the individuality of man. The moment man becomes aware of his individuality, he also wants to be free. By virtue of his anti-authoritarian desire, he longs for self-government and self-determination. The concept of man's self-determination makes sense only as part of the concept of freedom. The individual feels isolated at first, then he senses the need, as a human being, to communicate, live, and talk. This passage is sociology. In my opinion, sociology is nothing more than a scientific concept of love. The reciprocal exchange between man and man is the most important thing. When men have developed awareness, and have learned to live politically in accordance with these powers, then it will be possible to achieve a completely new political configuration.

ABO    Doesn't this vision of art also take up a theory of Schopenhauer's, of art and thought as will and representation of the world?

JB    Yes, but I'd also like to mention Kant and Aristotle. The development of philosophical speculation begins, roughly, with Plato. An inductive [*sic*]

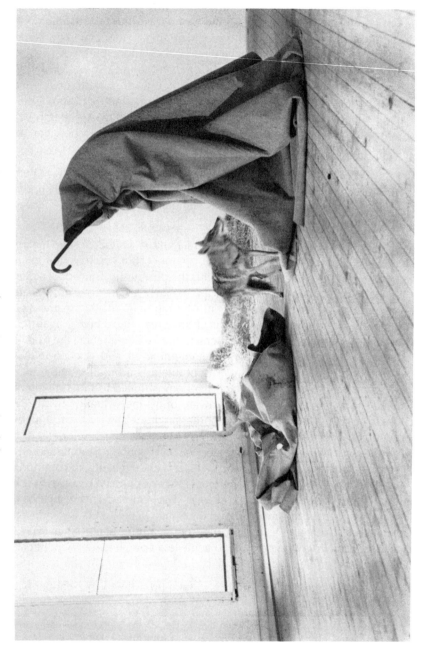

Joseph Beuys, Coyote, "I Like America and America Likes Me," 1974
Performance at Rene Block Gallery, New York, May 23–25, 1974.
(Photograph by Caroline Tisdall; courtesy Ronald Feldman Fine Arts)

method comes into use which leads to positivism. What is the sense of this philosophy and of all Western thought? It is a tension toward and an approach to materialistic thought, and hence to technical revolution. There is an analytic force in human thought that was not yet possible in mythic thought before Plato or in even more ancient civilizations. Before, one did not analyze nature, God, or matter. One accepted everything as a coherent whole, and one lacked the strength to make an individual, and hence a free, analysis. This is precisely the awakening of consciousness of Western man from Plato to our own days: the conquest of this power of analysis and criticism. At this point an enormously important figure comes into play: Christ and Christianity. Not the Christianity administered by the churches, but that which has developed along the scientific line, for Christ wanted man to be free. He said, "I will give you freedom." That means man must win this freedom through his individual strength. In the churches one practiced old collective mythological rituals. For the power to change human nature, Christianity turned to science. In this way Christ discovered the steam engine and the atomic bomb.

ABO   If the philosophical destiny of art is the liberation of mankind, what significance does the use of various materials like margarine, felt, animals, or even classical texts in your works have?

JB   If I want to create a revolutionary concept of man, I have to talk about all the powers that are related to him. If I want to give man a new anthropological position, I also have to attribute a new position to everything that concerns him. To establish his downward ties with animals, plants, and nature, as well as his upward links with angels and spirits. I have to talk about these powers once again. To ask myself: what about Christ and God? So, I must again place man in this whole; only then will he be able to acquire his greatness as man and the strength to carry out the revolution. In my actions I have always exemplified the identity, *art = man*. When I did an action with fat and margarine, I set this concept forth. At the beginning of the action the fat appeared merely as chaos, as pure energy. This energy has no direction; that is why it is chaotic. During the action this mass moves, and begins to take on a geometric form, to be part of an architectural whole, a space, a right angle. This is form. At the center, here, we can put movement. These are the elements that make up human nature. We can even complete it: add volition, feeling, thought. This is the musical score that underlies all of my actions. I've almost always succeeded in making people question, precisely because they felt attacked by my actions. I made something budge. It doesn't matter if I encountered resistance or insults most of the time. I think the man who protests has taken the first step toward becoming a man of action, revolutionary man.

ABO    Your activity appears, in my opinion, to propose a sort of "Socratic space" in which the works are a pretext for a dialogue with man.

JB    This is the most important aspect of my work. The rest—objects, drawings, actions—is secondary. Really, I don't have much to do with art. Art interests me only insofar as it gives me the possibility of a dialogue with man.

ABO    In your work there is the recovery of memory as an anthropological value. What is your position with respect to Freudian psychoanalysis or Jungian deep psychology?

JB    I think both are important, because they affirm the existence of a collective subconscious. Man must learn how to master the future, and gain an idea of how history evolves. The instant man realizes this, the subconscious will become conscious. Psychoanalysis and psychology aspire only to make peace between man and his subconscious. Man must free himself of his irrational demons, which are the defeats of the past, not only of fascism, but of all history. Only when he has become aware of his historic evolution, and knows his past, man will be ready for revolution, to become a future revolutionary. For this to happen, a new sociology must be created.

ABO    These statements seem to point to a notion of art as information, or better yet, as communication.

JB    For me information means everything the world contains: men, animals, history, plants, stones, time, etc. In order to communicate, man uses language, gestures, or writing. He makes a sign on the wall, or takes a typewriter and turns out letters. In short, he uses means. What means can be used for political action? I have chosen art. Making art, then, is a means for working for man in the realm of thought. That this should gradually become an increasingly political task is a matter of my destiny or my ability. In order to communicate, at any rate, there has to be a listener. In technical terms, a transmitter and a receiver. There's no sense in a transmitter if nobody's listening. There's always a consignee and a receiver for every word. But I don't [delude] myself in thinking I can talk to everyone; that's why it's important that men learn to talk and discuss things among themselves. Hence, language is indispensable: the concept of language which represents the entire content of information to me.

ABO    But capitalism, through the market system, favors your information, and thus interrupts your liberatory intention to turn it to account.

JB    Yes, but only if the market uses the merchandise inadequately. The potato grown and cared for by the farmer is not damaged, even if the grocer

who sells it is dishonest. The ambit of creativity, art, and the freedom of mankind is based on a different principle, the social and democratic principle of an equitable administration of justice. Therefore, art is not degraded by market abuse; it remains absolutely intact.

ABO    The market creates a vicious circle, in that instead of reaching man stripped of his economic power, art reaches only those who can hoard the product.

JB    Yes, this too is true, but it doesn't regard art alone. Injustice characterizes all markets, including the art market. It is a consequence of the capitalistic system, which should be abolished. However, we do not yet have a method for doing this. Capitalism has the word freedom on the tip of its tongue, affirming that it works for man's freedom, which is exactly why it cannot be trusted. It's the same problem I'm working on at the Academy of Düsseldorf. I say men want to study; they have the right to, because they are free, but the state says they can't. And so, I do all I can to make the majority realize that the system doesn't work. Your judgments stem from pessimistic considerations, but we have no way of knowing how a repressive system would behave with respect to a radical model of freedom. The tools used till now have utilized the concepts of democracy, communism, and socialism, which have failed because the concepts of freedom, creativity, and art, an ideal of absolute freedom, do not exist in their ideology. I don't think the system has any means of power at all against man's desire for freedom. The moment men say we are free, we want self-determination, the capitalistic principle is finished.

# Anselm Kiefer

*Donald Kuspit*

*Kiefer's intentions embrace a search for national identity, a looking to his own history as a source of meaning, a working through and replacing of the past. In his paintings much of this is projected through huge, scorched landscapes (around his studio in Odenwald) which, at the same time, reinstate painting in the grand manner. In this interview, his focus on Germany and regeneration, his use of mythological themes and his comments on American artists are particularly enlightening.*

*At the start a conceptualist, Kiefer's first one-person show took place in Karlsruhe in 1970. He showed in 1973 at Galerie Michael Werner in Cologne. In 1977, he was in Documenta 6, in Kassel, and in the Venice Biennale in 1980. In 1981 we were introduced to him in New York at the Marian Goodman Gallery.*

---

DONALD KUSPIT  It's been said that you're obsessed by things German. They're obviously no joking matter for you, yet your pieces dealing with Heidegger seem ironical.

ANSELM KIEFER  That's true. I'm interested in Heidegger's ambivalence. I am not familiar with his books, but I know he was a Nazi. How is it that such a brilliant mind was taken in by the Nazis? How could Heidegger be so socially irresponsible? It is the same problem as with Céline: here is a wonderful writer who was a rotten anti-semite. How do these thinkers, who

---

This interview is based on an informal, unrecorded conversation which took place on June 10, 1987 at the Museum Fridericianum, where Kiefer was installing his work for Documenta 8 in Kassel, Germany.

seem so intellectually right and perceptive, come to such socially stupid and commonplace positions?

I have shown Heidegger's brain with a mushroomlike tumor growing out of it to make this point. I want to show the ambivalence of his thinking—the ambivalence of all thinking. Ambivalence is the central theme of all my work.

There is no place so ambivalent as Germany. Even German thinkers saw this. Nietzsche and Heine, for example, were Germans who expressed their sense of Germany's ambivalence by hating it. This ambivalence is particularly evident in Germany's attitude to the Jews. The German Jews, being both Jewish and German, embodied this ambivalence. The Jews represent a moral contrast to arrogant German intellectuality. I want to embody both German intellectuality and Jewish morality, as Heine did.

DK   Many Americans think your work is very beautiful. They don't see the ambivalence in it. They don't see that you've found the beauty in ambivalence.

AK   Americans like to look at the surface of things. I have great difficulty with the notion of beauty. I have spent five years on one painting; for it to end up as "beautiful" hardly seems worth the trouble. I think it is beautiful to be justified.

DK   Adorno has said that after Auschwitz it is impossible to write lyric poetry. One might extend this to the idea that after Auschwitz it is impossible to make beautiful art—that beauty is irresponsible.

AK   I believe art has to take responsibility, but it should not give up being art. Many kinds of art are very effective as art. Minimal art is a good contemporary example. But such a "pure" art is dangerous to content, which must always be there. My content may not be contemporary, but it is political. It is an activist art of sorts.

DK   You have made many different kinds of works. Is there any particular type you prefer?

AK   I like book-making most, but I also like environments and actions. A painting is harder to complete for me. I have made books since 1969. They are my first choice.

DK   In your May 1987 exhibition at Marian Goodman in New York you showed a work dealing with the theme of Isis and Osiris and another work dealing with the theme of nuclear energy. They were on opposite walls, and seem related by size and handling. But they must be related in other ways. How do they go together for you?

AK    I am interested in the connection between spiritual power and technological power, one might even say the technological possibilities of spiritual power. The material reciprocity between the pieces, minimally indicated by the fact that Osiris is in 14 pieces and the nuclear pile has 14 rods, suggests a deeper spiritual reciprocity. The Isis and Osiris story is about regeneration, which is what I think the theme of the nuclear story is. It is woman's story. Isis, you may recall, couldn't find the penis. The nuclear pile is a kind of penis. It is a constructive use of potentially destructive power. It is full of connotations of regeneration of power.

DK    Is the issue the regeneration of Germany? Is it about the reunification of Germany?

AK    In a sense, yes. But regeneration does not necessarily mean reunification. Regeneration is a political theme, but it is tied to larger issues, including the issue of the regeneration of art.

DK    Do you feel art today is in special need of regeneration?

AK    I think so. There is too much *ars gratia artis,* which doesn't give much food for thought. Art is very incestuous: it is art reacting to other art, not thinking about the world. It is at its best when it responds to things outside of art, and when it comes from deep need.

DK    Apart from ambivalence, what else are you thinking about in your art?

AK    I can perhaps best say it by noting that I have become interested in a gnostic thinker, Valentinus, who thought that the world came into existence by an accident and will end by one.

DK    Then can we say that your work is full of despair, that its blackness is the blackness of despair?

AK    I do not portray despair. I am always in hope of spiritual purification. My work is spiritual/psychological *(geistig/psychologisch).* I want to show the conjunction of the spiritual and the psychological in a total environment.

Beuys was a total idealist, he wanted to change people. I want to show something, and then things may change. People think Beuys's work was dark, but this is to misunderstand it. He shows us the truth, which is one part of life. He gives us the truth to enjoy. His art is joyous.

DK    Can you say something more about your attitude to the Jews, who were the theme of a number of your works? How can that be a joyous theme for a German?

Anselm Kiefer, *Osiris und Isis*, 1985–87
Diptych, mixed media on canvas, 150″ × 220½″ × 6½″.
(Collection San Francisco Museum of Modern Art. Photograph © Jon Abbott 1987;
courtesy Marian Goodman Gallery)

AK   My answer has to say something about Germany. After World War II Germany touched the zero hour. Its myth of itself was bankrupt, it no longer really existed. Since then, Germany has become more self-reliant and cosmopolitan than it ever was. The Jews, through their history, were forced to become cosmopolitan. They are a lesson for the Germans. They are cosmopolitan in their relation to art. For example, most collectors are Jewish. My art seems to reach them. When I went to Jerusalem, I was a great success. This had much to do with the new cosmopolitan Germany.

DK   But many people think you are nostalgic for the old, xenophobic, mythical Germany.

AK   I am not nostalgic. I want to remember.

DK   I wonder if we can talk about American art. Are there any American artists who interest you? What do you think of Warhol, for example, who seems so antithetical to you?

AK   He is of interest because he shows the kitsch and garbage of society. He is very intellectual, though he deals with superficiality. He was perhaps a dialectician in that he gave it depth, which is what a real artist can do. I prefer Nauman, who has more distance from popular culture, and explains it rather than immerses himself in it. I am perhaps more sympathetic to Ryman and Rothko. I also like Orr. I like Minimalism in general, because it has no historical baggage, but it seems incomplete. I like artists who have a position, like Matta-Clark. His work is like my painting: it is a kind of archaeological cut.

DK   Matta-Clark's work was transient, and survives only in documentation. Some people have said your work is very frail, and may not survive.

AK   I am not interested in material survival. Its urgency will survive in other ways. You can work an eternity and be forgotten at once. But the unbearableness it articulated will be remembered. Much work, for example, much Cubist work and that of Pollock and Rauschenberg, is fragile, but the tension in it will survive. The way I handle the tension of German and Jew will survive, as it does in Paul Celan's poetry, which has engaged me.

DK   Do you write yourself?

AK   I write a lot, but unofficially, as a self-discipline.

DK   You seem to have a vision of the historical necessity of your art.

AK   I think it completes Minimalism and Conceptualism. That it is painting is not its point. Style or medium is not important. The thought is.

DK    Is the artist, then, for you, a thinker?

AK    There are three dimensions to an artist: will, time and space. In the United States the artist is thought of as an object-maker. Art is not an object. Art is a way of receiving. And it is full of archaeological potential.

DK    What is your relationship with other German artists?

AK    I am not in touch with other artists. I am not connected, but isolated. Baselitz bought my first paintings, and I once showed with Michael Werner. That is all past history.

DK    Does this isolation help your thinking?

AK    It helps me maintain a unity of thinking, feeling, willing. I want to synthesize them in a work. It is this unity that counts. Isis and Osiris is just a name. It is used arbitrarily, to help people understand, if they want to. People can see my point without knowing the myth.

DK    Is the same true of your German stories?

AK    They exist more for their connotations than their readability. I want those connotations to go against the material of the painting. For example, "Deutschlands Geistenshelden" is nonsense. The title is in contradiction to the material of the work. An irony is established. A precise distance is created. This obscures the work, keeping it from immediate consumption, easy familiarity. I don't mind if my titles lead to misunderstanding, because misunderstanding creates distance. The title is like the book the lecturer puts between himself and his public. The lecture is not about the book; it creates an ironic distance between the lecturer and the public.

DK    Is your irony related to your gnosticism?

AK    In a sense, yes. The point of gnosticism is to sense the not-tangible, the light. The world was born out of the not-tangible, and still retains a sense of it. The light became material. In the end, the sparks will be collected in the wheel and returned to the darkness.

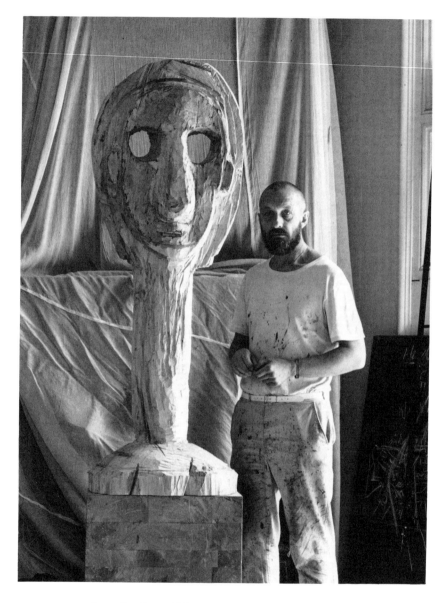

Georg Baselitz + *Make*
(*Photograph © Daniel Blau; courtesy Mary Boone Gallery*)

# Georg Baselitz

Henry Geldzahler

*Baselitz arrived in West Berlin in 1956. He had his first exhibition at Galerie Werner & Katz in 1963. Almost from the start his desire was to be both an abstractionist and a figurative painter (in this he has been compared to de Kooning). In 1969 he began his notorious practice of painting recognizable subject matter upside down. That is what New Yorkers saw first in 1981 at Xavier Fourcade Inc. He has repeatedly insisted that the reason for this gesture, which he continues to employ today, is to free the work for an abstract reading—to let no associations get in the way of observing the painting. (Conflicting interpretations are irresistible—a topsy-turvy world, the image of a world fundamentally at odds with itself, etc.)*

*In this interview Baselitz expresses his attitudes towards pure abstraction and his arrival at "self-invented figurative works." His opinion of Abstract Expressionism in contrast to European Tachisme is a striking disclosure.*

HENRY GELDZAHLER   Over the years your sense of color has changed several times, and these new works are probably the most color-saturated pictures that you've made. Is there a psychology or a rationality to your palette of various periods?

GEORG BASELITZ   The choice of colors is a conscious decision. It does not come from deep within or from some secret source. There are no general

This interview, conducted in German on October 19–20, 1983, in Baselitz's castle in Derneburg (outside Hanover), was originally published in *Interview* (April 1984).

precepts for whether I paint with green or yellow, or black or white. I have always varied, and I always keep the color-sense independent from what I am painting. Therefore, for instance, somber colors do not imply gloomy times or light colors gayer ones. Rather it is a decision I always make beforehand. And I may change it in a month. If, despite this, there should be some sort of psychological meaning to my use of color, then that is something that I don't know about. It's possible. One would have to ask someone who can interpret such things. But I don't maintain, for example, when I paint with yellow that yellow is the color of sadness or envy, or red the color of aggression, as concerns the paintings. it's another story with my sculpture. There the color is definitely used in the sense of aggression.

HG    So subverting accepted color-meanings in paintings is a good way to fight associations?

GB    I have always shunned associations in my painting. When I began the upside-down paintings, I actually put all associations aside. And if the things happen to turn up in a painting, leading somebody to say that it implies this or that—of which I am unaware—I make a change.

HG    I was, like everybody else, I suppose, a little bit surprised when I first saw your upside-down pictures about three years ago. Now it seems perfectly normal. Not normal in the sense that everybody does it, but normal in the sense that one looks at it as a picture and so it works or it doesn't work, and being upside down has nothing to do with it. It's not even a good excuse to say it's upside-down; one can't get away with it.

GB    It really is a very important matter because until 1968, I did all I felt I could do in traditional painting. But since I do not believe in traditional painting, cannot believe in it also on account of my training, I started in 1969 to use normal, standard motifs and paint them upside down.

HG    Could you define this tradition?

GB    Until 1968, there were problems in Germany that did not exist anywhere else. These problems have to do with tradition, a tradition that cannot be continued. Besides, there was a time when this tradition was set aside, and we lost the thread. I had no knowledge of this tradition. Up until 1968, there were always critical voices, negative voices, who said that I stood within this tradition, but I did not know anything of it. And I started to wonder, and I found out that the reason could only be that viewers always think that, if somebody paints a picture in which there is a cow or a dog or a person, that, in addition to what is to be seen in the picture, something else must be there. I have always seen my paintings as independent from meanings with regard to contents—and also independent from associations

that could result from them. If one pursues the logical conclusion of that thought, then it follows that if one needs a tree, a person or a cow in the picture, but without meaning, without contents, then one simply takes it and turns it upside down. Because that really separates the subject from its associations, that simply has to be believed; it defies an interpretation of the contents. If it stands on its head, it is delivered of all ballast, it is delivered from tradition.

HG   What is so brilliant about the upside-down device is not only does it free the subject, but it allows you to be a painter without the label "Expressionist." The painting can also be as abstract as you want, as far as the brush strokes go, yet it will never be fully abstract. So you don't have to fall into that trap either. it resists Expressionism and it fights Abstractionism.

GB   I am German, and German painting is called expressive, not only from the Expressionists' time but also from an earlier time; German art always presents itself as expressive. This starts with the primitive Gothic, then Romantic paintings, and ends with the present. But this modern concept of Expressionism is a word for a particular thing in the teens and 20s. It is incorrect to identify my work with that. For me that is out of the question. My problem was what you mentioned earlier: to fend off associations that might appear.

HG   On the part of the viewer?

GB   Yes, on the part of the viewer. And to make use of the whole abundance of forms in painting.

HG   You've made many etchings and more recently, linocuts. Is that part of an effort to reach a wider audience than is possible with painting and sculpture?

GB   I have never let commercial considerations influence my work, and that would be such a consideration. The small editions contradict that idea. Concerning the linocuts, which are extremely large for graphic works, I wanted to try to schematize the pattern I use to make a picture. I wanted to show, in a very simple way, mostly in black and white, the model I use to make a painting. It is a demonstration of my method.

HG   So you carry what you learn from the linocuts to the painting.

GB   Exactly.

HG   When you were a student, even then, did you ever paint what was in front of you?

GB　Never. There are people who say they can do everything. One needs talent for that. And I have no talent. I don't know how to paint. I believe that one can invent: one has to invent what one does, and that requires no talent. It will come when you have done a lot of work, certain things will then just happen in the normal way.

HG　Talent is very dangerous; character is necessary.

GB　Yes, people usually think that talent is required to become a painter. That is accepted opinion because all academies assume it to be true. The idea is contradicted by a lot of painters who didn't possess talent—actually, those who most influenced art history. If you have talent, then you are able to quickly put on a piece of paper what you see out there, so that everybody else can recognize it. I don't have that kind of talent. And what's more, I find that that kind of talent is obstructive. I am more in the position of a layman—grandmother who is told, "Paint uncle," and she begins with dots and lines or something like that. I have the same difficulties, the same problems in formulating, in transcribing.

HG　Cézanne is an earlier genius with the same problem.

GB　He made it the same way, equally clumsy.

HG　When you see early Cézanne paintings, you can't believe that he was trying to represent anything.

GB　Oh yes, the lesson of early Cézanne is that when you paint a picture you need an important approach, an important reason, an essential motive. The motivation has to be very important to paint a picture. In the early Cézanne, a crucifixion, or a murder, or a rape was definitely required to fill the canvas. The motif or the representation could not be important enough. Cézanne failed miserably in this. Had Cézanne had any talent, he would have been able to do it. Fortunately, he had none.

HG　He would not have found painting such a problem right up to the end.

GB　Well, I started as a student, as a young man in the G.D.R., also with those momentous things, as far as "contents" were concerned. I painted a Stalin portrait, a portrait of Beethoven, of Goethe: nothing could be important enough. I painted religious topics, but just during puberty.

HG　Then what?

GB　Then the influence of Picasso followed, because Picasso was a communist.

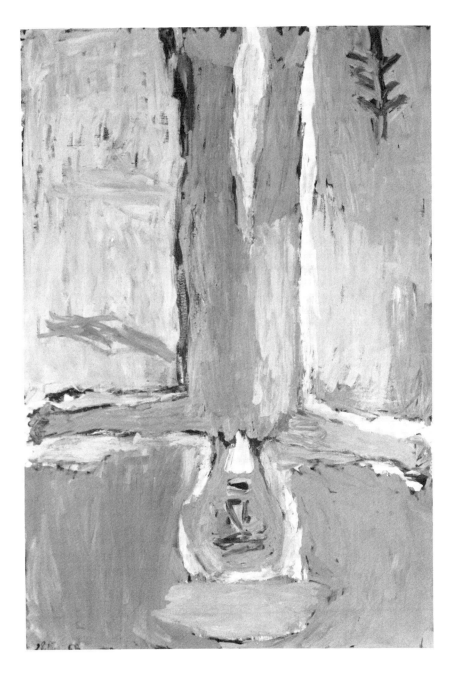

Georg Baselitz, *Kreuzigung (The Crucifixion)*, 1983
Oil on canvas, 122″ × 82″.
*(Photograph by Zindman/Fremont; courtesy Mary Boone Gallery)*

HG    Among American painters, you have mentioned Philip Guston as someone whose palette and way of brushing interested you when you first saw his work in 1957.

GB    Yes, I first saw the paintings of Philip Guston—the abstract ones, that is—in Berlin in 1957, in a big American exhibition that toured Europe. I was very excited by them. The Gustons that were done later, his "shoes and socks," are very difficult. Difficult for me, that is.

HG    They were difficult for Philip as well. Do you work on sculpture and painting at the same time?

GB    Yes. Sculpture work is physically very demanding; one has to conserve one's strength.

HG    So it's no good to do sculpture when you are angry?

GB    That's the best prerequisite, being angry.

HG    Do you find that the sculpture is a rest from the paintings and the paintings a way of resting from the sculpture?

GB    No. I believe these are two totally different things. I haven't made sculpture for very long, about four years, and I've made very few pieces. I looked around and there is a tradition in sculpting, a tradition that leads us to people like Carl Andre. And I saw that these people, these sculptors, were working in a fashion that is very far removed from my conception of sculpture. I thought that, as in painting, one has to start making sculptures without the academy, without this intellectual chain, that is.

HG    I find it fascinating that the same brush stroke occurs in the paintings of the last four or five years—not exactly the same but with a similar feeling of cutting away—as you have in sculpture.

GB    Yes, the impetus or the aggression is the same. My problem is never doing a thing in such a way that it would end up smooth looking. Rather, I stop when I have achieved what I was trying to do, and then it usually looks quite rough.

HG    What is the origin of the recent influence of Edvard Munch on your work?

GB    Influences such as this one are peculiar; I don't know where one takes them from. I don't know the origin. What I like is that Munch's content is—apart from the illustrations he made—noncontent; there isn't any.

HG    In the recent Whitechapel catalogue, the two manifestos you wrote in the early 60s were reproduced. Maybe it's time for a third manifesto?

GB    Those times are gone. A year ago, Penck and Lüpertz and Immendorff and I sat together, and we discussed whether to do something collectively— one should definitely do *something,* we thought, an exhibition or a journal—and we could not even come up with a title for the whole thing! Everybody is simply too busy with work. The belly does not seethe any longer.

HG    What are these two paintings?

GB    Well, the left one is entitled *Reading Boy* and the one on the right is an eagle. The eagle is hardly recognizable; it is actually hidden in the painting.

HG    The *Reading Boy* is very hard to see, too.

GB    Oh no, it can be seen quite distinctly in the ground color; but the eagle is hidden in the methodical application of paint. And it has no contours; the other one has contours. These are two principles that come to merge and expand in later works.

HG    Do you find that the size of the studio gets into the picture in any way?

GB    I worked in the smallest studio that I ever had, in Berlin, for 10 years, and painted some very big pictures in it—three by three-and-a-half meters. Now, of course, everything is much nicer, better and richer, but I can make do without it. I believe the size of my studio has no effect on the size of the paintings.

HG    You were 18 years old when you started living in West Berlin in 1956. The first 15 years of one's life are very formative. What aspects of your childhood do you think are still reflected in your work?

GB    I didn't leave East Berlin voluntarily. I had to leave the academy in East Berlin and so went to the academy in West Berlin. There, the teaching method was abstract painting, and in the beginning it impressed me a great deal. I also painted that way. I proceeded on the assumption that what is visible, in the environment, cannot be utilized for a painting.

HG    But the question was about childhood memories.

GB    Yes, and in abstract painting—dependent as it is on its origins in Surrealism—one is supposed to utilize those things that derive from the unconscious mind; they should flow into the painting. The source of abstract painting is Surrealism: an automatism must necessarily exist to paint a picture, so that things that lie hidden can come to light. So, in this respect, I have tried to let elements from my childhood come alive in my pictures, although often one cannot see anything of it. But a painting needs an exis-

tence of its own. Other than this, I have never really been able to incorporate past experiences or events into my paintings.

HG    Were you ever seduced or attracted by abstraction?

GB    Yes, in the beginning. That was absolutely fantastic, that was the greatest conception of painting that I had when I came to West Berlin—to paint pictures on which nothing was to be seen!

HG    At that time the influences would have been Kandinsky, Ernst Nay and Willi Baumeister. . .

GB    Yes, and there were many more farfetched things. The first exhibition that I saw in West Berlin, funny enough, was an exhibition by Emilio Vedova. Then there was a book by Nay that I studied and whose formulas I used to make drawings and watercolors. I tried everything that was within my reach within a half a year.

HG    The visual culture around you as a young man included Russian artists like Vrubel and Repin, whereas a Western artist would have no idea of who these people are.

GB    Yes, I recognized that my position was a different one than those artists in the West, who were in touch with a tradition that did not completely satisfy me. I started looking for sources that were more in keeping with my personality, and inevitably I hit upon other outsiders. A real outsider in his own time as well as in the 60s in Berlin was Vrubel. He was just about unknown. His paintings (which, by the way, I couldn't even see except in reproduction), excited me tremendously. There were a number of other painters who perhaps didn't exactly influence me but whose situation interested me because I thought theirs was similar to mine. For instance, there was Gustave Moreau in Paris. There was one of his paintings at the museum in West Berlin. In the beginning I rejected Moreau's paintings on account of their subject matter—I didn't understand them. Ten years later I reversed my opinion entirely. It was simply that at first, my existence, my position in West Berlin was very problematical, difficult, very constrained, and I had to search for something with which I could identify, with which I could surround myself. I really had to search for that. Actually, it was not there.

HG    When you were a student in West Berlin, what cities would you travel to in order to look at the museum collections?

GB    The first trips away from Berlin I made in '59, almost three years after I arrived in Berlin. I went to Amsterdam first, to see the Stedelijk Museum. They had a picture there by (Chaim) Soutine that excited me very much and that I had never seen before—the *Side of Beef* of 1925. Afterwards, I went

to Paris and looked up the Moreau museum. I saw Fautrier there for the first time, and most important, I saw the late (Francis) Picabia for the first time. And I saw Michaux. These were things unknown to me until then.

HG   Was a good art library available to you as a young man?

GB   At the academy we had a very good library. I myself had no books, except for literature.

HG   You referred earlier to the "New American Painting" show selected by Alfred Barr, which toured Europe in 1957–58. It included Pollock, Guston, de Kooning; 17 American painters in all. It must have been a shock.

GB   This exhibition took place in the building where we studied, in the academy, that is. The biggest shock was the huge crates in which Pollock's paintings came. They were so huge that they did not fit into the hall. We had never seen anything like it. That was madness! Pollock had the most paintings in this exhibition and also a separate, very large room. Nothing like it had ever been seen before, and there were no doubts about Pollock or his paintings. Nevertheless, at the academy, Pollock had very little influence, particularly with the younger students. De Kooning had much greater influence because his painting was European, or of European origin, and its means of depiction were more easily comprehended. The most important aspect of the de Kooning pictures at that time was expression—the caricature of a woman which had been painted—her horrible expression. She was showing her teeth, and that was decisive.

HG   Did Pollock look wild or controlled when you first saw him?

GB   Not wild at all, because I thought the European paintings, especially those that had been painted in Paris, those of the European Tachistes, for instance Bryen—a man who had great influence—that while they were much smaller in size they were more sensitive, more exciting, and were more appropriate to the European framework and spiritual attitude.

HG   More timid maybe?

GB   The European ones? No. The other way around. I considered a small painting by Wols or Fautrier more radical than a painting by Pollock. And if radicality is a criterion, then I am still of that opinion today.

HG   The development of your painting is very logical, "after the fact." It's not logical before you do it but, once you do something and an art historian looks at it, it has a sequence in your history. But only you can know what the next step will be.

GB   That's very interesting, but I don't have the answers either. That's a decisive question. One can provoke plans through additions. One can start with what one has already done, and then add to it formally and come to a sum. But this sum excludes all freedom, and constricts one terribly. Ambition doesn't satisfy itself in hindsight. I have always tried to avoid this kind of thing. That is why my painting over the past 20 years is not a continual flow, but interrupted by definite breaks. I can prepare myself conditionally, but then tomorrow I have to invent the picture anew.

HG   In the course of our discussions you've used the word "position" in a way that I'm not used to. It clearly comes from an orderly mind with a political and philosophical orientation. The paintings are for you an expression of your position, but for those of us who don't know about that, they are paintings by a man who, with great difficulties, frees himself every few years.

GB   I mean "position" in the sense of attitude. An attitude that one assumes as a demonstrative act. This is not something that one thinks about beforehand; one is forced into it. A normal course of studies does not include such an attitude. It is outside of the usual teaching methods. This attitude came into being as a form of defense, as a self-defense. When I started to paint figuratively in Germany in the late 50s and early 60s, the situation was completely different than it was in America or in France, because we had no hierarchy, no organized painting, no stars. There was just a lot of opposition. The hierarchy where one creates friction, where one accepts and learns, was missing. There was a general opinion that, for example, after the Bauhaus, after abstract painting and Surrealism and the accepted Tachisme, that figurative painting was no longer possible. But I was painting new, or self-invented figurative works. That caused constant fights. I simply was trying to find a position which could give me some breathing space as a painter.

HG   Defend yourself from what and opposition from whom?

GB   Well first of all, the academic circles. I had an exhibition together with a friend, Eugen Schönebeck, in connection with the First Pandemonium Manifesto. Our pictures hung there, and a few people came, not many, but what did ensue was a tremendous amount of criticism. There were attacks which sought to take from me what I was trying to do, to take that which made my existence as a painter meaningful. They said what I was doing was anachronistic. All the doors were opened by all that had been done before. It wasn't possible to start doing it again, they claimed.

HG   The fact is that your paintings look "nasty"—how do you translate that? As an art historian I can see that in the future these paintings will look more classical than they do now.

GB   I believe that that "nastiness" is probably more a handicap that I have and that many German painters share. It's something I didn't use to like but I couldn't help myself. In the meantime I've grown to love it, and I absolutely can't understand "pretty" painters like Nolde, for example.

HG   How would you say "nasty" in German?

GB   Brutal, maybe.

HG   Brutal. Once you get a taste of it, it's hard as a public to be satisfied with less.

Gerhard Richter
*(Photograph by Roland Fischer)*

# Gerhard Richter: Legacies of Painting

*Benjamin H. D. Buchloh*

*Although he had shown extensively in Germany, Paris and Tokyo starting in 1963, Gerhard Richter's first exposure in New York was in 1969 in the group exhibition "9 Young Artists," at the Guggenheim Museum. He had his first one-man New York show at the Reinhard Onnasch Galerie in 1973. It wasn't until 1978 that he had his first exhibition of abstract paintings at Sperone Westwater Fischer Gallery.*

*This is a startling interview. From a historical point of view, it reveals how Richter was occupied by Pop and other American art early on. But finally, he clearly positions himself as a traditional, even conservative painter, denying any cynicism, irony and other theoretical baggage that has been attached to his work. It is the clearest example of how much we have to learn about European artists who have been exposed only spottily in the U.S. This should change in the late 80s.*

BENJAMIN H. D. BUCHLOH   Were you familiar with the history of the avant-garde in the twentieth century when you came to West Germany in 1961? What did you know about Dadaism and Constructivism—about Duchamp, Picabia, Man Ray, and Malevich in particular? Was that all a great discovery immediately after your arrival? Or was it a gradual, unplanned process of learning and absorbing?

The original interview was conducted in Richter's studio in Dusseldorf in December 1986. This interview consists of a series of excerpts from the longer version which was published in *Gerhard Richter* (exhibition catalogue [Chicago: Museum of Contemporary Art/Toronto: Art Gallery of Ontario]) (London: Thames and Hudson, 1987).

GERHARD RICHTER    More of the latter—an uncontrolled and gradual learning process. I really knew nothing—not Picabia, not Man Ray or Duchamp. I only knew artists like Picasso and Renato Guttuso, Diego Rivera, and naturally the classics as far as the Impressionists. Everything after that was labeled in East Germany as bourgeois decadence. That's how naive I was when I visited "Documenta" in Kassel in 1958, where Pollock and Fontana made a great impression on me.

BB    Do you remember what it was in Fontana and Pollock that particularly caught your attention?

GR    The unashamedness. I was fascinated by that, really taken aback. I might almost say that these pictures were the real reason for my leaving East Germany. I noticed that there was something that was wrong with my way of thinking.

BB    Can you qualify what you mean by "unashamedness"? That sounds like it has something to do with morals. Surely that's not what you mean?

GR    Yes, that is what I mean. For at that time I was part of a circle that claimed to have a moral concern, that wanted to be a bridge, or to find a middle way, a so-called third way, between capitalism and socialism. As a result, our whole way of thinking was preoccupied with compromise. So, too, was what we sought in art. That simply wasn't radical, to use a more suitable word for unashamed. It wasn't truthful. It was full of false considerations.

BB    What sort of considerations?

GR    Well, for traditional artistic values, for example. What I chiefly noticed was that those "slashings" and "blotches" were not a formalist gag, but rather the bitter truth, liberation, and that here a completely different and new content was expressing itself.

BB    When you say that Fontana and Pollock were the first ones that affected you so much, that they practically brought about your emigration from East Germany, who came next in this learning process? Was it Robert Rauschenberg and Jasper Johns, or was it Yves Klein and Piero Manzoni?

GR    Well, naturally that was a slow process; at first I was chiefly interested in the transitional figures, who seemed less radical to me: Giacometti, Dubuffet and Fautrier, for example.

BB    Fautrier—can you reconstruct what interested you in him?

GR    The impasto, the painterly messiness, the amorphousness and materialism.

BB   Could one therefore say that it was the anti-artistic impulse in painting that interested you—in Fontana and Pollock, also?

GR   Yes; and also that which wanted to have nothing to do with the past.

BB   Did you ever ask yourself how it happened that American painting occupied you more than European painting, not to mention German painting?

GR   No. There was nothing up in Germany. That just seemed to me to be something one could take for granted, with such a past.

BB   And what about the past prior to the Nazi period? Why wasn't that discussable?

GR   I wasn't familiar with it.

.      .      .      .      .

BB   When did you first see Pop art in reproduction? Did you go to the Pop art exhibition in Amsterdam? Or did you see Pop art at Ileana Sonnabend's in Paris?

GR   Konrad Fischer first showed me Pop art in reproduction. It was a stove painted by Roy Lichtenstein. And then there was something by Warhol, something not so entirely "inartistic" as the Lichtenstein, or so it seemed to me then.

BB   That was 1963–64?

GR   1963 or 1962. And then we went with our portfolios to Ileana Sonnabend's in Paris in order to present ourselves as the "German Pop artists." It was there that we first saw original works by Lichtenstein.

BB   Lichtenstein was then suddenly more important for you than Rauschenberg?

GR   Yes. That subsided only later, when he became somewhat empty and decorative. At that time Lichtenstein, Andy Warhol, and Claes Oldenburg were important to me.

BB   Can you describe that more exactly? In what way were they so important for you? Was the singularization of the object, as opposed to the complex interrelation in Rauschenberg, a consideration?

GR   Rauschenberg was too artificial, and too interesting. He didn't have this astonishing simplification.

BB   Instead of a complicated composition, such as one still finds with Rauschenberg, which practically adheres to the collage principle, instead

of this we find an object presented in Lichtenstein and Warhol as a distinct object, like a "ready-made."

GR    Yes.

BB    What about the technique? Did Lichtenstein's perfectionism attract you?

GR    Yes, very much, because it was anti-artistic. It was opposed to *"peinture."*

BB    It's still somewhat puzzling for me when you say: Lichtenstein and Warhol, yes, but not Johns. The difference must really have been determined by the way of painting. That is, with Warhol and Lichtenstein the way of painting itself, the execution, becomes an object of critical treatment. Was it the complicated treatment, the artistic intricacy, that bothered you in Johns?

GR    Yes, because Johns retained a culture of painting, which also has something to do with Paul Cézanne, and I rejected that. That's why I even painted photos, just so that I would have nothing to do with *peinture*—it stands in the way of all expression that is appropriate to our times.

BB    But when Warhol went on to have pictures produced practically anonymously in silkscreen, didn't that strike you as an affront? That was a threat to your very existence, if someone suddenly demonstrated that painting is replaced by technique. That would be a threat to the meaning of all painterly techniques, regardless of how much they had been simplified?

GR    Perhaps I was admiring something that isn't possible for me, something I'm not able to do. That's also the way it was for me with the Minimalists; they were also doing something that I'm not able to do.

BB    Haven't you ever tried to leave a photo as a photo—to give it the quality of a picture only by means of enlargement, blurring of focus, and other manipulations?

GR    Rarely, and it works only on photos of pictures already painted.

BB    The theoretical implications which were then ascribed to Warhol, his radical opening up of the concept of art, his anti-aesthetic position (which had not existed since Duchamp), these had also been present in the context of Fluxus art. This must also have attracted you at that time?

GR    It attracted me quite a bit, it was very existential for me. Fluxus above all.

BB    These are contradictions that are very difficult to understand: the fact that on the one hand you were attracted to Fluxus art and to Warhol, but that you say, on the other hand, "I couldn't do that, I only wanted to paint, I was only able to paint"; the fact that you then, on the one hand, compare your own painting to this anti-aesthetic impulse, but at the same time you retain a painter's position. This seems to me to be one of the thoroughly typical contradictions out of which your work has essentially developed.

GR    Yes, it's curious. But I don't find it so contradictory. It's rather as if I'm doing the same thing, only with different means, with means that are less spectacular, less advanced.

BB    In other words the denial of the act of artistic production, such as it was introduced by Duchamp and revived by Warhol, has never been acceptable to you?

GR    No, because the act of artistic production simply can't be denied. Only it has nothing to do with the talent for "making things by hand"; rather it's a matter of the ability to see, and to decide *what* shall become visible. *How* that is then produced has nothing to do with art or with artistic abilities.

BB    When you began to paint nonfigurative pictures, Color Charts, in 1966, did that have any relation to the then-emerging Minimal art? Was it again part of that conflict situation with American dominance? Or was it a matter of personal development, with a basis here in the narrower local area around Düsseldorf? Was it perhaps influenced by the encounter with Palermo?

GR    It certainly was related to Palermo and his interests, and later to Minimal art as well. But when I painted the Color Charts in 1966, that had rather more to do with Pop art. They were painted color pattern cards, and the beautiful effect of these color patterns was that they were so opposed to the efforts of the Neo-Constructivists, such as Albers, etc.

BB    Were you acquainted at that time with Barnett Newman?

GR    No. But later on I really came to love him.

BB    So your abstractions were rather an attack upon the history of European abstractionism.

GR    It was an attack on the false and pious way in which abstractionism was celebrated, with a dishonest reverence—treating these squares as something to be revered, like church art.

BB    By contrast, the abstraction of Minimal art, that did interest you?

GR    Yes—it made two or three Color Charts gray. In the case of the Color Charts, above all the later ones, I might point to the influence of Conceptual art, to its theoretical, didactic dimension. But at bottom it was the simple need of *not* knowing how I could meaningfully arrange colors. That's what I tried to produce, as beautifully and as clearly as possible.

.    .    .    .    .

BB    Your painting from photos in the early 1960s does have an anti-artistic quality; it denies the autographical, the creative, the original. So to a certain degree you do follow Duchamp and Warhol. Moreover, your painting negates the importance of content in that it presents motifs chosen at random.

GR    The motifs were never random; I had to make much too much of an effort for that, just to be able to find photos I could use.

BB    Then was the selection in every single case a very complicated one, and clearly motivated? If so, my assertion in the Paris catalogue, where I wrote that it was basically completely random which photo you had chosen, is highly problematic?

GR    Perhaps it was good if it seemed as if everything had been accidental and random.

BB    What were the criteria for the selection of photos in your iconography?

GR    They very definitely were concerned with content. Perhaps I denied that earlier, when I maintained that it had nothing to do with content, that for me it was only a matter of painting a photo and demonstrating indifference.

BB    And now some critics are trying to ascribe to you this significance of iconographic content. Ulrich Loock and Jürgen Harten talk about the "death series": *Airplane* stands for death; *Pyramids* and *Accident* stand for death. It seems to me somewhat forced to construct a continuity of the death motif in your painting.

GR    And you think that there I was seeking motifs that were supposed to be just a little bit shocking, while in reality they were completely indifferent for me?

BB    I would agree to this extent, that no choice can be random, that some sort of attitude holds sway in every choice, however complicated and unconscious it may be. But if one looks at your iconography in the 1960s, I find it difficult to construct a continuous death thematic. The *Eight Student Nurses*, well, all right, but then what about the *Forty-eight Portraits*? There it makes no sense to construct a death thematic. What do the *Chile Pictures*

have to do with *Pyramids*? Or what do the *City Pictures* have to do with the *Mountain Pictures*? Those are iconographic elements that admittedly can be combined, but not in the sense of a traditional iconography, where one says: there is the death thematic. It seems to me completely absurd to want to construct a traditional iconography in your painting.

GR   Perhaps it's just a little exaggerated to speak of a death thematic there. But I do think that the pictures have something to do with death and with pain.

BB   But this content is not the determining, the motivating power behind the selection.

GR   That I don't know; it's hard for me to reconstruct what my motivation was then. I only know that there are reasons related to content for why I selected a particular photo and for why I wanted to represent this or that event.

BB   In spite of the fact that content can no longer be communicated by iconographic portrayal? There again you've got a contradiction. Even though you knew that a death thematic, for example, could not be communicated by the mere portrayal, you nevertheless tried it, knowing perfectly well that it was actually impossible.

GR   Well, in the first place it's not impossible at all. A picture of a dead dog shows a dead dog. It only becomes difficult when you want to communicate something beyond that, when the content is too complicated to be depicted with a simple portrayal. But that doesn't mean that representation can't accomplish anything.

BB   Were you aware of the criteria that you used in the selection? How did you go about selecting photos?

GR   I looked for photos that showed me actuality, that related to me. And I selected black-and-white photos because I noticed that they depicted that more forcefully than color photos, more directly, with less artistry, and therefore more believably. That's also the reason why I preferred those amateur family photos, those banal objects and snapshots.

BB   And the pictures of the Alps and the *City Pictures*?

GR   They came about when I no longer wanted to do the figurative photo pictures and wanted something different; when I no longer wanted an obvious statement or limited, discernible narrative. So these dead cities and Alps attracted me, rubble heaps in both cases, mute stuff. It was an attempt to communicate a more universal kind of content.

Gerhard Richter, *552–3 Bogen*, 1984
Oil on canvas, 102¾″ × 79″.
*(Collection Mr. and Mrs. Harry Macklowe; photograph by Dorothy Zeidman; courtesy Sperone Westwater)*

BB   But if it had really been this kind of content that mattered to you, then how do you explain the fact that at the same time, you were introducing nonfigurative pictures in your work? Color Charts, for example, or other abstract pictures which arose in parallel with the figurative ones. This simultaneity confused most of your critics. They saw you as a painter who knew all the tricks and the techniques, who was a master of all the iconographic conventions that he was simultaneously depreciating. It's that which makes your work particularly attractive to some observers just now. Your work looks as though it were presenting the entire universe of twentieth-century painting in a giant, cynical retrospective.

GR   That is certainly a misunderstanding. I see there neither tricks, nor cynicism, nor craftiness. On the contrary, it strikes me as almost amateurish to see how directly I went at everything, to see how easy it is to discern all that I was thinking and trying to do there. So I also don't know exactly what you mean now by the contradiction between figurative and abstract painting.

BB   Let me take as an example *Table,* one of your first pictures. *Table* contains both elements: a completely abstract, gestural, self-reflexive quality, on the one hand, and, on the other, the representational function. And that is really one of the great dilemmas in the twentieth century, this seeming conflict, or antagonism, between painting's representational function and its self-reflexion. These two positions are brought very close together indeed in your work. But aren't they being brought together in order to show the inadequacy and bankruptcy of both?

GR   Bankruptcy, no; inadequacy, always.

BB   Inadequacy by what standard? The expressive function?

GR   By the standard of what we demand from painting.

BB   Can this demand be formulated?

GR   Painting should be accomplishing more.

BB   So you would dispute the charge that has so often been made against you, that you have cynically acquiesced to the ineffectuality of painting?

GR   Yes. Because I know for a fact that painting is not ineffectual. I would only like it to accomplish more.

BB   In other words the simultaneity of the opposing strategies of representational function and self-reflexion has nothing to do with a reciprocal transcendence of them? It's rather an attempt to realize this demand upon painting with different means?

GR   Yes, roughly.

BB   So you saw yourself at the beginning of the 1960s not as the heir to a historically divided and fragmented situation, in which there was no pictorial strategy that still had real validity . . . ?

GR   And I see myself as the heir to an enormous, great, rich culture of painting, and of art in general, which we have lost, but which nevertheless obligates us. In such a situation it's difficult not to want to restore that culture or, what would be just as bad, simply to give up, to degenerate.

.     .     .     .     .

BB   Would you see it as a condition of your current painting to find your way further along in the dilemma which you have seen yourself facing from the beginning—that is, on the one hand, to play out the real conditions of mass culture, which you see represented for example in photos, and, on the other, to oppose this to the esoteric and elitist conditions of the high culture which you are a part of as an artist? In this sense you're working out of this dialectic and exposing yourself constantly to this contradiction; and there is practically no solution which you can accept. Is that still a condition? Or is that a condition that was valid only for the 1960s?

GR   Neither then nor now can I see these conditions in this way.

BB   But the Cézanne quotation speaks directly to this. When you say, "For me some snapshot photos are better than the best Cézanne," that seems to me to express precisely this contradiction.

GR   Yes, but that doesn't mean that I could immediately change something through painting. And it certainly doesn't mean that I could do so without painting.

BB   Why have you so expressly denied the real political demand in your own art?

GR   Because politics just isn't for me. Because art has an entirely different function. Because I can only paint. Call it conservative if you want.

BB   But perhaps precisely in the limitation to the medium of painting there is not only a conservative position, but also a critical dimension, one that calls into question the claim to political immediacy in the work of someone like Beuys, for example.

GR   Naturally I would want to see in my limitation to painting a critical stance toward much that displeases me, and which concerns not only painting.

BB   So you don't despair fundamentally of the vitality of the demand that art should realize a political critique?

GR   Apparently. But the decisive thing is that I have to begin from my possibilities, from the conditions that constitute my basis, my potential.

BB   Which you would claim are unchangeable?

GR   Largely unchangeable.

.   .   .   .   .

BB   Even your *Abstract Paintings* should convey a content?

GR   Yes.

BB   They're not the negation of content, not simply the facticity of painting, not an ironic paraphrase of contemporary expressionism?

GR   No.

BB   Not a perversion of gestural abstraction? Not ironic?

GR   Never! What sorts of things are you asking? How is it that my pictures are supposed to be without content? What content is it that the Abstract Expressionists are supposed to have in contrast to me?

BB   Obviously their paintings are painted with a different claim. Take Mark Rothko, for example. There, spatial illusion is evoked by a thinning and graduating of color, and it's not immediately negated, as with you. Depths, fogs, shimmerings, transcendence—all these are really represented. In Rothko's work, furthermore, the color combination is an important element: two or at most three hues or tonal values are set against one another in a very precisely calculated and differentiated way. As a result, a definite chromatic chord emerges from this combination, and it in turn is supposed to produce a psychic, emotional effect.

GR   In principle that's no different from what I do; the only difference is that different means are used to produce a different effect.

BB   No so. Because if the ability of color to produce this emotional, spiritual quality is presented everywhere, and at the same time negated, then it will cancel itself again and again. When it provides so many combinations, so many permutated relationships, one can no longer speak about the chords of chromatic ordering. Just as little can one speak any longer of composition in your work because ordered relationships just don't exist anymore, neither in the color system nor in the compositional system.

GR   I can't see it that way; I can't see that there are no longer any composition or chromatic relationships. When I put one color form next to another, then it automatically relates to the other.

BB   Yes, but these are different forms structured in different ways, and according to different laws of relationship, up to the point of recognition that even absolute negation is a composition. But everything in your *Abstract Paintings* aims at transcending traditional, relational orders, because an infinite variety of structurally heterogeneous elements is visible as a possibility.

GR   Yes, but I still have somehow to bring everything into the right relation. A relation that becomes more and more difficult the further a picture has progressed. At the beginning everything is still easy and indefinite, but gradually relations emerge that register as appropriate ones: that's the opposite of randomness.

BB   Certainly. But that amounts to a different kind of perception, and thus to a different form, possibly precisely the opposite of traditional compositional and chromatic relations.

GR   Perhaps. In any case, my method or my expectation which, so to speak, drives me to painting, is opposition.

BB   What is it that you expect?

GR   Just that something will emerge that is unknown to me, which I could not plan, which is better, cleverer, than I am, something which is also more universal. In fact, I've already tried that in a more direct way with the *1,000* or *4,000 Colors* in the expectation that a picture would emerge there.

BB   What kind of picture?

GR   One that represents our situation more accurately, more truthfully; that has something anticipatory; something also that can be understood as a proposal, yet more than that; not didactic, not logical, but very free and effortless in its appearance, despite all the complexity.

BB   Your pictures do have all these qualities in the best cases. They seem effortless, yet painted with verve, with indifference and virtuosity at the same time. But to come back again to the question of content, if a picture is made with an obvious emphasis on the way it was produced, how is it possible for you to say that a smeared surface or one treated mechanically with the palette knife doesn't represent pure process or pure materiality? If these qualities weren't important for you, then you wouldn't apply the color that way. To do so is to take away from the picture's color, composition,

and structure every possibility of producing transcendental meaning, be-yond the pure materiality of the picture as a picture. I believe that you have introduced a kind of painting that is process-referential as one of its many possibilities, but, unlike Ryman, you no longer insist on it as the only aspect. Rather, it's one characteristic among others.

GR    Then why do I give myself so much trouble making it so complicated?

BB    Perhaps because it's important for you to recite all the aspects, like a catalogue; because what really interests you is a rhetoric of painting, and a simultaneous analysis of that rhetoric.

GR    If it were only a demonstration of material, how the jagged yellow surface arises there against a blue-green background, then how is it possible to generate a narrative or to evoke moods?

BB    Mood? You think that your painting really evokes emotional experi-ence?

GR    Yes, and aesthetic pleasure as well.

BB    That's a different matter. I see aesthetic pleasure too. But mood, not at all.

GR    What is mood then?

BB    Mood has an explicit emotional, spiritual, psychological quality.

GR    That's just what's there.

BB    Only in the weakest parts, fortunately.

GR    You don't really believe that just the dumb showing of brushstrokes, of the rhetoric of painting and its elements, could accomplish something, say something, express some kind of yearning?

BB    Yearning for what?

GR    For lost qualities, for a better world; for the opposite of misery and hopelessness.

BB    The yearning to be able to adhere to the notion of culture as a contem-plative spectacle and maintain credibility at the same time?

GR    I could also say salvation. Or hope. The hope that I can still accom-plish something with painting.

BB    But that's again so general: accomplish in what respect? Cognitively, emotionally, psychologically, politically?

GR    All at once—how do I know?

.    .    .    .    .

GR    The reason I don't argue in "sociopolitical terms" is that I want to produce a picture and not an ideology. It's always its factuality, and not its ideology, that makes a picture good.

BB    That's precisely what I see in the fact that color is treated like a material process. Color becomes an object that is presented and altered by these instruments. It remains the same in all these diverse structures. It shows how it was produced, what instruments were used. There's practically no external reference that would motivate the appearance or the structure of the colors. These phenomena are all self-referential. Does this interpretation still seem too narrow to you?

GR    Yes. Because the whole process does not exist for its own sake; it's only justified when it uses all these beautiful methods and strategies to produce something.

BB    What could it produce besides belief in images?

GR    A painting, and thus a model. And when I think now of your interpretation of Mondrian, where his pictures can also be understood as models of society, then I can also regard my abstractions as parables, as images of a possible form of social relations. Seen in this way, what I'm attempting in each picture is nothing other than this: to bring together in a living and viable way the most different and the most contradictory elements in the greatest possible freedom. Not paradise.

Francesco Clemente
*(Photograph © Timothy Greenfield-Sanders 1987)*

# Francesco Clemente

*Giancarlo Politi [and Helena Kontova]*

Clemente exhibited along with Chia in New York for the first time in 1979 at *Sperone Westwater Fischer. He was then one of the "3 Cs," although he had been showing individually in Europe since 1974. He moved to New York in 1983 but maintains an apartment in Rome and a house in Madras, India and draws on experiences of all three places.*

*In his formative years he was exposed to Arte Povera. One might say he responded to this conceptual art in the same way American artists like David Salle responded to American conceptual art—by adopting some of the philosophy but reintroducing sensual matter into drawing and picture-making. Like Salle, Clemente is impossible to pigeonhole.*

*At the time of his first exposure here, Clemente was located in the new imagism which formed part of a resurgent nationalism and regionalism. He nevertheless contradicts the idea of stylistic classification. He salutes his heritage in techniques like fresco, but he also employs photos, collages, watercolors, pastels, tempera, oil, and mosaic, and makes books and miniatures that obviously were influenced by his stay in India. Part of the concept of the trans-avant-garde endorses the ransacking of art history for images—digesting and reanimating art of the past—an idea which is shared internationally. The interview explores Clemente's internationalism.*

GIANCARLO POLITI    I see you're working on a book with Allen Ginsberg. How did this idea come up?

This interview, translated by Paul Blanchard, was originally published in *Flash Art* (April/May 1984).

Francesco Clemente   We met when I was doing a series of watercolor portraits, and we discovered that we both loved William Blake, who as you know, always drew and wrote on the same page. From this coincidence came the idea of doing a book together.

GP    Does the book have a theme?

FC    It's a group of images of the city, as light as possible, I'd say. I think they're like haiku for Ginsberg.

GP    What do you think of working together with someone else?

FC    It's always interested me, even within my own work, to push the limits of the personal taste of the plan of a work, to see how far away from oneself and from one's own tastes one can lead the work. The extension of this idea is to work together with someone else, too.

GP    If I'm not mistaken you've already worked with others.

FC    Yes, there are several collections of my works that were done a *quattro mani,* even with "amateur" painters—in India with illustrators. For example, I did a work in miniature in India four years ago, in which the miniatures were done by the traditional method, passing the page around to each of the illustrators—boys of 13 or 14 who know one or two scripts, one or two motifs—according to a general plan that determines what goes where and with what motifs.

GP    But with "professional" colleagues, known artists, have you tried this kind of relationship?

FC    At the moment I'm trying to work in a threesome, with Jean-Michel Basquiat and Andy Warhol. I'm telling you now because I hope it works out, otherwise it'll just be gossip.

Helena Kontova   By what strange chance with Andy Warhol?

FC    It's the three ages of man . . . (ha!)

GP    How does this threesome work; do you get together from time to time? Who begins the painting?

FC    The work grew out of an evening when we found ourselves invited to a dinner party, all three of us, and we were all horribly embarrassed. I think that was the moment that precipitated this desire to mingle with each other on canvas. Now, we keep passing the canvases around from studio to studio, and they change . . .

GP    I see. You don't work together at the same time in one studio.

FC   It would be impossible. We have three completely different ways of working.

GP   So you don't even know who starts and who finishes a work.

FC   Sure, some things start out in one studio, others in another, and they get passed around.

GP   Who decides when a painting is finished, and how?

FC   I'm hoping we'll be lucky, and that it'll be the painting itself that decides, that declares itself finished. But this is a problem with every painting—deciding when it's finished—and there's a whole series of myths on the subject that I'd rather not go into.

GP   Are there paintings of yours that you consider unfinished—past works, I mean?

FC   In a certain sense none of my past paintings are finished, because their meaning is changed by the appearance of new works. I try to infuse each work I do with this image or desire that the time of the work will not be apparent until my entire opus is complete. I want an obscurity to hang over the meaning of the work.

GP   Are there any of your works that you regret doing?

FC   No, there aren't. As a matter of fact there are a lot of works by other people that I wish I'd done . . . (ha!).

GP   Other artists?

FC   Yes, other artists.

GP   How do you like working here in New York—the atmosphere, I mean? I can't say your paintings have changed between Italy and New York, because even in Italy you were always willing to run risks, especially from a critical point of view. You've always experimented on yourself. Do you think your attitude has changed?

FC   I keep on saying that Naples is a suburb of New York. In this sense I'm no different from the other members of the present generation of New Yorkers, who all come from the suburbs. Anybody who knows Naples well will certainly agree that Naples is very similar to New York.

GP   To the Bronx?

FC   Sure!

GP    But New York, and maybe even Naples, I don't know, exerts a certain kind of psychological pressure.

FC    Yes, it does, but it works the other way around, too. It's a physical pressure, I'd say, more than a psychological one. Being from Naples I need that kind of pressure in order to work. I have to be coerced, otherwise I won't get anything done. In reality New York is quite a "light" city. Don't forget that before coming to New York I was always running off to India, another crowded place, where for better or for worse there is that same sense of "lightness" due to overcrowding. There is such an overlapping of differences, pressures, violence and kindness that one is really very free . . . very alone, in the best sense of the term. If you say "no" to someone in New York, it's not a problem, because they'll find somebody else to ask right away.

HK    You mean these people are interchangeable, or replaceable?

FC    Great numbers of people means great wealth—a great variety of wealth, therefore much lightness and generosity. On the other hand this tremendous violence also leads to much tenderness and great delicacy, I'd say.

HK    Anyway there's a big difference between India and New York; I'm thinking of what you were saying about having to be coerced to work.

FC    The two places really have a lot in common, because both owe a lot of their strength to a well-defined choreographic system, and both are good teaching machines. They educate you, they teach you how to be ready, to be in good shape, and to simplify yourself a lot, precisely because you have to be light, fast and springy.

GP    So you don't miss Europe at all.

FC    I like to live on the street. I see Europe as a small community of upright people in a desert. In Europe the street makes me melancholy. When I think of Europe, I think of the names of 10 people I respect and love, who are scattered all over the continent; but if I think of what is happening in European society, nothing appeals to me. I don't like the mood of Europe, I don't like anything.

HK    All the same, your work remains closely tied to European models— Egon Schiele, for instance—at least in certain moments. Maybe it's more a question of atmosphere.

FC    There is a great variety. My work runs through iconography. It doesn't promote one iconography over another, so there's a great number of coinci-

dences that you can find, and then an invitation to look at the meaning of the works more than at this proliferation of iconographies.

GP   Yes, so it's an atmosphere and an iconography that you carry around inside you, in a certain sense, and it accompanies you wherever you go.

FC   I carry inside of me the idea that it's better to be many than one, that many gods are better than just one god, many truths are better than one alone . . .

GP   This show that you're putting together, will it deal with a theme, or is it a series of pictures that give an image of you over the last few months or the last year? Do you have a title, for instance?

FC   Not yet, the title is always the last thing to come along. They'll be collections of works. My work always contains this obsession to create as complete a panorama as possible, hence there'll be collections of works that contradict each other in terms of their technique and development. I think there will be another journey, the sense of a journey, and there will be another image of the body. Because this is what I see has happened in my work over the last few years, I don't think there will be changes in these things, which are the real roots of my way of thinking.

HK   I saw the two large works containing a series of 13 or 14 pieces, I think, in London, at Whitechapel and at Anthony d'Offay. Do you often work in cycles?

FC   Yes, I've always worked in what I call collections rather than cycles, always on this idea of starting from the beginning and working my way through a technique or a process, say of creating a frame and working inside this frame to try all its possibilities, and even go beyond. I've always wished that these collections would be scattered round the world, and that everyone would see just a fragment. I've always been interested in the idea of a collection on one hand, and in that of a fragment on the other—the idea that the work always refers to another work that can't be seen but that exists or will exist. The 14 stations of the cross at Whitechapel are unusual. The entire collection of works was kept together because there was a buyer who made it possible to keep the work united.

GP   It was a commissioned work, then?

FC   No, it was a work that kept me busy for a year, my first year in New York, at the end of which my closest friends insisted on the unusual character of this work and the idea that I absolutely had to find a way of keeping it together.

GP   Are you able to work on more than one painting at the same time?

FC   Yes. As you know oil painting can't be rushed, it has a rhythm of its own. All artists who work in oils work on more than one painting. When I use other techniques it's different, of course. Fresco, watercolor and pastels are very, very fast, so things simply come to you in rapid succession. Usually when I work there are techniques that are mutually compatible, and others that aren't. It depends on my mood.

GP   Do you begin a new cycle, or a new series of paintings, on the basis of an interior idea, or, let's say, on that of a series of projects, drawings or sketches?

FC   I drew quite a lot between 1971 and 1978. I did thousands of drawings, very dry and severe, each of which was tied to an idea. From that time on my energy has gone into executing these works that aren't born just like that . . . at the beginning they were born from the drawings, now it's increasingly difficult for me to plan them. At most I like to plan a technique, let's say a system of tools that I surround myself with, and later . . . it's harder for me to believe the images. Naturally, as the years go by one becomes more conscious of how one is made, but it becomes less desirable to explore one's makeup; what I mean is that the problem becomes one of knowing as little as possible, of doing, without knowing what one is doing. Naturally, the older one gets, the harder it becomes not to know.

GP   So your work is born right on the canvas in a certain sense.

FC   Yes.

GP   But are you able to work, for instance, on large and small paintings at the same time?

FC   There's an enormous variety of situations. I don't have habits in my life, and I don't have habits in my work. I change continuously.

GP   But a small painting is different from a large one.

FC   No. One of the singularities of my work is the absence of scale. All the things I've done are either very small or very large, and sometimes they are small or large regardless of their scale. This is good, because it allows me to hold a dialogue with European as well as American work, which have two different scales.

HK   But, for instance, when you begin painting, do you begin with the figures or the objects, and then go on to the background when they're done?

FC   This is another singularity and perhaps a success of my work: there's no contradiction between figure and background. This is where European art gets stuck, I think: Bacon said so last year in a very fine interview. He said, "I've never known what to put behind my figures." And American art has always painted figures and objects on a material. The background for American painters is the material: Warhol's silkscreen, Schnabel's velvet and broken dishes, the sculpture within the painting that's behind the images of Jasper Johns.

GP   You used to be a conceptual artist. Is that experience still with you? Do you think your work can be seen in the right light without knowing that you were a conceptual artist?

FC   I was a conceptual artist in 1978, just as I was a neo-expressionist in 1980. I'll let you decide if these simplifications are due to the originality of my work or to its lack of originality . . .

GP   Here in your studio I see a portrait of Andy Warhol and a painting by Picabia.

FC   And a Füssli.

GP   Are they indicative choices, or are they here by chance?

FC   I think the Füssli has a lot to do with that whole aspect of my work which is tied to bad taste. Füssli and Blake might be considered the first Western painters to take a close look at bad taste, to see truth as bad taste. Warhol is here because I love the generosity of his work in the same way I love the generosity and speed of Tintoretto. Picabia is here as a painting by de Chirico from the 50s might be—they're two painters that have claimed to be dilettantes in order to maintain the integrity of their inquiry, and they have shown that eroticism and humor aren't held hostage by an age, whereas ideas are.

GP   What difference do you see between painting in America and painting in Europe?

FC   I think it was Savinio who wrote of Europe and of the European middle class before the First World War, saying that we'll never be able to imagine what Europe was like then. I feel those very good years from 1913 to 1918 were largely a result of the disappearance of a way of life or a class in Europe that left these survivors, the painters, who found themselves suspended in a void and had to create a new world to replace the world that no longer was. The same thing happened in Europe in recent years, I think. The artists have passed through at least one war; and for the first time each one of them, from Enzo Cucchi to Anselm Kiefer, has succeeded in sinking

his roots into the soil of his own birthplace, just at the moment when ethnic differences were wiped out, as in the last 10 years. We've seen it happen in Italy: when everything that was pleasant and local had been leveled, a painter like Enzo—the painter of the Marches, the eternal periphery of a world that has become totally peripheral—came along. In America there's more continuity, there's a living tradition of contemporary painting. We come from this big silence, this great war, this leveling.

HK   After your first works with photography, which were more conceptual, you began to show drawings. How did this radical change come about?

FC   The core of my work, ever since the early 70s, had been these hundreds of drawings I made.

GP   But where did you find the "courage" to show them?

FC   In solitude, I'd say. There were years in the mid-70s . . . 1977 I spent a whole year in India. There was this silence, somehow, this solitude, this terrible lack of reality, and a great desire to restore reality to what we were doing as artists; whereas somehow all that esoteric and sophistic baggage of the late 60s, of the artists of those years, seemed to have been usurped by the politicians, by the street. It seemed that nothing could be done in that direction.

GP   So it grew out of a self-encounter—a sort of "spiritual exercise"—more than a cultural difference or an outside pressure. That is, India . . .

FC   It's just that I'm from the South and my spirit is one of contradiction. If everyone tells me, you can't paint, then I paint.

GP   Do you like to paint? That is, do you find physical pleasure too, in painting?

FC   I wouldn't call it pleasure, it's more like something that belongs to me. When I'm inside the work I don't have the impression that the work really belongs to me. It really seems that it's something that flows, and that I lead from one point to another. I feel like I'm a messenger between two worlds.

GP   But when you work, are you in a state of excitement, of emotion, or do you work in a very cold manner?

FC   No, I'd say both Dionysus and Apollo are present when I work.

GP   Has success changed anything in your work? Are you more sure of yourself, more aware?

FC   No, I don't think it has to be that way, I don't think painters should ever believe in the world, even if the world believes in them.

GP   Do you think you're a great artist?

FC   There are two kinds of Italians, represented by Sem Benelli and Savinio. I sympathize with Savinio and the pre-Socratics, and not with the Platonics. I'm one of the silent ones, not one of the noise-makers.

GP   You've always believed firmly in your work, though, even when you were getting less attention.

FC   Attention comes and goes, and that's the way it should be. And you always work for one person alone or for one person at a time. There are always two of you, the painter, the painting, and someone the painting is being for, someone you think about while you do the painting. There is an intimacy in painting.

HK   Do you also use models—people or objects?

FC   Yes, usually to finish paintings, rather than to begin them. When there are figures, I paint them first without a model, and then, when the painting is in a final stage, I use figures or models. Once again this has to do with working together, *a quattro mani,* because somehow the model makes the line come to me, in a surprising, extraordinary way. Very often the model knows exactly what line I need, and shows it to me.

HK   Why do you use reality only to correct your paintings, and not as a starting point?

FC   I'm always interested in building up my paintings as though they were force fields, like those diagrams in the crossword section of the paper where you have to connect the dots. In another sense they are born as ideograms. After the severity of ideograms they go on to a more theatrical state. I've always seen my paintings as ideograms in costume, clothed or disguised. They have the ideogram's capacity to express, to make references . . . they are a field of relations that makes reference to another field of relations without resorting to direct allusion. At that stage, if I think like that, I have no need for reality. I have to think, then afterwards I need reality to do away with the grotesque. And I need reality as a commonplace. I always have to lead the painting back to a commonplace appearance.

GP   I think artists in general understand each other's work better than other people. What about critics? Have they understood your work?

FC   As a Neapolitan I'm deeply suspicious of "thought" and of those who "think." Naples is poisoned by the East, and in the East the image of creation is this primeval tree on which one bird eats while another looks on and starves. It is the idea that thought carries this basic hunger as a hereditary

Francesco Clemente, *Inner Room*, 1983
Fresco panel, 95½" × 13½".
*(Collection Tom Newby; photograph © Dorothy Zeidman;
courtesy Sperone Westwater)*

defect, so that there's no knowledge that isn't a carrot. I trust all those who have "thought" with their bodies, too: Ezra Pound, René Daumal, Walter Benjamin, Simone Weil . . .

GP  What difference do you find between European and American criticism?

FC  New York is a special case, because in New York there's an audience for art that's the same as the audience for film or theater, or any other form of entertainment. I mean it doesn't have a personal interest in how a work develops. Therefore it's New York's biggest critic, because it can't be bought. People go to the galleries as they go to the movies, and they either like things or they don't—it depends on the energy and the mood of the city. In a newspaper here in New York someone wrote about my work, "We don't know what the devil he's doing, but it's exactly what we need right now." So critics here have a greater sense of their role. It's easier for them to have a sense of their role, because they have less space for whims. In Europe there's a curfew in the streets and art isn't seen by anyone—it can't be seen—and so, in my opinion at least, critics have a tougher time defining their role. I really think they slightly lose the sense of art, or of reality, and tend to live in this technocratic dream in which art is an instrument for governing who knows what.

GP  Who has a closer following, the American critic, or the European?

FC  I listen to the American critics with greater interest because it seems to me that they have a greater sense of reality and they are more concerned with transmitting between one artist and another . . . with explaining to an artist what another artist is doing, without fooling themselves into thinking they're promoting the artist's work—something that just isn't possible, as you know. That is, critics aren't capable of promoting any work by anybody.

HK  I see a sculpture by Julian Schnabel here in your studio. Have you ever done sculpture?

FC  No, but I would like to have done that one by Julian, if it weighed a little less.

HK  I know you've done "three-dimensional" works.

FC  Well, there are fresco fragments that are the closest thing to a sculpture, but I've never worked sculptures, I've never published sculptures, in the true sense.

HK  Before you paint, do you look at books for inspiration?

FC   Most of my paintings grow out of phrases, of things I hear or read. Coincidences; say, the fact that in a week I read and hear the same phrase in 20 different situations, I open 4 books and they say the same thing, I talk to 3 people and they tell me the same thing.

GP   Aren't there any literary stimuli, that you pick up reading writers of the past, for instance?

FC   I believe Ezra Pound has quite a bit to do with the process of my work. I believe what he did in poetry has a lot to do with what I do in my paintings.

HK   This painting, for example, shows a person lying on a tiger. Did it grow out of a phrase?

FC   "Tiger, tiger burning bright in the forest of the night" (Blake), or there's a poem by Penna that I don't remember, but in which he says he wishes he'd never been born, so he could live, asleep, in the heart of the world.

GP   Who are the artists of the past you like best, you feel closest to?

FC   I went to museums when I was seven, eight, nine, ten years old, and afterwards I never went back, so I don't remember names and dates. And somehow I don't believe in the past, I see fragments and I believe in these fragments: I go to the Frick Collection, I go in and I see a painting by Pontormo, and I go back out because I can't look at anything else. This happens time and time again, but I can't come to believe in dates. I believe in these oases of integrity in this desert of repetitions and failures. I like ancient Rome, the Rome of the third and fourth century, Hadrian's Rome in the Pantheon. There aren't many things I really like. They're like fetishes that give me energy: Paul Klee's small self-portrait, certain books of Blake's, Salvator Rosa's humor, Tintoretto's speed, Picasso's last works . . . all of late antiquity, those faces painted on wood by the Romans in Egypt, the mummies of the Romans at the Metropolitan . . .

GP   And among your colleagues, who do you consider important?

FC   I think Cy Twombly is an extraordinary artist. I like him a lot.

GP   Did you just decide to become a painter, or did you serve an apprenticeship of some kind? Are you self-taught?

FC   I'm self-taught; I never went to art school. I started painting when I was eight, though.

GP   While we're on the subject of memories, how do you remember Rome?

FC   As a walk I took every night, from 10:30 to midnight, across the town by myself, for seven years, with the river and all its bends, and so on, which ended at that fountain in Via del Babuino (Fontanella Borghese?). As this walk that ended up face to face with this mutilated triton.

HK   And the Roman art world? You seem to have lived a pretty intensive life during those years in Rome. Was it a formative period, or a period that gave you nothing?

FC   I think Rome, and Italy in general, is an extraordinary art school, and that it even brings good luck, if you think that everybody, even American artists, have always done their first works there. From Rauschenberg to Schnabel, they've always found someone there who supported them when they weren't even known here.
      Boetti was the person that helped me out in the beginning . . . a great friend, I mean in relation to what he was doing as well as actually . . . he helped me show my first paintings.

GP   When were your first shows?

FC   In 1974 with Sperone, who Boetti brought to my studio one day.

GP   Then at Toselli, right?

FC   That's right, Toselli. Minini . . .

GP   When did you first move to Rome?

FC   In 1970.

GP   Rome was the big city! But did you feel frustrated in Naples? Wasn't there an atmosphere that corresponded to your work?

FC   I got around a lot. I even went to Milan quite a bit and, for better or for worse, between 1968 and 1971 I saw a great deal of art; there were an extraordinary number of shows to see, and I was very curious to see what artists were doing.

GP   Do you still feel this curiosity?

FC   Yes, sure, of course . . .

GP   Do you think good painting is being done at the moment?

FC   I think so . . . I'm afraid so. I'm frightened because it seems so good that there may be another tragedy in the air. When there's so much good painting there's always a war about to break out or some terrible catastrophe. I prefer to think it has already taken place, but maybe that's not the case.

GP    Does the creative mood or frenzy always coincide with some catastrophe?

FC    It looks that way, doesn't it?

GP    I hope it comes after the catastrophe. How would you react, psychologically, to a possible moment of disattention to your work—not an inevitable moment, but a possible one?

FC    I'm Neapolitan: *faccio le corna* [touch wood]!

GP    How do you recognize a good painting—not your own, but somebody else's

FC    Henry Geldzahler showed me two ways that I believe and trust in. One is by remembering—if you remember, and continue to remember, the image. The other involves looking at a painting more than once and finding something new in it each time. The technique I use most is to keep looking, usually because I don't really look the first time! The technique of remembering doesn't work very well for me, because if I remember a painting and then go back and look at it again, I discover that what I thought I'd remembered was just a figment of my imagination. At any rate you should never believe in a painter's opinion of his own contemporaries, because it's always and necessarily a cynical opinion, in the sense that if you are doing something you need certain things and not others, and there is a strictness due to the fact that you don't need a lot of noise, you just need a few things.

GP    And to get to love and understand a painting?

FC    Maybe there's a third technique, the one I believe in the most, perhaps, though it's the most arbitrary, and that's to ask yourself if you could live inside the painting.

GP    What do you mean by "inside"? Together?

FC    No, inside. If you'd rather live inside the painting, or here where you are.

GP    To tell the truth, looking at that painting—I mean, with a tiger in the foreground . . .

FC    It's an ancient myth, an age-old story of a Chinese painter who painted this mural and then stepped inside it and nobody ever say him again. He just went into the painting and never came back out again.

HK    Can you go for a long time without painting?

FC    No, I can't go for a day without painting.

GP   And when you're on the road?

FC   I've always painted while on the road; I've done innumerable works while traveling. Half of my work has been done in hotels, courtyards, terraces . . . My best shows are the ones I've put on in airports, for customs agents at four in the morning, after an eight-hour flight.

GP   Do your drawings differ greatly from your paintings?

FC   No, I think there's a single thread that connects the drawings, the paintings, the large and small formats. There's really nothing contradictory between one aspect of the work and another. There's no hierarchy in the work. I don't consider one aspect of my work more important than another.

GP   Often your paintings have peculiar titles, very commonplace or even very literary. Do you start from the title sometimes, or is the title a point of arrival, a coincidence, a random thing?

FC   I often start from commonplaces, and commonplaces are often readymade phrases. The title doesn't always correspond . . . I might start from a commonplace, from a readymade phrase and arrive at another one at the end of the painting. And in the last few years I've chosen to paint in oil especially because, as I said before, I need to know less, I need there to be a possibility in the course of the work for more unforeseen events, for more surprises and for things I'm not aware of to happen. At this point the title is always added at the end with a view to conditioning the painting as little as possible.

GP   The Neapolitan aspects, the slang or images that were part of your childhood—do they still hold their own here in New York? Or are they part of baggage you left in Naples?

FC   I have a pretty close relationship with the city here. On the one hand I have a good rapport with the city and go out at night, I see what's going on, and so forth. On the other hand I read and follow the poets, and so I maintain a link with spoken language, even if it's an instinct which, as you say, comes to me from Naples, where spoken language is everything, where time is everything.

GP   Who do you see in your free time in New York? Do you mix with artists, writers, musicians, and poets? Or with everyday people, like your grocer?

FC   As far as artists go, the ones I see the most of are Julian Schnabel, Brice Marden, and Alex Katz. And then I sort of follow the rhythm of the city,

which leads me one place or another at night, and I end up meeting the same group, a sort of city audience, and so on.

GP     But do you talk to these people about art and about your work? I mean, do you talk about your work, say, with Schnabel, or are these just private encounters?

FC     Julian and I actually look at each other's paintings, especially at the mistakes. As you know, the management of errors is what makes a painting beautiful and distinguishes one painter from another . . .

GP     And what about Brice Marden? What do the two of you have in common?

FC     Oh, well, I guess it's the fact that I've always really wanted to be a modern artist!

GP     You have a very rich and complicated imagination and background. Do you think that a work based on extreme sensibility and even on extreme methodicalness like Brice Mardens's is topical?

FC     Certainly. There are many different times in a work. There are immediate times that you see right away, and there are longer times, periods of waiting. One of the great qualities of good painters is to know how to wait. Brice's work, his paintings, can be seen as Romantic landscapes, if you like. Anyway, what you always look for is the magic, and there is great magic in his paintings. What a painter looks for in another painter is clarity of process, of method, and on the other hand a surprise, the renewal of a surprise beyond this terrible compulsion. I don't know, somebody like Cy Twombly always brings this off, this tremendous, terrible compulsion of what he does, and there's this continuous exceeding of limits; he surprises you by outstepping his own awareness. This clarity is always fascinating. Clarity and integrity, this blissful relationship with the work is also fascinating. Brice has it, Cy Twombly has it, Katz has it, and Julian has it, too.

GP     But don't you think the contemporary world requires more complicated images, in which it can really get lost and then find itself again, instead of such rational, "abstract," and perhaps excessively internal images?

FC     No, we know now that there's no contradiction, or at least it's not useful to argue about a supposed contradiction, between abstract and figurative art. In the same way in which I see Brice's paintings as Romantic landscape, I don't see my paintings as figurative. I'm really not prepared to argue these points, but I really don't see things this way and I don't think they are this way.

HK   But you've never entertained the idea of painting a picture based solely on the gradation of a color.

FC   Again, I think that, after all, what I call process, or method, or frame, or limit is somehow incidental in the work of a painter. Everyone finds himself in the hands of a private life and a time to which he belongs. He chooses his own tools, and afterwards what counts is the magic, that is, the instants in which the canvas says something that the painter didn't know, that the audience didn't expect to find, and so on. I look at the painters that experience this dialectic between limit and magic.

HK   What is style for you? Do you tend toward style in your paintings?

FC   An anti-surrealist like René Daumal said that style is the weight of what one is on what one does. I like to imagine that style is the weight, exactly that weight which all the different fragments of what one is exert on what one is not, but nevertheless is there, and is firm. I don't trust all those works that express themselves through permutations of a stereotype, because it seems to me they don't leave the door open to further, or subsequent, meanings. On the other hand, a lot of good faith is needed to accept this continuous extension of meaning. And again I'm only interested in those types of knowledge that involve the feelings; and so I'm interested only in works that demand this step ahead in good faith.

GP   Do you believe in progress, or evolution, in art?

FC   No. I think, as I've said again and again, that there's a moment of grace, and that everything else is an obstacle, a repetition, hunger.

HK   For instance do you think pictures could exist without certain painters, certain painters of the past?

FC   They could exist without the world!

GP   How do you react to this New York atmosphere of continuous explosion—of graffitism now, for example—or this possible institutionalization that one sees in the East Village?

FC   I always remember Plutarch when he talks about the birth of dance in Sparta and of these incorrigible warriors who somebody taught to dance and who didn't go out to fight, but stayed home to make music and dance, instead. We're always at the beginning; each time it's the same.

GP   But are you embarrassed or annoyed to find yourself in front of a painting by Keith Haring, for instance?

FC   No. If you want there's a strong similarity between this ethnic characterization of painters in Europe and the ethnic characterization of these painters in New York. It's the same phenomenon of communities that are strongly defined ethnically and that feel this terrible pressure toward leveling and silence, and express their identity. The only difference is in the past. And I don't think Lorenzo Lotto is any less psychedelic than Central African tattoos . . .

Enzo Cucchi, 1986
*(Photograph © Timothy Greenfield-Sanders 1989)*

# Enzo Cucchi

*Giancarlo Politi and Helena Kontova*

*Cucchi, like Kiefer, draws directly on his surroundings for iconography and setting. He has lived and worked in the port city of Ancona on the Adriatic Sea, and life in Ancona revolves primarily around the harbor. The sea and the terrain, known as the Marches, form the landscape in many of his paintings. Figures of saints and primitive men are characterized by an energy or ferocity. They are primitivist depictions. Cucchi appears to draw on local legend; his private mythology remains mysterious and obscure. On occasion the work seems anecdotal; despite his disclaimer in the interview, he shares with Kiefer a narrative tendency.*

*Cucchi had his first one-man show in Italy in 1977. His first exhibition in New York was with Clemente and Chia in 1980. This was held at Sperone Westwater Fischer in Soho and received enormous critical attention.*

FLASH ART   Do you work on several paintings at the same time?

ENZO CUCCHI   I've never been able to work on just one painting, one idea.

FA   Is it usually a series or the same subject? Or are they linked in some way?

EC   They all form a kind of family, a brood. I tend to work on groups, and generally several paintings hatch together, linked to a project.

FA   So you have a precise idea. Are you obsessed by an idea before you start working?

This interview was originally published in *Flash Art* (November 1983).

EC   No, there's no idea. By project I mean an opportunity to paint a group of works—for a one-man show or something like that. I can only work when my head's completely empty. The problem is how to deal with all the phantasms you have around you all the time—it's a small, everyday problem. You always work around yourself, on what you can do around yourself. What's most important for me is where I am, and I work around these things. It becomes a physical reality, a bit like a chicken coop, a sort of battlefield. In a certain sense, it's a kind of economy. Art is an idea of economy; of spiritual economy. You can't think of discussing or talking about art, or looking at it, or studying it. How do you look at a boxer? Where do you go to look at a boxer? You have to look at how he moves, and how he starts shifting around ordinary, everyday things. How he moves in a small space, which is then projected outward, but in actual fact remains a small problem, surrounding him. It's a problem of surprise, of astonishment. You see how a beautiful woman moves: she's a cloud; it's what she leaves behind her, what she describes.

FA   Does the title of the work always come later?

EC   I give a painting five or six titles, and they become a little story around it.

FA   But doesn't the story ever come before the work?

EC   Nothing ever comes before the work. A painting's something miraculous; it's a problem of astonishment for whoever makes it. And you only make it because you have to be astonished. Because there aren't other things that astonish you enough.

FA   But is it just visual things that astonish you?

EC   Yes, because this is the problem of the world. What else is there except that—even if in a moment of weakness the world is clinging to the image and clinging on in the wrong way.

FA   Does your work contain references to images you've seen somewhere else?

EC   No, if anything there's the astonishment of that image. It's like looking at a mountain. A mountain's really boring because it's static and always the same, but it's also incredible because of what it contains, and that creates a state of astonishment in you. When you see this mountain, it could be a problem of realism—you ask yourself if you should describe it or if the inner problem is more important. I believe that the inner problem is what matters, because what you see has already gone, and it's not so important to describe it—but there's a lot of painting that does just that. A train's derailed and

straightaway there's a painter doing a picture of the derailed train, or an earthquake. Something always has to happen before you do something— which is just not true—in fact it's the exact opposite. But then it starts being a question of energy.

FA   Why do you think these images of yours that originate here in Ancona from this "astonishment" you talk about—but which are nevertheless a personal obsession—have so much success all over the world? How do you think they're interpreted?

EC   It's all a question of legend! It's obvious that a crisis-stricken world has to cling onto something, to a solid image bearer. In this incredible state of weakness, the image is the last hope for the world. Remember when Coppi was cycling champion and people went wild during the races?* It's the same thing, even if the problem with Coppi is how to describe his spirituality. It's like art, a small blot in the world that in some strange way becomes a problem that concerns all the rest of the world, when it's not their problem at all, because it's a selected thing on a small island. Just think about this art that all the world's talking about. It's an art selected by the culture and spirituality of a certain population in a small corner of the Mediterranean. Yet funnily enough, the aggressiveness of this world has taken hold of this art and thrown it all over the place. Does that mean that all the other art is nothing, even if other artists have produced and selected a certain kind of spirituality and a certain kind of culture that is just as valid as ours? And yet they keep on talking about how there's no painting any more, and that some day it will come back. But there's always been painting because man's spirit remains the same.

FA   You're intellectually very curious about different cultures, and yet you spend most of your time in Ancona. Why don't you travel more; why not spend a few months in the Far East or in the States?

EC   What for? An artist doesn't need anything. What does he need? We're back with the same old story. You think you can create a boxer, but you can't! It's a natural talent you can enhance and perfect, but first and foremost it's a natural talent! It's energy that's either there or it isn't.

FA   Do you like New York?

EC   Yes, I like it, but that's all. It doesn't affect me, and when I have to go, the things that interest me most have nothing to do with art.

FA   Like boxing, perhaps?

---

*Fausto Coppi, famous Italian champion of the 60s.

EC    Right. I told you I'm a big boxing fan and I already sponsor a boxer here in Ancona.

FA    Why are you so interested in boxing?

EC    Because in this century prizefighters and prostitutes are the only spiritually selected representatives—they represent a healthy selection of life, of difficulties. They are the real moral restorers.

FA    Are you ever tempted to go and live in a big city?

EC    No, I go to Rome every so often when I feel the need to see the others and be with other people. Rome's the most incredible city in the world. I go and sit in front of Rosati's.* There's the altar in front of Victor Emmanuel's monument, Nero's tomb . . . Rome's the city of madness, it's Christian and pagan all in one. But after two days in Rome I'm so tired I have to get back to Ancona.

FA    What do you feel when you paint or work?

EC    Nothing. I'm a hawk—I'm like a tiger. When I was painting in Rome people used to say, "Look at the Torpignattara tiger."** I didn't realize, but it takes strength and speed to make a painting—they were just joking, but I didn't realize. Painting's a physical problem, a question of being in form, of feeling right. You have to be in good shape to make a painting. I'm not like some painters who make paintings when they're feeling ill, when they're suffering! When I feel ill or start suffering I go to bed, I can't paint. When you've got a toothache, you can't think of anything else, you're just obsessed by the toothache. I can't stand the studio—often I just can't stay here. I go out a lot, nearly always, then I wake up at night and come here and do nothing. That's awful, it's really lousy, but you can't help it.

FA    Are you saying you don't get any pleasure out of painting?

EC    No, it's awful, it's really sickening, why should it be enjoyable?

FA    So why do you do it?

EC    O.K., because I can't think of anything else. Because there's the question of astonishment—you do a thing because you absolutely want that thing. Painting a picture is an obsession, it's like some ridiculous vice, like a superstition.

FA    How many hours a day do you paint?

---

*Well-known Roman bar frequented by artists and film-makers.
**Torpignattara is a Roman suburb where Cucchi occasionally goes to work.

EC    I don't know, it varies. It depends on how I feel.

FA    You've also been a conceptual artist.

EC    I went to school. I've never been a conceptual artist. Those early experiences that you're referring to were just part of my studies.

FA    Which school did you go to?

EC    They turned me out of school because I threw a book at a teacher. But I liked the idea of studying, of going to school. Later on I went occasionally to the Macerata Academy.

FA    But has conceptual art taught you anything?

EC    I think that all activity passes through the bodies of other artists, through spirituality, and through each artist's idea of the world. This is the really important thing, no matter what kind of art you do. I owe everything to everybody. Perhaps I owe more than anybody else to everybody, because I'm a terrible "collector."

My life has something legendary about it—even as a boy, I've always seen myself . . . a bit later, I don't know how to put it, it's like being half-asleep. I don't know if it's good or not, but it's something legendary.

FA    Are you very attached to this place, this region?

EC    No, because I don't even look at it. I just can't look around me; I'm not interested. I never look at what surrounds me. I'm interested in the places around me in terms of race, and flavor and presence, but I'm not interested in looking at them.

FA    Do you often meet up with your artist colleagues? Do you talk to them about your work?

EC    Not much at the moment, because I'm almost always here. When I go to Rome I'm glad to see them. As far as work's concerned, what can we tell each other?

FA    Do your images derive from a popular, peasant culture?

EC    I think you have to start from the images you're familiar with, the ones that come natural. Never apply a method to an idea like the Surrealists did—that's crazy and it produced the worst paintings of the century.

FA    Who are the great artists of the past that you admire?

EC    Masaccio because of his calm and serenity, and because he gives me a great feeling of relief. The relief that comes from understanding that he had nothing in mind either—just two or three ideas that were always the

Enzo Cucchi, *A Fish on the Back of the Adriatic Sea*, 1980
Oil on canvas, 2.06 m × 2.73 m.
*(Collection Eric Marx; photograph by Bevan Davies; courtesy Sperone Westwater)*

same, and so banal, but so incredible and closely linked to the universe. Like the idea of putting a man in a standing position, which is what I do when I wake up in the morning—I mean I put my feet on the ground. What I'm saying is that they're very simple, true things. I mean if I look at Masaccio's crazy heads and his incredible relationship with the universe, they're still natural, simple things. What interests me are these little everyday certainties. If you think about Carrà, he wasn't a great painter, but he was important as a pictorial support. Like Boccioni, who said two or three fantastic things about art, Picasso and Picassism, incredibly important things that are still valid today, but as a painter he gave very little, almost nothing. In formal terms his work isn't all that good, and yet he said two or three very important things about art! So Boccioni's a saint, a great personality, someone we just can't help loving. On the other hand, if you take Caravaggio or El Greco, they may have said some very uninteresting things, but their work was incredible.

FA    Which people and what events have been decisive in the success of the trans-avant-garde?

EC    It may sound incredible but it's true, the all-important people were Fred Buscaglione* and Fausto Coppi—why not! That's how it feels to me. Then obviously, there's the dealer who gave us a hand, bought pictures straightaway, had the courage to back us. But if you want my inner, spiritual message it's this: Coppi and Buscaglione are the ones who gave the flavor to the little everyday things, and it was through them that one day I understood my painting had become something else.

FA    Yes, but in concrete terms?

EC    I've known the others for ages; we met in Rome when I had my first show at Giuliana De Crescenzo (1978). I didn't know anyone before then. Checco [Clemente] and Sandro [Chia] lived in Rome, I was in Ancona but often in Rome too, and Achille [Bonito Oliva] had shown a few of my drawings around and the others kept saying, "Who's this bighead who doesn't even come to our shows?" Then we met at my show and became friends. I started doing drawings with Sandro and got Achille Bonito Oliva involved as well. That was when we had the idea of a book; the idea of doing something strange and incredible with no names; just picking up what was in the air, this impalpable situation that you could feel in the atmosphere. Before then, there had been a show with me and the others in the "International Art Meetings" organized by Achille, but the works that took shape there were still conceptual.

---

*Italian singer of the 60s.

FA   Last year you did a sculpture with Sandro Chia, and you once told me that you'd worked with Mario Merz. What does it mean for two artists to produce a single work? Does it cause limitations, frustrations; does it require a lot of self-discipline, or can it represent total liberation? Do you work in complete freedom, like you do when you work on your own?

EC   I think that everything is possible when there's discipline. Spiritual discipline is the most ferocious kind of discipline, but it's also what makes it possible to form an opinion on the world. Working with another person really becomes a tribute to an idea; it involves discipline and heroism, the desire to discover . . . not exactly a common path, but how to lie down, how to rest.

FA   What do you mean by rest?

EC   It's like a museum. You find good paintings in a museum and people worry because in the basement there are lots of paintings that are never put on show. But that's how it should be because paintings that don't rest, don't have a peaceful sleep. They'll come to light when they're finally rested, when they're asleep, and then all the world will be able to see them.

FA   Do you have anyone to help you in your work, an assistant who prepares your canvases, for example?

EC   No, I work on my own, but not alone, because often there are lots of people around to keep me company when I work. I enjoy that.

FA   Is the choice of a format important for you?

EC   No, I never paint on a mounted canvas. I can't stand that. I paint with the canvas stretched out directly on the wall. Sometimes the image and the size of the image is a physical factor, depending on how I feel.

FA   What about graphics?

EC   I hate media. I dislike technique. I use different mediums for my obsessions, for an image, because with certain materials you can do it, with others you can't. I pass through this body of techniques feeling totally indifferent and uncomfortable with this fussiness, this fetishism about media today.

FA   Do you consider yourself a great artist?

EC   I think I'm the only artist; that is, I'm certainly the only legendary artist. And that's true—I'm not being conceited—because if you look very frankly at my works, I think that some of them may be necessary to art history. That doesn't mean I have a poor opinion of my artist friends because all of them

are really important for their individual contributions—one for irony, the other for something else—and I've got a lot of respect for them; but funnily enough I also see a lot of images around that aren't necessary for art. Take literature, for example. It always talks about women; there are no novels that don't talk about women, and I think it's absurd that painting has to have this narrative kind of problem. The painter's problem is different: it's not the description of a woman, but woman as the relationship with the world, with the universe.

FA    What do you mean by legendary?

EC    Legends are the only real things that exist, that will keep on existing. The rest is history, but history, as you know, is false. History leaves us with the facts about an event, but not the spirit of it. Legend gives us the spirit as well, the smell of the events.

FA    What do you think of the situation of art in other countries—Germany and the United States, for example?

EC    Germany is still living on Beuys's legacy, like most of Europe, and the young German artists realize this. They're working around Beuys's materials, even if in a watered-down, narrative way.

FA    What about Kiefer? Do you rate him an important artist today, the spokesman of Germany's anxieties and unfulfilled dreams?

EC    Kiefer is an excellent painter from the 60s, just like Baselitz and the others. The youngest are fine artists, but they're still stuck to their radical, existential, nonformal problems, because their existential problem remains unsolved. And their current rejection of Beuys reflects their point of reference. Beuys is a war depository. He's done an enormous amount of work on different materials through which he attempts to formalize an image. We can admire him, love him, but it's unlikely that we'll ever get to know him. Like the sound of the Rhine: we know it's marvellous and indescribable, but the Germans are the only ones who can really know what it's like. That's why Beuys is the great mystery, and the only true depository of the mystery. Kiefer is very close to Beuys, but his limit is that he's forced to narrate, to identify himself with a narrative tendency. Salomé and Castelli I like very much, but they're both caught up in an existential problem, a kind of liberation through the creation of an image. But the real depository, the essential locus, is Beuys.

FA    Who do you find most interesting at the moment—the American artists or the Germans?

EC    Julian Schnabel has a fine mark, and great energy, but his dream is a bit too open—a total dream that wants to pass through the body of everyone and everything. I can understand that, but I think that art has to focus on a small thing—it can't take care of a global dream. So I don't think Schnabel's dream is possible, but I appreciate his enormous energy. David Salle is a very intelligent artist, but his show at Mary Boone was disastrous, repetitive, a blind alley. Art doesn't need intelligent people, it needs open roads. A work must open up a path; it has to break through. But we're still talking about very, very interesting artists. I don't know Robert Longo very well—I've seen a show of his through the gallery window. He seems very American though. The world's problem, in my opinion, is Italian art. I think that right now the real source of light is Italian art—it may not be true, but it's great that everybody thinks it is. The art world is in a state of bedazzlement, and it's being dazzled by Italian art. If it weren't for Italian art, there would be nothing. We live side by side with artists like Guttuso and have a great deal of respect for them, but what can we expect to understand? It's like something silent that we know exists, but that's all. He's on a different parallel level. Like the trains. A train's derailed, a storm kills a hundred people, and he feels the need to do a painting. Whereas I'm all for earthquakes and catastrophes, but simply for the energy they bring. I think that now there'll be a huge, general catastrophe, like nothing that's ever happened before. Everything will go adrift—the critics, the people that talk about art, because they'll be forced to have a rethink if they want to find the least bit of energy to go on working. I was talking to somebody in New York and nobody wanted to believe it when I said that soon there'll be no more than 50 galleries because it's pointless to have more. There's no room for more than 50, and at the moment there are 2,000!

FA    Don't you think you're being a bit catastrophic?

EC    Look, the world changes from one minute to the next. Incredible things happen, you can be sure of that. The world should be listening to artists in that sense, and not just for what they do. When we started working, if we talked about things outside work—about the atmosphere, about what we'd picked up—people started laughing. You know how sometimes we talk about when we didn't think something would happen and then it did? Something else can always happen. For the past two years, Leo Castelli's been asking me for a show either directly or indirectly through Gian Enzo Sperone. And I keep explaining to both that it's not possible. I think highly of Leo Castelli, but I can't do a show in two galleries. If Gian Enzo insists that I do a show at Castelli, he can give him his show—I'm not bothered; one gallery is as good as the other. But in this case it means that one gallery

has to give up part of its program if the other wants the show. But that's not the real problem: if I agree to do shows in both galleries, instead of four or five works, I'd have to produce twenty. And that just becomes impossible. And when things become impossible, you know what happens? Chaos.

Julian Schnabel
*(Photograph © Hans Namuth 1981)*

# Julian Schnabel

*Donald Kuspit*

*In 1977 Schnabel, 26, returning from Texas to New York with big ambitions for his art and his career, met Mary Boone. This association contained the right ingredients for his rapid development. He had his first one-man show at her new gallery on the ground floor of 420 West Broadway in February 1979. In December, in a second show, his plate paintings were exhibited for the first time and immediately caused a big stir in the art world. He went on to affix to the surface other unconventional materials—cowhide, antlers, pieces of wood. He has consistently worked on found surfaces— velvet, linoleum, rugs and lately Kabuki backdrops. His scale, starting large, has grown to monumental proportions that have been equated with his lofty themes.*

*Schnabel received some favorable and a lot of negative criticism in the early 80s. Despite the latter, he remains provocative and compelling. The admiration of other painters is attested in several of these interviews.*

*When he left Mary Boone in 1984 to join the Pace Gallery uptown, perhaps he left behind what he refers to as "the art crowd."*

---

DONALD KUSPIT    You first achieved a certain prominence with your plate paintings. What led you to make them?

JULIAN SCHNABEL    Desperation. It was 1978, I was at a loss, unsatisfied with everything I was doing. I happened to be in Barcelona, where I saw two mosaics: one very famous and beautiful, Gaudí's in the Parque Guell, and

---

This interview was conducted at the artist's studio in New York just prior to the opening of a survey of his work since 1975 at the Whitney Museum in November 1987.

the other crummy and banal, in a restaurant. I decided I wanted to make a mosaic also, but one that wasn't decorative. I liked the idea of the image and the object itself—the mosaic—being one and the same thing, and I liked the agitated surface. It sort of corresponded to my own state. Technically I liked the idea that all the parts were equal, whatever their position and color, whatever their function and place in the whole.

DK   Looking at the works, this technical aspect hardly seems their most significant part. The agitation seems more important, and particularly its function in the scene. You seem to use the mosaic idea to generate a complex, dynamic space that stretches, as it were, the scene rendered on it to the limit.

JS   Maybe. Most of my paintings convey a sense of landscape, and the mosaic space makes it more dramatic and evocative. It doesn't matter to me whether the scene is overtly abstract or representational; what counts is the deep space that is at once behind and simultaneous with the scene. The mosaic gives this space a molecular bodilyness.

DK   I've always been struck by the sense of rich, dense materiality in your work. Is the material mosaic landscape a surrogate body, at once metaphor for an elusive bodily wholeness and an articulation of the body in metonymic shambles?

JS   In a sense, yes. I want a body viewing a body. The entire picture is like a body or figure. I want it to be on a par with the spectator's figure, to engage his or her person on the most intimate bodily level. The picture is also like a body because of the weight of its material, and I want it to make the spectator feel the weight of his or her body. This sense of heaviness has been important to me from *Jack the Bellboy* on. I really don't want to make just another picture on a plane, I want something that denies the plane— denies pictoriality itself and at the same time contains pictoriality. I want to make a work that is reality itself, not just an illusion of it.

DK   You seem to think of your pictures as though they were alive, and as though you were a Pygmalion bringing them into being.

JS   I experience it like a fictive person. It's a kind of psychoparadigm of an imaginary person.

DK   Why did you choose plates to make your mosaic point? You could have used other things. Are plates, more than any other objects, associated with human beings for you?

JS   It was natural for me to use plates, not just because, as some people think, I worked in a restaurant at the time, but because they are utilitarian.

At the same time, of all the things I could use, they were the one thing that struck me as most unsettling to use. I had no idea what they would look like. It is important to me to get this unsettling effect, and at the time the plates seemed to me the best way of doing so. Not only were the plates unsettling in themselves, but when paint was put on top of them.

DK   What is your sense of the body?

JS   Anita Ekberg is my sense of body. I want a picture that has the same "weight" as Anita Ekberg.

DK   So your plate paintings are erotic objects to possess, in the literal as well as figurative sense of the term? They're full of sexuality and psychosexuality?

JS   Sure. And I'm a large person. So my paintings are larger than those of most other artists. I'm very comfortable with large size. My paintings are in fact bigger than I am.

DK   Many American artists have worked large. I see nothing new in largeness as such, although no doubt many of your works would win the prize for largeness. They certainly tip the scales on the heavy end.

JS   But there's something different about the largeness of my works. I want largeness not simply to make an oversize image, expand the small, but to alter the spectator's sense of his own scale.

DK   You want to create an altered state of consciousness?

JS   Something like that. I really want to become invisible—despite what people think—and give all power to the painting, so that it can engage and affect the other person directly. I want the painting to last as long as a person, in the sense that when you look at a person for 30 minutes he or she is very different than when you look for 5 minutes. I want people to be able to look at a painting by me for many years and keep seeing its differentness. I want to make paintings big enough to absorb all the looking possible. My paintings are really slow, not fast.

DK   Are you saying there's no end to them, they're unlimited?

JS   In a finite sense, yes. I want to be able to accommodate all the different ways different people, and sometimes the same people, see.

DK   So they're very complex, deliberately overdetermined paintings?

JS   Yes. I want to get seeing, hearing, smelling back together in a single painting. The senses have all been separated in life. Their separation has made us unbalanced. I start from this lack of balance and get a new poetry

Julian Schnabel, *Painting without Mercy*, 1981
Oil, plates and bondo on wood, 10' × 14'.
*(Photograph by Phillips/Schwab; courtesy of the artist)*

of balance. Anybody who's good at anything is unbalanced, but always tries to circle back to balance.

DK   People have said your works are full of complicated feeling, almost over-expressive. Does this have anything to do with what you're talking about?

JS   I don't know. I want paintings that are like actors rather than vases. Artists deal with color and form—they've missed the boat. Actors deal with feelings. My paintings act feelings.

DK   Feelings are very particular, very individual. Do you generalize them?

JS   I suppose so. But the important thing for me is that my works appeal to the feelings of individuals, not the art audience's notion of art. I really don't make my works for the glory of art or my own glory, but for the glory of the feeling self.

DK   So your works are about your feelings and how they engage the unknown or imaginary feelings of the spectator?

JS   Yes. It's that moment of engagement that's important for me. Take Tom McEvilley's catalogue essay about me, for example. I was interested not in the first part, where he coolly analyzes the work, keeping his art-historical distance, but when, near the end, the language changes, and he loosens up emotionally. Hilton Kramer also liked my work for art-historical reasons, but he never reached its content, as McEvilley did when he reached his feelings—the feelings the work aroused in him.

DK   Picasso once said that what engages us in Cézanne is his anxiety. Do you think it is your anxiety—very different than Cézanne's—that engages the spectator subliminally, and finally wells up and overpowers him or her?

JS   I don't know, but I'd rather call it anxiousness, the sense that things aren't right. I want to put something in the world that can communicate this in a concentrated, shorthand way, that finally becomes explosive. Such a thing simultaneously destroys and saves you through its constant anxiousness.

DK   What if people become used to your anxiousness?

JS   It doesn't matter. I expect the scene to change. It always will. I'll no doubt eventually look boring to the art crowd. But I'll reach the anxious individual. I'm not interested in winning a popularity contest, but in articulating the anxiousness that's everywhere, and that's the source of the most individual spirits.

DK    So you want your painting to be used emotionally?

JS    I can't make a distinction between emotion and intellect, but this has something to do with my use of iconography. When I use a skull, it's not because it exists in Bellini or El Greco, but because it makes a certain emotional sense when it's painted in a certain work. That means it has a certain relation to life, expresses a certain attitude or outlook. I think of my painting as effecting an attitude which makes life livable for someone else. I don't think life is too livable in general—too human. I want my painting to make something humanly possible—something that will show you the face of fear yet let you survive. I want it to show you whatever keeps you from being free and thereby makes you free.

DK    Is there any particular group of works which you've made that you think do this in a particularly important way?

JS    Yes, the *Stations*. They get at inarticulateness—the inarticulate anxiousness of an inanimate object in the world as a receiver waiting to be charged by a witness. They're remote because they're mostly language—language as image—but for that same reason they destroy the distance between myself and the spectator.

DK    What about the plate paintings?

JS    They do it also, but in a less succinct way. And yet when you stand back from the works and look at them they are very succinct. But now some people only see the plates. They don't want to stand back from the surface. These paintings really are not about aggressive surfaces, but about an imagistically focused inarticulateness, which shows itself as agitation. I don't really want my works to overwhelm people, but to bring out into the open inarticulateness which is the core of their most intimate sense of self. This anxious inarticulateness is perhaps most evident in the light that shines in my work and that nobody has noticed. Mosaic space has always been inarticulate, intimate, anxious light.

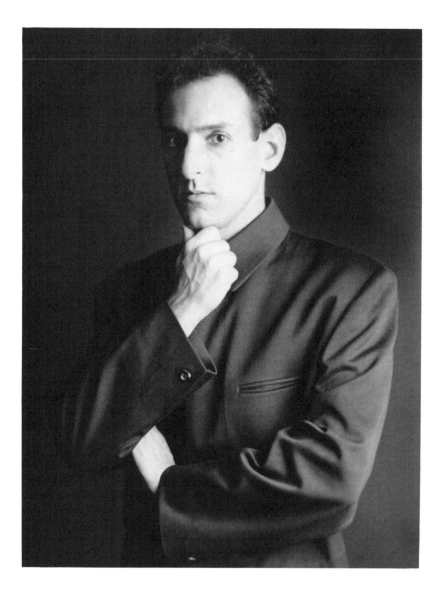

David Salle
*(Photograph © Timothy Greenfield-Sanders 1986)*

# David Salle (I)

*Peter Schjeldahl*

*Salle had his first solo show in New York in 1980. The first paintings, rather romantic, introduced his style of layering images. Soon after, he was linked with Julian Schnabel (they were close friends at the time and joined in 1981 to show at the new Mary Boone Gallery) as an American Expressionist, which was a decided misnomer. Also, although he appropriates images, Salle is removed from the Postmodernist "Deconstructors." As he points out, in his work an image is not a criticism or a response. He locates his own sources.*

*At the beginning, there was a good deal of critical reservation centering on questionable draftsmanship. Around 1984, new imagery of women in explicitly erotic poses appeared in Salle's paintings, which drew fresh criticism from the feminists, who found it degrading. At the very least, he was perpetuating a cultural stereotype. Was he a misogynist? In the second interview, Salle undercuts these objections by placing some of this imagery in historical context. By 1985, when he was given a retrospective at the Whitney Museum, even the most obdurate critics had softened.*

---

PETER SCHJELDAHL  When I first saw your work it was something of a shock. The style seemed new in a way that very little else had in a long time. I wasn't sure how much I liked it, but it sure was different. Since then I've come to like it more and more, but the shock hasn't worn off completely. I'd like to inquire about how you arrived at that look, what experiences and

---

This interview, conducted at the artist's studio in New York in February 1981, was originally published (in a longer version) in *Art Journal* (September/October 1981).

tastes and ambitions led to it. Then I'd like to get some general comments from you about art in its present situation.

DAVID SALLE   It's interesting to think about having a look, having made a look, because for so long when I talked about my work it was in terms of not having a signature style. It was an issue to not have one, and one thing I was reacting to, not just in New York but in general, but certainly it became much more intense when I came to New York, was how much everyone is identified with their work as a kind of concrete and identifiable look.

PS   But you really do have a look.

DS   That's why it's so ironic, because out of my disengagement from what I brashly and tenaciously characterize as official New York taste, what I consider to be total disengagement from that, total withdrawal from that, shunning that and working on some kind of obsessional line, I resurface with this very concise look. Well, I think that tells us something about what a successful look is.

PS   Let me put this in a scheme of personal development. As I understand it, you had a lot of art training as a child in Kansas. You were an art student at Cal Arts in the early 70s and at that time you abandoned painting. Why did you quit and what got you started again?

DS   The situation when I went to California in the early 70s was clearly intellectual opposition to painting. It was a time of putting everything to severe critique. Also there is very little tradition of painting in Los Angeles that stands up to painting in New York—there are other kinds; it's just different. So the lack of a traditional painting in Los Angeles combined with this historical situation in the 70s set up an opposition where on one side there were the painters and on the other side there were the thinkers. But even when I was a kid in the Midwest making figurative paintings which given their time and place and their context were successful, even when I was doing that, relatively satisfactorily, I always knew I wanted the work to reflect more what I would have then called a state of mind. Early on I was conscious of the fact that a painting, maybe it was a great painting or an O.K. painting but it didn't have that other thing, somehow, and I remember in a very straightforward, naive way—you know the way an adolescent wonders how the world works—I remember wondering almost out loud, how do artists get thought into work? How do you do that?

PS   Who were your artist heroes, your ideals of what the real artist was, when you were in your teens, and then when you were in school?

DS   It had always been Jasper Johns. I had read the Max Kozloff monograph (he later became a teacher of mine) and there was very clearly a situation of how this guy managed to get all these ideas into his paintings, and I looked at my own paintings—they were O.K., they had sensibility, they had a mood, they had an established sense of something, but they certainly didn't have that stuff. I was very conscious of the lack of that; in retrospect, it was sort of natural going to school where this way of thinking was practically traditional. The exciting people were not painting. And so if you wanted to hang around interesting people, it was easy to forsake your painting background. I mean, it's not entirely true. For two years I arduously painted away. But the paintings began to get more inward, more self-reflexive, and less about color, less about form, less about anything that had to do with painting, and more about the painting being a mirror of itself. And I did begin to become more involved with those ideas and less involved with what I was supposed to with a paintbrush in my hand.

PS   Would you describe some of your nonpainting activities?

DS   The first things were videotapes, which incidentally I am doing a lot of work from now because they were overtly sentimental. What was strange was that the paintings were getting more pared down, more austere, more self-reflexive, more clearly about a certain kind of intellectual presence, and the videotapes were becoming more sentimental and theatrical. I wasn't even aware of this. The paintings I was making were quite cerebral—for instance, a gray rectangle, a canvas filled with gray paint, balanced on a stick, with photographs on this stick of the painting being knocked off the stick. A similar gray painting next to photographs of someone taking a knife and slashing it. So it was like looking at the paintings in another state. They were didactic and they were also kind of pernicious and aggressive.

PS   Sounds kind of Robert Morris-ish.

DS   They had the same kind of unresolved anger and misunderstanding of the willfulness of Johns that Morris's work has.

PS   Who are some of your favorite artists of your own generation? Do you think of yourself as belonging to a generation?

DS   On the one hand I can't think of anyone of my generation whose work I really in an unqualified way like or feel in love with, and also I shun almost every conceivable association within the obvious generation net. And at the same time I constantly refer to things being "generational" or of having a "generational problem"—the reason for X, Y, Z being that there's a generational shift in sensibility—and that's very real and very palpable to me. And yet, when asked to demonstrate that in terms of people, I become

mute. I can name two artists my age who pretty consistently interest me, for different reasons: Francesco Clemente and Julian Schnabel. Those are artists whose work I'm interested in tracking. Julian for his unpredictability; Francesco for the images themselves.

PS   I've written down some terms that seem germane to your work or that have been used already in discussions of it. And I'd like you to sort of free-associate with them one by one. First word: literary.

DS   I think "literary" is the battleground of this generation, if there is one. That probably, in a negative way, defines the generation more than obvious things like "media." It's a love-hate relationship. It's like loving a lost parent—like being abandoned by a father, searching for him, but not recognizing him. I think that there's an unconscious literary love in the generational sensibility which never finds its expression because the generation itself is not literary.

PS   Meaning not literate?

DS   Close.

PS   Another word: eroticism.

DS   It is simply one of those things that you want. I think "eroticism" is this generation's word like "authenticity" or "authentic" were for another generation. It's the thing that shifts around the most the more you try to remain true to it because of what it's really about. What it's about is the distance between you and the object of scrutiny, the shortening of the senses. The closer you get to the object, the more distorted it becomes and the less able you are to perceive it as what it is. Because of the very nature of eroticism, it's the thing that is the most difficult to be true to. Philosophically, the erotic is an integral part of understanding the aesthetic.

PS   Is that the pleasure principle? Is it about preference?

DS   It's really about perception, it's about how you know to single something out. Whether the something is a painting motif or someone you follow down the street. To deal with that is like a lesson in the aesthetic.

PS   But doesn't it impinge on the question of taste?

DS   Well, again, that's the kind of comment about which I would say it's generational. In this generation, whatever it is, questions of taste are kind of foregone conclusions. That's why this generation is accused of being more fascistic than previous generations.

PS   Because it knows what it likes?

DS   Because it takes what it likes as a kind of given, instead of wondering why it likes it.

PS   Do you wonder or not?

DS   Of course I wonder. But the difference is some kind of belief that whatever mythologies are behind why you like what you like are somehow good for you as opposed to things to be purged. If you're honest, even bad myths are good for you.

PS   Would it be fair to say that the images in your pictures are all images that you like, meaning that they're erotic to you?

DS   No. Certainly some are images I don't like, but I feel they work in a context. What I like, if I like anything about a picture that I do, is the overall feeling of extreme cancellation. But that just seems like a basic tenet of art sensibility. Just today I was reading in the *Times,* some reviewer quoting Nabokov saying about Joyce that, for all his admiration for Joyce, he didn't really approve because of what he thought of as Joyce's unnatural inclination toward the disgusting.

PS   So our resistances to the disgusting are to be beaten down, in other words?

DS   No, maybe it's quite the reverse. It's interesting to think about things being "disgusting" but using them anyway and not having them be neutralized by art. One hopes they're not aestheticized, that they just spread a wider net of implication on everything; the viewer, the context, the object.

PS   I think that's very good. Let me throw this out: "Illustration and Allegory," Carter Ratcliff's title for the show he included you in at the Brooke Alexander Gallery.

DS   Well, "illustration." About 1973–74 I made pieces that were just fashion photographs cut out of magazines and pasted on pieces of cardboard that were a color related to the dominant color in the fashion photographs. Because you know the way an art director works with fashion photographers—it's always planned around something, it's never random. And then I lettered the name of the photographer underneath in a kind of show-card style, and what I was interested in was "presentation," which I think is a more apt word to describe my work. I always considered the presentational modes as simply "what I saw," which I think is what got me back into painting. I sort of worked back into painting, via this obsession with presentation. Like, can you make a presentation of a presentation? Can you make a presentation without the thing presented? It's difficult to talk about because it starts to sound like tautology, which it's not.

PS   Memory.

DS   It's a word that has so many points of access. I mean certainly one of the ways that my work functions is to provide various memory triggers which are not logically or hierarchically organized, but they are cross-referenced. It's like cross-referencing without an index.

PS   That sounds rather Joycean.

DS   The important point to me is, you never want to have it pinned down with: "this artist works with memory." That is said about maybe 1,000 to 10,000 artists anyway. I guess the thing for me to avoid would be the sense of autobiographical memory, personal memory. It's not even memory in the sense of a deep cultural secret. It's just the continual manipulation of the surface of recognition.

PS   Well, I think there's an ambiguity in your work, how much is actually associated and how much is arbitrary. And it doesn't seem to be a question that is answerable. And that may be the nature of painting. Next word: sentimentality.

DS   That's a very specific kind of concept. Memory, eroticism, illustration, allegory, those are things which I think float in and out of time, that have always been around, and will probably always be around. They have more or less application at a certain time, but they are sort of constants. But with sentimentality, maybe we're on to something which is really about this time and attitude. Because, the flip side of cool is always extreme sentimentality. You could see it as a counter to the dogma of Minimalism but in a very particular way. It doesn't just say "yes we can" to their "you can't do that" (although that probably would characterize three-fourths of the generational output). It works with a complicity between the work and the world. A work of art becomes a different kind of model of human interaction. Also, you have to understand that objectifying sentimentality in a work establishes a much different dynamic than objectifying some visual perception.

PS   I associate the sentimental in your work with the use of the sentimental by some Pop artists. To Lichtenstein one way and perhaps Rosenquist in another. The assembling of images that associate with each other in some mysterious way is, of course, the keynote of Rosenquist's style. The ambiguity is whether he is endorsing something or simply objectifying the sentimentality of the image.

DS   I guess that's a real question. Pop art is very formal and reductive. They emblematized everything.

PS  So is it part of your intention to make that Pop kind of quick public identification difficult?

DS  No, just to make that process visible, to make that one of the mechanisms of the picture. What that implies, requires, is that there is a very delicate balance between the personal and the so-called universal. It's like trying to come up with everybody's favorite story, everybody's favorite color. I have to make it seem like I'm working in your favorite color, but it has to be close to generic.

PS  I notice a tendency in your current work to use more images drawn from recognizably public or inherited sources. Your earlier images seem more personal or studio. Is that the case? I'd like to talk about the quality of longing or absence or otherness in your work, which I think is important in a number of ways. One means you use is certainly the color. Which I think is quite remarkable, but the only terms I can think to describe it in sound very negative: sort of dead, flat. In a funny way it always feels like the wrong color.

DS  The longing has to do with the quality of something that is remembered or may be misremembered; missed, but not widely off the mark, just vaguely missed. As you say, when you start talking about it, it all sounds quite reprehensible. The color is extremely precise, but it is precisely imprecise, precisely "off." There aren't really too many words to talk about how something works by not working, except to make it sound kind of anti-art, which it's not.

PS  To me the vocabulary of your work has a peculiarly vernacular, or maybe "everyday" focus. You can think of most "high art" as being something for "high holy days"—I think Valery said "holidays of the mind." Yours seems to have to do with the more everyday persuasive state of our existence, not knowing exactly what we think or feel. And its power for me is the way I think it comes in underneath my expectations.

DS  It's anti-declarative. That's partly my antagonism to the official New York art. It seems like art in general has been flogged into being so over-declarative that it has become an empty metaphor. That is the part of American Culture, that hyper, souped-up, bigger-is-better, or even smaller-is-better thing that I despise.

PS  That part that has been emotionally and spiritually oversold?

DS  It has to do with what kind of metaphor for creativity is being offered. Is it just about Yankee ingenuity or something, as in "we can build it better"? That's vile.

PS   Let's bring up sense of humor.

DS   My highest professional regard is for stand-up comedy, improvisa-
tional comedy. I'm not sure exactly what that has to do with my work, if
anything, but I could return to my rant against official New York art in this
context. What has always been missing from it, in my opinion, is any sense
of improvisation, any sense of making it up as you go along. What Manny
Farber calls "Termite Art." And not that my work looks improvised, or that
my paintings change so much. I don't think it's about working process, it's
about thinking process.

PS   Well, humor also implies being guided by a sense of the incongruous,
and perhaps even the humiliating.

DS   Humor is often at someone else's expense.

PS   In the highest cases of humor the expense may be everyone's—laugh-
ing because the whole human lot is so utterly hopeless.

DS   If you look at Godard's career, in his early films, they're beautiful,
they're romantic, and they have shocking elements of cruelty, but they're
all really under the heading of the beautiful. And then there's the point
where he turns a corner, and all of a sudden he's involved with real cruelty.
It's a ghastly realization, that this man who has a sensibility, the taste of an
angel, and culture, is involved with cruelty. It was one of the most wonder-
ful things in my life to realize that here is a mature artist who could cross
the line into forbidden territory, and not in the way of Genet, not in the way
of a surrealist writer, but in the way of a modern man, a modern thinking
person.

PS   You don't feel though that there was a certain failure of humor involved
in that? Or just a perspective.

DS   I'm not saying that it was like the grooviest place to be. I'm just using
it as another example of that kind of thing which you would never encounter
in the Whitney Museum, for instance. You'd only encounter fake cruelty.
Now this is a very vague rambling, but I think we're getting to a point in the
culture where the notion that something happened that wasn't supposed to
happen—the notion of humor or the absurd, the unexpected, the irra-
tional—that these notions of how to see one's life, and how to be involved
with one's own life, conjoin to make a sensibility which is more accepting
than the sensibility of previous generations. I'm thinking of an art that func-
tions as an accidental trigger rather than a logical one. And that probably
does have to do with certain things everyone has pointed out, like media
glut. Like ho ho, maybe we really are morally bankrupt. And maybe it's fun.

PS   Right now, I'm looking at a painting that has an image of two women and a man on a pier, that is drawn from Reginald Marsh, I believe, and superimposed is the image of a horse-faced man, grotesquely comical. What can you tell me about this painting?

DS   It may require another element; it has a "short track." If you think about the attention that accrues to the painting as being like one of those old-fashioned railroad cars where you pump the handle and it just goes between two stations, the "track" gets variously longer and shorter. This painting appears to have a fairly short track so you can only pedal so far. It's like a ball bearing that comes to rest sooner than you'd like it to.

PS   Are you saying that the painting is too simple?

DS   Maybe. Also, I'm trying to bring out whatever qualities it was of the Marsh that made me want to repaint it in the first place. That's the kind of traditional aesthetic conceit which I love. It's like Michelangelo trying to "bring out" the figure that was buried in stone. I'm not trying to resurrect Reginald Marsh. In a way I'm giving myself in these pictures a great luxury. I'm making the picture by adding these other things. I'm giving myself a way of calling attention to the picture in certain ways.

PS   By quoting other art?

DS   Well, by adding a backdrop. I can over-dramatize it or dedramatize it depending on what else I group it with, I could let this picture go—it's sufficient—but I could also make it a lot more perverse. There are ways to push away from pictorialness toward something else, toward a perverse situation where the picture is at war with itself. There's all kinds of ways in which you could push it. I can't imagine that it's all that different from writing poetry, where you're pushing meaning around in each line.

PS   I think poetry and painting are very similar. And certainly the literariness of your work is very attractive to me.

DS   The other analogy that I always like to make which might seem less apt but in my mind is probably more operational is the theatrical one. There's a character. You sort of decide how you're going to play the character—the dialogue's just one element; there's the staging and direction, the costume, all these decisions defining the character and pushing the meaning of the character around. Characters are malleable.

PS   Obviously, popular culture enters your thoughts and your paintings. You borrow from various levels, from Reginald Marsh to whatever hideous old joke book that horse-faced man came out of. I think it has to do with this sort of vernacular quality which also goes back to Pop art.

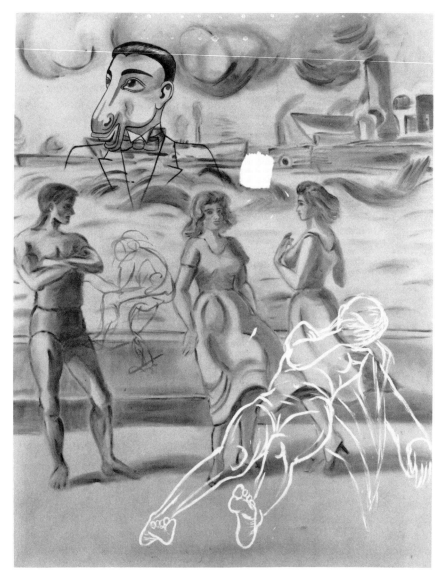

David Salle, *Savagery and Misrepresentation*, 1981
Acrylic on canvas, 80″ × 62″.
*(Courtesy Mary Boone Gallery)*

DS  I never think of what I'm doing as being involved with popular culture. My objection to Robert Longo is because his work is too culture-specific, too much about a certain aspect of, literally, popular culture. I never felt that my work located itself within any specific subculture, any specific segment of popular *or* high culture.

PS  Perhaps if I feel that your work has something of an original position in the question of high culture versus popular culture, it is that it seems to situate itself past the point where the questions mean anything.

DS  I like to think of the work as totally promiscuous and omnivorous. Certainly, there are things which I am not interested in doing but it's not that they aren't "do-able".

PS  Like what?

DS  I haven't painted any scenes of concentration camps or scenes of dead dogs.

PS  But there's nothing inherent in your style that would forbid you from doing this?

DS  The meaning of the style is precisely that it is promiscuous and at the same time the sensibility acts as a filter and as a net. Certain things continue to get through, others continue not to get through. Certainly it's not being in love with popular culture or any other kind of culture. If the work is about anything it's about a certain kind of representation, a certain kind of presentation which is more often found in popular culture than high culture because high culture is about exalted means of presentation—in my mind—and popular culture is about denying you access to the means of presentation, to the mechanics of presentation. That's why popular culture is more mysterious than high culture, because it's more covert. In all my images there's a notion of complicity and covertness that makes you think about popular culture—but they're not "pop" in the sense that they are celebrating anything, that they are in love with anything like that. Conversely, in my work an image is not a "criticism" or a response. Even if it's borrowed, it must feel primary.

PS  Well, there's sort of a wonderful and horrible thing about popular culture in just how incessant it is—it never seems to get tired. A word just popped into my head: ventriloquism. In popular culture you never know who's talking to you.

DS  Precisely. The mechanism of the media is always covert, which is why I can't look at it. For instance I never, ever watch television, I can't stand it for even 10 seconds.

PS   Let me throw out an idea. Your work seems to me to be about weakness. Weak moments. Your people are often very exhausted, lying down, vacant-minded. I'm looking at another painting in which a cup of coffee is being spilled. What do you think?

DS   I used to have enormous identification with handicapped people. I did a piece last summer which is a tape of sentimental music played in a space with paintings of blind children. Some very emotional experiences were triggered for me by my being in the same room last year with some handicapped children, which is a weird thing to talk about. It usually happens to me in the subway. I once followed a crippled girl in the subway for hours. I went where she went. And once I was on the subway and saw this little girl and her mother. She was blind and I followed them around for awhile too. I don't know what it was I wanted, because you can't go home with them. Just the fact that that moment of recognition to me is one of excruciating beauty.

# David Salle (II)

*Georgia Marsh*

GEORGIA MARSH   In the dining room of the Barnes Collection in Philadelphia, above the sideboard, is the naughtiest Courbet I have ever seen. It is a painting of a woman lying on a riverbank, naked except for her socks. She is on her back with her legs up over her chest, coyly looking back at the viewer (to make sure she is being watched) as she pulls off one of the socks. It's a great crotch shot, right there in the middle of his evening meal.

DAVID SALLE   Robert Rosenblum called it "the preeminent beaver shot painting in Western art." He assumed I had seen it. I haven't seen it. My painting which uses a similar image is from a photograph I took without having any specific art-historical reference in mind.

GM   You've used that crotch shot in several paintings. It seems to be a favorite.

DS   Well, different kinds. The reason that one works has a lot to do with chiaroscuro shadow, with the way the shadows fall. And that's generally what makes an image interesting to me, or makes it usable in paintings . . .

GM   There's always a sort of sketchy, homemade little figure stuck in there somewhere.

DS   There are some that have the linear drawing on top of the chiaroscuro image. They can be pretty anatomically explicit. I remember one in particular that must be remarkably similar in pose to this Courbet painting of Barnes, as I imagine it. There was a woman with one knee up and one ankle resting on the opposite knee so you could see her head between her legs.

---

This is an excerpt of an interview conducted in July 1985 in Sagaponack, Long Island; it was originally published in *Bomb* (Fall 1985).

This was a drawing of mine on top of a painting. In other paintings, the cunt was a disembodied image. Unlike a cock, when a cunt is detached from the body it exists in, it's not necessarily recognizable. It could just look like a lot of things. Sylvia Townsend Warner wrote in one of her letters, "Hymen without his saffron robe is just another forked radish." Devoid of its context it's not even necessarily recognized as a shape. Whereas a cock is always a cock.

GM    What about the slit shapes in say, *Bigger Credenza?* You've got this fantastic woman in this crotch-shot, and no crotch at all, and on the other side you have all these slits. And asses. You've got an awful lot of those, too.

DS    Yes, it's strange. I don't know what to make of it, exactly. There's an essay by Octavio Paz in a book called *Conjunctions and Disjunctions:* in various cultures and various times from ancient to rather recent history, there was an equation made between the ass and the face. There's actually a Goya painting of a face superimposed on an ass which is reproduced in the book. Maybe it's a Velásquez that Goya copied. Anyway, apparently this is a long-standing theme for Spanish-speaking people, but not only for Spaniards.

GM    Is it in the language? Is there a similarity in words?

DS    I think it's an anatomical and basic, not to say profound, reciprocity between the ass and the face and between other parts of the body and the face: how other parts of the anatomy become like faces. . . . The ass is the opposite end of the person, so to speak, the most ignoble part of the person, and the face is the most noble, the site of specificity and recognition. Or the ignoble unspecificity of the ass is . . .

GM    Is the unsmiling orifice?

DS    Unsmiling and if expressive, expressive in the wrong way. It expresses something you don't want to have expressed. I'm working on some pictures using faces superimposed on asses again. I think it's a confluence of several things, some of which are conscious and some of which are not. I seem to be backtracking to the original inspiration for the superimposition paintings, which many people have assumed to be Picabia's transparency paintings. Actually, I didn't see those Picabias until I had made the overlaps and superimpositions. Remember the scene in *Apocalypse Now* where Martin Sheen's head is in the corner of the screen and superimposed over that is a ceiling fan in the room that he's having hallucinations in? The fan turns into helicopter blades and the soundtrack is the Doors' "This Is the End." It's a great moment in the history of cinema, I think, one of the great cinematic events.

GM   Certainly a great cinematic event for your painting.

DS   That was 1979. It was not the actual concrete source for those paint-ings but it made me feel so clearly that I was on the right track.

Walter Robinson

# Walter Robinson: Eye on the East Village

*Jeanne Siegel*

*Walter Robinson is an artist whose paintings range from illustrations of kitsch and commercial subjects to large-scale "spin-art" abstractions. He is represented by Metro Pictures and has shown there since 1982; he also had solo exhibitions at the now-defunct Piezo Electric gallery in the East Village in 1984 and 1985. He is also a critic—a career which began with his co-editing (with Edit DeAk)* Art-Rite, *a small but very visible journal that appeared from 1973 to 1978. After that, he became active in Collaborative Projects, an artists' collective best known for its 1980 Times Square Show, and served as the group's president during the following year. From 1983 to 1985 he was art editor for the* East Village Eye. *Robinson is presently a contributing editor of* Art in America.

JEANNE SIEGEL    Where would you locate the East Village geographically?

WALTER ROBINSON    With a few exceptions, the galleries were located between Houston and 14th and Second Avenue and Avenue B. But from the beginning it was more a dream world than a real place. It was about making an "art movement" seem more real by anchoring it to a concrete physical area.

JS    Who were among the first to arrive in the East Village? How did it form?

WR    You don't have to be first, just on time. It's less than the whole truth, but you can say that the first four East Village galleries also happen to map out four aesthetic poles: Fun, for graffiti and wild style; Gracie Mansion, for

This interview was conducted at the artist's studio in New York in December 1987.

Dada, Pop and Kitsch; Civilian Warfare, for conceptualist painting and sculpture; and Nature Morte, for Postmodernist art and photography. This was something of a convenient fiction from the beginning. For instance, it overlooks 51X, a lesser-known artist-run graffiti gallery that opened the same time as Fun, and ignores all kinds of art galleries that preceded all the East Village hype. Or you can see something of that a little later on, when the East Village served as the site of resurrection of the careers of older artists who had become what could be called Soho rejects—people like Vito Acconci and David Diao, for instance. Another artist who hit it big over here was Jeff Koons, who had been knocking around Soho for years before anyone caught on to what he was doing. It was a much more fluid situation than the nametag might suggest.

On a social level, I liked to think of it as a community, a large group of people made up of smaller, overlapping circles, people who were friends and friendly acquaintances. Our opposition to the mainstream art world, which didn't have room for all these young artists anyway, partly evolved from the 70s alternative space movement, extended even to geography. The East Village just looked like a bunch of small commercial storefront galleries; really it was one big alternative space.

JS    Why do you think the East Village came into being?

WR    I used to joke that it arose because of Hispanic cuisine—rice and beans, chiccherones de pollo, things like that which are, quite seriously, one of the undeniable rewards of living over here on, ah, a gut level. But more and more the East Village art scene appears to be a direct result, like the larger 80s art world boom, of Reaganomics. More rich people meant a bigger art market, which meant more new artists, which meant gentrification of urban slums like the Lower East Side. And you have to remember that long before the city let the area become such a remarkable ghetto that it had been something of a bohemian crucible for years, with beatniks and happenings and punk rock and God knows what before the yuppies appeared. Parts of the neighborhood are still not effectively gentrified, because there's no subway, because of the city's unusually strong rent stabilization laws, and because the drug economy down here is so powerful. I guess artists and rich people both have some use for drug dealers these days.

JS    Did artists who belonged to organizations like Colab or Group Material or Fashion Moda flow into the East Village? What role did Collaborative Projects play in the late 70s? Why did it form in the first place?

WR    All that is complicated, and more or less lost in the junkheap of history. As it turns out, those kinds of groups served the same larger purpose the East Village art scene did, as a kind of finishing school for young artists

who later graduated to the major leagues. Colab people opened ABC No Rio on Rivington Street in 1981, before even Fun opened on East 10th Street, and the art world didn't care. No Rio is still there, and the art world still doesn't care. Now there's a crack den upstairs.

Colab came out of 70s performance and media art and the alternative space movement, and though some of its members lived on the Lower East Side before the East Village art boom began, the Colab people didn't take part in it very much. Colab artists were part of a slightly older generation, people like Jenny Holzer, Robin Winters and Tom Otterness, people who show in Soho or uptown. Most East Village artists were still in art school in the late 70s when Colab was set up.

JS   Do you think the artist-run galleries in the East Village were established specifically for marketing subcultural products such as graffiti, cartooning and other vernacular expressions or imitations of them?*

WR   We did tend to ignore barriers of class and race that elite art world types like Owens helped maintain. As it turned out, the real money was in marketing emblems of upscale, academic philosophies imported from Europe.

JS   Do you think it picked up on Warhol's awareness and adoption of business techniques—openly acknowledging their economic role?** Was he a catalyst for that? Did everybody in the East Village look up to Warhol?

WR   You can't deny Warhol's importance, but nobody in the East Village paid that much attention to him, or to anybody in the real art world for that matter. Part of the whole thing about the East Village was its studied and stubborn ignorance of the rest of the art world and its hierarchies. It was very parochial in a sense, even though we were only a mile away from SoHo. We made our own art world, with an entire range of different styles, as if to prove that anyone could free themselves from institutional authority. We had our own expressionists, we had our realists, we had our conceptual artists, we had every kind of artist. We had our own dealers, collectors and even our own special gallery day, Sunday, when all other galleries were closed. For a while it looked like we actually might get away with it, pretending the real art world was irrelevant. That's one of the reasons it came down so hard on us.

---

*See Craig Owens, "Commentary: The Problem with Puerilism," *Art in America*, Summer 1984, which analyzes the East Village art "scene" as an economic rather than aesthetic development, one tied to the avant-garde's need for this exchange between high and low sectors of the cultural economy. It is, also, a response to an extensive article on East Village art by Walter Robinson and Carlo McCormick in the same issue.
**Ibid.

JS    Name six artists who you consider to be truly East Village artists.

WR    I'll give you six who are worth money, who now show in Soho galleries and museums all over the world: Vaisman, Haring, Taaffe, Schuyff and Halley. That's only five. Add Mike Bidlo, not because he's so successful but in honor of his making the inevitable literal, moving the East Village to Leo Castelli's basement (with his show of his copies of Picassos there). My personal favorite painters in the East Village are Luis Frangella, Keiko Bonk and David Wojnarowicz, and also Martin Wong, Stephen Lack and Rhonda Zwillinger. I like Julie Wachtel's paintings a lot. I like also the work of the guys who started Nature Morte—Peter Nagy, Alan Belcher and Joel Otterson. And you can't forget people like Mark Kostabi, Richard Hambleton and Rick Prol. There's lots more—most mentioned in the *Art in America* article.

JS    One of the more successful survivors of the East Village was Keith Haring.

WR    Maybe because he was one of the first to leave. The Lower East Side was always a place to move *out* of, you know, as soon as you were able. Haring was showing in Soho at Tony Shafrazi's when the East Village really started happening; his shows at Fun were like gestures of solidarity with Patti Astor and all the Wild Style artists who she represented.

Haring is a good example of the way the art world processes a complicated social reality into something much simpler, more emblematic, more marketable. He and Kenny Scharf and Jean-Michel Basquiat are called graffiti artists. Real graffiti art of course was done on subway trains, and has been at least since the late 60s. But none of those three ever did any train art. Those guys aren't strictly speaking graffiti artists or East Village artists, but when I was writing for the *Eye* I was happy to reach out and claim them. My theory, which came from my experience in Collaborative Projects, was that as a group we were much stronger, so we claim everything we can get our hands on and we all share the rewards. Needless to say, I was a little naive on that score. Keith did have one of his very first shows in the East Village though, at a basement social club and bar on St. Mark's Place called Club 57.

JS    Criticism escalated around the question of the invasion of artists, galleries and real estate promoters into a poverty area, presumably causing havoc for the people, mainly Hispanics and blacks, living there. Do you as an artist and a critic feel complicit with gentrification on the Lower East Side?

WR    I should make it clear that I'm not talented at real estate; I still pay rent for my apartment and could hardly afford to buy it. But more generally, I'd say that of course artists are as naive, self-centered and ideologically

Walter Robinson, *Bring Back Her Body,* 1984
Acrylic on canvas, 24″ × 24″.
*(Courtesy Metro Pictures)*

blinded as anybody else. Personally I feel helpless. Because I'm a college-educated white male I should somehow be able to exercise more control over my destiny than those less privileged—that's the leftist's version of the Protestant ethic. It's worth noting that the basic argument of all those critics—forcing individuals to identify with a social group, and then telling that group to go live somewhere else—is the same one made by Hitler, Stalin and racists of every stripe. Actually, it's symptomatic of what you could call the art world's East Village Syndrome—a projection of negative qualities characteristic of the entire body onto a small segment of it, a scapegoat.

JS    By 1985 you announced the demise of the East Village in the *East Village Eye.*

WR    Actually Carlo McCormick wrote that prescient bit of prose and generously shared credit with me. The joke now is that the East Village may prove to be in the vanguard even in its death, if the end of the Reagan era and the crash of '87 lead to a massive art world recession, as one might think it would.

I was art editor of the *Eye* for two years, from '83 to '85 and to me those are the only two years that the East Village art scene really existed. As a community it was definitely at its most intense then. You could have 14 one-day, one-night shows in a row at the Limbo Lounge, a tiny storefront on East 10th Street, and each artist was willing to mount and take down their show in one day just to provide an excuse for everybody to come and see the work and talk and drink.

JS    What do you think caused its demise?

WR    I think the institutionalized art world stepped on it, squashed it like a cockroach. The art world mounted a unified attack. Look at the list of people who slagged us off in print: Gary Indiana, Barbara Haskell, Robert Hughes, even *October* magazine chimed in. Then the money people, the barracuda, came and picked off what they could use and left the rest of us behind. I was wrong to think that we were a community, that we could resist the real art world's economic power, that we could create this monster and control it to our own benefit. The larger art world easily took over the monster and used it for their own ends. First it created the East Village by giving it a certain amount of attention and then it projected all its own negative qualities onto it and destroyed it. For instance, to refer back to your question about Warhol, his foregrounding of the business aspects of art, that was one universal art world attribute that was projected onto the East Village. We were nothing but a bunch of hustlers, going after the vulgar dollar. Mark Kostabi was exemplary in this regard; he consciously modeled his persona

after Warhol and was called cynical, though he just thought of himself as someone who was being frank, not deluding himself or his public.

The avant-garde has always had trouble with its ties to commerce, with its dependency on the patronage of the rich. You can see it in Conceptual art, or in performance and video art, for instance. Even our most widely admired political artist, Hans Haacke, watched one of his works sell at auction for $90,000, if I remember right, to an admittedly unusually enlightened rich person. It's a contradiction that haunts the avant-garde, that has to be continually repressed or negated. Most East Village artists were facing up to this contradiction in their actual practice as artists, making the commodity function of their art overt. We see this now theoretically distilled and made somehow more acceptable through being more abstract. You know, what is being called Simulationism.

JS    Do you accept this as part of Postmodernism?

WR    What I like about "Postmodernism" as an art term is how, about two years ago, it suddenly found its art market meaning. For years nobody understood what it meant except a bunch of critics who read all the time, and they weren't really inclined to explain it. Then all of a sudden a friend of mine who works for a private dealer is saying "Po-Mo, Po-Mo, that's all they want, Po-Mo," and it turns out that all the dealers' clients are looking for Taaffes and Schuyffs and things like this. So it seemed another art movement was born, a name that meant something else altogether was attached to a bunch of real objects, and it meant something new because it had rich people behind it to make it stick.

So I thought, the 80s are all done, it's going to be Neo-Expressionism in the first half and Postmodernism in the second half. Everything else is going to be left out, including the East Village and tons of other stuff besides. But now Baudrillard and some other people have weighed in and they want to call the second-half stuff Simulationism instead. And that may win out because it's more of an art-type term. Another candidate is Neo-Geo. Were you around when they invented Minimalism? Weren't there other alternatives? Didn't it almost become ABC art, or Primary Structures, or something else? "Minimalism" won that contest; I mean it's capitalized in *Art in America* and you never hear about the other candidates from the time. This is what I find amusing now, watching the art world create its own truncated history, watching Simulationism fight it out with the other terms in the battle to define the two handfuls of artists who will be "made men," as they say in the Mafia, the ones you can't mess with no matter what they do.

Keith Haring
(*Photograph by Heinz-Günther Mebusch*)

# Keith Haring's Subterranean Signatures

*Barry Blinderman*

*A year after leaving the School of Visual Arts (where he studied with Joseph Kosuth and Keith Sonnier), Haring began drawing white chalk figures on the black paper which was pasted over expired billboard ads in New York City subway stations. He developed personal signs—crawling baby, barking dog, TV sets, telephones, flying saucers—that have remained mainstays of his private mythology. Blinderman discusses with Haring this iconography as well as his abbreviated drawing style and its relation to graffiti. He characterizes Haring's tableaux as lying somewhere between the realm of cave art and cartoon—capturing the mystery of ancient ritual and the obsessions of high-tech society.*

*From the start of his career Haring was superenergized and directed. Between 1980 and 1981, he exhibited in the "Times Square Show," "New York/New Wave" at P.S. 1, Fashion Moda's "Events" at The New Museum, the Mudd Club, P.S. 122, "The Monumental Show" in Brooklyn, and Club 57. He became a good friend of Andy Warhol, echoing Warhol's discarding of distinctions between high and commerical art. Haring died February 16, 1990.*

BARRY BLINDERMAN   How did these drawings come about?

KEITH HARING   I was interested in what using images could convey that using words could not. I had been doing performances and video pieces with a lot of verbal elements, and was getting frustrated with the use of words. The images became another vocabulary—signs and symbols which became

This interview, excerpted from a conversation with the artist in July 1981, was originally published in *Arts Magazine* (September 1981).

more significant through redundancy. The crawling figure that I draw, for example, has become a sign.

The first images were of flying saucers zapping dogs, who were then worshipped by people. Also, there were flying saucers zapping people who were masturbating or having sex. These were done in July and August of 1980. After that I posted a series of Xerox headline pieces on the street ("REAGAN SLAIN BY HERO COP ... "). The earliest subway drawings were done with black Pilot markers over Johnny Walker Red ads depicting a snowy landscape with train tracks. I would usually draw a crawling baby or a dog, or combinations of the two, getting zapped by a flying saucer. They were done on the same scale as the ad's landscape. Whenever I would see one of those ads, I'd do that drawing over it. Then, around January, when the black paper (used to cover unrenewed ads) came along, I started doing chalk drawings on that paper. Chalk is a great medium—clean, economical, fast; just stick it in your pocket. I lived near Times Square and worked downtown, so I was on the subway at least twice a day. By moving from the East Village to Times Square, I increased my audience by tens of thousands of people.

BB   The writer Richard Goldstein recently referred to your drawings and the work of the best graffiti artists as unofficial public art. Your art is truly accessible to a wide range of people.

KH   Yes, but most people are so overloaded by sounds and images around them that they block out a lot of the good things there are to see on the street. Some don't pay any attention to graffiti or street art. I've always been interested in Chinese calligraphy, Mark Tobey's work, and Dubuffet's idea of *art brut*. That's why I was attracted to graffiti right away. I wanted to paint like that anyway, to make lines like that. Even the graffiti that people say are just names represent some of the most beautiful drawing I've ever seen.

BB   Conciseness is a key factor in your work, both in your use of line and in your system of symbols.

KH   I am trying to state things as simply as possible, like a prime number. So much information can be conveyed with just one line, and the slightest change in that line can create a totally different meaning. Economy has played a big part in the work from the beginning in all senses—materials, form and function.

BB   One of the major themes I notice in the drawings is communication, especially through electronics. There's that persistent TV screen and a telephone that is perpetually off the hook.

Keith Haring, *At the 7th Avenue, No. 1 Train at Pennsylvania Station*, 1982
*(Photograph © Tseng Kwong Chi 1982; courtesy Tony Shafrazi Gallery)*

KH    The TV and telephone have significance in my drawings just as everyday things that have so much power over our lives. People who grew up in the "modern world" tend to take these things for granted, without stopping to think that they are new and that the world existed without them for so long. We can't live without acknowledging that things are different now.

BB    Some other themes that seem important in your work are domination and submission, fear and worship of a higher entity.

KH    A lot of the drawings are about power and force: the transfer of power, power being used for different reasons. One of the biggest issues in the world now is the amassing or balance of power, supposedly to avoid total destruction. The flying saucers represent an ultimate power—the unknown.

BB    What about the dog?

KH    It's really a four-legged animal rather than a dog. It's a basic symbol for animal life or for nature. We don't really understand animals after all this time—what they think or if they think. When the animal is bigger than the man, it stands for nature, or a predator. Scale becomes a tool as much as line or redundancy. The scale is often manipulated to give things different meanings. When the animal is small, it could be the man's pet.

BB    You've recently done some drawings of Mickey Mouse. When you show Mickey beaming in the sky like one of your saucers, it seems to be making a statement about the power of popular culture. Mickey Mouse was also one of the first images of Pop art.

KH    The Mickey figure came out of drawing Mickey Mouse a lot when I was little. I've appreciated this anew because the drawings I'm doing now have more to do with what I drew in high school than with anything I did in art school. I did it partly because I could draw it so well and partly because it's such a loaded image. It's ultimately a symbol of America more than anything else. I did the drawings right after I saw the Whitney Museum's Disney show. As for Pop art—the people who were doing it 20 years ago were calling attention to new cultural things from somewhat of an objective stance. I was born in 1958, one of the first babies of the space age. I grew up on TV. I feel more that I'm a product of Pop, rather than a person who is calling attention to it.

BB    Any thoughts toward the future?

KH    I've come to the realization that I can draw anything I want to—never believing in mistakes. I don't really have any doubts that I'll be able to follow this work with something else. It has progressed like that since I started.

Mike Bidlo
*(Photograph by Tom Warren, 1985)*

# Steal That Painting!
## Mike Bidlo's Artistic Kleptomania

*Carlo McCormick*

*Mike Bidlo came to New York after getting an MFA from Southern Illinois where he had a double major in art and art history. He was introduced to the New York art world when he participated in the "Times Square Show" where he had 3 works—a body art piece that dated back to 1975 and kinky photographic collages of bondage, in keeping with the theme of the show. In 1982 he was given a studio at P.S.1 and he exhibited at Gracie Mansion (one of the first galleries in the East Village) along with 79 other artists in its inaugural show "Famous".*

*The East Village was about spectacle. Clubs were as important as galleries. Perhaps that's why Carlo McCormick thought of Mike Bidlo as the quintessential representative of the East Village art scene. His "Peg's Place" installation at P.S.1 in 1982, which recreated Pollock's bad boy act of peeing in Peggy Guggenheim's fireplace, won Bidlo instant notoriety. Along with this gesture were full scale recreations of Pollock's drip paintings, which had instant market success. Bidlo went on to copy Schnabel plate paintings, Picassos, Brancusis, Morandis, and others. Another spectacle in 1984 recreated Warhol's Factory.*

*Bidlo, as the interview reveals, is a populist and also somewhat of a crusader. In the act of appropriating, while demystifying the artist, he wants to inform the viewer about art. Like Sherrie Levine he questions the concept of originality but for different reasons.*

This is a revised version of an interview conducted at the artist's studio in New York in May 1985, and originally published in the *East Village Eye* (October 1985).

---

CARLO MCCORMICK    What started you on appropriation?

MIKE BIDLO    A multitude of reasons really. Basically, I was interested in making an art which was both seductive and subversive at the same time. I wanted to take certain final steps to explore certain taboos.

CM    When was that?

MB    1982. But in essence I've been doing it all my life. Copying is the instinctive means of learning. Most people copy what they like, regardless of the irony involved.

CM    Have you ever painted anything that you don't like?

MB    I've thought about it. I once contemplated making a George Mathieu. He was considered the worst abstract expressionist. It is a fascinating problem to consider, but so far I've stayed away from it.

CM    The first artist you imitated was Jackson Pollock who I believe became somewhat of an obsession for you. Do you feel in that intensity that you consciously became Pollock?

MB    No, never.

CM    You certainly adopted much of his personality and behavior.

MB    The identification involved makes this inevitable to a certain extent, but there was never a conscious decision to become Jackson. Anyone who is working with a passion in their art has to become obsessed with it.

CM    What was the attraction of Pollock? The myth?

MB    I think it was Pollock's futile gesture of peeing in Peggy Guggenheim's fireplace, in conjunction with the drip paintings themselves, that captured me. It just seemed his myth needed renegotiation—a certain art-historical reshifting. As the East Village becomes so public it's frightening and exciting to think of the immense influence we can have.

CM    I think I had forgotten that the original impetus was revisionistic.

MB    I forgot it as well, as it started to take on more of my history.

CM    The focus seemed to change from the mass market production of art, to the monetary preciousness of Pollock's work. It became in effect an anti-market stance.

Mike Bidlo, *(Not) Blue Poles*, 1983
Enamel on canvas, 6'11" × 16'.
*(Collection Tony Shafrazi; photograph by Phillips/Schwab)*

MB   Well, more a shifting in focuses which included many variables—including those of art and commerce. I also liked bringing back that original anti-modern opinion of Pollock, that anyone could do it, and since then so many have imitated his gesture, privately, for their own purposes. I am constantly hearing anecdotes from people of the Pollock they once made.

CM   I once accused you of hero worship in your plagiarism of various artists, which you strongly objected to. Why?

MB   Many people assume that wrongly. It has much more to do with a toppling of the gods—especially of changing my relationship to them. In a sense it deals more explicitly with demystification and empowerment.

CM   Starting with *Peg's Place*, many of your ideas have culminated in installations and performance. There are those who believe that your impact is as a performance artist. Do you separate the spectacle of the public events from your work in the studio, and is one more important to you?

MB   I never considered myself as a performance artist, but perhaps you cannot make those sorts of distinctions anymore. For me, doing a public performance brings art to a level more people can understand and interact with. When I did my Yves Klein piece, his work became accessible to people who had previously never heard of or understood him before. Who the hell is Yves Klein? Or Mike Bidlo? Yet, rematerializing the image of the naked women spreading the shocking blue paint on themselves and making prints of their bodies drew everyone in as entertainment, made them become more intellectually aware.

CM   Something like this quote of yours on the wall: "When I am alone with myself, I have not the courage to think of myself as an artist in the great and ancient sense of the term. Giotto, Titian, Rembrandt and Goya were great painters; I am only a public entertainer who had understood his times and has exhausted as best he could the imbecility, the vanity, the cupidity of his contemporaries. Mine is a bitter confession more painful than it may appear, but it has the merit of being sincere."

MB   Well, to tell you the truth Picasso said it—not me! It's quite an amazing statement I think.

CM   Do you ever feel that the entertainment becomes an empty spectacle?

MB   It can become that if you let it. For me at least, recreating a work in any form becomes revelatory.

CM   At times however, you focus almost entirely on the superficiality that exists within the drama of the original act of creativity. Such as your massive Schnabel, which emphasized the fascist presence of the museum guard as

played by Thom Corn. The spectacle of your recreation of Warhol's factory also was more about social aspects than artistic.

MB    The Warhol piece was really a group activity. It was about the production, the collective effort and combination of personalities. For so long people had told me to do *The Factory,* eventually the mass will became the creative impulse. One aspect of my work is about living out your fantasies; things you wish you had done, moments in history, places you wish you could have been at.

Each project manifests a different focus. I really don't have any specific programs—I'm more aware of and interested in internal contradictions. I want the work to frustrate the public into looking a little more closely, while at the same time allowing them to see something "known" in a new way. Ultimately, my goal is to confront and challenge the viewer to accept these works as mine.

Robert Longo
*(Photograph by Frank Ockenfels 3)*

# Men in the Cities: Robert Longo

*Barry Blinderman*

*Longo's "Men in the Cities" spanned a period from 1979 to 1983. Giant figures of men and women (from 5 to 10 feet tall) that formed the series (there were 60 in all) were involved in a kind of death dance. Isolated, frozen in strained poses, they registered anger, tension. They resembled black-and-white film stills, only starker. At first, Longo appropriated images from magazines, newspapers, or movie stills. Then he began to use his friends as models, posing and photographing them himself. Art world characters—Brooke Alexander, Cindy Sherman, Gretchen Bender—are among them.*

*Blinderman saw something heroic in the struggle and the pain expressed in their contorted bodies, and connects them to Longo's city edifices that lean and jut ominously. At the same time, he argues that the figural reliefs bring the artist back to the Renaissance, to Donatello's* St. George and the Dragon *or Ghiberti's* Gates of Paradise, *tapping the grandeur of a past era.*

*Like a number of young artists in the early 80s, Longo had a meteoric rise. He had his first one-man show at Metro Pictures in 1981. By 1983 he was in "The New Art" exhibition at the Tate Gallery in London. In the same year he had a double show—at Metro and at Castelli Greene Street.*

BARRY BLINDERMAN   How would you view the relationship of your work to Pop art?

This interview is an edited version of a taped conversation with the artist in New York in January 1981.

ROBERT LONGO   I look at Pop art as my "hero"—it's the first really American art that's important. My relationship to it beyond that really isn't that deep. Warhol is impressive because of the scope of the work and how it really becomes monumental. The content in my work is different. I'm aiming at a kind of dramatic realism, whereas he eventually pursued an avenue of fashion and status. But the thing he said about everybody being famous for 15 minutes—I'm fulfilling his destiny in an ironic way. In the drawings, I'm taking these people and making them really special, but at the same time, keeping them anonymous. Not a Jackie or a Marilyn, just a Jim or an Anne.

BB   Like the stillness and anonymity in Hopper, only more heroic . . .

RL   When you think of Hopper, you think of a specific time; that relationship to style is important. What has occurred with the new wave art is that it established the idea of nostalgia closing in on itself. It goes back to the modernist dilemma—there's no room to go forward, so you go laterally and pull up the consequences. Stylistically, someone can look like they belong in the 50s, and still look very much like they belong in the 80s. It's the gestures that link to time rather than the fashion of the clothes. Gesture extends beyond fashion; it travels that line above and beyond.

BB   A lot of writers have focused on the issue of style, missing out on the importance of the gestures.

RL   The thing about gestures—I just want to take that imbalance and freeze it forever. It was like using the traditions of art, only introducing the gestures of the 80s. I don't like modern dance; I think the best dance is the way people die in movies—they reel and jerk and explode in space. Sports is good dance, too—the beauty of a slam dunk. The way people die in movies is a new subject matter—you watch the way James Cagney died in old movies—he kinda goes "Ugh-g-hnnn!" and falls off the chair, whereas now, somebody gets shot and they get blown through the wall. Before, people ran around a baseball diamond differently than they do now. Gesture changes.

It's an artist's job to catch his time. I think I jumped in at the right time. It's like this river and you've got to jump in without a life preserver. If art is a linear structure that has this ball rolling on it, as an artist you approach it as an energy source, and you hit the line. I think the ideal way that the artist should enter is to do so when the wheel is turning at a formative period, a beginning of something, a raw period. It's important to throw the right dart at the right target with the right enthusiasm.

BB   The clothes worn by the figures in your drawings create strong distinctions between the sexes, and really do become linked to gesture.

RL    I'm picking an archetypal uniform or costume. Men wear suits, shirts and ties, and women wear dresses. I would *never* do a woman in pants. At this point, it's a uniform. I would love to just draw people in uniform. When I was a kid, I used to draw football players. I chose a kind of uniform that nobody assumes is a uniform until you think about it as being a uniform— obviously a twentieth-century uniform. It doesn't activate itself as a uniform in the sense of authority and government and teamwork—it's more a uni-form that establishes a kind of alienated individualism. Everybody who wears suits and ties, it doesn't necessarily mean that they're in the same unit. It's funny, because you can use the word "company" in relationship to the army and also in relationship to Exxon, or the C.I.A.

The shirt and tie is kind of a cliché. Clichés can be monumental; they become icons. I don't think about the structure underneath the clothes. There's no difference of sex. That's why the women came about. Because I wanted to eliminate any issue about this being "male" art or whatever. Although it is very much "male" art in the sense that—there is a band called the Theoretical Girls—that's what I think most men I know are. There's a whole confusion about sexuality at this point. So by introducing women, it was important to eliminate the notion of sex.

Troy Brauntuch uses uniforms in his work. His work was inspirational to mine in that it helped draw the lines around my work. He uses such incredibly charged images—he uses pictures from World War II and makes them so beautiful. I take pictures that aren't necessarily that charged up. If you look at the pictures of the people on the roof as photographs, they're not that hot. But I want my drawings to become better than photographs, like the whole idea about customizing people. The drawings are more accurate realities than the people.

I'm obsessed by a degree of control; of giving orders. For a while, I constructed the boundaries of my art, and it started to feel very limiting, and all of a sudden, it's developed manifest destiny, it's so incredibly expansive. I can do anything, and just slam the system down on it and make it work. The system is like a fly swatter. It hits, and what's worthwhile passes through it. Like when you swat a fly and all the guts pop through. I want to totally enclose my creative energy. I take the pictures that I make the drawings from. I take the pictures I make the reliefs from. I want to make music I listen to while I make the drawings.

BB    The installation of your exhibition of the "Men in the Cities" series at Metro Pictures is formidable.*

---

*The exhibition referred to is the artist's first one-man show at Metro Pictures in New York City.

RL    The whole show was thoroughly planned out as to where the pieces were going to go, so that the show was envisioned with a kind of drama. In the show, I divided the men and the women. I liked the idea that the viewer stands in the middle, like no-man's-land. It reduces the viewer to a participant in the drama. I'm impressed by the idea of "place" as a vehicle for meaning, like Gettysburg. Each room had to have a certain atmosphere. You walked in and the room was dark in front of the gallery; it was almost like somebody was buried there. I wanted to make like a place where you could come and die. I wanted it to have a stillness that was different from the stillness of being in a still life. A thing that's gone through my art for a long time, even when I was a student, I constantly played with dichotomies like yes and no, black and white—two extremes that I tried to pull in towards the middle to a balance line. The fact that the images are taken from a photograph, taken in a sixtieth of a second, they're like this tiny, minute piece of time. Bam! It's like stopping time forever. Smithson had that entropy idea that nothing is forever; this swings back the other way. This is like a split second turned into forever.

BB    Like insects in amber. How do you see yourself in relationship to the media?

RL    I think of myself as a media artist, but this show frees me from all the references that have been written about me and how I take my photos from the media. I don't do that anymore. The media was my teacher. There's a real important videotape by Richard Serra called "Television Delivers the People." This is an important thing that I've always thought about—you get to watch TV but you never get the chance to fight back. Artists are the culture watchers. They're the people who fight back against the media. They understand what the media is doing to you. But that also has a relationship to the fact that the media's advertising imagery of the twentieth century embodies some of the most innovative notions of image to come along in ages. But, at the same time, it's so traditional in the sense that it's selling something. Michelangelo was selling God, and this is selling Mars Bars or something. I think of myself as a media artist because I use the authority of editing. Television, movies and the media in general present you with a highly edited product, and there's something behind that media which I want people to think about in relationship to my art. There are people behind the media. I like that phrase, "warning sign."

I think I make real political art. When people call my work fascist, or when they get into the tedious part about how I don't do my drawings or something like that—it's like I'm doing something I hope Reagan will do to this country. And that's to get people infuriated about the practices. It's neat having Reagan as a president because I'm reading the paper again—and I

think, "Holy Shit! Look what you did now!" Like hiring that anti-environ-mentalist for the environmental advisor. I think choosing Haig for the Secre-tary of State is *frightening*, but it's great.

BB    Your art, like the media, is involved with images that seduce.

RL    In making the images real seductive . . . I concentrate on all the differ-ent levels on which my art functions, but I'm very concerned with that initial trip that pushes you down the stairs. The interesting thing about Nazi Ger-many is that it shows how a country can be visually seduced. We've seen the atrocities, but now it's important to understand a movie like *Triumph of the Will*. "Will" is a very special word—to put willfulness into your art is really important. The stronger the will is in the work, the more effect it will have on lots of levels. I like that word "will" a lot. Will and longing. I like words when they sound like sculpture. You can kind of see that word carved in granite. I think Albert Speer is incredible because he was part of con-structing a visual seduction of a country. I'm glad he went to jail, though; he was irresponsible.

BB    What do you see as some of the tenets of the kind of art you're making?

RL    The representation of images is a necessity because of the culture we live in and the responsibility of the artist. I don't want to look at pictorial images of someone's neuroses. I don't want to see gooky paint. I don't want to see abstraction. I don't want to see the artist. There's no such thing as abstract art anymore.

BB    Scale plays such an important role in your work.

RL    I was fortunate enough to be able to present the work on a certain scale. By making a drawing that big, it starts to become like a statue, which makes reference to the reliefs. It starts to look like a stage set or a theater or a film. When you're dealing with scale, a big statue or a building or a film is capable of a kind of influence—one of wonderment of a basic natural scale. With monuments, you don't usually know who made them. I was always intrigued by that—they were always like over-exaggerated acts.

    People accuse the work of not being personal. I think that it's incredibly personal because I don't allow myself to get in the way of it being personal. I'm just putting the spirit into it.

BB    Speaking of the spirit, the figures in the drawings seem surrounded by some malevolent force.

RL    I like the idea of the "poltergeist"—when the spirit invades the body, takes over and controls it and uses it for a purpose other than what it appears to be. Like the devil coming into someone's body so that he becomes

Robert Longo, *Men in the Cities III*, 1979
Charcoal and graphite on paper, 40" × 60".
*(Photograph by Kevin Noble; courtesy Metro Pictures)*

president and screws up the whole country. When you look at some of the drawings, I believe that there's a real physical and personal relationship to the viewer. You experience the gesture. Did you ever see James Chance of the Contortions, or David Byrne of the Talking Heads? Wouldn't you like to be able to move like them? But that's what these drawings end up doing. When I make reliefs, I would go for a much more clichéd image than previously, like men beating up on each other—violent actions that had an erotic balance or dance to them. Violence has always been a helpful thing in my life. If something didn't work, you hit it; if there was something you didn't like, you hit it; if you were pissed off, you hit it. Seemed like in the beginning, it made a lot of sense. One of the games I used to play as a kid was who could fall dead the best—it was acting out being shot. It's a scene that makes total sense. Peaks of real violence are what you don't normally see.

BB    Your employment of assistants to help create the work has created a lot of controversy.

RL    In the old days, the church funded the making of art, and lots of people helped to make the art. Then later, the government funded art. What would it be like for an individual to make art on that kind of scale? That's something that's real interesting. So . . . one afternoon when I was working on a drawing and having a real problem with it, I realized that my frustration with making it had gotten in the way of making the image itself. Here we are, in modern times, and I want to get done what I want to get done, and I'll do anything I have to do in order to get it done. So, why couldn't I get someone to do my drawings? I had someone to print my photographs. Instead of wasting my time trying to perfect a craft, I could get someone who already has it perfected. It seemed real logical to me. I mean, I could draw real well, but like I had this problem with drawing the chin on this guy and I kept drawing it over and I just wanted to finish it so I could go on to the next thing. It just seemed so stupid. So I hired this woman who's a professional illustrator. She came at that point and just fixed up the chin. And then I asked her to do this shirt. What ended up happening was that she totally adapted to my drawing style. It's gotten to the point where it's like a production in the movies. She's the cameraman, and I have to tell her to make a picture in a certain way, but I have final edit. I do a lot of cosmetic work. I'm very much involved in doing the drawings, but her expertise allows me to concentrate on what I want to get at.

The same thing applies to the foundry that casts the work. I like working with these people, too. It's very traditional. I only go out into the world to function when I have to work with these people. Basically, I don't go out that much, maybe to a club or something. Mostly, I stay home and watch

TV. On the other hand, I've taken this tradition of working for the artist and turned it into the movie production theory. I want to make art that extends beyond the notion of an individual's effort. The more people that are involved in it, the better. . . . Touch is so important—just imagine that many more people touch it to make it. It's important for me to acknowledge the people that I work with because they play a real integral part in it. In that sense, the way I set things up enables me to concentrate more on what I want to make and not leave so much room for chance. I want to get it to the point where it's on such a scale that the individual who makes the art drops out. It's like the overtones. When you hear a piano playing, eventually you don't hear the piano hitting the strings anymore, you just hear the overtones. I want to make art like overtones. I want you to think about me and the people who help make the art only after you have experienced it visually.

BB   It's interesting how you've avoided the whole loaded issue of painting style by doing reliefs and drawings.

RL   Drawings and reliefs occupy this realm of high art that hasn't been totally exploited—they're about frontality, like a television. So, I don't have to contrive new mechanisms—I don't have to paint on foam rubber, or paint on the wall. There's a lot of refreshing energy that can come from drawings and reliefs. They're such an old media, but they're not tainted yet. I couldn't paint because I wouldn't believe it. I think there are a lot of liars around now. I mean, I take all this stuff real religiously.

# Robert Longo: The Dynamics of Power

*Maurice Berger*

*When the 25-year-old Robert Longo burst upon the New York scene, we were captivated by his first performance piece,* Sound Distance of a Good Man, *presented at The Kitchen in 1978. This interview reveals Longo as a performance artist and locates him within a Postmodernist rhetoric. According to Berger, "The impulse toward temporality and theatricality in the work of Longo was an impulse that resulted in an aggressive challenge to the relative stasis of the modernist art object. In this interview, Longo deals with the aggressive attitude of his work, his obsession with the power of the modern media to manipulate its public, and ultimately, the pervasive presence of violence and death in his work. The conflation of these attitudes, Longo believes, results in an elaborate pattern of visual 'warning signs for modern culture'."*

MAURICE BERGER    In your performance piece *Empire*, Eric Bogosian summons the audience below him in the atrium of the Corcoran Gallery in Washington, D.C., "Meine Damen und Herren, seien Sie glücklich. Das ende ist nahe. Kommen sie, bitte" (Ladies and Gentlemen, be happy. The end is near. Come please). He goes on to say, "Culture is not a burden. It is an opportunity. It begins with order, grows with liberty, and dies in chaos." Is *Empire* about the chaos in which culture dies?

This interview, recorded in the artist's New York studio on March 10, 1984, was conducted in preparation for the exhibition "Endgame: Strategies of Postmodernist Performance" (New York: Hunter College Art Gallery), and was originally published in *Arts Magazine* (January 1985) and later in Italian in the Milan edition of *On Stage New York* (October 1985).

ROBERT LONGO   Yes, and since the piece took place across the street from the White House, it was even more significant. I wanted to give the feeling of crossing *Dawn of the Dead* with a waltz. I've always fucked around with history in the most bizarre way possible.

MB   One section of *Empire* is called "Surrender." Surrender to what?

RL   It's the word surrender in image without details. It's about surrendering to a new sensibility in art. Things have changed. When I did the piece, I had to decide whether to become an artist or an entertainer. I became an artist while someone like David Byrne became a musician. I mean, it all of a sudden required you to go back to those traditions, but all of this new knowledge required a total crossover. Like all of a sudden I watch movies, I watch TV, I know about Michelangelo, I'm into dance. All of a sudden I go back to a tradition, which is like making art objects or like making record albums. Surrender is about the pressure of being an artist. It is as if the artist really becomes essentially the worm in the bottom of the bottle of culture. You absorb all of the poisons.

MB   And you feel there are a lot of poisons to be absorbed?

RL   You must face those poisons. It's like I want to learn the future and learn how bad it is. I believe the people who look at my art are willing to face it rather than to avoid it.

MB   In other words, it is toxic, but you are not going to go backwards like Julian Schnabel did.

RL   I agree completely. The only way to deal with the situation is to say, "Yeah, go ahead, drop the bomb on me. See. Big deal. You think it's going to change the way I see injustice in the world or the rest of the bullshit. You think I'm going to really be worried about the bomb." Instead, the bomb just becomes a mannerist ploy to make you forget about all the other things. I'm going to be the person who blows the whistle. It's a kind of guardian quality that comes to me. I watch the visual mechanisms of culture, which are so sophisticated—the way the Nazis turned Germany into a Nazi state, for example. That is like Child's play compared to the mechanisms that exist now to turn this country into something quite horrific. So one of the things about the artist, what the artist has to do, is that he has to be like a policeman. A great deal of my art, particularly the relief *The Sleep*, is about blowing the whistle on society. I made the piece right after Jonestown and right before the Phalangist murders. [The image is actually taken from a family leisure wear ad.] Here they are selling the image of genocide in family sportswear. *The Sleep* is the perfect example of the artist serving as guardian of culture.

MB    What is death about in your work? What is it about politically and what is it about vis-à-vis art?

RL    I think death in relationship to the political has to do with the fact that I am quite appalled by the lack of value of human life in the world. And the fact that most people are numb to death.

MB    What about death in relationship to art? Do you think that something has died?

RL    They always give you tombstones. You're remembered in this world by sculpture. There's some kind of equation that when someone dies, instead of the body being eliminated in the air space, you have to create some kind of object that will replace it.

MB    That is a good way of putting it. What are your works tombstones for?

RL    They are more like warning signs. But I really dig tombs. I like battle-fields because of Vito [Acconci] in particular. Vito really exploited place as a vehicle for his art. He made this installation which I ran for three weeks at Hallwalls in Buffalo, which was like ghosts—it was so beautiful. He was a major point of influence. I wanted to objectify these transient feelings. So for a long time, a lot of my exhibitions were about understanding that when you hang your art in the world, in the gallery, it is the last time you really have control over the way it is going to look. Therefore, I tried to make installations that were places. With my first show at Metro and my show at Castelli, I wanted to take on a much bigger battle, to avoid the place and go to a complete, autonomous unit which is going back to very strong, traditional elements of art.

MB    But also a unit that can be disseminated, like a movie.

RL    But now the new pieces are autonomous. They are not like "Men in the Cities." Because of economic reasons and misunderstandings, the piece had to be broken up. My show in Akron now is something like the army of terracotta sculptures in China. It's one piece. It's an army like the terracotta sculptures underground. it's an army, and they're all meant in a specific order.

MB    That's interesting.

RL    Beyond theater, I want to be the instigator. I'm always the person who is trying to start a fight. There's been so many things; all the pieces now start to dictate their order. They have painting, drawing, sculpture—in their own way, almost a sentence structure.

MB    What do you think is the viewer's responsibility? Let us take one piece, for example, like *Sleep*. What is the viewer's responsibility? And what are you doing to the viewer?

RL    There is a degree of education. I enjoy it when I meet somebody who can teach me something. The interesting thing is to develop the exchange. For instance, in *Sleep*, I wanted to create something that, in relationship to the climate of art, would present the same kind of irony that exists in mass media or in history. You can look at this thing and pay attention because it is a bronze relief—made with hands and all that crap from history. On the other hand, you're going to see this other thing, which is the commercial image taken from a magazine. The basic conflict has to be corrected. So all of a sudden, I'm presenting something that we've all participated in creating. It's like putting a bad mark on your report card, or something like that—something we have to be accountable for. And it's not a moralist point of view at all.

MB    How much of your work is about making the viewer uncomfortable? The painfully high volume and menacing sentinels in *Iron Voices*, or *Empire* with its blinding lights and air-raid sirens, seem brutal to me.

RL    A great deal of that has to do with the fact that I have a lot of hostility toward the viewer. I always imagine I make art that's going to kill you either way, mentally or physically.

MB    But you force the spectator into a threatening situation. The viewer has no choice.

RL    One of the most interesting things about art is that it objectifies something that is so basic in life: the art of choice. The fact is that choice fundamentally shapes you as a human being and as a spirit in the world. I choose to smoke cigarettes and endanger myself—and so I choose to look at these pictures.

MB    That's not entirely true. I may walk into metro Pictures and you may confront me with something that I didn't expect to see. And then, consequently, you've disoriented me. I may choose to go to one of your performance pieces at The Kitchen, but I may not choose to have my eardrums blown out. There seems to be an edge in your work which is about removal of yourself from the immediate situation, but what is left is an extremely aggressive presence.

RL    Aggression aside, there is also the issue of heroism. The whole idea of heroism in art is ridiculous, unless it is completed by the fact that the

viewer who looks at the art is as much a hero as the person who is making the art.

MB    It has been said that one of the innovations of Richard Serra and his peers is that they removed the reverence from the art object and granted a certain prestige to the spectator.

RL    To the point of killing him.

MB    To the point of "killing" him in *your* case.

RL    I always imagine that I want to make art that is going to kill you. Whether it's going to do it visually or physically, I'll take either way. If it doesn't kill you visually, it's going to fall off the wall and kill you physically. A great deal of my work is a meditation on power. But the thing about power is that you can't play with it without understanding its consequences. Ultimately, it's about not closing your eyes to power but actually being able to enjoy it. The perfect example of this is a piece called *The Sword of the Pig* which involves a church, a body-builder, and an anti-ballistic missile site. It was all about masculinity, all about being able to basically jerk off in public, but on the other hand . . . understand its own demise built into it. I want to feel free to use certain power systems. There's nothing wrong with the macho mentality, per se. It's entertaining, it's interesting, but once you start fucking around with it without the consequences, it's dangerous.

MB    Does all this power scare you?

RL    No, because I know who I am.

MB    You are planning to make a film entitled *Empire/Steel Angel,* but entirely apart from the earlier performance piece. Could you give me a synopsis of it?

RL    It's about a nightclub comedian [played by Eric Bogosian] who is more like a town crier. He's sort of the last bastion of truth. His comedy is not like "did you ever notice" or telling you how fat his mother is. It's much more like "did you see what's happening in the world."

MB    Like Lenny Bruce.

RL    Right, one step past Lenny Bruce. It's his attempt to maintain his integrity when the system wants to absorb it. He flirts with it and basically gets kicked in the face and freaks out. He then tries to go a very practical route by running a nightclub. He acquires all the regular things in life and then gets mugged. But the way he gets out of being mugged is by turning back into the old comedian. The movie ends with his going back and putting on all his old clothes and getting all his old equipment out. It's like the gun-

slinger trying to go right, hanging up his guns, and then getting kicked in the face—forced to put his guns back on.

That's basically what it's about. But it's also about a guy who has no sense of who he is. The most intimate moments he has are with magazines rather than with people. Yet, as a comic, he deals with the consequences of his humor. He's very much like me as an artist; the film is somewhat autobiographical. I want to be able to tell the world what it's like being an artist. It's not like cutting off your ear or hanging out in bars and drawing pictures of barmaids. It's a very sophisticated thing, very much like being a lawyer or a doctor. The most important thing about it is that the artists I've known, or that I can appreciate, all want to be the best. So you also have this standard level to a situation which is a highly independent, free kind of invention, but one in which I'm inventing the systems that I become the authority of. It's bizarre in a way. I've always been so anti-authority, and to wake up and suddenly realize that I am the authority. . . . Then what I do, almost daily, is to try to create some kind of subversive thing.

MB    Is subversion a strategy of yours?

RL    It's always been very much a part of it, from the moment I brought in a professional illustrator to make the drawings. If you were going to appreciate these drawings because they are drawings, there is going to be a surprise.

MB    A professional illustrator would circumvent that appreciation.

RL    The amount of time that the illustrator had involved in it is not important. The fact is, I put in more. But it's like always wanting to slide something underneath, so you can turn it over and sort of see the worms under the rock.

Thomas Lawson
*(Photograph by Susan Morgan)*

# On Art and Artists: Thomas Lawson

*Kate Horsfield and Lyn Blumenthal*

*Lawson is an intellectual artist in the tradition of Conceptualism. He is engaged in a shifting examination of the issues of representation in both art and everyday life. His work of the early 80s was concerned with connections between art and mass media—square monochrome paintings based on front page images from the NY Post of battered children, spectacular disasters, etc. Victimization of the innocent subject, depersonalization, etc. in the press was a central idea. An interest in images of public terror gave way to an interest in images of public power. Architecture as a sign of the dominant culture as a system of repetitions and copies (as evidenced by standard styles for museums, banks, government offices, and so on), again were matched with painterly signs of Modernism.*

---

KATE HORSFIELD   When you first started painting, what kind of goals, what kinds of things led you further into it? Just the procedures and practices of being an artist? What were you looking for then?

THOMAS LAWSON   I think I have this urge to keep making pictures. When I was an undergraduate I was really quite isolated in terms of art. I was in this old college called St. Andrews, which is in a Medieval city on the east coast of Scotland and a very traditional school—quite distant from the art world which is in Edinburgh. And strangely, considering what I have done since,

This interview is an edited version of a text transcribed from a videotape produced by Lyn Blumenthal and Kate Horsfield at the Video Data Bank in Chicago. Horsfield conducted the interview and Blumenthal was the camera person. It was originally published in *Profile* (March 1984).

I was making paintings there that were based on newspaper photographs. I cut out newspaper clippings that gripped me in one way or another and turned them into paintings.

KH    What year are we talking about right here?

TL    1969–1970–1971. Somewhere in there. I didn't know why I was doing this. I didn't have any reason for doing this. Reading my art history and looking at art—it seemed to be that people made art about what they saw. And I had no interest in painting this incredibly pretty town of ruined castles and cathedrals, which is what the artists that I saw in that town were doing. It didn't seem meaningful in any way. So I was doing this thing with newspapers. I didn't know exactly why. When I moved to Edinburgh, I was very much an outsider figure. I wasn't part of the art school group, so it was difficult to get people to take my work seriously. Serious artists were trying to be conceptualists or minimalists, and the rest were doing their old-fashioned landscapes. But I kept doing it anyway. I had an urge to have some kind of social thing in there. Not exactly . . . well, at that time it was subject matter. I wanted to make paintings to do something directly about everyday life. Although there was always this constant realization that no matter how . . . this sort of distance between getting angry about something and trying to put it on the page. It was a distance that couldn't be crossed very easily. And so I hung around in Edinburgh a couple of years doing Masters work in art history and doing these paintings. Then I came to New York.

KH    To what extent would you say that there was widespread influence of ideas coming out of New York and the American art world in Edinburgh at that time?

TL    It wasn't widespread. We are talking about a very small art world and within that an even smaller group that had any interest in real, hard, contemporary art. But because of the festival, things did happen. There was an important show of Peter Ludwig's collection at the Royal Scottish Academy one year. And one part of that particular show was a lot of Gerhard Richter's work, which was important to two or three of my friends, not just myself. We saw that and began to think, oh, maybe there is something out there that we do have some connection to. At school, we got *Artforum* and *Arts. Studio* was still published at that time and *Art International*. So there was a way that you could read about it. But I remember the first time I came to New York, I was just totally wiped out by the experience of seeing things. The Museum of Modern Art in particular was just astonishing. *Demoiselles d'Avignon* just sitting there—the real thing. It took quite some time to get used to the idea. One of the major realizations was just exactly what it means to see a real painting right there in front of you. For example, I had

always sort of dismissed Stella as this decorator, because I had seen these color reproductions on the pages of *Artforum* where it just looks like magic marker. There is no sense of what it is. And that particular year, the month that I was there, the Whitney had a collection of recent American art—one of those kinds of shows. They had one of the "Protractor" series up. And I had this realization that, oh, that is what it is about. It is this scale thing. Its presence. So suddenly I realized that there was something to be talked about. And it was then that I realized that, if I was really serious about myself, I had to be a part of that—come to New York and deal with it. So in 1975, when I finished my Masters, I packed my bags and came right over to New York.

KH    What type of impact did being in the city have on the development of your work when you first got there?

TL    When I first got to New York, it was so shocking that there was this abrupt stop. I kept doing things, but they were real confused and uncertain. It was the excitement of the city and the excitement of being around real art—seeing so much of it and not having to explain it. One thing about Scotland is that art is very much a peripheral activity. If you are in a bar talking to someone and they say what do you do? You say you are an artist and they give you this really funny look. Oh yeah? What do you really do? Or does that mean I can buy a little landscape—about £10 or something? It's a real drag. You spend a lot of energy justifying yourself. It was nice to come to a city where there was absolutely no need for that. If you say, "I'm an artist" here, everyone understands. In fact, it now seems that there are far too many people willing to say, "I'm an artist." At the time, that was a real breakthrough for me. That you could just be an artist. And it took about a year to feel in any way set or comfortable. It took about that length of time to get back into making work that I could consider of any use.

KH    What did that first work look like once you started to make contact with it?

TL    It was sort of odd. It was this mixture of new New York vocabulary that I had learned and minimal kinds of things with Scottish imagery. This blend of nostalgia and spatial weirdness. And so I had cartoonish pipers and dancers on minimal fields, juxtaposed with minimal fields and squares. They were part melancholic and part funny.

KH    Simultaneous to this, how would you say that you were beginning to analyze your reactions, critical reactions, your sense of wanting to make a contribution as a writer or at least make a statement as a writer?

TL   I got into writing because, once I began to understand what was going on, I understood that in fact it had been going on too long. And that the late minimal hegemony really had become intolerable. Every show was just the same, and the magazines were sort of stuck. They weren't talking about anything new exactly. Not that it was clear that there was anything new to talk about. There were artists who were trying to get back the image in some way. But it was very much this underground thing. And bar talk. And whenever we would visit one another in studios it was all such image-bearing work. But it was difficult to get really excited about it. It did seem more interesting than more of the site specific installations and whatnot. It kept getting pushed out a little.

KH   Who are we talking about now in terms of the beginning development?

TL   Well, people I was friendly with at the time. Sherrie Levine, Robert Longo, David Salle—people who lived in the neighborhood or hung around. We would also talk about our work and talk about the possibility of getting anyone to pay attention to it. Helene Winer, who was working at Artist's Space, was supportive in what limited ways were possible, given the job that she had there. But it was kind of difficult to get anyone else to take it out to the public.

So I started writing out of frustration—you know, if there is one more of these goddamn shows, I'm gonna either tell them what I think of it, or write about what they should be looking at. I remember some of my first reviews were for early Nick Africano and Lois Lane—people like that who seemed to be getting out in this image way—who now are maybe not doing exactly what I'm interested in, but at that time were close enough to be real allies in some way. And then I discovered I had this ability to write fairly clearly. And so I went from there.

KH   What were the first reviews that you wrote, and who were they for?

TL   I think the Nick Africano one was the first that I wrote, and it was for *Art In America*. What happened was that I had been taking a course at the Graduate Center with Rosalind Krauss, and I met Doug Crimp. I wrote a paper for that course on Stella's bird paintings—the new paintings. I just wrote this thing because we all had to write something—and Doug suggested that I send it to Betsy Baker. So I sent it to Betsy. And she called back and said that she liked it but wouldn't be interested in publishing it; but if I would consider writing short reviews, she would like that. So I started writing them. And she was great as an editor. The first two or three times, she had me come up to the office, sat me down, and explained line by line what had to be done. What kinds of things were hopeless, what kinds of

things were good, just what you have to do to make something readable. And this compacted lesson in writing was really quite useful. I would get to do what I wanted to do. But after writing for her for a while, I got dissatisfied with it being a call-in thing that was filled with uncertainty. Plus, she wasn't that interested in allowing me to write about the stuff I knew best. The two shows which I remember rebelling about, and therefore deciding not to do any more writing for her, were Cindy Sherman's show at Artist's Space and a David Salle show at The Kitchen or someplace like that. She claimed that I was too familiar with them, which seems like nonsense. Obviously she just wasn't comfortable with the work and didn't want to help promote it. Anyway, I thought it was time the stuff was talked about. And around that time I was introduced to Helena Kontova and Giancarlo Politi. They run *Flash Art*. So I wrote for them instead. I did quite a few things for them. That was around the time when I started really. I didn't write for *Artforum* until much more recently—that has only been about three years.

KH  How would you say that the development of your writing was parallel or in opposition to the development of your painting?

TL  I think it was parallel. The day is long and I think a lot. And, to clarify my thinking, I write. It helps clarify my position to myself. Writing articles gave me a financial reward for doing that. And with that clarified head, I would go to the studio and paint. And, while painting, the thought would begin to change and develop in some other way that would perhaps lead to some further thought in the writing. So it was a back and forth. But no opposition, no conflict in that. They are two different ways of thinking. And so they can work around the same sort of area without messing up one another.

KH  How would you describe what that area is? What those ideas are?

TL  Very simply they are ideas about representation. How one represents oneself. And how it is represented. And so it is about image. And the way things look and the appearance of things. I think the writing either develops for my own purposes or tries to measure other people's art against that standard, to see if I think they are doing that or not. So sometimes everything seems a bit tough, because I try to be as tough as I can on myself. Why should I calm down for others when it seems important to judge everything on a sort of even standard. When I look at a show that seems to be trying to get away with something, I want to talk about that.

KH  Some place, in reading about you, I noticed you made a statement about the fact that the artist's job is to mediate a relationship between the

self and the world. How would you describe that in terms of your own work and ideology?

TL    There is a major fact about the world that it is corrupted and tainted by the photographic images that are broadcast by the media, the TV, magazines and newspapers. There is a kind of screen between our real experience and the way that we see it. And I think that, when I work in the studio, I try to do work around and through that. My method tries to drag the image back out from the screen that is hiding it, and then hide it again in the depths of some other screen, an art screen—a screen that is very visible. Translating this transparent, invisible mesh into one that is very physical and very much there. The mechanism of the obscuring effect is almost tactile; particularly in the most recent work, it is this thick, goopy mesh.

KH    I think you have also said that your process and procedure in being an artist is to select images, edit them and send them back out in a different form. What kind of political or social commentary are you making through this process, and how does it show up within the parameters of the painting itself?

TL    That's a big one, isn't it? I think that there is no political content in the way that political art supposedly works. I mean, it is not in the image. It is not a picture of politics. It is more about a model. I am trying to make sense of this stuff myself, and make it in such a way that what I am doing can perhaps be seen. Having the effect of, "He is looking at this kind of stuff in that kind of way." And I have tried various methods of getting the viewer to have an initial reaction of thinking. I have tried humor, shock tactics, displacement and sort of hands-off. Currently I am trying a more seductive, beautiful approach. They always seem to work in different ways. The person who is attracted by the humor is appalled by the horror. The person who is attracted by the horror thinks that the beautiful thing is somehow lightweight. You never seem to get everyone. But each time you get someone different. A different group. I think that it is important to do that—to change direction in a sense. Not the direction of the work but the direction of the impact and the direction it is facing. I'll do one set of work that looks this way and another set that looks that way. And perhaps over time that pattern will become clear enough to be recognized. And maybe more people can get at it. I don't mean to make anything that is very easy to understand or to like. It has to be difficult. Because it is difficult to make it, it should be difficult to deal with it. And it is in facing that difficulty that the politics somehow reside. That is where the political content is. Somehow taking responsibility I suppose. And respecting individual activity.

KH    At the beginning of your article, "Last Exit: Painting," you started to describe two positions in the art world, one being the aesthete, the other being the moralist. Where would you locate yourself between those two polarities?

TL    I don't think I fit into either. Sometimes being an aesthete seems sort of interesting. But I can't always pull that off. There is a tendency, particularly when you are talking about political issues or social issues, to sound moralistic. But in fact, I don't mean it to be that way. A criticism that has been voiced quite often in the press about my work is that I take a moral position against the media, that I hate the media. And that, in fact, is not the case. There is a much more complicated relation to the media. I love it. I really enjoy watching dopey shows on television. I kind of look forward to seeing "Magnum P.I." I look forward to it in lots of different ways. I enjoy the goofy acting, the goofy stories and also the look of it—that kind of television color, the way they use the cameras. There is a lot of pleasure to be found in that. At the same time, one does get appalled by it. That seems to be a pleasure too. You can sit back and be appalled. So I would reject the idea that I am a moralist about it. But then again I sort of am. I would much prefer the world to be a better place.

KH    I think you have made some very important points for all of us to look at in terms of the collapse of meaning—irrelevance in terms of the way that things are presented or filtered through the media. Would you talk a little bit about that?

KH    Well, to continue the "Magnum" story, here we are at the minor tail-end of the private eye drone with the Philip Marlowe voiceover and all that. But it is reduced to a real "character." One of those real stereotyped characters. He is an ex-GI, there is an English butler, and it is in Hawaii. So there is all this information being presented that is supposed to mean something. That he is tough, that he is a loner, that he is sexy, and the butler implies all this other stuff about culture and old-world values. That they have something in common. But it has all collapsed into nothing. And then opened up again by this joke thing—that it is in Hawaii, in the middle of the Pacific. So it is like the whole world is the same nowhere. It could be a back lot in Los Angeles, which is where you would expect it to be, with the location shots put in to sell a few extra ads. There is this complete inability to really differentiate where the hell anything is. On any Thursday night you can watch the news, then watch "Magnum," then "Simon & Simon," which is another private eye story in San Diego, and then switch channels to "Hill Street Blues" which is set here in Chicago or some city like this. They all have their different styles and they are supposed to be different—but it is all

Thomas Lawson, *Metropolis: The Museum*, 1983
Oil on canvas, 60" × 84".
*(Photograph by D. James Dee; courtesy Metro Pictures)*

the same. They run through the same group of stereotypes and clichés, and basically "Hill Street Blues" is "Magnum" on a rainy day. And the whole evening is bracketed by the news—you've got Dan Rather and Ted Koppel or someone else telling you that is the way it is. And that *is* the way it is.

KH   What have you got to say about the way that human beings are portrayed in the media—I mean this giant gap between reality and what we think we look like on visual media?

TL   There is a giant gap. But what seems to happen also is that we try to model ourselves on that. Not perhaps so much in the way that people look, although obviously the fashion industry exists to make that attempt. People buy makeup or whatever to try to look like that, but it also involves the way that we relate to one another. Love affairs and all kinds of friendship can become imitations of these things that are supposed to be imitations of our lives. It seems to be a role reversal. People identify with different characters, and think wouldn't it be great if my life were like that and I had this kind of relationship? So everything becomes more and more faked in a way. More difficult to separate what is really yours and what is yours just by being a part of the way we are learning to be. I think it is because of TV's presence. Obviously this has always gone on. The movies have always given fashion clues—the Bogart look and all that. But now television is in practically every home in the country and on all the time, and the same shows run all the time on prime time or in reruns later at night or during the day. Even the real, if small, difference of fashion that occurs over a couple of years gets collapsed because of the rerun thing.

KH   What ultimate effect to you think this has on the way we see ourselves?

TL   It is not just the media in terms of . . . the nonspace of television. There is a real spatial element of that too, which is an architectural phenomenon. I travel around quite a bit going to colleges and give presentations. So I have seen a lot of America. And what is so amazing is that you turn off the highway from the airport and you are on this strip—and suddenly you could be anywhere. You think that you are going to some quiet corner of Virginia or down to the south in Louisiana, but instead you are driving down mainstreet U.S.A. The Burger King, Big Mac, Jack-in-the-Box . . . plus the gas stations. And it is just the identical strip, and it is in every goddamn little city. So there is a sort of bizarre lack of difference in places. It even goes as far as the food we eat. There are no regional differences. That everyone eats in those places is an increasing denial of regional differences. Instead of eating their local food, people eat the standardized product. If we all eat the same, dress the same, think the same, it potentially is really scary. It makes a mockery of the whole idea of American individualism.

The way that relates to my art practice is that it makes me want to be more and more traditional. I find this odd contradiction in making advanced art and needing more and more tradition. I started making paintings thinking that there was a conceptual game going on with the paintings. Painting was dead, but performance and conceptual art seemed pretty much on their last legs too. And so perhaps one might make a fake painting—a painting that wasn't quite a painting, something that was fast and very obviously fast. And had some elements of performance in it. Europeans and Americans were interested in the same kind of thing. Increasingly, that no longer seems to work. It was too easily adapted, easily mimicked by other people—basically it was a tactic that was too easy. What seems to be important is to go back to this idea of difficulty, to insist on individual particularity. In art that seems to mean making people take the time to really stop and look and think. Complex, fairly traditionally worked paintings still have that ability. Not to say that is the only thing. I've seen some extraordinarily complex film and video that has the same importance, but it is this traditional value of making art that demands a great deal of attention. That seems to be counter to what we thought in the 1960s and the 1970s, where a lot of art was fairly easy; meant to be easy. But the only way to make any dent on the leveling effect is to say, "No, I am not going to take this."

KH    Well, how do you relate this to the Postmodernist trend of appropriation where a lot of artists have engaged themselves in a critique of the media and the use of media images? What kind of effect do you think that this can really have in the overall structure of cultural similarity?

TL    The appropriation idea was once appropriate, but it was a way station. It was only part of the idea. It relates to fast painting. It is a fast idea. One that has unfortunate repercussions—too many people can pick it up and do it. We have seen that already. A more complicated amount of work is required at this point. In 1978 or 1979 Sherrie Levine cut things out of magazines. And it worked, but she no longer does that. She knows that. A lot of other people don't, and you still find people cutting things out of magazines.

KH    When you are talking about returning to traditional ideas of art, what does that exactly mean? Which part of the tradition?

TL    Well, the traditional idea of the privileged art object. Of this thing that has to be valued as something that you come to and look at—give special attention to, think about and respond to. Something that stays there for a while and demands that you stay there for a while also.

KH    In fact couldn't you just be talking about a new thing that can be absorbed into ideas of fashion?

TL    I think not. I think that kind of more traditional silence has an unfashionable scent to it. But it is obviously something that aligns itself very easily to being just another commodity. We have had that critique already. We know that. But then we do live in a society where that's how commerce works. That is how we exchange things. And so to pretend otherwise is a little bit naive anyway. Part of the quarrel I have with some other left-wing strategy in art is that it pretends it were already in a potentially socialist condition, and we are certainly not. And so they marginalize themselves before they even begin. So there is a critique of the left as much as a critique of the establishment that becomes important.

KH    How do you use the word traditional in regard to describing your own work? How does that show itself? Technique or image or combinations? Use of color?

TL    Some sort of combination of these things. The works that I am engaged in right now are much more worked than anything I have ever done before. They are much more painterly. The imagery also is much less confrontational. It is architecture and landscape. They are clichéd, dead landscapes and buildings. They are not picturesque. They have a real banal quality. They are not that traditional, and the color is weird. It is video color gone off. Kind of postnuclear. A lot of off-reds and blues and metallic stuff mixed into that so there is a sheen to it. And the paintings are built up as images which are then increasingly obscured with layers of paint. And each layer, from the image through the final surface, is very slowly and carefully worked so there are all these marks of passage of time and crossing the canvas. And they are big canvases—6' by 8'. So it is quite a large surface to have so much attention paid to it.

KH    What is your source of images?

TL    It varies. There was this period when it was quite simple. I decided it was the front page of the *New York Post,* and all I had to do was go out every day and see if it was worth buying. That was quite straightforward. More recently it's the landscape, cityscape thing. And it is a combination of photos I have taken and postcards that I have collected. The photographs resulted from my travels. I was carrying a camera wherever I went. So there are pictures of German cities, pictures of American cities, visiting in Milwaukee and Los Angeles, all these different places looking for real banal modern architecture. Plus hunting in drugstores for postcards. Postcards that would commemorate buildings that are of no interest. Local monu-

ments—not the Art Institute—some other place in a suburb somewhere. So I would gather all this information and start looking at it, and sifting it and eventually, you favor some over others.

KH    What kind of effect do you hope your painting has on the spectator?

TL    That varies. These new ones I hope, will somehow be overwhelming. They are very luscious. And at the same time they are kind of mysterious but resistant. They don't tell me very much. So I hope that they are appealing and attractive, then repellent. Previous years it was more repellent. The idea was that it would push you back. And this one will suck you in first and then push you back out.

KH    How do you feel about the fact that, increasingly through the past 30 or 40 years or even longer, art has spun into this very small, tight, compact elitist circle that is not really giving too much out to the larger population? What is your particular feeling about that in terms of the role of art within the society?

TL    I think that its role is elite in the way that it's like any academic work—that it is available to anybody who has the equipment to deal with it. But it is a difficult thing and it needs to be. You can't just expect to come in and like it. That idea of art is appealing on one level, but on another it is, in and of itself, an idea of art as entertainment. That is what a lot of folk art is. It is a way of passing time and it is not a bad thing. But as the role of the artist has developed in this society, we're involved in this much more rarified activity that is extremely elite. But it is not an elitism that is necessarily economic. It tends to favor the economically favored because they have the greater opportunity to spend time reading and looking. But theoretically it is open to anyone as long as they have the time and the equipment to deal with it. And I think that it is important that it is that. Otherwise it becomes easy art and either serves some kind of propaganda for left or right, or becomes some kind of entertainment. In performance areas there is more chance of a popular kind of art.

KH    What was the point for you in terms of founding *REAL LIFE* magazine, and how would you describe the outlook of the magazine?

TL    As I said earlier, there was all this work beginning to be made by people I knew of that wasn't getting very much attention. And it seemed quite clear to me that it would never get attention if it wasn't made public—and it wouldn't grow. You need a certain amount of critical discourse to know what you are about and develop it. And the major magazines were quite clearly not going to do that. They just weren't interested for whatever entrenched reasons. They didn't want to be in the avant-garde at that time.

They had had periods when they had wanted to be, but in the late 1970s they didn't. The little local magazines that had existed, like *Art Rite,* seemed to be dying, or dead! There was a real vacuum. So perhaps someone can start a magazine. And I realized that I could do it. So it began with this idea of being a forum for talking about certain kinds of art and media influences and trying to get artists to talk not only about art but about the media, about TV, music and other things that influence them.

We are now putting the finishing touches on a big double issue about politics and art. There is quite a range of things in it. There is stuff that discusses the potential—you know, is it possible to make political art? What is political art? Are people who make pictures of raised fists kidding themselves or what? There are interviews (with the people who make up Group Material, with Komar and Melamid, Lawrence Weiner, and others), and also some real political things, such as Susan Morgan (associate editor) discovered this horrifying piece in a *Life* magazine that was published in October 1939, in the period of the "phony war," when Poland had been invaded and Britain and France had declared war, but fighting hadn't quite started on the Western front. And there is a human interest story about Hitler's painting. The text is just so sickening. It is sort of patronizing and bland and really awful. It calls him a shrewd politician who at heart is an artist.

They reproduce paintings and interior shots of his house in Berchtesgaden. And they critique the paintings. And I mean they are just terrible watercolors. So they point out all his formal weaknesses—he can't do figures, he doesn't paint figures very often because he can't do it. There is a picture of a battleship in a big cloud of smoke and they say something about that, that he must have made an error and just corrected it by making the smoke thicker. And they they talk about the good taste of his interior decor. That the furnishings are furnishings a man would like—solid but comfortable. And there are paintings of nudes on the wall. And so, the ending of the article says it might be a loss for world politics if he retires; but, if he does, he would probably be better to retire into interior decorating than into art. It is just astonishing. So we are going to reprint this thing verbatim with a little paragraph explaining when it was published.

Also included is a piece by Coosje van Bruggen on the repression of the University of El Salvador.

KH    Do you think that art really has the ability to affect social change in any kind of positive way?

TL    I think so, but not in any direct, quick way. Again it is this whole idea of art's elite position. We are involved in the conscience of society. That is where we operate. Where we think we are going, what we think we are, who we think we are. So the importance that art has is in that region. And

if artists want to make political change they have to work on making a change in the way that the power elite present ourselves. So it has a long-term possibility. And I think it's genuine. I think that America does, in particular, have an image of itself as being a morally good place. And the actuality doesn't quite match up to that. Part of that moral condition is a source of embarrassment—and a brake on some people who would prefer to straightforwardly exercise the power that they want. There are people in this administration who would clearly like to go into Nicaragua and clean up. And into El Salvador and just fix things to their satisfaction. But this image of America as a nice place prevents them, or slows them. Our strength lies in reinforcing that moral content. If you are genuinely outraged by political conditions, art is not the field to exercise that outrage. You have to do something more directly if you want to see real, concrete change.

KH    How do you see your own role, in terms of being a painter, a critic and a writer as contributing dialectically to this sense of consciousness that has always traditionally been a part of what we thought artists were?

TL    I hope there is a disruptive, interruptive presence so that the work, in whatever form it appears, makes you stop and think. And not be as complacent.

Ross Bleckner
*(Photograph © Timothy Greenfield-Sanders 1987)*

# Geometry Desurfacing: Ross Bleckner

*Jeanne Siegel*

*Bleckner had an "Op" show in 1981, but what little critical attention it received was negative. He only began to be noticed to a significant degree when the focus on appropriated images opened up to abstraction, particularly geometric painting. Peter Halley wrote a piece on Bleckner's work in 1982, lauding his ability to make art in which the inconsequential and the transcendent coexist. In choosing Op art, Bleckner used a discredited mid-60s movement which served as a symbol of the failure of idealism. Although his stance was read as being ironic, he doesn't see it that way. While he is interested in degraded idealism, he is at the same time a romantic. And the interview reveals an exploration of a subtle formal concern—that of perceptual light, which is to continue to unfold in later work with a different subject.*

---

Ross Bleckner   With the "Op" paintings of 1981–82, I wanted to deal with the fact that a lot of painting, a lot of surface in painting, a lot of the tension in an image is a result of what's repressed within the painting. So that was a kind of psychodynamic as to what was under the surface. I think that essentially the glut of imagery in my own work and other work made me feel very oppressed, and I was trying to look for a way to metamorphize the relationships to light and to landscape, which are things that I have always worked with. I wanted somehow to deal with my inability to choose an

---

This interview, conducted in the artist's studio in New York in November 1985, was originally published as part of an article, "Geometry Desurfacing: Ross Bleckner, Alan Belcher, Ellen Carey, Peter Halley, Sherrie Levine, Philip Taaffe, James Welling," in *Arts Magazine* (March 1986).

image. So they addressed a certain confusion I was having at the time, and I wanted to make my confusion confusing.

JEANNE SIEGEL    Can you be more specific about why you chose "Op," which used a lot of geometry?

RB    I think it had somewhat of an influence visually on me because when they had that show, "The Responsive Eye," it was the first show I saw. I was 16! But number one, I chose Op art because that was a movement that had interested me. It attempted to construct a conceptual relationship to abstract painting. It was trying to fix art outside of itself onto ideas about a belief in idealism and the scientific notion of progress. As an artistic idea, it didn't go anywhere; built into it was its own obsolescence. It was a dead movement from its very inception. I like that idea because everything seems to have its own destruction built into it.

What I wanted to do was not deal with the mechanistic or the optical. You see, that's the difference. I was not at all interested in the optical; I was interested in the metaphorical relationship of a place in a painting or the perceptual inability of a spectator to choose a point of focus in a painting. I was interested in collapsing the idea of an image. So as soon as something begins to congeal, because of the retinal pulsation, if you will, it also almost expands and collapses at the same time. I felt this because of my own relationship to science, progress and methodology. I don't have that belief in the universality of image, whether it be in the world (media) or "in the person" (expressionism).

JS    What did the vertical stripes in these "Op" paintings mean?

RB    I saw these in almost a narrative way as a jail, as bars. There were these lights inside the painting and as a viewer I would be this person who was perpetually locked out of the painting. I think a lot of the theme of death was also implied in the sense that you have ideas, you put them in a painting, and they are locked in there forever. They die in there. Then you move on. My work is very much about a kind of degraded sublime, like Barnett Newmans gone wild.

JS    There appears to be a big leap from the "Op" paintings to the ones you are doing now.

RB    I don't really know how I see the difference or if I see it at all. The thing I am most interested in is not so much a single painting, or painting "in a style," but how a body of work connects to ideas that an artist wants to "uncover." I have seen my paintings as meditation on light. The kinds of light that exist in painting I see as having a nonfigurative, geometric relationship to the body so that they almost take place stylistically as geometry but

physiologically as places in the body. When I am saying geometry, I am also holding in mind a sense of its dissolution, an anti-matter. I saw the "Op" paintings as being about an idea of light that is theoretical in the sense that they take place from the eye to the back of the ears—they have that kind of throbbing. They have that kind of retinality.

The paintings that followed in 1983, on the other hand, have to do with reflected light. I saw them much like coming from the middle. Emanating from the center, these bulbs became like places in a landscape (I thought of Rothko).

JS    Often the composition is symmetrical and is locked into a grid. What purpose does that serve?

RB    There's always a kind of underlying geometry like these lines that I inscribe in a painting. It's a structuring device. I think that's like the sense of when you are painting and always looking for an image, there is a libidinal restlessness with singularity having to do with an inability to find a perfect image. It's just something that has a meaningfulness at that particular moment, as well as something that's ridiculous and impossible (at this point in time). The fleur-de-lis in *Bedflower* was an image of childhood. It's taken from a blanket that I had when I was a kid. So I was in a sense elevating, illuminating that as a light over things.

JS    Your work is self-referential, not only biographically but metaphorically.

RB    Yes, it's self-referential in the sense that I visualize works over a period of a few years and try to map that site as a geometry. Every time you draw a circle, you could describe things two ways. You could talk about everything that's not in the circle or you could describe everything that's in the circle. I always have the feeling that every time I feel closure in my work, what I want to do is open up the circle again and bring some new ideas in—the circle being the body of work and the new ideas being the possibility for change within the thematic continuity because thematically I see my work as being very continuous.

I was much more interested in making something romantic out of a very, very mechanistic geometry. Geometry represents to me an idealized, classical place that's very clear, where there are proportions. In a way I always try to infuse my paintings with that. I'm not interested in geometric paintings. But whether it's an interior or an exterior or an abstract painting, I always like to have that sense of degraded idealism and there is enough in my painting that undermines the geometry.

JS    The geometry, then, seems tied to your ideas of perception.

Ross Bleckner, *Untitled*, 1982
Oil on canvas, 90″ × 72″.
*(Photograph by Zindman/Fremont; courtesy Mary Boone Gallery)*

RB    Absolutely. Another idea for these paintings was an actual perceptual idea. It had to do with light and with schizophrenia and with seeing. In a way I felt like I was going to investigate paint and imagery and that kind of vacillation, that thin line between what's expressed and what's repressed, each having an equal weight in a painting. You also have to investigate the phenomenology of looking. You have to create a ground—this becomes ground zero. You have to create this hypnotic, hallucinatory, blank space where the possibility or the impossibility of actually perceiving anything becomes an issue. I was reading in the paper about these poplar trees in France; the drivers were driving down the highway and the light flickering through the trees was causing a momentary schizophrenia where there was a perceptual rupture. They were having tremendous accidents on these highways. Eventually they had to cut down all the poplar trees.

It seems logical because if you have ever been in a nightclub you know the effect of a strobe light. It's so disorienting the way your body moves, the way you become totally alienated from yourself, based on that kind of flickering visuality. That was really fascinating because what it produced was the idea of dislocating yourself momentarily, so that you can't see really anything, which on a metaphoric level calls into question the idea of values—the kind of wavering quality of things around us and the fragility of perception. I was attracted to the fact that it was trees because I was interested in ideas about landscape, although I would hate to be a landscape painter, strictly speaking.

So from that point of view the light became very interesting because it wasn't only the light of landscape, it was also this perceptual light. This light has the ability to rupture what we see as opposed to also illuminating it as, let's say, in a classical still life where you get some light and you put it on an object and you have modeling. So I like the more subverting quality of psychedelic light. It's dissolved in this illusion of an object and I like the idea of that.

As much as you think of geometry as concrete, it isn't. The interface of perception and geometry allows for a certain dissolution of that concreteness. If perception is fragile, if it's contingent not only on consciousness but environment, you have a lot of other ways of manifesting geometry. Suddenly geometry becomes a very unstable force. In a sense, there's always that kind of relationship between concretion and dissipation. So a geometry always enters, but it always enters in a sense to be deconstructed (I hate that word).

Peter Halley
*(Photograph © Timothy Greenfield-Sanders 1985)*

# The Artist/Critic of the 80s: Peter Halley

*Jeanne Siegel*

*The role of the artist as critic raises questions. Is there something special that he/she is able to contribute? Does the artist/critic affect a specific methodology? What is the relationship between the writing and the art? How does the criticism relate to the broader context of 80s critical thought?*

*Halley prefers to think of himself as a theorist. He published his first article in 1981, "Beat, Minimalism, New Wave, and Robert Smithson," containing the seeds of his theoretical position. He believed these groups shared a preoccupation with postindustrial culture and a fascination with media images (rather than a nostalgic conception of nature) which informed them of reality. For Halley, Smithson was a genius, and he adopted Smithson's position that the artist must acquire a coherent methodology.*

*Halley calls himself a geometric artist. In this interview he expounds on what he means by his application of geometry, how he defines abstraction and realism—a strongly considered issue today. He explains the relevance of Baudrillard's theory of the simulacrum to the geometric art of the 80s, discussing his own art within this context.*

---

JEANNE SIEGEL   Will you explain how your ideas on Minimalism relate to your own evolution?

PETER HALLEY   I was very interested in Minimalism and very interested in Pop art. But I felt that Minimalism especially was really to do with issues about social and industrial development and the modern landscape rather than

This interview, conducted at the artist's studio in New York, was part of an article originally published in *Arts Magazine* (September 1985).

being hermetic the way Minimal artists thought it was. So I wanted to transform some of those issues into a vocabulary where that connection becomes more explicit. I tried to take that simple geometry and transform it into figures such as jails and cells with smokestacks, and put in a schematic landscape-type setting that would point to the connection between those configurations and actual configurations in the world. The jails came about as a way of describing the Minimalist square as a confining structure. I thought if I put bars on the square, it would very quickly go from being a classical or pure element to a sort of negative one, or one that would be a quick way of making it into a critical element. The other part of the iconography is the idea of the conduit. I'm using shapes that refer to buildings or structures that you can't enter or leave, but information or something can get into or out of them by means of a conduit that goes into and out of the cell from underground. I think that's a description of a psychological condition, and it's very relevant to industrial and postindustrial social structure in which you have apartments and subdivisions and telephone lines that come in, and water and radio and TV.

JS    Do you see the work becoming more complex?

PH    I see myself as having set out elements of an imaginary or theoretical world and that slowly I'm building in more and more elements. It's sort of a through-the-looking-glass thing, as if one were inside this imaginary world and gradually walking around and discovering or finding out more and more elements. I'm reminded of that movie *Tron* that came out a few years ago; it described somebody playing a video game who was actually thrown into the video game environment. This person was walking around in an entirely synthetic geometric world, and that's what I'm trying to describe in my painting more and more.

There's one other thing about the geometry that I really would like to emphasize. I don't think of my work as abstract at all; instead of using the word abstract I always use the word diagrammatic. The issue to me is that at a certain point when all these artificial systems of communication and transportation were being laid out, *that* was the age of abstract art. So in a Mondrian or even in a Frank Stella, what you have is an ideal of depiction of what circulation and the flow of information or transportation would be like if this goal of circulation were completed. But I think in the contemporary world this has been completed and the geometric has become the real in terms of what's out there in the world. Geometry is backtracking and enclosing the old idea of the natural in the diagrammatic. I think the video game is very important in this regard, as are computer graphics. In a video game you might have a little geometric man walking across the screen and

you have a situation in which these ideal geometric elements are being deployed to represent an old kind of organic natural reality.

JS   Another compositional feature which appears often is the division of the canvas into two component parts. Usually the gridlike structure appears in the bottom. This is eccentric in terms of our usual association with grids as an all-over pattern. What does it mean?

PH   For me the canvas underneath is always underground; it is the underground element. When I generate the imagery I'm really thinking in terms of a sectional view. In other words we're seeing something from the side and we're seeing it straight on so that it's a very frontal situation and the shapes are built up on the canvas. That implies three-dimensionality but it also implies a sort of facade. Then there's a break and below that the section continues and we're getting into a world underground, a hidden world, and that usually involves the conduits and things flowing from one of the cells to the next.

JS   What do you see as the relationship between theory and art that is obviously important to you and your art work? Have you used Foucault or Baudrillard as theoretical guidelines?

PH   I'm interested in getting ideas or information from different kinds of sources. In fact, reading Baudrillard is very similar to looking at Andy Warhol's paintings—I get almost the same thing out of them. It's very natural for me to equate one medium with the other.

JS   The relationship between your theory, paintings, and writings seems close.

PH   I see my work over the last few years as being about working through a change in the way geometry functions socially, from an industrial type of geometry to a postindustrial type. I started with a situation of coercive geometry symbolized by the jail. Then I moved to a more seductive geometry, symbolized in the dayglo colors, the systems of conduits, and the sort of video games space that I think my painting has now. That corresponds to a movement from Foucault, who mostly talks about the coercive geometry of industrialism, to Baudrillard, who is more interested in seductive geometry.

JS   This sounds like the theory came first.

PH   No, just the opposite. Before I'd read Foucault, I was doing these jail paintings, which were inspired by a totally subconscious situation. I lived in a building on 7th Street. On the ground floor on the street there used to be a bar or a pub that had a stucco facade and windows with bars over

them. I began to do the jail paintings, paintings of prison-type facades. I was out in front of my building waiting for a friend one day and realized that I had, in fact, been using this image which I had never consciously noticed before—it was completely subconscious in origin. But I think of myself as not a very good conceptualizer. So when I read Foucault's *Discipline and Punish,* some of the things I was trying to get at in the paintings were very clearly conceptualized there and it helped me make conscious my own feelings about the subject. For me, things surface from subconscious sources and then I try to find out what they're about, essentially. In terms of Baudrillard the same thing happened. The colors had become dayglo, which I think of as simulated colors, and the stucco material (rather the Roll-a-Tex material which is simulated stucco) had become a consistent feature in my work. Finally I read Baudrillard a year or two later and it gave me a framework in which to understand how I had used these elements.

JS    How did you get into writing in the first place?

PH    When I came back to New York in 1981 my first article was about a Colab show that I saw. I was interested in how this work related to previous work—to other nearly contemporary art like Minimalism and Pop. I was also interested in relating works of art to issues about society at large, and the Colab work offered a very direct way of doing that since it had a good deal of directly social iconography.

JS    Wouldn't you say that generally what you choose to write about has that as a primary quality?

PH    Until about last year I was principally writing essays that were motivated by wanting to reinterpret the history of postwar and twentieth-century art with an eye to integrating it with changes that were taking place in culture. But in the last year I've almost stopped writing about art; I'm more interested in writing about patterns in culture and patterns in society directly. I'm writing about how cities are put together and how postindustrial society is organized.

JS    Have you written for publications outside of art ones?

PH    I've always seen myself as addressing the art world; I'd be very uncomfortable writing for another audience because there's an assumption that my audience shares a certain body of knowledge that I have with me.

JS    Has your involvement in writing influenced your work?

PH    In the piece about Ross Bleckner I talked extensively about the concept of modernity, which was something I was wrestling with in my own work. In the Postmodernist piece, "Reconsidering Ortega," I was wrestling

with the ideas of the role of irony in a work of art, which applied to my own work.

In my more recent work, especially "On Line" and "The Deployment of the Geometric," I've tried to record my ideas about how postindustrial society functions. These kinds of thoughts directly affect the type of images I make. So in a sense I'm trying to give the background behind the art-making more and more.

JS    As an artist, aren't you especially sympathetic to other artists' critical writings?

PH    Definitely. My favorite is Smithson. I'm sort of a Smithson fanatic. I really adore his ability to work in a fictional mode. His ability to write about lived experience in terms of his ideas about culture and his ideas about art is really amazing to me. And I like Barnett Newman.

JS    What about critical writing today?

PH    I'm very involved with Collins's and Milazzo's writing. I find that it's the closest equivalent in writing to the type of art I'm interested in.

JS    You described it as coded. I think there's more coding in this writing than in your work.

PH    It *is* highly coded. It is also highly theoretical and more involved with concept than mine. I admire that about it. The fact that it's radical in form also interests me. For a lot of people it's hard to read, but for me the fact that it has such an unusual syntax and rhythm makes it a positive thing.

JS    I belong to a school of thought that believes, unlike fiction or other writings outside of criticism where I would accept and might even be in-trigued by such obfuscations, criticism should be clear. The reader should not have to labor over criticism to appreciate the ideas being expressed.

PH    That's a good point. But while at first it is hard to read, once you understand the rhythm and the ideas behind it, it becomes a lot of fun. And it seems so interesting—the idea of inventing a different style.

JS    Do you think Clement Greenberg was a good critic?

PH    I'm very interested in Greenberg; I guess the reason is that his work is so stylistically good—that he has such an interesting voice in terms of style—and also because of the way he was able to integrate Marxian ideas into the general vocabulary of post-World War II American art, enabling them to stick around for 30 years, from 1945 to 1975. It can almost all be attributed directly to Greenberg, who I guess got it from Meyer Schapiro.

My own thoughts on Schapiro are influenced by Serge Guilbaut's book

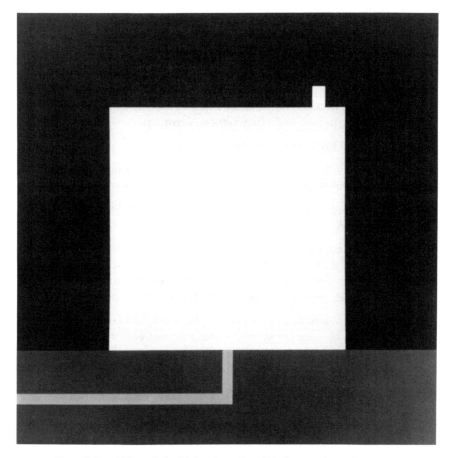

Peter Halley, *Yellow Cell with Smokestack and Underground Conduit,* 1985
Acrylic, Day-glo acrylic, Roll-a-tex on canvas, 63″ × 63″.
*(Collection Chris Weir; Courtesy International With Monument Gallery)*

on Abstract Expressionism, which explained very well the widened role Schapiro created for abstraction—the fact that he was able to create a relationship between abstract art and social issues, cultural issues.

I guess the essential idea in Greenberg for me, although I'm sort of against this idea, is his materialism. I'm interested in what a strong force he makes of the idea of materialism and how much mileage postwar American art got out of that. The most amazing thing about Greenberg is his ability to integrate the idea of quality, which is extremely capitalist, with his Marxian ideas. That synthesis is extraordinarily outrageous and for that reason interests me.

JS   Do you think Greenberg was totally aware of it?

PH   No, I have a theory about that: on a conscious level the work was Marxian and on a subconscious level it was *haute bourgeoise* in its ideology. He never was willing to acknowledge the idea that the subtext was *haute bourgeoise,* and for that reason that idea of quality in his work has to remain unspoken—the whole idea of quality had to be beyond the verbal realm. I disagree with Greenberg in just about everything in terms of his ideas about what's important in a work of art. Almost none of it makes sense to me anymore. But nevertheless I find it a cogent theory.

JS   Although you're ideologically opposed to Greenberg, you share with him an oracular urge in that you too make pronouncements on what you think art should be.

PH   I find after I write an essay that I've tended to be very provocative and condemn everything that doesn't conform to my way of thinking. On an informal level I don't feel that way. I like a wide range of things. But I do think that the function of an essay is to be provocative and so I tend to exaggerate my ideas. Actually Ortega said that to think is to exaggerate; I really like the idea of creating an exaggerated statement of what I advocate and condemn—it creates a little bit of energy or interest.

JS   What do you see as behind the pervasive need to use an authority figure to substantiate theory today? You share this critical approach.

PH   In one short piece, "Notes on Nostalgia," I spoke about Baudrillard's idea that nature has been completely wiped off the slate, and what we're left with is just decontextualized history. When you're in that sort of situation all you can do is refer to other people's thoughts. You can't really make reference to any sort of absolute and so the intertextual situation becomes very intense. I think that is the current situation and can't be avoided. There's another situation we're in right now which is that the idea of an original utterance is also much under attack, and I think for the same

reason: an industrial age of original and unimpeded action is at an end, and we're in a much more circular situation, where interrelationships between ideas become very important.

I also consider my paintings extremely intertextual, and in order to understand the paintings one has to be aware of the intertextual relationships. In other words, if I have a centered image with two bands on either side in a painting, if you know that's a device used in Newman, you can go more quickly to my meaning. If you didn't know that was a device used in Newman, the meaning of my painting would be less strong.

JS    Then you want your audience to bring information to both your painting and your writing.

PH    I do, although for both the art and the writing I do see two audiences. I think on one level it's addressed to somebody who shares most of the information that I have. On another level, it's not a problem for me that my work might be hermetic.

JS    Do you think that there were always these levels of misunderstanding?

PH    Yes; I'm not one of those who believes in a golden age of populist painting, and I think this is supported by recent art historical research. I remember reading one book by Michael Baxandall concerning iconographic issues in Florentine painting, which made it clear to me how interrelated this painting was to the coded knowledge of the bourgeois and aristocratic classes of that society, and how the imagery in a lot of that work would have been almost senseless to the peasantry or to a popular audience.

JS    Do you admire Robert Morris's writing of the 60s?

PH    His writing's too straight. There's not enough humor or any sense of irony. Contrary to the role of criticism in the 60s and 70s, the most interesting project in the 80s is the artists who have more directly injected themselves into the economic and distribution system of art—the artists who are running galleries, curating shows, writing newsletters to collectors.

JS    Why do you find that significant?

PH    Because it's something that's always been mystified for artists and that artists have been excluded from. It's not that I think artists should take over in a populist way. I just think it's a provocative gesture on their part, one that's yielded certain interesting issues for the artists who are doing it, like Meyer Vaisman and Peter Nagy, whose art to some extent has been about the actual distribution system and issues of the art world.

JS   With the exception of Thomas Lawson, you are the only artist/critic writing as a theoretician.

PH   I'm always surprised that more artists don't write theory. It's not too remunerative but certainly it's an easier way to get a forum than showing work. But it's not that open . . .

Another phenomenon that interests me very much now is some of the newer magazines that are floating around, like *ZG*, which I've written for, *Effects*, and *Real Life*. I think they have a more immediate voice in terms of what artists are thinking about.

JS   Are there other links between your writing and your art?

PH   I do drawings that are clear lines on black acetate which are either just words or use words in relation to diagrammatic images. They represent a bridge between the writing and the painting. One of these drawings is just two words, *power* and *volume*, in capital letters. I came up with those words looking at my radio—the idea of the power switch and volume and the overtones of those words, and it's on the left and the right. I continually do these paintings with cells on the left and the right, so it seemed to constitute a bridge between an observation about something cultural, making it into something visual, and then in the painting it becomes more distilled or more generalized.

Sherrie Levine
*(Photograph by Jorge Zontal 1988)*

# After Sherrie Levine

*Jeanne Siegel*

*For the past eight years Sherrie Levine has dealt with appropriated imagery. Her first confiscations were collages. She cut pictures out of books and magazines and glued them on to mats. Since then she has made copies of photographs after Edward Weston, Walker Evans and Alexander Rodchenko; drawings after Willem de Kooning, Egon Schiele and Kasimir Malevich; watercolors after Mondrian, Matisse, El Lissitzsky and Léger, to name only a few.*

*After the initial shock of discovering the artist's audacity in quoting and mounting famous artists' works, the question becomes, "What then?" Does her magnetism rest merely in the paradox of originality through copies? Does she recast the principle of the copy in a new and contemporary light? Why does she choose only male artists to copy? How does she view her own work and the considerable rhetoric that has accumulated around it?*

---

JEANNE SIEGEL   You were educated at the University of Wisconsin. How did this influence your direction, if indeed it did at all?

SHERRIE LEVINE   I think growing up in the Midwest certainly did. I grew up in St. Louis and I went to school in Wisconsin for eight years. I got my undergraduate and graduate degrees there. Having the feeling of somehow being outside of the mainstream of the art world had a lot to do with my feelings about art. Seeing everything through magazines and books—I got a lot of my sense of what art looked like in terms of surface and finish.

---

This interview, conducted in March 1985 at the artist's studio in New York, was originally published in *Arts Magazine* (June 1985).

JS   One feature that serves as a clue is the way you preserve in the copy the faint tints or discolorations that were the result of the photo-printing or reproductive process. This distinguishes it from the original. So you were conscious of the notion of a secondary source from the start.

SL   Yes. It was the 60s. I was in college and a minimal painter and Minimal art looked even flatter in magazines. I felt that my work was becoming very mannerist and empty for me. I began to use photography as a way of introducing representational imagery into my work.

JS   It seems significant that you received your graduate degree in photo-printmaking.

SL   I was interested in the idea of multiple images and mechanical repro-duction. I did a lot of commercial art for money from the time I was in college until very recently.

JS   Do you see that as an influence also?

SL   I think it had a lot to do with it. I was really interested in how they dealt with the idea of originality. If they wanted an image, they'd just take it. It was never an issue of morality; it was always an issue of utility. There was no sense that images belonged to anybody; all images were in the public domain and as an artist I found that very liberating.

JS   There are specific methods that commercial artists use, for example, tracing.

SL   And the use of copy cameras.

JS   It occurred to me that your process of working from prints is somewhat like the custom popular in the seventeenth century of copying a painting to make a print. What the print artist did was to remain true to the composition and poses of the figures, but they didn't necessarily hold to the original expression on people's faces. They thought of the print as being slightly original. In other words, it stepped away to become something new.

SL   I think that copies and prints were the main way of distributing images at that time, before photography.

JS   The Caravaggio exhibition currently at the Metropolitan Museum fo-cuses the idea of copying in another way. An original Caravaggio is mounted next to a copy or to works that have been attributed to Caravaggio. The exhibition reflects the modern need for uniqueness, whereas at that time one commissioned a copy of a master because one loved the painting or because a pious patron might want an image of John the Baptist.

SL   So much of our sense of art history is based on copies, fakes and forgeries. I just read *The Caravaggio Conspiracy,* a book about art theft and forgery written by an investigative reporter. While he's looking for a stolen Caravaggio painting, he comes across an incredible amount of forged art. There's always been a lot of it around. Some entire museum collections are forgeries.

JS   My point is that in the sixteenth century a copy was not necessarily frowned upon. People respected copies.

SL   I think it was a different relationship to history at that time. It was more like an Oriental belief in tradition. You strove to be fully mature in your tradition. Originality was not an issue. I think that's where modernism was a real break.

JS   In the process of copying from an original painting to make a print, the size is reduced. This seems to have some connection to your work.

SL   In most cases it is reduced from the original but maintains the size of the book plate. Maintaining a uniform format has a democratizing effect on the images that I like. The watercolors and drawings are traced out of books onto 11-by-14-inch pieces of paper. The paintings are easel-size on 20-by-24-inch boards.

The pictures I make are really ghosts of ghosts; their relationship to the original images is tertiary, i.e., three or four times removed. By the time a picture becomes a bookplate it's already been rephotographed several times. When I started doing this work, I wanted to make a picture which contradicted itself. I wanted to put a picture on top of a picture so that there are times when both pictures disappear and other times when they're both manifest; that vibration is basically what the work's about for me—that space in the middle where there's no picture.

JS   Can you elaborate on what originality means to you?

SL   It's not that I don't think that the word originality means anything or has no meaning. I just think it's gotten a very narrow meaning lately. What I think about in terms of my work is broadening the definitions of the word "original." I think of originality as a trope. There is no such thing as an ahistorical activity (I mean history in terms of one's personal history, too).

JS   What about the idea behind the introduction of your hand? This came about when you stopped copying photographs and began to draw "de Koonings."

SL   A lot of the most sophisticated psychoanalytic and feminist critiques about art and film posit the supremacy of the visual over all our other senses

in a patriarchal society. I think a lot of what's alienating and oppressive about our media culture is its voyeuristic aspect. It's ironic that most of this theory that is applied to art has been mainly in support of photographic work. There seems to be a denial of the rest of the body. In art, the hand becomes the metonymical symbol for the body.

JS   There is something in the work that suggests that you thoroughly enjoy this hand work. It's visceral on occasion.

SL   Oh yes. There's no other reason to do it. For me, art's basically about pleasure. I'm not saying there's no pleasure in making or looking at photography, but there are definitely some different kinds of pleasure in making and looking at painting.

JS   Can you see this process of copying from a print as a manifestation of the recent revival of craft?

SL   I wouldn't want to deny that. I think a lot of people see this evidence of the body as antidotal to an overmechanized culture.

JS   Do you concentrate on matching? Do you investigate and reconstruct the original colors?

SL   I give it a couple of shots if necessary. I stop when the color works with what I've already got on my page. I don't make it a photo-realist activity because that's mechanistic again and then I'm back where I started. I'm trying not to be tyrannized by the original image. What I'm really interested in is constructing my relationship to the image.

JS   Does your choice of artist or particular work of that artist have any relation to this question of craft?

SL   Painting very complex images would become drudgery for me, and I have no interest in that.

JS   In titling your works *After Kasimir Malevich* or *After Egon Schiele* you are alluding to an accepted earlier convention in art—one which flowered in the Baroque period and continued into the nineteenth century. Viewed historically, you could say that during the Renaissance Vasari established a canon of greatness which was adhered to by later generations. Is there a parallel to this pattern in that you chose the so-called heroes from earlier Modernism?

SL   There is. I think about it a lot in psychological terms. I mean, in an Oedipal way, about the authority of the father and the authority of the father's desire. My work is so much about desire and its triangular nature. Desire is always mediated through someone else's desire.

JS   And this is why the someone else that you appropriate is always male?

SL   A lot of what my work has been about since the beginning has been realizing the difficulties of situating myself in the art world as a woman, because the art world is so much an arena for the celebration of male desire.

JS   So his desire becomes yours in order to make this explicit? Then it's in the nature of a critique, really.

SL   I prefer the word "analysis." Somebody recently referred to my water-colors as position papers. One thing I'd like to make clear is that I make the things I want to make. The language and the rhetoric come afterward when I attempt to describe to myself and to other people what I've done, but I'm not making the art to make a point or to illustrate a theory. I'm making the picture I want to look at which is what I think everybody does. The desire comes first.

JS   Egon Schiele could be considered a possible exception to your choices of "greats." How did that come about?

SL   I haven't done this just in relationship to the history books, although obviously they form everybody's ideas about what's important. It's also been about my own personal relationship to this work, and Schiele is some-body who's been important to me.

JS   Why?

SL   There is something in his eroticism that strikes a chord. Partly it's the self-conscious representation of his own narcissism. I don't want to say too much on this topic. A girl's gotta keep some secrets.

JS   There seems to exist a kind of contradiction. Does your attitude have something in common with Lichtenstein's? Although he parodied the Ab-stract-Expressionist brush stroke, he said he liked it.

SL   It's a dialectical relationship, I think, which is the kind of relationship one has to authority. That's where the irony in the work is located. But the parody is not in relationship to the original; it's in how I perceive the original.

JS   In discussing the history of the changing approach to the object in the twentieth century, particularly in relation to its uniqueness and originality, Suzi Gablik *(Has Modernism Failed?)* mentions your duplications of photo-graphs of famous photographers. This follows a discussion of Rauschen-berg's *Erased de Kooning Drawing*. It seemed to me that in a way you are doing the reverse of what Rauschenberg did: whereas he wipes out, you are putting it back, albeit in another form.

Sherrie Levine, *Untitled (After Walker Evans: 2)*, 1981
Photograph, 8" × 10".
*(Courtesy Mary Boone Gallery)*

SL  A lot of people do see my work as an erasure. I think the people it offends most imagine it's an erasure.

JS  In what sense?

SL  In the sense that it's a screen memory—a memory that blocks a more primal memory.

JS  What was your reaction to Gablik's analysis of your intentions and her conclusions? I quote:

> Levine lays no claim to traditional notions of "creativity." By willfully refusing to ac-knowledge any difference between the originals and her own reproductions, she is addressing her work in a subversive way to the current mass cult for collecting photo-graphs, and their absorption into the art market as one more expensive commodity. Obviously ideas like these are successful as a negation of commodity-oriented culture. Only until commodity culture succeeds in accommodating even these "pirated" crea-tions and turning them into yet another saleable item within the framework of institution-alized art-world distribution . . . at which point they become more parasitic than critical, feeding on the very system they are meant to criticize.

SL  My works were never intended to be anything but commodities. It's taken a while for the work to sell but it has always been my hope that it would, and that it would wind up in collections and in museums. You know, money talks but it don't sing.

The work is in a dialectical relationship to the notion of originality. Originality was always something I was thinking about, but there's also the idea of ownership and property. Lawrence Weiner has this nice quote about wanting to make art that makes us think about our relationship to the mate-rial world. That's something that I feel very close to. It's not that I'm trying to deny that people own things. That isn't even the point. The point is that people *want* to own things, which is more interesting to me. What does it mean to own something, and, stranger still, what does it mean to own an image?

JS  Do you believe that viewers outside of the inner circle of the art world know what it is?

SL  There's a lot of irony in this problem because when I first started mak-ing this work I thought that anybody could understand it. It didn't seem elitist to me at all. Any thoughtful person could understand that a picture of a picture was a strange object. I still think it's true that anybody can understand the work. Some people think they're not understanding it, that there's something that they don't know about, and that's when they feel deceived or betrayed. A picture of a picture is a strange thing and it brings

up lots of contradictions; it seems to me that anybody can understand that. Obviously not everybody likes it.

JS    Some of the people who look at it might not even know the original, so they don't have a basis of comparison.

SL    I don't mind that. People enjoy or don't enjoy the pictures that I make. My pictures have other relationships than their relationship to me. I like to think that it's complex work and it can be appreciated on a lot of levels, or not appreciated on a lot of levels. For one thing, I think this work is very funny. I'm always surprised when people apologize to me for thinking it's funny. I want the work to be funny, but that doesn't mean I'm not serious.

JS    The practice of copying another existing artwork is often identified with the formative years of an artist. Are you connected to that or is it just coincidental?

SL    No, I've thought about it a lot, especially when I think of what I want to do next. I realize that this was something that I needed to do. It's interesting to me because I never consciously thought of myself as a student or apprentice, but I realize that it's a step that I wanted to take. I'm not in any way demeaning the work or saying that it's immature. But the irony to me is that people were so worried about what I would do next and it's been so generative for me.

JS    Could you discuss some of those developments generated by the use of the copy? For example, in the "1917" show (Gallery Nature Morte, October 1984), you coupled works by two artists that gave them a meaning beyond their showing separately.

SL    My appropriated images have been dealing with the Modernists and their ideas, a lot of which were utopian. This summer when I was doing drawings by both Malevich and Schiele, I started to realize that the dates all circulated around 1917. It was amazing to me that these two extremely radical and yet seemingly mutually exclusive activities could be going on at the same time. I thought it might make sense to show Schiele's erotic drawings with Malevich's suprematist works. [This was discussed earlier in an unpublished interview with Cindy Carr.]

JS    So this represented a comment on your part on the naive optimism in art's capacity to change political systems?

SL    When I began this work I was thinking about my relationship to the utopian ideas expressed by the Modernists. We no longer have the naive optimism in art's capacity to change political systems—an aspiration that

many Modernist projects shared. As Postmodernists we find that simple faith very moving, but our relationship to that simplicity is necessarily complex.

JS    In the more recent "Repetitions" show (Hunter College Art Gallery, March 1985), you used another strategy. You repeated six pencil drawings of an identical composition by Malevich.

SL    When Maurice Berger, the curator, told me he was doing a show called "Repetitions" and wanted me to be in it, I was very excited because I had been thinking about doing a piece where an image was repeated several times. Repetition's implied in the work anyway (i.e., if you can make one copy, then you can make any number of them). So I thought this was a perfect opportunity to repeat an image six times.

JS    Also, you now seem to be anxious to keep works together in a group that previously you showed singly. This is true of the works in the current Whitney Biennial.

SL    People have been loathe to discuss the work iconographically for some reason. Last month I was talking to the writer Howard Singerman who lives in Los Angeles; he was saying that people tend to look at the work as if it starts at the frame and goes out, as opposed to looking at the picture from the frame in. What he meant was that we've become so sensitized to context that we sometimes just see the picture as a hole in the wall. In fact, they are pictures. They're very complicated pictures, but they can be read iconographically. The images in the "1917" show are crosses and people masturbating. Most people who have written about the work have either ignored or denied the iconographic content.

   I think a lot of people seem to get lost in the gap and think that there's no picture there, when in fact there are two pictures there.

JS    Coming back to appropriation again, how do you feel that you differ, for example, from Andy Warhol, to whom you have expressed an affinity?

SL    There's an emptiness in Warhol's work that's always been very interesting to me because of that vibration I was talking about. There are three spaces: the original image, his image and then a space in between, a sort of Zen emptiness—an oblivion in his work that's always been very interesting to me.

JS    Your choices of images are quite different from his.

SL    Yes, although I often think that Warhol chooses images that he loves, which is what makes the work much less nasty than it might be, and that's important to me, too.

JS   A few months ago you were invited to show in an exhibition, "Production Re: Production," which dealt explicitly with appropriation and you refused to participate. Why?

SL   I never aspired to belong to a school of appropriators. "Appropriation" is a label that makes me cringe because it's come to signify a polemic; as an artist, I don't like to think of myself as a polemicist.

  I think I've softened a lot since I first started talking about this work. I should make it clear that I don't think art should be any one thing—my work only has meaning in relationship to everyone else's project. It has no meaning in isolation, and on the level of desire everyone's project is different. I believe that one of the most important advances that feminist artists and writers have made has been in establishing the possibility of difference, the possibility of a plurality of voices and gazes. It's important to me that my work be situated in the totality of contemporary art-making. I'm not trying to supplant anything; my work is in addition. The idea is to broaden the discussion, not to narrow it.

JS   In the process of becoming recognized, you have been grouped with certain artists referred to as "deconstructors." In what ways do you separate yourself from them?

SL   I may have a more traditional relationship to art. I grew up in St. Louis which has a very beautiful museum that I loved going to as a child. Although I have a conflicted relationship to art world institutions and culture industries, I do love art and modernist art in particular.

JS   Your work has triggered a good deal of rhetoric. I am interested in your response to some of the ideas that have been articulated. One, which we have already touched on briefly, is the role of the Oedipus complex as stated by Lacan. In an article on Lacan and Freud (*The Massachusetts Review* [Summer 1979]), Neal H. Bruss says:

> For Lacan, it is the resolution of the Oedipus complex which reduces the infinitude of potential desires and linguistic choices to a manageable system; it does so by initiating the child into a third order, the "Symbolic," the code of language and custom by which the larger community operates. Lacan takes the Oedipal resolution as a parable like the mirror stage, justified by Freud's own recognition that it could be reached without the child having actually witnessed a primal scene. Lacan's parablistic reading of the Oedipal complex, for example, does not exclude female children from the Oedipal role.

SL   That's why I've been so interested in critiques of Freud and Lacan by feminists like Jacqueline Rose and Juliet Mitchell, because they show us a way to have ideas about feminine desire. They talk about how culture creates an indivisible bond between gender and sexuality, a bond which

becomes a yoke, a bond which is even more complex in the case of femininity.

JS    You have expressed interest in Jean Baudrillard's critiques. According to Craig Owens (*Art & Social Change, U.S.A.* [April 1983]), Baudrillard argued that power is no longer exercised exclusively or even primarily through control of the means of production, but through control of the means of representation: the code. What was needed, then, was a critique of representation, but one free from a productivist bias. Owens concludes, "It was such a critique that this new group of artists set out to provide." As you were included in this group, please comment.

SL    This writing exposed the indignity of speaking for others. Like most women, I'd gotten pretty tired of being depicted and represented by men.

JS    A year ago, when asked whether you anticipated a change in your work away from working "after" other artists, you responded by saying that this was really your desire at the moment. "I'm making the pictures I want to look at," you said, which implied that you were not thinking about any change. How do you feel now?

SL    I'm in a transitional period right now. I'm thinking of making more kinds of choices . . . I guess I'm reluctant to speak about it too much yet.

Nancy Spero
*(Photograph by Cosimo Di Leo Ricatto 1986)*

# Nancy Spero: Woman as Protagonist

*Jeanne Siegel*

*Until the late 70s Nancy Spero had only an underground reputation, but the return to figuration coupled with an accelerating general interest in feminism accounts, in part, for Spero's shift in position to that of an "insider." Finally, with her political content expressed through a conflation of image and text, she was catapulted into prominence in the early 80s.*

*Spero's rich, attention-getting content, one primary emphasis of early 80s art, is distinguished by her obsession with form or, more accurately, process. In contrast to the work of Barbara Kruger and Jenny Holzer, Spero's hand is still explicit and felt. And her feminist position expressed in this interview should be compared to the stance of Postmodernist feminists of the 80s.*

---

JEANNE SIEGEL    When did you begin to participate in feminist activities?

NANCY SPERO    I got into the women's movement in the arts with the inception of WAR, Women Artists in Revolution, in '69, an offshoot of Art Workers' Coalition. Several of the women artists in WAR had been members of the radical feminist Red Stockings group in New York, mid-60s. Their analysis of the women artists' situation within a radical men's group interested me greatly. Inevitably such discussion sessions led to affirming activist exhi-

---

This interview draws material from three sources: a talk delivered by the artist in March 1984 at the School of Visual Arts, entitled "Sexual Difference/Art without Men"; a conversation with the artist at her studio in May 1984, for an exhibition I curated, "Collage Expanded" (New York: Visual Arts Museum, October 1984); and an interview with Spero at her studio in June 1987. It was originally published in *Arts Magazine* (September 1987).

bitions and museum petitionings. Eight of us went to John Hightower at the Museum of Modern Art demanding parity. Then Lucy Lippard and three women artists started picketing actions at the Whitney early in 1970. They were the nucleus of a group of other women artists interested in challenging the status quo. Women artists were trying to figure out their status in the art world. One would think that the human spirit surpasses gender, that gender would not be a consideration in art production, but we found out that it was.

So I started participating in the Ad Hoc [Committee of Women Artists] meetings, as there was going to be picketing at the Whitney. Lucy and Brenda Miller, Poppy Johnson and Faith Ringgold had been putting Tampaxes around the museum, and raw white eggs and hard-boiled black eggs symbolizing white and black women artists. And I wrote an article about this action in the *Art Gallery* ("The Whitney and Women: The Embattled Museum").

We picketed the Whitney, standing outside in the cold with placards, speaking to passersby, interviewing visitors inside, explaining the disparity of female to male artists in the exhibition. Four percent women! And the percentages went up to twenty to twenty-five percent, and remain that way. I interviewed some of the curators at the Whitney at that time, and they explained these appalling statistics by saying they chose only "quality" work and by consensus. It made me realize how women artists are excluded from public discourse. I had felt excluded and thought that it was due to the nature of my work—that it wasn't mainstream, and that I was addressing issues that were really anathema to the New York scene. My work wasn't formal. It wasn't minimal. It was tending toward what could be defined as expressionist. It could be addressing political issues which were absolutely verboten. At the time I was doing the "War Series" and then went into women's issues, all of which I felt had a political bias to them.

So I felt forever kind of swiveling on the edge of the art world. Perhaps I *was* excluded on the basis of political content, but perhaps ultimately more by gender discrimination. The women I worked with, their work did not in any way resemble mine, nor mine resemble theirs. This created a kind of political umbrella to cover group actions and analysis.

JS   It was during this self-investigative period that you abandoned painting and began to use collage.

NS   I started working on paper and collage earlier in 1966. The "War Series" were initially paintings on drawing paper. I then tested some beautiful Japanese rice paper, and I couldn't work in the same way—scratching, scrubbing and blurring the images. The rice paper was resistant to this method. So I began painting the figures on the drawing paper, and then cutting them out and collaging them onto the Japanese rice paper. And that

was the start of it. It was just a technical difficulty that I was having with the work.

I carried this into my work as a kind of liberation. It was absolutely terrific to be able to paint these images, to juxtapose and position them on the paper. When I was oil painting on canvas previous to the war paintings, I would work and rework a surface for months at a time, trying to get the right expression, trying to get the "essential." After a number of years of making the "Black Paintings" (Paris, 1959–64) it became oppressive going to the studio every night reworking them. They became darker and darker. It's not that I disavow them, it's just that I started to wonder why I was doing this year after year; I wanted the work to have more immediacy.

JS   In thinking about your move away from painting to collage, accompanied by your new unconventional format, I am tempted to conclude that it was a response to macho painting—so-called heroic painting dominated by male artists. Were you conscious of that at the time?

NS   I was reacting to the self-importance of oil painting, its value as a commodity and how I wanted to undermine this notion. It was important that I discard what I felt was an "establishment" product and critique not only the art world by implication, but the politics of war. The "War Series" is full of phallic projections—mostly male—a collusion of sex and power.

JS   One of the characteristics attached to the early definition of collage, particularly Dada collage, was the element of chance. Is that a significant factor in your use of it?

NS   I continuously shift images, which is conscious, but there are a lot of chance aspects to the placement—the way an image or a section of typing happens to fall onto the sheet—especially on an extended linear format. In the "Codex Artaud" series in 1971–72, and subsequently, I've used an extended format. It's like a controlled sense of chance, juxtaposing figures in unusual combinations in the blank undefined space of the paper.

JS   Some of the finest early collages, Schwitters's for example, were quite small and intimate. You share a contemporary propensity for expanded collage with artists like Rauschenberg and Krasner. Could you explain why you use the sizes you do?

NS   The larger works are 20 inches high and run from 125 to 210 feet. They consist of nine-foot panels, each made up of four sheets of handmade paper. The reason for their extended format is that, depending on the nature of the piece, I am trying to put down some kind of extended history, report or ritual. I think of these as perhaps cinematic in their movement in time. I even conceive of them as a visual equivalent of extended oral witnessing.

JS   And the big spaces?

NS   They are like time lapses and sequences. And it's space in which to move, to rest and to go on. It's like the pauses in music. There's a certain rhythm, movement, a staccato or calm or a block of images, and then you temporarily stop.

JS   The difference between yours and other contemporary collages that employ text is that first you fracture a quote and then you make certain what remains is coherent.

NS   The message has to get through! There are messages that are imperative.

JS   But it's not narrative.

NS   It's not narrative in the conventional meaning. It's not even sequential, fragmented moments or incidents. One looks at each image separately—like a photograph caught as a still or the images clump up—this pile-up, the repeated image.

JS   It becomes a reproduced image.

NS   The most recent images are printed in an opaque way, that is, densely colored, or they can be transparent, and printed from zinc plates with different pressures of the hand and different amounts of ink. When they are finished, you just don't know if figures are in front or in back, or are they running? In just what sequence of time has this been printed or put down as a marking, as a sign of what I'm doing?

JS   Did you draw the images that have been made into stamps?

NS   That's right.

JS   What about the Greek figure with the dildos?

NS   I took the image from a photograph about one and half inches high. I enlarged it, changed proportions, hair, etc. I ransack art history and photographic sources. I usually change the images in some way. But I do unashamedly appropriate from found images. I feel that I can take something that's in the public domain, either text or image.

JS   Even though you alter them, they trigger a memory.

NS   There is memory and recall, and images from the past are juxtaposed with the present.

JS   What are some of the different ways you use text and letters?

NS    I use several different bulletin typewriters—old things with just upper case letters and I use them so that you can read them. If I'm going to have artwork it has to be able to be seen from a certain distance. The larger letters are made from a range of wood type alphabets. I print each letter of the wood type separately with varying pressures. I often collage the typed information, frequently asymmetrically.

JS    How do the text and the image work together?

NS    They are set in tension with one another and are not illustrative in any way. For instance, when I used the texts of Antonin Artaud, I wanted them stressed or isolated from the images, loosely related but free-floating in space. *Torture of Women* puts together mythological references to torture, contemporary case histories of women political prisoners, etc., in a range of both quotations and image.

JS    Your first radical use of text was drawn from Artaud. One might ask, "Why Artaud?" Donald Kuspit (*Art in America* [January 1984]) answered this way: "Artaud gave Spero the confidence of criticality—the confidence of her outsider nervousness in the world, of her experience of the world as suppressive of existence." So you identified with Artaud as the outcast and then you played on his vulgarity?

NS    I did indeed. Often, there is a juxtaposition of his writing and my head that more or less coalesced. The more vulgar the language, the more delicately I would inscribe it. In using Artaud's extreme, obscene fragments—putrification, for example—I would transform the look of the words by separating them with dots between each letter as in concrete poetry. The lightweight paper gives a sort of floating form to the language amongst the scattered images.

JS    When you used Artaud's words, did you feel as if you were in collaboration with him?

NS    No. When I used Artaud quotes, I felt he would have hated me as a woman for doing this. I had that feeling during the four years I worked and fractured his texts. Now with the American woman poet, H.D., whose texts I used too, it wasn't an antagonist position. Not that I wasn't sympathetic to Artaud. His stuff moves me tremendously. With H.D. I tried to extract the stuff that I thought would bring her to this moment, make it current because she did say some really relevant things.

JS    Around this time, you made a startling decision to make art without men, that is, to depict only women in your art. How did you arrive at this decision?

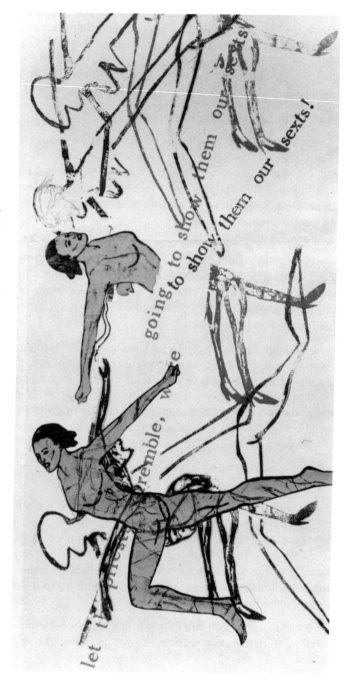

Nancy Spero, *Let the Priests Tremble* (detail), 1984
Handprinting and collage on paper, 20″ × 110″.
*(Photograph by David Reynolds; courtesy Josh Baer Gallery)*

NS    After the "Codex Artaud," I decided I couldn't go on forever using ᴜ∪ᴄ language of Artaud. At this time, I was in A.I.R., an all women's gallery, and I decided I would coalesce my activities as a woman artist—try to get my ideas about women into the artwork. Since it was a cooperative, I could use the space as I wanted for a piece, *Torture of Women*. There are 14 panels that went around the gallery in a band 20" by 125' long.

I had started to investigate the conditions and the status of women. There are more male political prisoners than female, yet women prisoners are victims par excellence. In the "Black Paintings," I was expressing an internal state of mind, of a timeless, existential mood. In the Artaud series I wanted to view the artist's mental and physical condition in a Western bourgeois society that ignored the artist's message. *Torture of Women*, by using bulletin type and actual case histories, becomes a much more public notice.

JS    One of the major critical focuses for the early 80s in discussing feminism has been on the way the artist, particularly a woman artist, articulates "difference." In *Let the Priests Tremble*, which combines hand-painted scrolls of images with collaged texts, you interweave a quote from the French feminist Hélène Cixous's *The Laugh of the Medusa* which says, "Too bad for them if they fall apart discovering that women aren't men, or that the mother doesn't have one" with images of women's bodies. "The grace and hope of freedom in women's bodies is what I'm about," you say. Would you elaborate on what you mean in using the body, what you mean by the body as a symbol?

NS    I think that if you don't use the body there is an absence. And to use the body embodies an idea and, in a sense, it's the most complex and challenging kind of conceptual reference. And also for me, the body is a symbol or a hieroglyph, in a sense an extension of language. And so, in making a statement about women's bodies I want the idea of a woman's body to transcend that which is a male ideal of women in a man-controlled world. The realities of war, primary power, the bomb, etc., are depicted in my work through the images of woman as victim of these catastrophic events. But what I suppose might be most subversive about the work is what I'm trying to say in depicting the female body—that woman is not the "other"—that the female image is universal. And when I show difference, I want to show differences in women, women's rites of passage, rather than a man's rites of passage. Woman as protagonist. The woman on stage.

JS    Your sources for imagery are vast—icons such as the Venus of Willendorf, Helen of Egypt, archaic or paleolithic figures. They include sky goddesses, a suckling she-wolf, athletes, mother and children. They range from

5000 B.C. to current newspaper clippings. In *Torture of Women* in 1976, you embrace the opposition of the timeless cruelty toward women to women placed on a pedestal—the unattainable woman which is the myth of the virgin. The range within these oppositions is timeless and universal. Your images are, in this sense, archetypal mythic depictions.

NS   These depictions of ancient goddesses along with images of contemporary women become palpable reminders of our relationship to the past and our memories of the past. The past and the present become inextricably interwoven.

JS   There is nothing ironic in your depiction. Is it a glorification of women? Is it essentially a utopian view?

NS   While there is only occasional irony in my work, there is frequent humor and playfulness. For instance Sheela-na-gig, the Celtic goddess of fertility and destruction, is both beguiling, childlike and funny, yet she has a frightening aspect as well. In *Notes in Time on Women* I copied a Greek vase painting of a nude woman carrying an enormous dildo—which is quite amusing. I don't think I am glorifying women so much as bringing women to "center stage" in active (not passive) roles. Perhaps this would be considered utopian.

JS   You rely heavily on movement and gesture to convey feelings. *The First Language* is an example of using body language to show women in control of their own bodies—a more positive joyful image. You have called it "the jouissance of the female body." Could you discuss that?

NS   Especially when I portray athletic or dancing figures, I want them to be unselfconscious—activators, not passive objects of a voyeuristic male gaze.

JS   You have a reservoir of poses. How important is "pose?"

NS   I have made approximately 100 zinc plates with images of women—many different sizes, shapes, historical periods, old, young, black, Vietnamese, white, etc.—all in what I would consider natural poses for their roles. A "pose" is how one carries oneself, identifies oneself—how one confronts the world and the gaze of the viewer, male or female.

JS   You have also emphasized parts of the body. The most obvious has been the tongue. What has that symbolized?

NS   To tell you the truth, I was embarrassed about the tongue but I didn't think anyone was observing! In 1960, in Paris, during the time I was making the "Black Paintings," I made a few small paintings on paper and I called

them nightmare figures. These were strange, humanlike figures sticking their tongues out entitled *Merde* or *Fuck You*. Six years later, in the "War Series," the tongues appeared again as violent heads in the clouds of the bomb vomiting or spitting poison onto the victims below. I was sticking my tongue out on the world, using Artaud's language to express my dissatisfaction in an existential resistance, as a woman artist.

Three or four years ago, in reading French feminist philosophers about how women are silenced—that their tongues are castrated—I thought, that's what I have been portraying. I have been defiant but my voice has not been heard. I have had no power—the silencing of women's tongues, my tongue. My tongue means that I as an artist have not been acknowledged by the art world. I haven't been able to have a dialogue with the art world.

JS   By 1983, you were catapulted into a major dialogue with the art world through a focus on the question of sexual difference. You were included in an exhibition, "The Revolutionary Power of Women's Laughter" (Protetch-McNeil Gallery), and were singled out critically (Weinstock, *Art in America* [Summer 1983]) as producing feminist art in which a danger lay "in its celebration of Otherness." Your mythical women were cited as projecting "an Other-worldliness which reinscribes the traditional male-female opposition." By contrast, Barbara Kruger was credited with attempts to expose myths rather than creating them. How did you respond to all this?

NS   I think that the writer's idea about feminist art is programmed and rigidified in not allowing for the female image, the female body! On top of all the other kinds of limitations and restrictions, and lack of openings for women in the art world, this is yet another repression. And so when she says my work restricts to a vision of otherness, that's just a reflexive action on her part to any images of women—that it has to be, for her, obliquely done or in reference to photography and advertising.

JS   Do you consider yourself an existentialist?

NS   Yes, somewhat. I am pretty pessimistic about the human condition and situation. Nevertheless, the work today is more buoyant and seemingly has a sense of utopian possibilities. I continue to insist on depicting woman as victim in rape or war but I also show women in control of our bodies—and thus of our space.

JS   Don't you think this change in attitude could have come, in part, from the sense of your own recognition?

NS   Definitely—that I had found my tongue, a dialogue, an end to the silence.

JS   With *The First Language,* your work became nonverbal. That must have been a big decision.

NS   During the 70s, I had used so much language, from the Artaud works to *Notes in Time on Women* (93 references). On completion of that piece (210 feet long), I decided to try to do a large piece without language, using the language of gesture and motion.

JS   With the work in the early 80s where you've discarded text, you've introduced more color.

NS   I have. Where some of the earlier works, in grayed or metallic colors, were spare and the images distanced and isolated, now many of the female figures are full of activity and color.

JS   It's been 15 years since you joined A.I.R., and you just left. Have your ideas on feminism changed radically over that time?

NS   No. It can be argued whether the art world is any more open to women artists today than it was in 1969–70 when WAR and the Ad Hoc committee of women artists made their first forays. Note the Guerilla Girls!

JS   In discussing your work in *The Nation* in 1974, Lawrence Alloway prophetically said, "Though her subject matter is political, she does not assume immediate efficacy is possible in painting: she has no naive expectation of reform ... Spero is stricken by human behavior but does not assume that art can transcend history." Do you still feel the same way?

NS   I am still skeptical of the extent to which art enters into public discourse. I have attempted to do so with images and themes of public intent.

Cindy Sherman, 1987

# Cindy Sherman

*Jeanne Siegel*

*Cindy Sherman left Buffalo with her friend Robert Longo in 1977 to settle in New York City. Encouraged by him, she shared with Longo an interest in photography, film, and performance. She showed first at Artists Space in "Pictures," a ground-breaking show which included a group of young artists who were quickly to achieve high profiles in the early 80s—ushering in what was then labeled Postmodernist. In 1980 she had her first one-person show at Metro Pictures. By 1982, she was selected for Documenta 8 in Kassel, Germany. In 1987, at the age of 33, she was given a retrospective at the Whitney Museum.*

*What was heralded from the start was the masking of self (female) identity—using her own image in disguises to suggest roles derived from the culture. This started with poses culled from the mass media and moved in the mid-80s to myth and fairy tale as sources.*

*What is particularly refreshing in the interview, despite the extensive rhetoric surrounding her work, is her antitheoretical stance and her intuitive approach to art-making. Given her recognition as an innovative photographer in the fine art world, paradoxically, the interview reveals her sensitivity and vigilant attention to critical response to her work.*

---

JEANNE SIEGEL   Let's begin retrospectively. That seems appropriate since the Whitney Museum has just closed a 10-year survey of your work after a national tour.

---

This interview was conducted at the artist's studio in New York in October 1987.

You received your B.A. in 1976 at the State University College at Buffalo. What was your work like in those formative years?

CINDY SHERMAN    I was using photographs of myself but I began to cut them out. They were like paper dolls in kind of a corny way; I would put them together to make scenarios printed in different sizes to portray children, or women.

JS    Hadn't you been making paintings before this?

CS    Yes, but I didn't do anything serious with painting. It was when I started taking pictures of myself that I felt like I was doing something different.

JS    This is all while you were in school?

cc Yeah. I don't know if there was that much of a leap, because I was the kind of painter who would copy things. I copied things to make them look as real as they could possibly look, whether it was from a photograph or a magazine ad. It wasn't even about art, it was just about realism. I didn't have a good art history background. I've never acquired one, even at this point. But I was just interested in reproducing a picture with somewhat surrealistic overtones.

I started in the painting department. I tried to switch and they wouldn't let me, but I became more interested in photography as a tool, and I think when I finally made that switch, it was as a result of about a year's worth of frustration of not knowing what to do. This was about the point where I met Robert Longo and the Hallwalls crowd and learned what was going on in the art world up to that moment. I hadn't learned anything about this in school and never knew about it from growing up on Long Island. Once I learned about what was going on, I felt like it was useless to paint anymore.

It was really exciting for all of us having New York artists come up and visit. We were so far away from the real art scene in the city but we would read about these people in magazines, and they were our heroes. It was funny; when I finally moved to New York I'd see those so-called heroes walking in the street in SoHo looking like everybody else, and it kind of brought me back down to earth a bit.

JS    Who were these people?

CS    Oh, Hannah Wilke, Liza Bear, Willoughby Sharp, Robin Winters, Vito Acconci . . . people who either did installation or performance work. I was inspired by a lot of performance like, say, Chris Burden (although what he did at Hallwalls wasn't too great). One person who I don't think ever came to Buffalo who did influence me (but only mythically in what I *heard* about her "performances") was Adrian Piper.

JS   In 1976 you were included in a show at Artists Space in New York. How did that come about?

CS   We did an exchange show with Artists Space where Hallwalls artists showed at Artists Space and vice versa. Helene Winer, the director of Artists Space at that time, chose people like Jack Goldstein, Troy Brauntuch, Matt Mullican, and David Salle—Cal Arts people—for the show in Buffalo. Longo, Charlie Clough, Michael Zwack, Nancy Dwyer and myself were included in the New York show. That's how the association with Helene (who now co-directs Metro Pictures) began.

JS   What did you show?

CS   As I said, I was doing these cut-out figures. Cutting them out was the only way to fit all the different characters together, but it was presented in a filmic sort of way; scenes went all the way around the room. The one at Artists Space was like a murder mystery. It was more experimental for me, because it wasn't a story that I would really want to see on film, but about how to put all these different characters together and tell a story without words.

JS   Were you the only figure in the story? Why?

CS   I just wanted to work alone. I didn't even think of asking my friends, and I certainly couldn't afford to have an assistant or model. It was the most natural thing for me to do—just hide in the back of Hallwalls, because Hallwalls was a very busy sort of place; it was communal in that respect. There were three of us living upstairs from the gallery, and it was kind of the game room where all the other kids from all the other little studios and places around the city would come and watch TV every night and hang out with the current visiting artists. So it was a very busy place. I got sick of it often and retreated into the back room into my studio and bedroom and would work back there by myself just to get away.

JS   The need for privacy seems to be a continuing characteristic of yours. How did the "film still" images come about?

CS   When we moved to New York, I had grown tired of doing these cutesy doll things and cutting them out. It was so much work and too much like playing with dolls. I still wanted to make a filmic sort of image, but I wanted to work alone. I realized that I could make a picture of a character reacting to something outside the frame so that the viewer would assume another person.

Actually, the moment that I realized how to solve this problem was when Robert and I visited David Salle, who had been working for some

sleazy detective magazine. Bored as I was, waiting for Robert and David to get their "art talk" over with, I noticed all these 8 by 10 glossies from the magazine which triggered something in me. (I was never one to discuss issues—after all, at that time I was "the girlfriend".)

JS   In the "Untitled Film Stills," what was the influence of real film stars? It seems that you had a fascination with European stars. You mentioned Jeanne Moreau, Brigitte Bardot and Sophia Loren in some of your statements. Why were you attracted to them?

CS   I guess because they weren't glamorized like American starlets. When I think of American actresses from the same period, I think of bleached blonde, bejeweled and furred sex bombs. But, when I think of Jeanne Moreau and Sophia Loren, I think of more vulnerable, lower-class types of characters, more identifiable as working-class women.

At that time I was trying to emulate a lot of different types of characters. I didn't want to stick to just one. I'd seen a lot of the movies that these women had been in but it wasn't so much that I was inspired by the women as by the films themselves and the feelings in the films.

JS   And what is the relationship between your "Untitled Film Stills" and real film stills?

CS   In real publicity film stills from the 40s and 50s something usually sexy/cute is portrayed to get people to go see the movie. Or the woman could be shown screaming in terror to publicize a horror film.

My favorite film images (where obviously my work took its inspiration) didn't have that. They're closer to my own work for that reason, because both are about a sort of brooding character caught between the potential violence and sex. However, I've realized it is a mistake to make that kind of literal connection because my work loses in the comparison. I think my characters are not quite taken in by their roles so that they couldn't really exist in any of their so-called "films," which, next to a real still, looks unconvincing. They are too aware of the irony of their role and perhaps that's why many have puzzled expressions. My "stills" were about the fakeness of role-playing as well as contempt for the domineering "male" audience who would mistakenly read the images as sexy.

JS   Did you see these "narratives" as stories or parables?

CS   At the time I never analyzed it. Looking back now, I think they are more related to allegory.

JS   How much influence did advertising images have on you?

CS   I don't remember consciously thinking about it. I was commenting on

it later when I was mocking advertisements, when I did the ads for Dianne B and Dorothée Bis. I've always been interested in ads on TV and in magazines, in terms of the artificiality and the lying. But I never thought in terms of incorporating it into my work at any one point.

I was interested in film noir and psychodrama. I was more interested in going to movies than I was in going to galleries and looking at art. Sam Fuller's *The Naked Kiss, Double Indemnity,* those kind of classics. I would go to the Bleecker Street Cinema just to look at the Samurai movies. But I'd go to see any kind of movie, really. I was more interested in that media than art media.

JS   In 1982 you were included in the exhibition "Image Scavengers," at the ICA in Philadelphia, which caused quite a stir. It brought a great many painters and photographers together under the rubric of appropriating from mass media. You were included because of your reference in the film stills to 50s- and 60s-vintage "B" movies with their declassé ingenues that translate into filmic clichés. At one point, you said you imitate things in the culture and reuse them. Did you think of yourself as an "appropriator"?

CS   I don't think so in the strict sense. I didn't actually lift the image as Richard Prince or Sherrie Levine had. I would rehash it and spit it out, which was a different sort of process. Watching a lot of movies, looking at a lot of movie books, I absorbed as much information about the "look" of movies as possible. No one had ever literally seen any of my images until they were produced, and yet one felt the gnawing of recognition upon viewing them.

JS   By the time this exhibition took place, you had made your horizontal series. You called these "generalizations of stereotypes." Does that make sense?

CS   Probably not. But perhaps what I meant was that they were to be the ultimate stereotype. I guess I must've come up with that one when I couldn't think of any other way to describe the work.

JS   Critical writing catapulted your work into prominence, along with others, by prescribing a particular way of looking at it. One of the first points that was made was its use of stereotypes. This, according to the argument, shifted the focus from using yourself *as* yourself in a personal, inner way. You were projecting the image out into a public one—the image of already-known feminine stereotypes. Rather than revealing the artist's true self they show the self as an imaginary construct, contingent on the possibilities provided by the culture.

Another point, related to this, was predicated on your relationship to what is traditionally the accepted role of photography—to record the truth.

Cindy Sherman, Untitled Film Still, 1978
Black and white photograph, 10″ × 8″.
*(Courtesy Metro Pictures)*

In contrast, your photographs are self-consciously composed, manipulated, fictionalized. They use the "truth" of photography against itself. Instead of revealing your true self, you disclose the fiction of the self, which is— according to the argument—a discontinuous series of representations, copies and fakes.*

Did you, or do you now, agree with these conclusions?

CS   The only way it makes sense to me now is because you've paraphrased the core of what was in those articles. Even though I read them at the time and understood the general concept, I couldn't have repeated it to someone else if my life depended on it. I've only been interested in making the work and leaving the analysis to the critics. I could agree with many different theories in terms of their formal concepts but none of it really had any basis in my motivation for making the work.

JS   Another critical issue attached to the work was the notion that the stereotypical view was exclusively determined by the "male" gaze. Did you see it only in this light or did it include the woman seeing herself as well?

CS   Because I'm a woman I automatically assumed other women would have an immediate identification with the roles. And I hoped men would feel empathy for the characters as well as shedding light on their role-playing. What I didn't anticipate was that some people would assume that I was playing up to the male gaze. I can understand the criticism of feminists who therefore assumed I was reinforcing the stereotype of woman as victim or as sex object.

JS   You're referring to the work you did in 1981 where you enlarged the image and more or less eliminated any background except for a few tiny props? They were studio shots, and they were mostly in horizontal positions—you on the floor reclining or half-reclining. They became less situational and more assertive physically and psychologically. Exactly what were your intentions here?

CS   I was asked to propose a project for *Artforum,* which included a center-fold project. And I liked the idea of mocking traditional centerfolds, so that's how the format of that oblong rectangle came about. But I wanted to make the viewers embarrassed or disappointed in themselves for having certain expectations upon realizing that *they* had invaded a poignant or critically personal moment in this character's life. That was my intention.

---

*See Douglas Crimp, "The Photographic Activity of Postmodernism," *October* 15 (Winter 1980).

The problem with filling up the horizontal format is that the subject is usually prone, which can be a potentially suggestive position, no matter what the character's state is or how she looks. The locations are either on a bed or on the floor, which would suggest having been thrown down or waiting for someone to lie down next to her. But I don't see these women (or girls) as enjoying their angst, agony or anguish, which is usually a factor in intentionally suggestive photographs which one would find in a detective magazine.

JS   In other words, their victimization or vulnerability was not primarily sexual?

CS   I've never quite figured out how people read them as sexy, except when they are thought of as my personal, sexually motivated fantasies.

JS   You certainly have avoided focusing on the erotic. You set up the opportunity for yourself to show naked parts of the body only later, when you began to use fake body parts. You never did it when you were just showing your own body.

CS   I wouldn't consider that a viable costume. Even if I was using another model I wouldn't do that because it automatically implies "get a load of this." There's too much of a cheesecake implication. Especially since people are so preoccupied with what I must really look like, that would be counterproductive.

JS   As a matter of fact, I read them as romantic, occasionally sentimental.

CS   Yes, like the girl waiting by the phone. Well, after reviewing the problems with that work and how people interpreted it, I consciously switched to a vertical format featuring strong, angry characters, women who could have beaten up the other women, or beaten up the men looking at them.

JS   You had described those vertical works yourself as "emotions personified."

CS   That's when I got tired of using makeup and the wigs in the same way, and I started messing up the wigs, and using the makeup to give circles under my eyes or five o'clock shadows, or hair on my face—to get uglier. I also emphasized the lighting much more. That's why the moodiness of the whole series made me think of personified emotions, although I hate that phrase now.

JS   In the horizontal series you began to emphasize fabric and texture, pose and body parts; in getting up close, you highlighted an arm or a leg, a robe

or floor pattern, for example. The props working as contrast to and against the body are hallmarks of the "Pink Robe" series.

CS   Right. Maybe working in a bigger format at that time, I became more conscious of trying to fill up the whole space with interesting visual detail. But I wasn't consciously working in terms of patterns or textures. I was trying to make the body a part of the landscape, to blend in with everything else.

JS   It was in those pictures where one became most conscious of framing and cropping—the power of the camera to create an unbearable intimacy. Were you, at that point, trying to make some comment on the formal properties of photography?

CS   I don't think so; I was being as irreverent as ever by cropping the top of a head off or at the knees or the arms. Some of it was accidental because I couldn't see through the camera to know exactly what I was leaving out of the frame. But mostly I just liked the way it looked.

JS   By 1983, you abandoned the image of the romantic young woman for something more extreme, perhaps more exotic, often less beautiful, on its way to becoming more grotesque, certainly more costumed, staged (I mean more explicitly staged so that the viewer is aware of the staging). You even introduced false body parts. By '85 they had fake asses or pigs' noses. What inspired that series?

CS   I was asked to do some ads for Dianne B using clothes from Issey Miyake, Comme Des Garçons, et al. They were really weird clothes that were fun and inspiring, but also very powerful on their own terms—overwhelming in fact. To balance them, I started making the characters as bizarre as the costumes so that they would fit together and neither would overshadow the other. Then I did a job for this French designer, and right away I started feeling antagonism from them, not really liking what I was doing, because they expected me to imitate what I had done in the last series. But I wanted to go on to something new, and since they were going to use these pictures for Paris *Vogue*, I wanted the work to look really ugly. The clothes were boring and not the ones I had asked to use so I thought I'll just go all out and get really wild. That's when I started using the rotting teeth or bad skin on my face, while trying to mock those *Vogue* model poses. They hated it. And the more they hated it, the more it made me want to do it, and the more outrageous I tried to be. Finally I had to finish the job and shot some less insulting pictures just to end it. I was real disappointed that they didn't use the best ones in the magazine, because it would have looked great.

JS   Wasn't the source for these images fairy tales? If so, do you interpret mythological characters as stereotypes in the same way?

CS   No, that was about a year later when *Vanity Fair* suggested I illustrate a fairy tale. That's when I really crossed over the line into using theatrical masks and so forth. I wasn't stereotyping these mythical figures in any conscious way (the witch with the hooked nose is the one I found least successful, perhaps because it looks like a Halloween character). While I was reading fairy tales for research I did find an abundance of standard characters but I was seeking to find the quirky characters, or most bizarre scenes.

JS   These works brought out your sense of humor, coupled with mocking (a characteristic to which you frequently refer).

CS   In a sense, that's become the most important thing to me in the work. Perhaps it's the easiest protection against criticism; whether or not the work is really mocking something, at least it's pleasing to me. My critics just don't get the joke or see who or what I'm referring to. I suppose it's a built-in defense just so long as it's entertaining somebody out there. It's the way I feel about the art world and the critical world; after being around for a while, I don't want to take anything that seriously in this field. So I'm making fun of it all, myself included, in various stages.

JS   Your black humor connected here with the exaggeration of fakeness— the big asses, the false breasts . . .

CS   Well, again, the false ass and tits were, at first glance, perhaps as much of a lure as nudity would be in any photograph, but once the viewer looked up close, not only are they fake, they belong to a hideous character, the face, the teeth and everything. So, it's a kind of a slap in the face to those who would get off on nudity to think that I would have to stoop to that.

JS   You have relentlessly pointed out that you are not interested in self-portraiture. In the traditional sense, this is true. But, in light of your choosing the character and garb, isn't it plausible to assume that as fantasies they are extensions of yourself?

CS   No, I don't fantasize that I'd like to look a certain way or be in a certain situation in order to take a photo or set up a scene. Fantasy only comes into play after I've made myself up and I need to imagine how this character would behave in order to capture the expression I'm after. I work in a very logistical, methodical way, from series to series, analyzing faults and trying not to repeat myself. While working, I'll look at what I've done so far in a series and make generalized decisions about what I need to add to it. I may

have too many images that are similar in color, character, mood or composition, so I'll construct a new work solely on the basis of adding variety and although all the other details are more intuitively constructed, it's really a matter of what kinds of props or body parts I've purchased rather than some deep-rooted fantasy.

JS   It would appear that where, at the start, your images typified glamour or prettiness, now you concentrate on ugliness.

CS   I think the early work was misinterpreted as being about these pretty young actresses, because I never saw them or myself as an imitation of prettiness. Looking back, perhaps applying a lot of makeup in a style from the past is now synonymous with a stab at beauty. But I was involved with this work before the age of retro-fashion. Coming out of the 70s, which were concerned with the "natural" look, I was intrigued with the habits and restraints women of the 50s put up with. I remembered as a preteen, sleeping with orange-juice-can-sized rollers in my hair, wearing a girdle and stiff, pointed bras. At that time, the idea of putting all that together with heavy, exaggerated makeup seemed more amusing and ridiculous than pretty.

JS   Do you feel a distance from ideas that concerned you, for example, the idea of the stereotype of the self?

CS   Stereotypes don't concern me so much anymore now that they're everywhere in fashion. I feel my old concerns helped me to grow to where I am today, but I don't need them anymore. Perhaps these issues are like so many givens now.

JS   To return to the beginning, what artists have influenced you?

CS   My friends, mostly. But early on it was people like Vito Acconci and Bruce Nauman, the ads that Linda Benglis, Robert Morris and Eleanor Antin did in *Artforum*.

JS   What appealed to you in those ads?

CS   That they were using themselves as a commodity, to make fun of their art as a commodity. And, that they made fun of the art world as a sort of playground for hype.

JS   One of the most innovative features of your work is that you not only drew on film and photography but absorbed elements from performance art, which had been central in the 70s, and incorporated them into a pictorial mode. In regard to performance, was Acconci an influence?

CS   Definitely.

JS In what way?

CS He mocked everything—himself, the art community, sexuality, even the notion of performance art. When I first saw a catalogue of his, I was appalled. There was a series of pictures showing different places to hide his penis and one of them was in the mouth of some assistant of his. I thought, my god, what do people go through in the name of art? But when he came to Buffalo, I realized that he was mocking people with attitudes just like my uptight background. Seeing what a gentle, shy person he was I found it remarkably funny that he made the work he did.

JS What was your exposure to John Baldessari?

CS When I was in school, what interested me was his sense of making a game out of art. It didn't seem highbrow; it didn't seem like you had to read magazine articles to figure out what he was trying to do. He was funny, like William Wegman; you can just watch TV and relate to their work, and yet it wasn't about TV. It was much more interesting.

JS There are other contemporary artists who use themselves consistently as subjects. Gilbert and George for example. The obvious difference is that they are always explicitly themselves.

CS My biggest disappointment in their work is that it's so exclusively for a gay audience. It makes me mad that they can't include something that women can relate to, but it's all about young boys. It seems misogynist to leave out half of the population. Even though in my photographs there usually aren't any men in them, it still implies an interaction that men can relate to, even gay men.

JS Another artist/photographer is Lucas Samaras. In his Polaroids he also transforms character, manipulating and fictionalizing himself.

CS Maybe I'm just being overly critical but I see too much of his ego in them.

JS One thing you have repeatedly pointed out is that you create intuitively. Yours is not an intellectual pursuit; you're not involved in reading theory.

CS Yeah. Yeah. Yeah.

JS There's no question that you're still very involved in the art world, but I have become aware of the fact that you like the idea of infiltrating or associating yourself with a larger audience. You are more interested in that world out there.

CS   It could be seen in two different ways. It could be seen as just trying to be popular, which is not what I'm making out of it. I just want to be accessible. I don't like the elitism of a lot of art that looks like it's so difficult, where you must get the theory behind it before you can understand it.

JS   Are you saying that you think when people saw the Whitney show there was immediate readability?

CS   I don't really know if people understand what my intentions are, looking at it, but they can recognize things right away and recognize whether they're turned off or laughing or what sort of immediate reaction they have.

JS   Would you say, then, that you're communicating on two levels? There's the immediate reaction where the viewer can get something that seems valuable and then there's the other one that requires longer thinking.

CS   Some of them are like portraits so the audience can relate to it like portraiture, and some of it looks like it could be a movie poster.

JS   What do you see as your relationship to photography?

CS   It's kind of a love/hate relationship, I guess, because I hate the technology of it. I hate people who are obsessed with the technology of it.

JS   You don't concern yourself with technology at all?

CS   Well, I've had to learn much more than I ever would have cared to, but only because I needed it for what I wanted to express. It was necessary for this work to grow. In the beginning, in the black and white stage, I purposely would underexpose or overexpose and wouldn't care if it was printed properly because it was about cheapness and not high art. That's very opposed to the concerns of the photographic community—the sacred image/print in full frame, etc. But there's a whole history of photography that I don't like. I can't stand street photography—people who walk around with cameras and take pictures of shadow patterns of trees and their ilk.

JS   One area where you have made a considerable contribution is in the changing role the art institutions are playing in acknowledging so-called fine art photography. You showed first in the 1983 Whitney Biennial. In the 1986 Biennial the Whitney Museum took a step by incorporating and presenting photographers side by side with painters of similar perspectives in a move toward comprehensiveness. In the summer of 1987, the museum mounted a 10-year retrospective of your photographs. This represents a radical step in that you are the first fine art photographer (as well as one of the few women) to be given a retrospective there. This admits you into the exalted realm of high art.

Within the museum context, your work looked more like painting, particularly the new work which suggested an all-overness reminiscent of Abstract Expressionism. Whereas in the first works you had appropriated the aesthetic of film stills, here the iconographic symbol systems, the assembling of objects (rather than a single figure) could be read as simulated Abstract Expressionist ideas about the primacy of surfaces. It's like you're saying, "I can make photographs that look like high art—painting." The fact that you've increased your scale also contributes to this.

CS    I wasn't thinking of painting per se (although the toy penises were a reference to the pervasive macho-dom in "high" art). I was concerned with fields of matter that, objectively, were colorful, tactile as well as textured, and subjectively could inspire amusement, curiosity or revulsion. I see them as landscapes of a sort, but not based on any reality.

JS    The Museum of Modern Art is a different story. After numerous major European museums showed your work, MOMA, in 1985, included you in a survey titled "Self Portrait." It would seem that any investment on their part in acknowledgment of fine art photography remains on the level of tokenism. Do you believe their attitude is changing?

CS    I'm not so trusting of it, but I guess a little more so than in the past. Photography departments still don't trust me (much less the archival-ness of the work). Until the photo and art departments erase the fine line between them, artists like myself will continue to be shuffled around.

JS    Is it possible for you to sum up what you're trying to communicate?

CS    Maybe I want people to look at my work and use what they're seeing to help themselves to either see or recognize something that they realize is really stupid, like, "See, I'm sort of like that and I shouldn't be," or, "Why am I attracted to that? It's really ugly." The role-playing was intended to make people become aware of how stupid roles are, a lot of roles, but since it's not all that serious, perhaps that's more the moral to it, not to take anything too seriously.

Jenny Holzer
(Photograph © Timothy Greenfield-Sanders)

# Jenny Holzer's Language Games

*Jeanne Siegel*

*Jenny Holzer set aside abstract painting in order to be more explicit and to establish more direct contact with a larger, more public audience. A populist, she wants to touch the mass of people while using the art world as a home base. Furthermore, the importance of context and placement so fundamental to determining content, genre, and even the presence of art in the 70s forms a principal thread of Holzer's discourse. Context is crucial to the impact of her work in its underlining and relating of the political systems of the "art" world and the "real" world.*

*Holzer situates herself between literature and visual art. Her art appears in the form of texts, essays, posters, and more recently, computerized signs to disseminate information. Her writing style is clear, terse, straight, presented as factual. Thoughts (aphorisms) range from the recognizably platitudinous to some surprising ones that would seem not to have been vocalized before. Topics sweep over a wide field from the physical or scientific to interpersonal relations. Any subject seems suitable, all are given equal importance, and they are often contradictory, negating each other.*

*The works are postmodernist both in their technologies and in the literalization of their meaning. They are not only about power (political or personal, but in all cases based on language), but its manifestation.*

JEANNE SIEGEL   In a panel discussion on "Politics and Art" in October 1983 at the School of Visual Arts, you said something like this: "People are

This interview, conducted at the artist's studio in New York in September 1985, was originally published in *Arts Magazine* (December 1985).

concerned with staying alive . . . these are dangerous times and our survival is at stake. We should do whatever we can to correct it." Did you see this as the main activity of art?

JENNY HOLZER   I see it as what should be an activity of almost any person in any field. I try to make my art about what I'm concerned with, which often tends to be survival. I do gear my efforts toward that end: I work on people's beliefs, people's attitudes, and sometimes I show concrete things that people might do. I try this on myself all the time, too. I don't think it's what everybody does in art and certainly it's not what everybody should do, but it's an accurate representation of what I try.

JS   You mentioned that its appearance on the Spectacolor Board at Times Square (1982) gave the work impact that it wouldn't have had in a 9-by-12 foot white-walled room sitting on something small. Aren't you doing a lot of work today for these very walls?—in the Whitney Biennial, for example, and the smaller signs exhibited recently in galleries.

JH   I have shown things in galleries and museums in the last few years, but my main activity and my main interest is still the public work. From the beginning, my work has been designed to be stumbled across in the course of a person's daily life. I think it has the most impact when someone is just walking along, not thinking about anything in particular, and then finds these unusual statements either on a poster or on a sign. When I show in a gallery or a museum, it's almost like my work is in a library where people can go to a set place and know they'll find it and have a chance to study. I think it's also really a question of distribution . . . I try to make work go to as many people as possible and to many different situations. I even put stuff on T-shirts.

JS   You also stressed the importance of spending a certain amount of energy at large, actively participating in what you believe in.

JH   If I remember the discussion at SVA, people were trying to find some kind of balance between what you might do in your private life to "save the world," for lack of better words, and what you might do in your professional life. I think what almost everyone came up with is it's fine if your saving-the-world activities are integral to your work, or it's certainly fine if you paint cows in a stream and then spend 20 hours a week lobbying Congress. For myself, I find it less schizophrenic to have lobbying and my work very closely related.

JS   Can you give me an example?

JH   Something that I think would be a fairly concrete or a fairly literal attempt at improving things would be the project I organized at the time of the last presidential election where I set up an electronic forum "Sign on a Truck" for people to discuss their own views on the election. People could speak not just on the quality of the respective candidates but also about the issues that were brought up by the election. This was not only a forum for men and women in the streets to speak about this; it also let me and a number of other artists make very pointed remarks on this topic.

JS   Don't you feel, however, that the mixture of artists' contributions such as those of Vito Acconci and Keith Haring, who obviously felt more in command of the technology and had prepared their segments in advance, with the spur-of-the-moment quality of the "man on the street" interviews finally slanted your message to an anti-Reagan one?

JH   There was a slant insofar as the artists came out against Reagan or against issues normally associated with his candidacy. However, the program as a whole featured prerecorded and live interviews with people who supported the president and his platform. These unrehearsed comments were convincing and they balanced the program. In fact, sometimes the live remarks—in support of either candidate—were the best moments of the event.

JS   Do you think alternative spaces still have as much power, as much place, as they had four or five years ago?

JH   I don't think they have as much power, but they have a very real function for younger artists and for work that's not necessarily commercial. There's a chance for things to happen that perhaps wouldn't in a commercial gallery. Many times things in galleries have to be certain sizes and shapes and be saleable.

JS   I find it a little ironic that an artist such as Justen Ladda can move with such ease from Fashion Moda in the Bronx to the Willard Gallery on Madison Avenue where he is currently showing.

JH   I don't think it's a necessarily bad thing for him. His work was fabulous in the Bronx. Even if his work is adjusted for the gallery situation, that doesn't preclude his going back out again to do installations. I don't think it's an "either/or" proposition—or it doesn't have to be. It's up to the artist.

JS   Isn't it also reflective of what Lucio Pozzi expressed on the SVA panel when he said anything can be bought? Everything becomes a kind of cliché because everybody sooner or later steps into the gallery situation, becomes

part of that political scene that was considered corrupt when the artist started.

JH     But I don't see, and have never really seen, the galleries as entirely corrupt and working on your own as inherently beautiful. If you're working on your own, you're washing dishes or you're selling insurance or cleaning someone's house. Your money comes from someplace and there's all kinds of clean and dirty money in the real world and in the art world. So I think it's not simple.

JS     Before you came to New York in 1977, you were living in Rhode Island and you were an abstract painter. It appears that you shared an attitude with so many young artists at that time—for example, Barbara Kruger—which was that it seemed imperative to find an alternative to painting. Was that a political position? Was it an aesthetic position? Was it that modernist painting seemed trivialized?

JH     There was a political and aesthetic reason for doing it. From a political standpoint, I was drawn to writing because it was possible to be very explicit about things. If you have crucial issues, burning issues, it's good to say exactly what's right and wrong about them, and then perhaps to show a way that things could be helped. So, it seemed to make sense to write because then you can just say it. From an aesthetic standpoint, I thought things in 1977 were a bit nowhere. No painting seemed perfect. In particular, I didn't want to be a narrative painter, which maybe would have been one solution for someone wanting to be explicit. I could have painted striking workers but that didn't feel right to me, so painting at that stage was a dead-end.

JS     Now you are using two tools that are outside of traditional art. One is language, which you started with, and the other is a machine. What both of these share is that they remove the hand. Let's talk about language first. In your use of it, the idea of contradiction is a key one. Here are two examples of conflicting truisms.

> CHILDREN ARE THE CRUELEST OF ALL
> CHILDREN ARE THE HOPE OF THE FUTURE
>
> EVERYONE'S WORK IS EQUALLY IMPORTANT
> EXCEPTIONAL PEOPLE DESERVE SPECIAL CONCESSIONS

In discussing the "Truisms" (several hundred statements listed alphabetically), Hal Foster pointed out that this contradictory approach reveals beliefs and biases rather than truths; that this presentation reveals that language is

true and false, that all truths are arbitrary. Finally, each voice is lost in a plurality of voices by a displacement of language.*

JH   I'd buy that, but I also wanted to show that truths as experienced by individuals are valid. I wanted to give each assertion equal weight in hopes that the whole series would instill some sense of tolerance in the onlooker or the reader; that the reader could picture the person behind each sentence believing it wholeheartedly. Then perhaps the reader would be less likely to shoot that true believer represented by the sentence. This is possibly an absurd idea but it was one of my working premises.

JS   What I was extremely conscious of, but which hasn't been emphasized in criticism, is the sense of absurdity.

JH   That was the other part. My painfully sincere intentions to instill tolerance via the "Truisms" were just as described. The other thing I was going for was the absurd effect of one truism juxtaposed against the next one. I hoped it would be adequately ridiculous.

JS   Would you talk about the range of the subject matter?

JH   What I tried to do, starting with the "Truisms" and then with the other series, was to hit on as many topics as possible. The truism format was good for this since you can concisely make observations on almost any topic. Increasingly I tried to pick hot topics. With the next series, "Inflammatory Essays," I wrote about things that were unmentionable or that were the burning question of the day.

With the "Truisms" I was aware that sometimes, because each sentence was equally true, it might have kind of a leveling or a deadening effect. So, for the next series, I made flaming statements in hopes that it would instill some sense of urgency in the reader, the passerby.

JS   Does the specific site (or the form it took) determine the kind or size of audience you attempt to attract?

JH   In general, I try to reach a broad audience, the biggest possible. But yes, in specific instances I do select material or tailor the presentation to the type of people that I expect will be walking by or riding by. On the truism posters I would have 40 different statements and they would be from all over the place. There'd be left-wing ones, there'd be right-wing ones, there would be loony ones, there'd be heartland ones. When I found that I had the opportunity to do the Times Square project with the Spectacolor Board, I suddenly didn't want to put any up that I disagreed with, so I chose half a

---

*See Hal Foster, *Art in America*, November 1982.

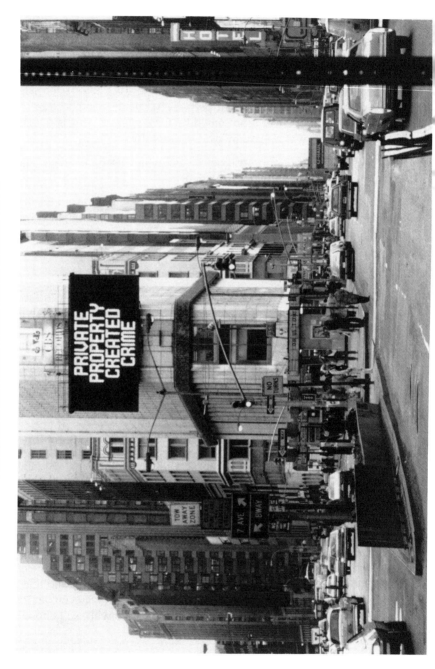

Jenny Holzer, *Selections from TRUISMS*, 1982
Spectacolor Board, Times Square, New York.
*(Photograph by Lisa Kahane; courtesy Barbara Gladstone Gallery)*

dozen that I felt comfortable with. That was a funny development for yours truly.

JS    Let's talk about what I consider to be the other significant material in your work, the recent use of electronic signs.

JH    I came to the signs as another way to present work to a large public, in this case a very different way from the posters. The early writing was all on posters which are very cheap and, to the limits of your endurance, you can plaster them everywhere. So the way to get your work out with posters is through multiplicity. The sign is a different medium because it has a very big memory; you can put numberless statements in one sign. Because signs are so flashy, when you put them in a public situation you might have thousands of people watching. So I was interested in the efficiency of signs as well as in the kind of shock value the signs have when programmed with my particular material. These signs are used for advertising and they are used in banks. I thought it would be interesting to put different subjects, kind of a skewed content, in this format, this ordinary machine.

JS    Your need to function on the street, to engage a larger audience, seems related to Dada manifestations. Do you see these as a source for your work?

JH    Dada influenced me. I particularly liked that the Dadaists were, in their way, grappling with the conditions that led to the war. I found that very interesting and very ambitious.

JS    What about the element of absurdity that we mentioned before?

JH    Dada was poignantly absurd, which is the best kind of absurdity.

JS    Are there other sources in early art?

JH    Other sources for my work have very little to do with the art world proper. One source was an extremely erudite reading list that I received at the Whitney Independent Study Program. The "Truisms" were, in part, a reaction to that reading list which was impenetrable but very good. I kind of staggered through the reading and wrote the "Truisms" as a way to convey knowledge with less pain. Otherwise, most of my sources for the truisms and for the other series are either events in the real world or books on any number of topics—from no particular list.

JS    Can you name a few of those books that impressed you?

JH    For the "Inflammatory Essays," for instance, I read Mao, Lenin, Emma Goldman, Hitler, Trotsky, anyone with an axe to grind so I could learn how.

JS    Are the "Truisms" original?

JH    The "Truisms" are meant to sound as if they are real ones. I try to polish them so they sound as if they had been said for a hundred years, but they're mine.

JS    One of the compelling things about them is the fact that you feel they're not quite right or they reveal something that you hadn't thought about before.

JH    To write a quality cliché you have to come up with something new.

JS    Did early political posters by, say, Heartfield, mean anything to you?

JH    I like his work very much but I didn't know about it when I started. I had kind of a sketchy art history education. The only other art influence was a copy of *The Fox* that a friend gave me when I was at the Rhode Island School of Design. From it I had a vague idea that there were people who didn't make material objects but instead worked with ideas. My comprehension of what they did was almost nil, but I realized that perhaps you didn't have to make little red or green art creations but could concentrate on something else.

JS    Your work is difficult to categorize but, in a general way, one could say that Conceptual art acts as permission for its existence. Joseph Kosuth's focus on idea rather than making, with the ensuing rejection of the object, would ground your work. Then, of course, there is the use of language to convey meaning.

JH    Yes, but often in Conceptual art they excerpted meaning, they used prepackaged meaning, as when Kosuth showed a dictionary definition of art. It was language on language.

JS    However, you do share with Kosuth a desire to reach out to a global situation. You translate texts into other languages and present them simultaneously. He did the same with his billboards.

JH    Yes, I think that's a crossover from Kosuth's and Daniel Buren's efforts to find ways to convey meaning to a large public. I think those guys certainly pioneered that in recent history.

JS    The ticklish question becomes: how can you be simultaneously universal and timely? Your "Sign on a Truck" piece at Grand Army Plaza last year was an example of topicality in that it was structured largely around Reagan just before the election.

JH    Yes, but the event was perhaps more topical than it was art. I would think that it was more of a community service with a dose of art in it.

JS   The line between art and propaganda is a tenuous one. On what basis do you make the distinction?

JH   I find that writing is more effective if it's not dogmatic and if it's not immediately or not entirely identifiable as propaganda, because then it becomes something you would hear on the news or it becomes a line—a left-wing line or a right-wing line. One reason why I started to work was because I found that a lot of the statements of the Left were tired, and as soon as people would hear a few catch phrases they would tune out. I thought I would try to invent some ways of conveying ideas and information that people wouldn't dismiss within two seconds of encountering them.

JS   Are there artists today working in this sphere that you admire?

JH   Justen Ladda, for instance. I liked the many levels that his piece in the Bronx operated on. I thought it was very successful because it was about important issues but was not didactic. I also thought his siting was inspired and was a wonderful way to bring up social concerns without being embarrassing, without saying, "We must all band together to save the Bronx or to save Western civilization." That was inherent in the piece because of his location.

   I like John Ahearn's work for many of the same reasons. In his case, for the one-on-one human interaction that goes into the casting process of his portrait heads. I also think that Leon Golub's work spotlights an important phenomenon: men who murder for fun and money. I like painters like Sigmar Polke who have content and an incredible beauty in their work as well. I like Gerhard Richter for his range of subject matter; his mind and his paint range over all topics. I appreciate graffiti artists like Lee Quinones who take their content to the streets.

JS   What about artists who use words?

JH   I like Barbara Kruger's work very much. It's so obvious that I didn't think to say it. I admire Lawrence Weiner's early *Works* book—the art pieces where, for example, the reader is supposed to throw a bag of paint on the wall and that's that. I think that's great.

JS   Bruce Nauman converts neon into words.

JH   I enjoy Nauman's work very much. I appreciate the way he plays with the language, makes it funny but still retains an edge of seriousness. He's also interested, I think, in devising formats that are appealing to people so that they are sure to read his work—my same desire.

JS   Do you feel it is the area of the art critic to discuss the philosophical and political implications of your work?

JH   Sure. A lot of art concerns itself with the history of thought or with social and political realities, so when a critic writes about this kind of art, he or she would need to address these subjects just to describe the work, much less to analyze it or pass judgment on it.

JS   Then should criticism of content supersede criticism of formal issues?

JH   Best of all would be a criticism that remarks on all aspects of the work. For the art to be successful, and for that matter, for the content to be compelling, the subject must be presented in a way that's appropriate. Appropriate means that formal considerations have been attended to, that they are as marvelous as the message. That's what the artist has to shoot for, and that's what the critics need to recognize and describe.

JS   The focus on and radicality of content have been uppermost in discussions of your work to a degree that your various manifestations of style have gone unnoticed or at least unexamined. In recent works where you use electronic signs, what seems significant is the movement. How do you think of movement? How do you use it?

JH   A great feature of the signs is their capacity to move, which I love because it's so much like the spoken word: you can emphasize things; you can roll and pause, which is the kinetic equivalent to inflection in the voice. I think it's a real plus to have that capacity. I write my things by saying them or I write and then say them, to test them. Having them move is an extension of that.

JS   The words move along unremittingly. They move from right to left but then, all of a sudden, one will go up and down or left to right or even stop. You use an assortment of such stylistic devices.

JH   The trick is to keep the whole thing hypnotic. But to sustain hypnosis you have to have variety, so you throw in fits and starts, and up and down, and round and round.

JS   So it is primarily to keep the viewers' attention?

JH   To hold their attention and also to be appropriate for the content. I tailor the programming to what is being said; I also attempt to give the whole composition enough variety. It almost gets musical.

JS   You're involved in rhythm, pauses, pacing.

JH   Time . . . and then you can get into typography, too. I had a stint as a typesetter so this comes out in various ways.

JS   I was particularly struck by the shaping of words or letters, their size and type, their flickering. All seem to me very important in terms of emotional tone—what you want somebody to feel about what is being said.

JH   I try to make the special effects appropriate to the sentences. I familiarize myself with the capacities of the various signs and then use these fireworks to the max.

JS   Are these effects that you saw in advertising signs or have you devised some of them yourself.

JH   I use signs that have a set number of effects, but there are so many of these effects that the combinations are infinite.

JS   The fact that you've chosen this machine actually makes a comment on our contemporary technological environment. It's fast, transient; it comes and goes; unless you repeat it, it's gone. In that sense, it's highly reflective of our overloaded, media-bombarded world.

JH   It's funny, though. It's only in the art world that it's a "comment on." When it's in the real world, it's just a modern thing. It's a good gizmo. I'm not so interested in the self-referential aspects of it.

JS   This brings us back to your forms of writing. You have used aphorisms and manifestoes, for example. Are you working on anything right now that will take a different form?

JH   The thing I'm doing now is less a recognizable form. It's not a manifesto. It's not a cliché. It's just simple assertions or simple observations, one or two sentences.

JS   The one or two sentences stand by themselves?

JH   They literally stand by themselves for an instant when they're programmed in electronic signs. They're always in a moving sequence. They're often one of 60 remarks or one of 500 remarks. I want them to be complete and interesting individually, but I pay attention to sequencing and I compose the program as a whole.

JS   That was true of the "Truisms."

JH   Yes, but when I started with the "Truisms" they only gradually became a series with the signs I set out in the beginning to create a program. I know the size of the memory of the various signs, so I create something that will make sense within those limits.

JS   How did you determine the length of your so-called program?

JH    I usually fill the signs to capacity. To date, the L.E.D. signs have had a memory of 15,000 characters, which is 15,000 letters or commands for the special effects. They're coming out with signs that can play a library of programs. You pop in one 15,000-letter chunk and then you take it out and you can put in another. I'm trying to develop a collection of programs that can be displayed.

JS    But don't you also have to take into consideration the endurance of your audience? How long is somebody actually going to watch?

JH    I realize that people's attention span, especially if they are on their way to lunch, might be 2.3 seconds and so I try to make each statement have a lot of impact and stand on its own. That still doesn't mean that I don't try to make a whole program that works. I want the statements to reinforce each other so the whole is more than its parts. I just try to make the parts O.K., too. I also want to supply people with a cheap electronic retrospective of my work.

JS    One of the remarkable things is the fact that you recognized the problem of reading dense texts in small type in an art gallery. Even I as a critic resist reading in a gallery.

JH    It's miserable. It's hard enough to stand up and look at paintings.

JS    You found the answer by making it clear, short, and readable.

JH    Punch and wiggling are the secret. But people are much more tolerant about how long they'll stand and read in a gallery than they are at rush hour on the street. Since most of my experience is trying to stop people on the street, I'm very aware of how much time you *don't* have with your audience.

JS    With the Spectacolor Board and other electronic signs, you've introduced images.

JH    Again, it's almost like the sign leading the artist. I found a sign I liked very much that had graphic capacity and I thought, why not use it? People respond to images. I thought, go with it. I like to draw. I haven't had a chance for a long time. What I'm also doing that's different is using videos of people saying my sentences. The "Sign on a Truck" is compatible with videotape so it lets me have real people make pronouncements, which of course is not possible with writing. With text you can't always have the kind of richness that's natural in a voice. You can't have the information that you get from looking at people's faces. I'm hoping to have that as a new element in the work.

JS    Along with that came a growing sophistication in your use of color.

JH    It just wasn't possible with the little signs. You can have them in red, yellow or green—that's it. With the larger signs, there are a number of colors, so you might as well play with them. I had my Albers training.

JS    It seems you're moving toward a more painterly situation. As a matter of fact, with all of these elements coming together, what I am becoming more conscious of is the aesthetic. They look more like ''art.'' The small boxes are more objectlike.

JH    Well, they might look more like art in an art gallery, but if you see them in an airport—actually these signs are at JFK with Gucci ads on them—they just look like, hey, that's the best electronic sign I've ever seen (that is exactly how I found them). I like the complications of the larger signs and I like having the chance to use colors and to draw. I'm all for it—I just get nervous when people say it looks like art.

JS    What are your plans for new work?

JH    I'll try in some situation or another to do a second truck event. I'm also going to work on a couple of spots for television (30-second or 60-second pieces). I'll have a chance to do that in New Mexico in January. I'd like, if possible, to develop a lot of spots because my big discovery of the year is that television time is not prohibitively expensive. I had an internship recently with a station in Hartford and found that you can buy 30 seconds in the middle of *Laverne & Shirley* for about seventy-five dollars, or you can enhance the *CBS Morning News* for a few hundred dollars. The audience is all of Connecticut and a little bit of New York and Massachusetts, which is enough people.

Again, the draw for me is that the unsuspecting audience will see very different content from what they're used to seeing in this everyday medium. It's the same principle that's at work with the signs in a public place. An example of this is a piece which appeared on the Spectacolor Board: PRIVATE PROPERTY CREATED CRIME. It shows how you can surprise people by putting unexpected remarks on a familiar sign board where people expect to see an ad for a restaurant.

JS    Will you have any gallery shows?

JH    I've been asked to show at the Pompidou. I hope to do something both on the facade of the building and perhaps in their new gallery. In the new gallery there are walls I can use that face the streets outside. They also have an enormous canvas banner that they can stretch on the strutwork of the exterior.

Barbara Kruger
*(Photograph © Timothy Greenfield-Sanders 1986)*

# Barbara Kruger: Pictures and Words

*Jeanne Siegel*

*Kruger makes a big point of stating that she comes out of advertising (she worked as a designer and picture editor for various Condé Nast publications for 10 years). From the poster and magazine advertising, she learned how crucial it is to convey the urgency and feeling of the moment: this occurs both in her choice of image and a style that suggests quick execution.*

*She combines compelling images, whether in seductive or threatening poses, with pungently confrontational assertions to expose stereotypes beneath. She uses aphorisms that are lifted straight or, like some of Duchamp's Readymades, are aided to inflect their meanings. This lends a familiar ring to the work which, in Kruger's words, is "part of its strategic innuendo." Although many of Kruger's targeted "myth explosions" appear to be universal, and some of them certainly are, she predominantly focuses on unmasking late capitalism's consumerism, the role of power in patriarchal societies, the power of the media, stereotypes of women and occasionally art. Within these themes, she juggles the universal with pointed specificity—no small task.*

*In common with other leading contemporaries, Kruger views the flattened spaces of Modernism as a given which no longer simulate or refer but engage in an active sense of play with the spectator, who questions the elements of the disembodied space but is also questioned or judged in his or her reading of these same figures. It should come as no surprise that her closest friend is the painter Ross Bleckner, and that her early career developed in close proximity to David Salle, Julian Schnabel, Sherrie Levine. She*

This interview, conducted at the artist's studio in New York in March 1987, was originally published in *Arts Magazine* (June 1987).

*now also functions as a television and film critic, but her writing is directed to an art audience.*

_____

JEANNE SIEGEL    You had your first solo show in 1974 at Artists Space. But it seems that you didn't get any serious critical attention until 1982—the kind of critical attention that raised issues that we're still discussing today. Why do you think there was that time gap and why do you think it happened in 1982?

BARBARA KRUGER    Why things "happen" as you say, in the art world as they do, does not differ greatly from the mechanisms of other "professional" groupings. Why certain productions emerge and are celebrated is usually due to a confluence of effective work and fortuitous social relations, all enveloped by a powerful market structure. Of course, just what the effectiveness of work is becomes pivotal and it is this area which is of interest to me. I see my production as being procedural, that is, a constant series of attempts to make certain visual and grammatical displacements. I didn't pop into the world with a beret on clutching a pair of scissors and a stack of old magazines. I don't think that an artist instantly materializes chock full of dizzying inspirations and masterpieces waiting to be hatched. I think the work that people do can be determined to some degree by where and when they've been born, how they've been touched, the color of their skin, their gender, and what's been lavished upon or withheld from them. I think it took me a while to determine what it could mean to call myself an artist and how I could do work that was questioning, yet pleasurable, for both myself and others.

JS    How did that transition actually take place?

BK    I attended art school and college for only about two years, but even in that short time, the educational system had begun to do its unfortunate work. I remember being at Parsons and asking a teacher whether an artist could work with photographs and magic marker. I was told in no uncertain terms that if I was planning to be an artist I would have to hide out in a garret for 10 years and learn how to grind pigment. I have no doubt that if I had been at Cal Arts in 1973, my educational experience would have been a bit different. Well, anyway, I left school and worked as a graphic designer for quite a while, doing mostly magazine work and book covers. When I finally began doing so-called *artwork,* it was the processes of painting and stitching to which I gravitated. That lasted about four years, and although it offered me some really pleasurable, cozy-wozy studio activity, I simply

couldn't continue doing it. The sirenlike call of photography and magic markers was continuing to beckon me and I guess I was determined to follow it.

JS    But it took until the early 80s for you to shift to a more political work that caught the critical attention to which I referred a moment ago.

BK    It always amuses me that when an artist chooses to foreground the tray of stylistic hors d'oeuvres from which they are obliged to make their choice of visual signature, people react with a kind of impatience. I find the labeling of my more recent work as *political,* to the exclusion of my early activity, to be problematic. First, I am wary of the categorization of so-called political and feminist work, as this mania for categorization tends to ghettoize certain practices, keeping them out of the discourse of contemporary picture-making. My early work was relegated to the category of the decorative, long before the short-lived celebration of "decorative art." Turning to craftlike procedures was a conventional, historically grounded way for women to define themselves through visual work. However, I don't subscribe to the uncritical celebration of this work, which might suggest that women have a genetic proclivity toward the decorative arts. Women were allowed to develop certain virtuoso visual effects within the interiorized, domestic space of the home. I had the pleasures and problems of indulging in this type of artistic activity for a while, and I think that the relations which produced the sanctioning of this work certainly do constitute a politic.

JS    What followed?

BK    I started writing and performing narrative and verse while I was still painting and found that the entry of words into my work soon brought my painting to a grinding halt. By 1978 I was working with photographs and words.

JS    However, the general climate in the country was shifting too at that particular time. Reagan was elected in 1980.

BK    My work went through big changes around 1976, if we have to get numerical about it. And although changes in electoral leadership can symbolically affect how people live their lives, I think that a number of artists working today developed an awareness of the mechanics of power and dispersal that predated the election of Ronald Reagan. To get really concrete about things, my disenchantment with my own work and the subculture which contained it coincided with a period of forced economic exile from New York. Having no money, I was fortunate to get a number of visiting artist jobs which removed me from the city for scattered semesters over a period of about four years. During this time, I read a lot, drove around a lot,

went to lots of movies, and generally tried to rethink my connections to my work, to the art world, and most importantly, to the games and relations that congeal, disperse and make the world go round.

JS   Were you more conscious of Reagan in California? Perhaps already aware of Reagan as the quintessential figure of "appearance" or "illusion," a point which is fundamentally made in your work?

BK   Ronald Reagan is an actor. He is directed and produced. He stands where he's supposed to stand and says what he's told to say. He was president of the Screen Actors Guild and a government informer. He and his directors know that television elects presidents.

JS   His growing media image coincided with a second possible framework for the new development in your work. That is the change in attitude in the art world toward photography, which came about at about the same time— in the late 70s or early 80s. In the 70s photography had extremely limited exposure in the art world. Perhaps we could pinpoint this change in recep- tivity in terms of artists; for example, in 1977 Laurie Anderson used media images in her performances.

BK   If you want me to name names one would have to talk about Warhol, and then later Ed Ruscha, John Baldessari, and later on David Salle, Richard Prince, Sherrie Levine, Sarah Charlesworth, Troy Brauntuch, Laurie Sim- mons, Jack Goldstein, Cindy Sherman and Robert Longo. The "Pictures" exhibition at Artists Space was organized in 1977.

JS   Did that make a difference for you?

BK   I think there are precedents for working with pictures excised from the media which go back a long way. But of course, I had friendships with many of the artists who were developing a vernacular sort of signage. How- ever, the use of words lent my work a kind of uncool explicitness. I have to say that the biggest influence on my work, on a visual and formal level, was my experience as a graphic designer—the years spent performing serialized exercises with pictures and words. So, in a sort of circular fashion, my "labor" as a designer became, with a few adjustments, my "work" as an artist.

JS   Specifically, what do you think you held onto from that experience?

BK   Almost everything. I learned how to deal with an economy of image and text which beckoned and fixed the spectator. I learned how to think about a kind of quickened effectivity, an accelerated seeing and reading which reaches a near apotheosis in television.

JS    How does the image and the text work in advertising?

BK    It's difficult for me to engage in an analysis of advertising. Like TV, it promiscuously solicits me and every other viewer. In the face of these global come-ons I claim no expertise. I become as fascinated as the next person, but every now and then I feel the need to come up for air. In these forays above the watermark, I try to figure out certain procedures and manage some swift reversals. But there is no single methodology which can explain advertising. Its choreographies change from medium to medium: from print, to billboards, to radio, to TV. Each medium, according to its own technological capabilities, stages its own brand of exhortation and entrapment.

JS    Weren't you attracted to advertising because of the awareness that the image gets one's attention—it piques the viewer's curiosity of desire? Then you use its seductiveness to reveal some aggression.

BK    I have frequently said, and I will repeat again, in the manner of any well-meaning seriality, that I'm interested in mixing the ingratiation of wishful thinking with the criticality of knowing better. Or what I say is I'm interested in *coupling* the ingratiation of wishful thinking with the criticality of knowing better. To use the device to get people to look at the picture, and then to displace the conventional meaning that that image usually carries with perhaps a number of different readings.

JS    In a recent show of commercial work by art photographers at the International Center of Photography, one could hardly distinguish between this and their atelier work. They are, in a sense, criticizing cultural commodification in their artwork by inserting the same commodities they were creating ads for from which they profited—a strange kind of crossing of boundaries. Do you have any argument with that?

BK    I think that social relations on a neighborhood and global level are contained by a market structure, a calculator of capital that fuels a circulatory system of signs. We sell our labor for wages. Just because something doesn't sell doesn't mean it's not a commodity. None of us are located in a position where we can say "I am untainted and I'm pure." I think it would tend to be deluded if one thought that way.

JS    You are for an art of "social change." You have said you hope "your work can change things a little bit."

BK    I would rather say that I work with pictures and words because they have the ability to determine who we are, what we want to be, and what we become.

JS   Let's put it another way. You show us a stereotypical image of a woman and then, through the juxtaposition of image and text (in Craig Owens's words "The Medusa Effect . . . ") you "force us to decode the message." This should effect a change in our thinking or attitude.

BK   I think the issues are complicated. The media, I prefer to speak of television, has become a site of fascination, which is watched but not seen. TV is an industry that manufactures blind eyes. Likewise, the information industry effaces all remnants of specificity, leaving only faint and embarrass-ing trails of remembrance. It's problematic to speak of the liberation of the medium of TV, as television is already removed from the site of any recipro-city. That's the long view. But when we move closer to the screen, we begin to make out certain figures, figures without bodies—which, of course, is the site of the stereotype. It is in this area of representation that the rules of the game can be changed and subtle reformations can be enacted.

JS   In reading through your work on stereotypes about women, it struck me that you have stressed certain characteristics, for example, immobility ("We have received orders not to move"), silence ("Your comfort is my silence"), passivity, woman as spectacle ("Your gaze hits the side of my face," "We are being made spectacles"). In defining masculine stereotypes, you stress aggression, intimidation, violence and terror. A broad and signifi-cant category of interest is "difference"—the stereotypical inability to ac-cept difference and at the same time, where advantageous, to preserve it ("We won't play nature to your culture"), ("You destroy what you think is difference").

BK   I would rather say that I work circularly, that is around certain idea-tional bases, motifs and representations. To fix myself, by declaring a singu-lar methodology or recipe, would really undermine a production that prefers to play around with answers, assumptions and categorizations.

JS   Barthes discusses the role of text in its ability to control the projective power of the image. He says

> Elsewhere than in advertising, the anchorage may be ideological and indeed this is its principal function; the text *directs* the reader through the signified of the image, causing him to avoid some and receive others; by means of any often subtle *dispatching,* it remote-controls him toward a meaning chosen in advance.

Would you say that this element of control figures in your work?

BK   I think it applies somewhere; I think it's a movement in and around. I think that sometimes there is an openness in terms of the possible readings of my work. But I'm also a body working within a particular space who is making work to further her own pleasure. And that pleasure means a certain

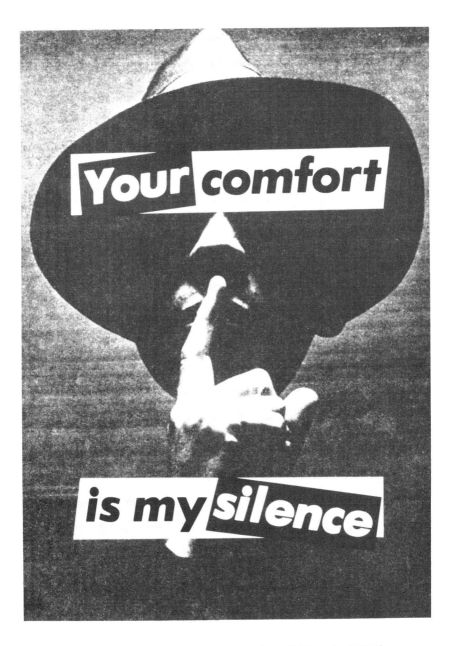

Barbara Kruger, *Untitled ("Your comfort is my silence")*, November 1981 Show
Photostat on museum mount.
*(Courtesy Annina Nosei Gallery)*

investment in tolerances, in differences, in plenitudes, in sexualities and in pleasure rather than desire. Because desire only exists where pleasure is absent. And one could say that the wish for desire is the motor of a progress that can only efface the body.

JS   How do you see the meaning of your work expanding from the realm of personal pleasure to the stereotypical?

BK   It was Roland Barthes who suggested that the stereotype exists where the body is absent. He had a knack for being so economically eloquent. One of the possible meanings of his comment could be that the repetition of stereotype results in a figure which is not embodied. Not an empty signifier, but a perpetual ghost with a perpetual presence.

JS   The role of the stereotype and body positioning is so important in the images that you use. For example, in *Untitled* (*"We won't play nature to your culture"*), passivity is coupled with recumbency. Also, you use body fragments—hands, feet, and heads—a lot.

BK   I do use lots of hands. But I think I choose images with lots of expository space in them. It's a clean-cut overture that promises fast results.

JS   That usage is prevalent in earlier posters—particularly the use of hands in political posters. They're used symbolically for a number of different reasons—solidarity, power, numbers. Also hands may stand for other parts of the body, particularly in Surrealist depictions.

BK   I agree with what you're saying but my work was not informed by the history of poster design nor Surrealist photography because I simply wasn't aware of it. I think people who are basically very situated within art historical practices and don't know anything about the world of magazine work and advertising, who are very naive about the repertory and choreography of type and photography, look at my work and say "Heartfield." And I was not even aware of Heartfield till '80 or '81.

There are also people who come from, say a left art historical place, and who look at my work and say "Heartfield," because there are certain other things in the work that, especially if they're not American, are too difficult for them to really welcome into the discursive practices of art and art history. For instance, I was speaking to a curator from Europe a few weeks ago, and he said to me, there is much history in terms of your work in Europe, especially in Germany there's a historical grounding. And I said, well what's that? And he said Heartfield and Moholy-Nagy and I said I didn't know that Moholy-Nagy was doing work on gender and representation.

JS   One of the major differences between Heartfield's approach and yours is that Heartfield was so specific.

BK   My work tends to be rangy, but it tries to critically engage issues frequently not dealt with in much so-called *political* work: that is, the terrain of gender and representation. If one believes that there's a politic in every conversation we have, every deal we close, every face we kiss, then certainly the discourses and intercourses of sexuality have a place around or even on top of the conference tables of international diplomacy.

JS   In locating contemporary myths, Barthes makes a point that essentially he's talking about the French. Would you say yours are more about Americans?

BK   Not exclusively. No doubt there are site-specific discourses which have their meanings fixed within locations: indigenous struggles, community issues, labor relations, various national identities. I will foreground frequently, when I'm speaking, that every sort of address has some place. But I think that one should be very critical and very thoughtful when one tries to speak for others, which is a very problematic thing to do. So I will frequently say—when I'm speaking on a humorous level—now I'm talking about the Tri-state area. On another level I could say there is some kind of site specificity involved in what one does. I just did a show in Paris last week. I know that that work said something to that culture. It doesn't mean I'm going to be having a show at the ICA in Katmandu, but I think of that all the time when I do billboards. But it is also possible to suggest global linkages: systems of signs and codings which, dare I say, implode into a global glob of seemingly meaningless associations.

JS   There is a long tradition of posters that contained only graphic images. Dawn Ades [Photomontage] says "a photograph is not a sketch of visual fact, but an exact fixation of it. This exactness and documentariousness gives the photo a power of influence over the observer which graphic images can never attain." Do you agree?

BK   I think that the exactitude of the photograph has a sort of compelling nature based in its power to duplicate life. But to me the real power of photography is based in death: the fact that somehow it can enliven that which is not there in a kind of stultifyingly frightened way, because it seems to me that part of one's life is made up of a constant confrontation with one's own death. And I think that photography has really met its viewers with that reminder. And also the thing that's happening with photography today vis-a-vis computer imaging, vis-a-vis alteration, is that it no longer needs to be based on the real at all. I don't want to get into jargon—let's

just say that photography to me no longer pertains to the rhetoric of realism; it pertains more perhaps to the rhetoric of the unreal rather than the real or of course the hyperreal.

JS    One critic said that your use of "you" and "we" was so compelling that one can't escape into aesthetics. Would you discuss this strategy?

BK    I think that the use of the pronoun really cuts through the grease on a certain level. It's a very economic and forthright invitation to a spectator to enter the discursive and pictorial space of that object.

JS    But ultimately it becomes ambiguous.

BK    It can be. Again, it depends on the spectator very much.

JS    Early on, you said one of your main purposes was "to welcome the female spectator into the audience of men." Have your ideas on the issues of gender changed over the past 10 years?

BK    Obviously, the need to destroy difference is as rampant as ever. Nevertheless, I think a number of new games have been put into place: games fitted with prized plenitudes and horizontal grids as opposed to the usual ladders, and relentless verticalities of refinement and challenge. On a concrete level, in many countries feminism has clearly been the only revolution in town. But struggles against oppression exist globally, with no sign that tolerance or benevolence are on the upswing. I think that this particular administration has certainly done more than many to efface the body in the most general form, to efface the pleasure and desires and the ability for people to survive with some kind of benevolence.

JS    In 1977, in discussing the rhetoric of the image, Barthes said

> Today, at the level of mass communications, it appears that the linguistic message is indeed present in every image: as title, caption, accompanying press article, film dialogue, comic strip balloon. Which shows that it is not very accurate to talk of a civilization of the image—we are still, and more than ever, a civilization of writing, writing and speech continuing to be the full term of the informational structure.

BK    Obviously, speech, text and captioning still function as sites of meaning. But I think there's been an evacuation of the specificity of language into the black hole of the image. Facts, fictions, realisms, all disperse into an aerosol which reconstitutes itself into a cohesion of non-senses. Just take a look at the American electoral system, or for that matter, any national political structure. We've come so far, I'm not sure in which direction in the past 10 or 15 years, loosening any sort of image from the notion of meaning, from the notion of truth. So that's where the whole lapse into the simulacral discourse has been.

JS    And this, of course, is where Baudrillard picks up on it.

BK    Yes, and in a kind of riveting, yet highly problematic manner.

JS    What interests you the most in Baudrillard's ideas?

BK    Well, to be concrete, the essay "Design and Environment" in which he talks about fashion and its territorial scope, its ability to subsume everything. That's a really important essay. Also "Requiem for the Media," which is a critique of the notion of liberating the media, as the media itself is responsible for the murder of response. Also "Gesture and Signature" and "The Art Auction" are both stringent analyses of the commodification of the art object.

JS    Baudrillard believes that the new information of the electric mass media, namely TV, is directly destructive of meaning and signification, or neutralizes it. But Baudrillard is the theorist par excellence of nihilism and I don't see you as sharing his cynicism. Do you see contemporary art in Baudrillard's recently expressed terms as "a simulation of its own disappearance?"

BK    Definitely, and I hope so.

JS    Since Benjamin and Baudrillard, the role of the "original" has become a major issue in contemporary, theoretical writing. Where do you stand on this?

BK    I always stand in a few places at once. As long as there's a market, as long as art objects function as a vessel for capital, the notion of the original will remain intact. I produce work in ways which make them as effective as possible, which means that I produce images that are called "one of a kind" as well as multiple lenticular works. However, new technological capabilities are clearly doing their part in playing havoc with the traditional place of authenticity.

JS    How important is the role of theoretical writing in your work?

BK    I get great pleasure out of reading certain theoretical work. Some texts seem to interface with the moments of my life on the most apparent and pleasurable levels. It really feels quite uncomplicated and seldom intimidating. I especially experience this with Barthes, Kristeva and Baudrillard, to name a few.

JS    Then you don't feel that the critical material that has gathered around your work boxes you in?

BK    Not at all. I think that criticism can be a very important, pleasurable form. Walter Benjamin wanted to write criticism which would be more generative than that he was writing about. And I think it's possible for critics to do that at times too.

But I don't need another hero. I'm a failure as a groupie. I admire people's work, admire their writings, admire their visual work, and I'm not religious about my affections for them. Which means that it's just another practice that interfaces with my own, which I enjoy.

JS    Do you find a difference in the way art critics and photography critics address your work?

BK    I don't really categorize them that way. I just see a large ongoing text of commentary coming from different social positions, different ideological constructs, different institutional positions, whether they're educational institutions, or whether they're journalistic institutions. So I see it as all of one piece.

JS    You mentioned that you like to show your work in different ambiences which embrace both public and private spaces—galleries, museums, billboards, etc. Do you make specific works for specific sites? Do you have any feeling about which is more effective?

BK    I think that the images do their work within a various number of places, within a various number of sites. And that's important to me. And also, making billboards has become much easier for me, having entered the discourse through a gallery structure which develops the notion of the personage and makes projects easier to realize.

JS    I enjoyed the Spectacolor Board in Times Square in 1983 where your message read "I AM NOT TRYING TO SELL YOU ANYTHING."

BK    I hope that work said what it had to say. It's really a very charged site. There's a tremendous pedestrian density. People look up at that sign. It's a great place to work. I also see the museum as a medium, as a way of reaching people, of reaching spectators. A tremendous amount of people walk through museums. They become dense theaters of receivership.

JS    You're going to be exhibiting in a lot of different situations shortly.

BK    In April I did a show with Monika Sprüth in Cologne. I just had a show at Crouse-Hussenot in Paris, and Mary Boone in May. The Whitney Biennial opened in April and Documenta in Germany in June.

JS    Was there any new direction registered in the Whitney pieces?

BK   In the Whitney show I wanted to be more thematic. The focus was on the theme of shopping, buying and getting your money's worth.

JS   One huge and striking work, *Untitled ("A picture is worth a thousand words")*, contained only words. In the pieces with words alone, the revelation that occurred as a direct result of the confluence of image and word was jettisoned. What is put in its place?

BK   I'd rather say that different things occur in other places. The spectator is met with words that are inflated into the visual costume of the image.

JS   Another big change was scale.

BK   I started doing large-scale billboards about two years ago. I've realized a number of these projects in Minneapolis, Berkeley, Chicago, 30 billboards in Las Vegas and 80 sites in England, Scotland, and Northern Ireland. These projects allowed me to see the possibilities at work in large-scale images. They also brought up questions of context, site-specificity, publicness and the momentary loss of the proper name.

A way of looking at it is that I'm interested in occupying a number of positions in the space located between the cartoons of emancipation and possession. Navigating within that broad area is something that engages me. And there are any number of ways to perform that activity and make that journey. I'm just trying out as many as I can.

# Contributors

MAURICE BERGER is Visiting Assistant Professor of the History and Theory of Art at Hunter College of the City University of New York. He was a Junior Fellow at the New York Institute for the Humanities at New York University in 1983–85.

BARRY BLINDERMAN is Director of University Galleries, Illinois State University, and a Lecturer on contemporary art. He was Director of Semaphore Gallery, New York City, from 1980–87, and has published numerous essays on art.

LYN BLUMENTHAL is an artist, the Executive Director of the Video Data Bank, and the Producer of the video series, What Does She Want. Her videos have been screened at the Museum of Modern Art, The Whitney Biennal, the Berlin Film Festival, the Centre Pompidou, The American Film Institute.

BENJAMIN H.D. BUCHLOH is currently the Beatrice Cummings Mayer Visiting Professor of Art at the University of Chicago. He is the Editor of the Nova Scotia series and received the Frank Jewett Mather award for distinction in Art Criticism in 1986.

HENRY GELDZAHLER became the first Curator of Twentieth-Century Art at the Metropolitan Museum in 1966, and in 1978 was appointed Commissioner of Cultural Affairs for the City of New York. Currently he is lecturing, writing, curating, and advising corporations and collectors.

KATE HORSFIELD is an artist and instructor in Theory and Criticism as well as in studio courses. She is co-founder of the Video Data Bank.

HELENA KONTOVA is an editor of Flash Art.

Donald Kuspit won the Frank Jewett Mather Award for distinction in Art Criticism (1983) awarded by the College Art Association. His most recent book is *The New Subjectivism: Art of the 1980s* (UMI Research Press).

Georgia Marsh is a painter living and working in New York City. She has had one-person gallery exhibitions in New York, Paris, Milan, Rome, Los Angeles, and Philadelphia. Her work was featured in the "New Romantic Landscapes" show at the Whitney Museum, Stamford, in 1987. She writes for *BOMB* and *Art Press*.

Carlo McCormick is Associate Editor of *Paper* and Contributing Editor of *High Times*. He is a frequent contributor of *Artforum* and a number of other publications on art, performance and music.

Achille Bonito Oliva is Associate Professor of the History of Contemporary Art at the University of Rome. He has organized many exhibitions in Italy and abroad, and has authored *The Italian Trans-avantgarde* (1980). He is a Contributing Editor of *Flash Art*.

Giancarlo Politi publishes extensively on art, including *Flash Art*, of which he is also Editor.

Peter Schjeldahl is senior art critic of *7 Days* and a Contributing Editor of *Art in America*.

Jeanne Siegel chairs the Fine Arts Department and the Art History Department at the School of Visual Arts in New York City. She is Associate Editor of *Arts Magazine*. Her first book of interviews, *Artwords: Discourse on the 60s and 70s* was published by UMI Research Press in 1985.

Robin White was Executive Director of the Media Alliance in New York from 1983 to 1988. Currently she is a consultant with Electronic Arts Intermix, with the National Alliance of Media Art Centers, and with the production company Owen Electric Pictures, and is also co-producing *Rock Soup*, a film about New York City's homeless population.

# Index

# Other DA CAPO titles of interest